Comics Sketchbooks

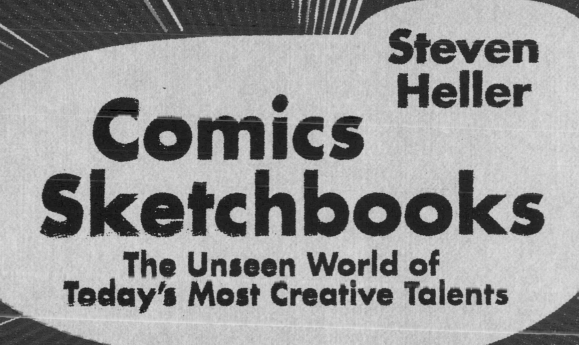

Steven Heller

Comics Sketchbooks

The Unseen World of Today's Most Creative Talents

Thames & Hudson

CONTENTS

DOODLES, NOODLES, AND SKETCHES
STEVEN HELLER

DOODLES NOODLES AND SKETCHES

STEVEN HELLER

Looking through artists' sketchbooks is like viewing those artists naked through a picture window. With twenty-twenty eyesight or high-powered binoculars you'll see everything: warts, blemishes, and all. Even in this book, in which sketches have been culled and edited, not once but thrice – by the artist, author, and designer – the occasional unintended embarrassing image will inevitably come through. It is risky to show unfinished art, regardless of the medium, for it is the curtain pulled back. A sketchbook is even more like looking into the artist's thoughts – a scary prospect indeed.

I have much respect for the artists herein who have agreed to expose themselves. While it may appear easy enough to submit pages from a sketchbook, sketch file or sketchpad to be reproduced in a book (indeed, it does not take much more than scanning what already exists), it actually demands considerable courage on the part of the contributor. At the very least, it may reveal secrets of the trade that might be better kept secret. At most it could show the hidden, perhaps ugly, side of the artist's personality or talent ("Now they'll see what a fake I am," said one of the contributors).

Some artists were readily able to share their unrealized work – and even eager to open their windows to all. Others were more modest, circumspect, or self-conscious about showing what they called "bad" work. Still others claimed they did not keep their sketches, but discarded them after a project was completed. So what about doodles? They were too ephemeral to save.

The myriad pages and scraps compiled here should be considered gifts to you and me. Sketches are intimate offerings. Some are incredibly rough, while others are surprisingly finished; yet all are private artifacts. Many, given the focus of this book, are witty, and others are poignant. And there are also plenty of random ones that, in the tradition of all good sketches, simply crop up like weeds as an outgrowth of the artists' idle thinking.

The common denominator of this volume is comics, though not all the sketches are made for comics. All the artists nonetheless make comics either as their primary occupation or in addition to other illustrative or art work. The artists come from the US, Europe, South America, and Japan. For some, their national cultures influence their style, form, and content. Others are inspired by the rampant popular culture that flies through the air and permeates the media. And there are even a few artists featured in this book who are profoundly influenced by others who also appear here.

The artists herein are both veteran and neophyte – young, old, and older. The vets, such as R. Crumb, Victor Moscoso, and Kim Deitch, emerged during the golden age of underground comix – when I learned to love the medium. Arnold Roth is the most "venerable" of the those included here; an original *MAD* magazine artist, he is still working at the very highest level. *MAD*, of course, was the father of underground comix. Gary Panter and Charles Burns, also elder statesmen, came to prominence during the punk period, when *RAW* magazine revolutionized the comics form, promoting more introspection and, of course, through Art Spiegelman's *Maus*, introducing autobiography to the mix. And Jim Steranko, comics historian and superhero "marvel," is revered by many.

Every page in this book contributes to our collective appreciation of comics art – and of art in general. For those who savor craft, this unfettered look is an intimate perspective. For those who enjoy a good narrative, many of these sketches will doubtless entertain. And for those who simply love the comics form, well, that's what this book is all about.

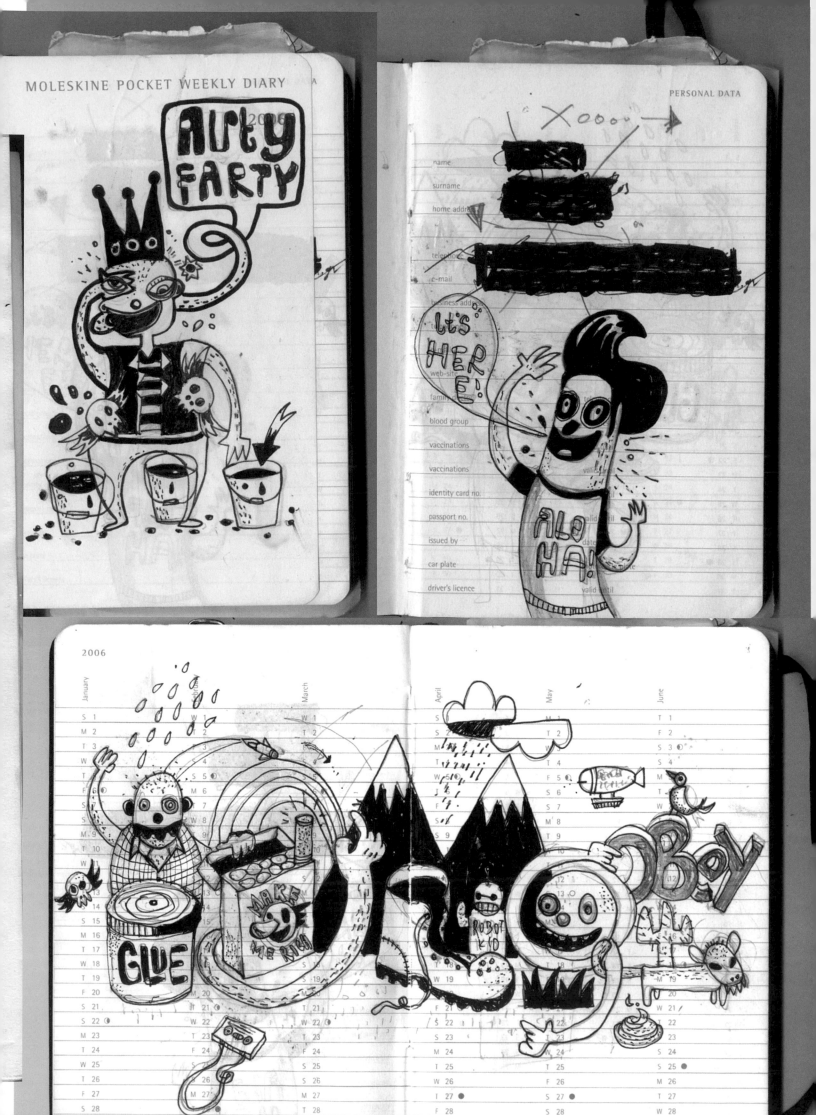

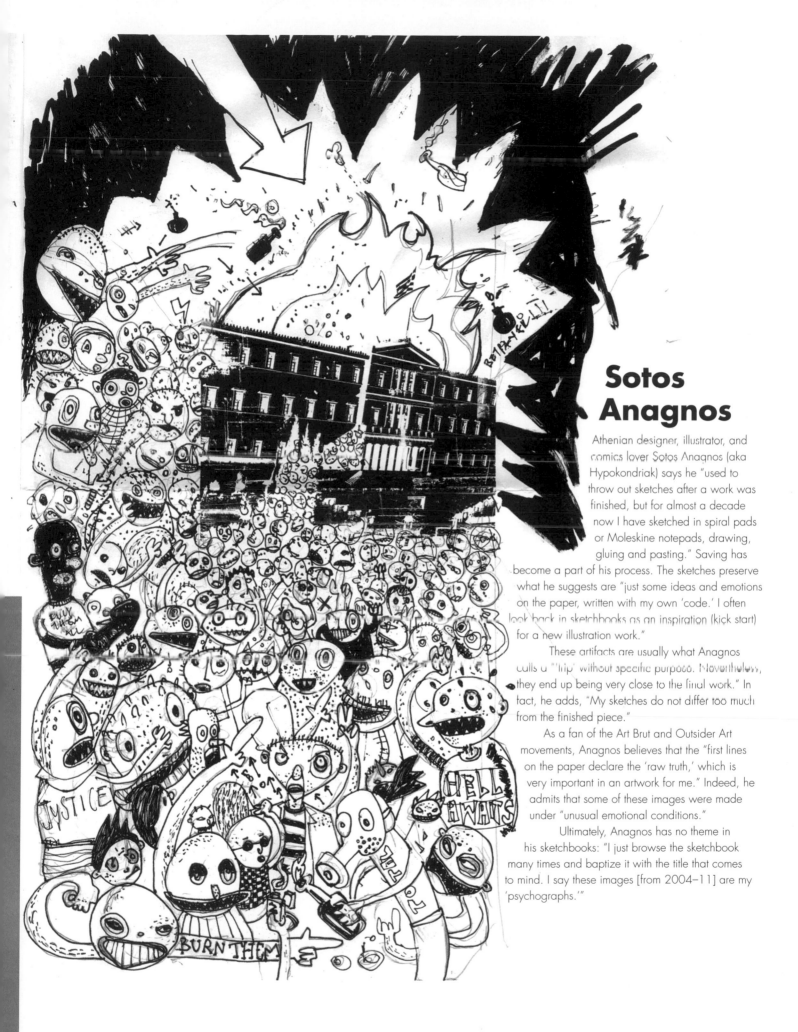

Sotos Anagnos

Athenian designer, illustrator, and comics lover Sotos Anagnos (aka Hypokondriak) says he "used to throw out sketches after a work was finished, but for almost a decade now I have sketched in spiral pads or Moleskine notepads, drawing, gluing and pasting." Saving has become a part of his process. The sketches preserve what he suggests are "just some ideas and emotions on the paper, written with my own 'code.' I often look back in sketchbooks as an inspiration (kick start) for a new illustration work."

These artifacts are usually what Anagnos calls a "'trip' without specific purpose. Nevertheless, they end up being very close to the final work." In fact, he adds, "My sketches do not differ too much from the finished piece."

As a fan of the Art Brut and Outsider Art movements, Anagnos believes that the "first lines on the paper declare the 'raw truth,' which is very important in an artwork for me." Indeed, he admits that some of these images were made under "unusual emotional conditions."

Ultimately, Anagnos has no theme in his sketchbooks: "I just browse the sketchbook many times and baptize it with the title that comes to mind. I say these images [from 2004–11] are my 'psychographs.'"

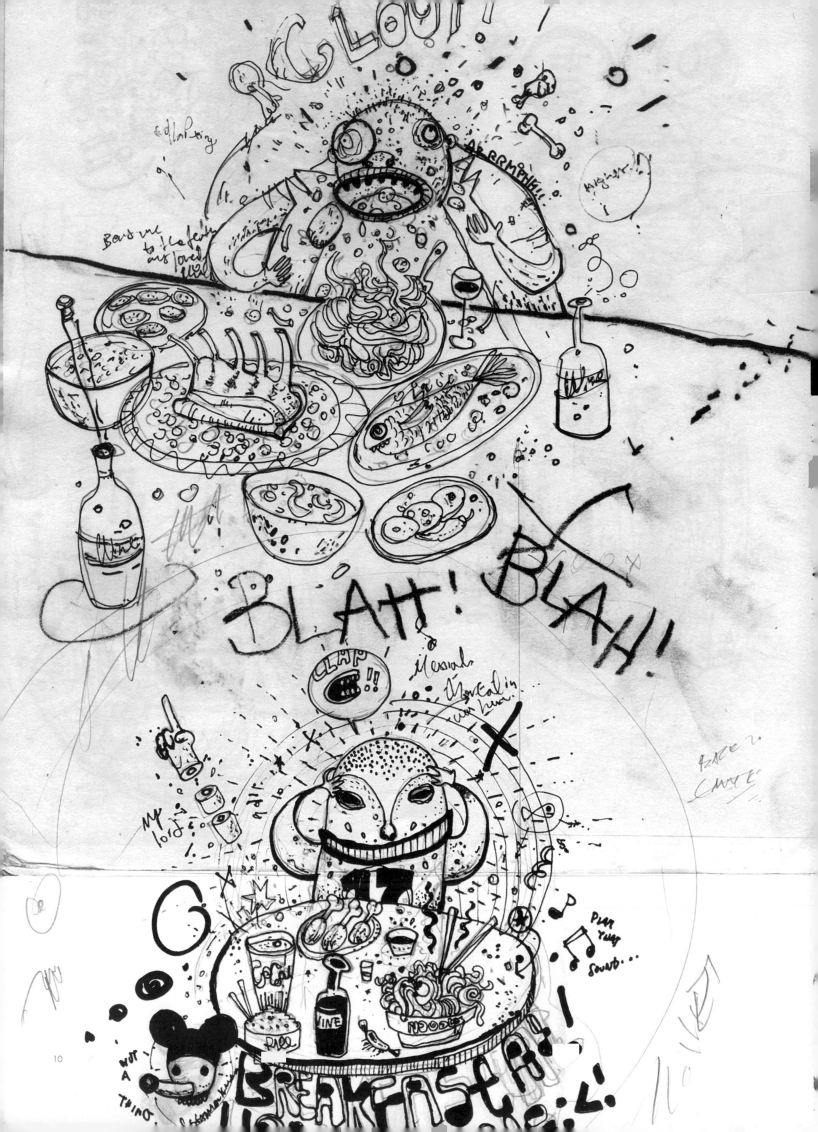

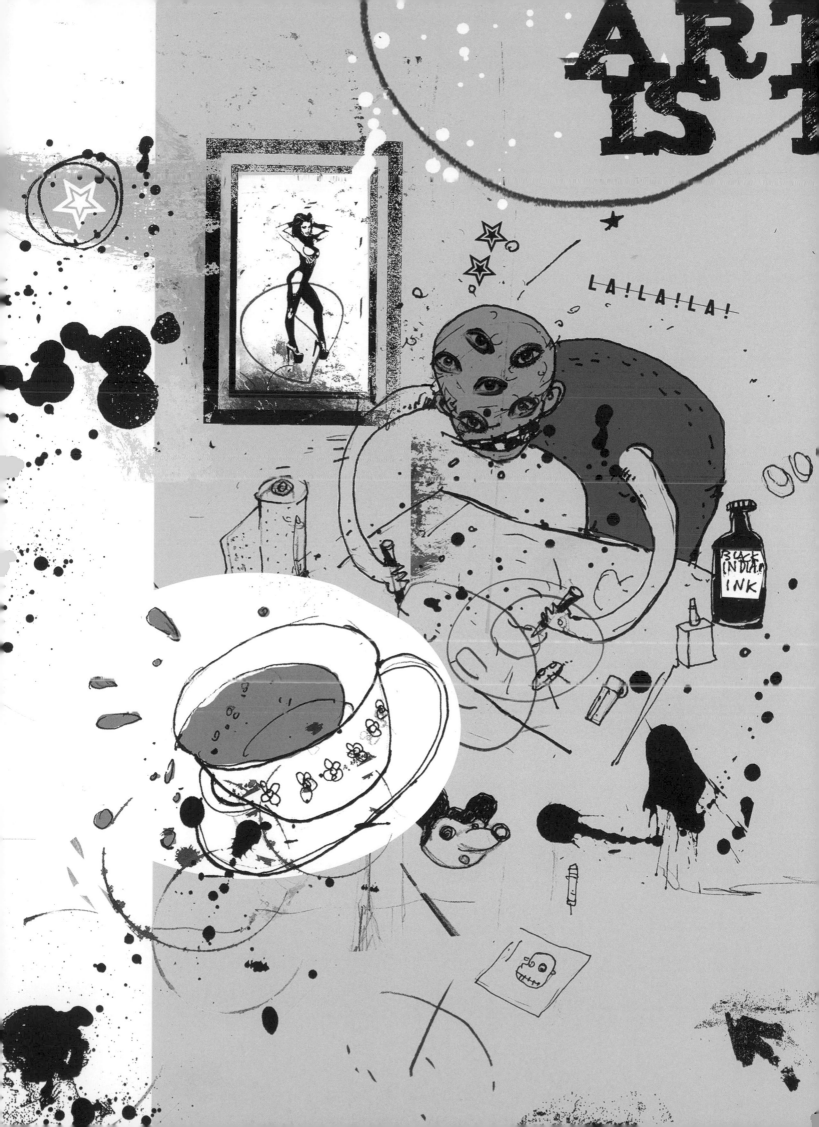

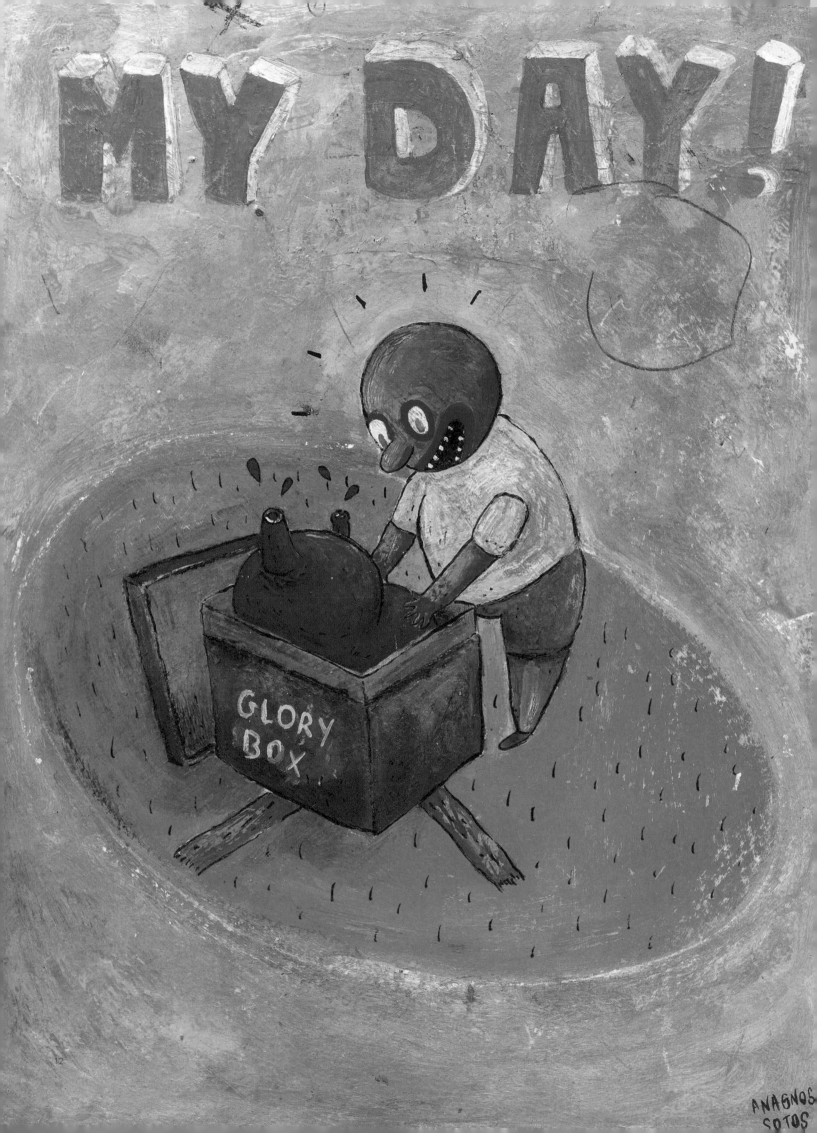

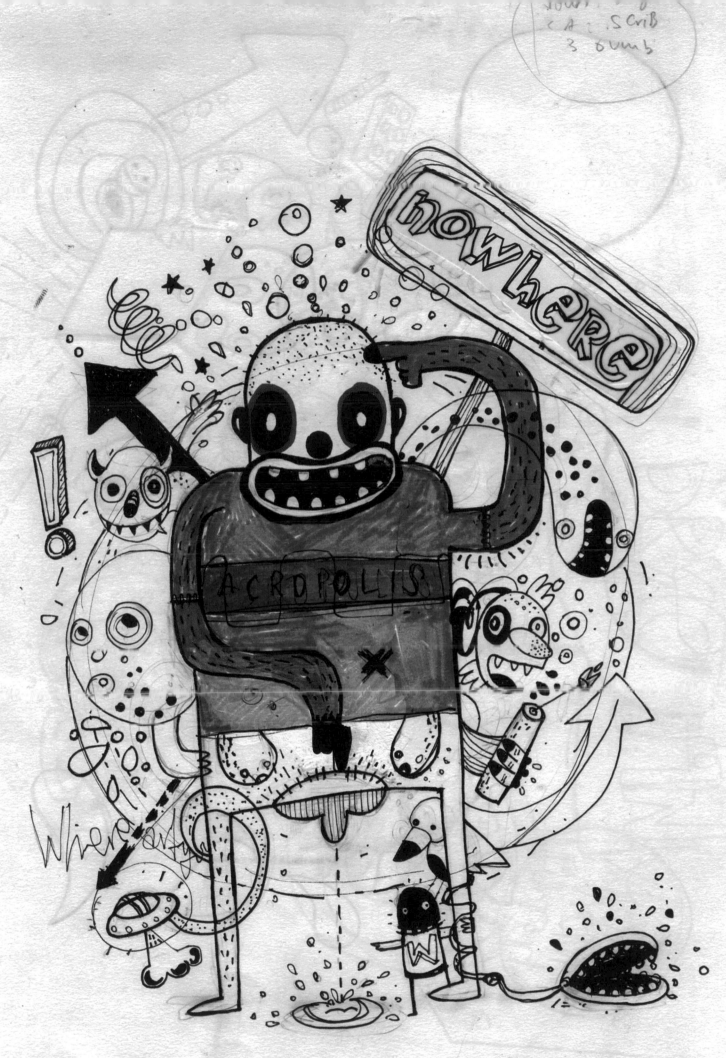

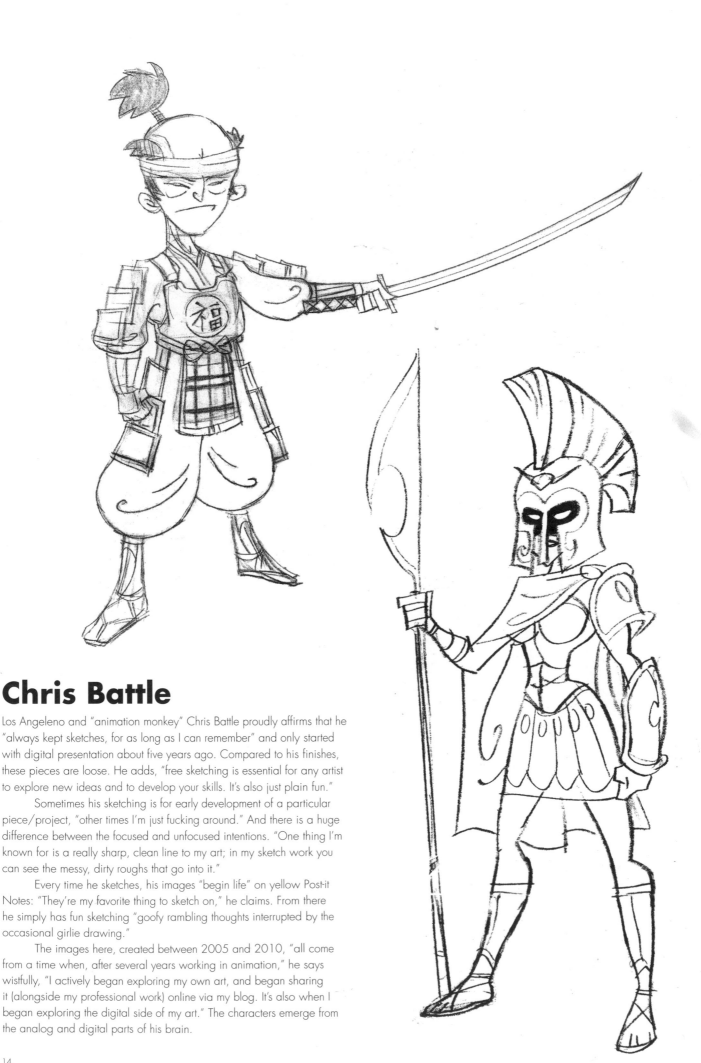

Chris Battle

Los Angeleno and "animation monkey" Chris Battle proudly affirms that he "always kept sketches, for as long as I can remember" and only started with digital presentation about five years ago. Compared to his finishes, these pieces are loose. He adds, "free sketching is essential for any artist to explore new ideas and to develop your skills. It's also just plain fun."

Sometimes his sketching is for early development of a particular piece/project, "other times I'm just fucking around." And there is a huge difference between the focused and unfocused intentions. "One thing I'm known for is a really sharp, clean line to my art; in my sketch work you can see the messy, dirty roughs that go into it."

Every time he sketches, his images "begin life" on yellow Post-it Notes: "They're my favorite thing to sketch on," he claims. From there he simply has fun sketching "goofy rambling thoughts interrupted by the occasional girlie drawing."

The images here, created between 2005 and 2010, "all come from a time when, after several years working in animation," he says wistfully, "I actively began exploring my own art, and began sharing it (alongside my professional work) online via my blog. It's also when I began exploring the digital side of my art." The characters emerge from the analog and digital parts of his brain.

Lou Beach

Los Angeles-based Lou Beach, whose metier has long
been editorial collage, has kept sketchbooks and journals
for thirty years. "Since I'm a collagist," he acknowledges,
"there are no real 'sketches,' just pictures in different stages
of completion. Some never make it to the finish line, so
I guess they remain as sketchlings."

For Beach, "there is always an end purpose, even
if I don't realize it." And sometimes the unrealized images
are, in fact, more realized than he thinks they are. He says
these visuals lead to "an editing process, so what I start with
is added to, then subtracted from to create the keeper." In
the end they fulfill the narrative mission, which is to tell a story
through pictures.

Most importantly, these books provide him with
"a rambling road" for a journey he takes almost every day
through the visual artifacts of popular culture.

End of Day

Roland Clark

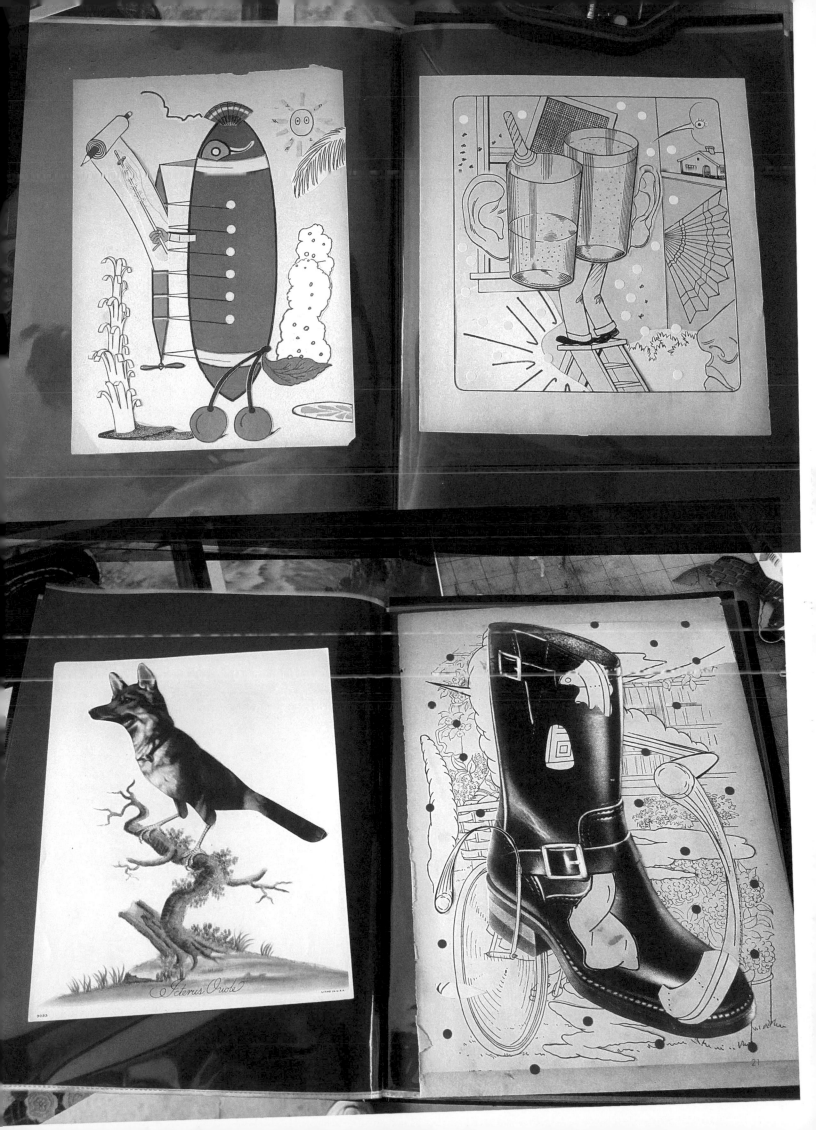

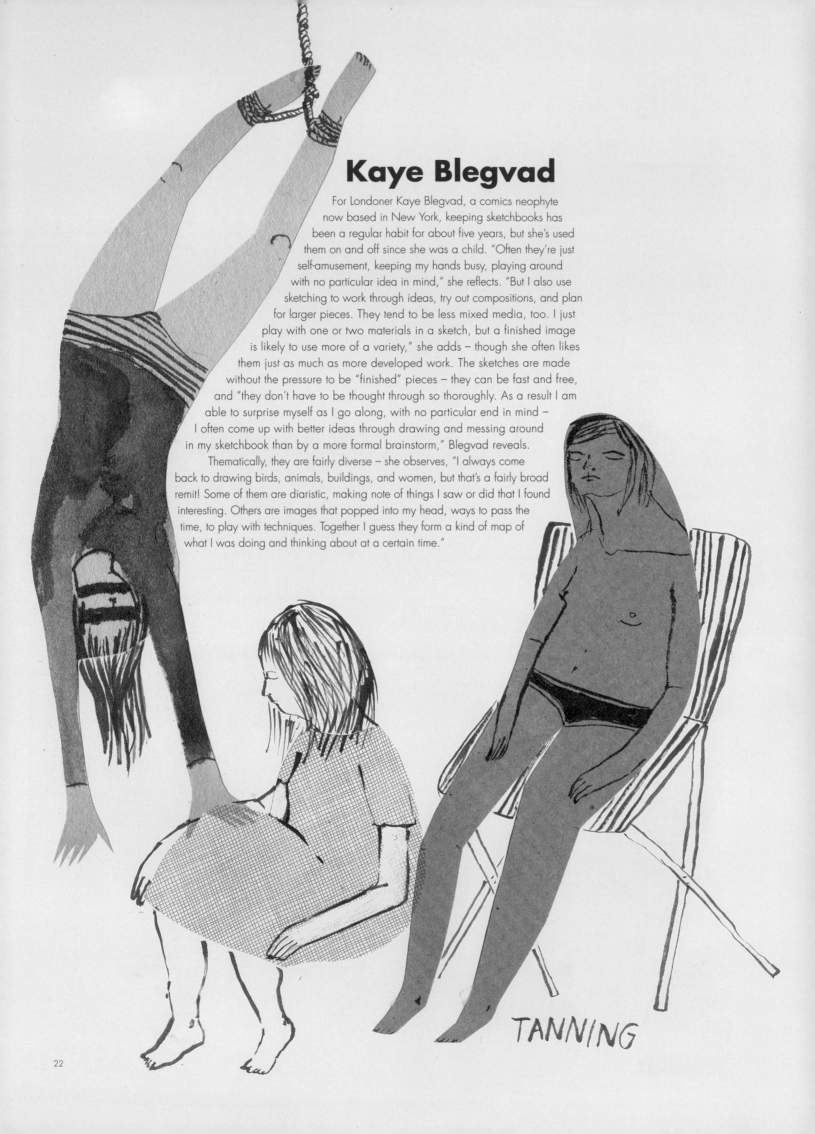

Kaye Blegvad

For Londoner Kaye Blegvad, a comics neophyte
now based in New York, keeping sketchbooks has
been a regular habit for about five years, but she's used
them on and off since she was a child. "Often they're just
self-amusement, keeping my hands busy, playing around
with no particular idea in mind," she reflects. "But I also use
sketching to work through ideas, try out compositions, and plan
for larger pieces. They tend to be less mixed media, too. I just
play with one or two materials in a sketch, but a finished image
is likely to use more of a variety," she adds – though she often likes
them just as much as more developed work. The sketches are made
without the pressure to be "finished" pieces – they can be fast and free,
and "they don't have to be thought through so thoroughly. As a result I am
able to surprise myself as I go along, with no particular end in mind –
I often come up with better ideas through drawing and messing around
in my sketchbook than by a more formal brainstorm," Blegvad reveals.
 Thematically, they are fairly diverse – she observes, "I always come
back to drawing birds, animals, buildings, and women, but that's a fairly broad
remit! Some of them are diaristic, making note of things I saw or did that I found
interesting. Others are images that popped into my head, ways to pass the
time, to play with techniques. Together I guess they form a kind of map of
what I was doing and thinking about at a certain time."

TANNING

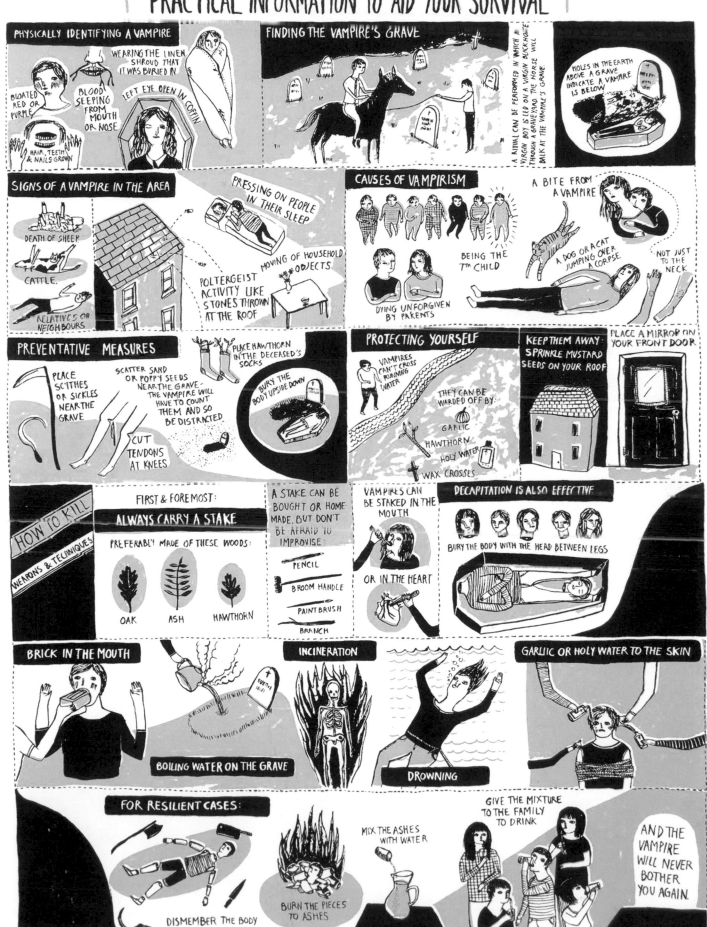

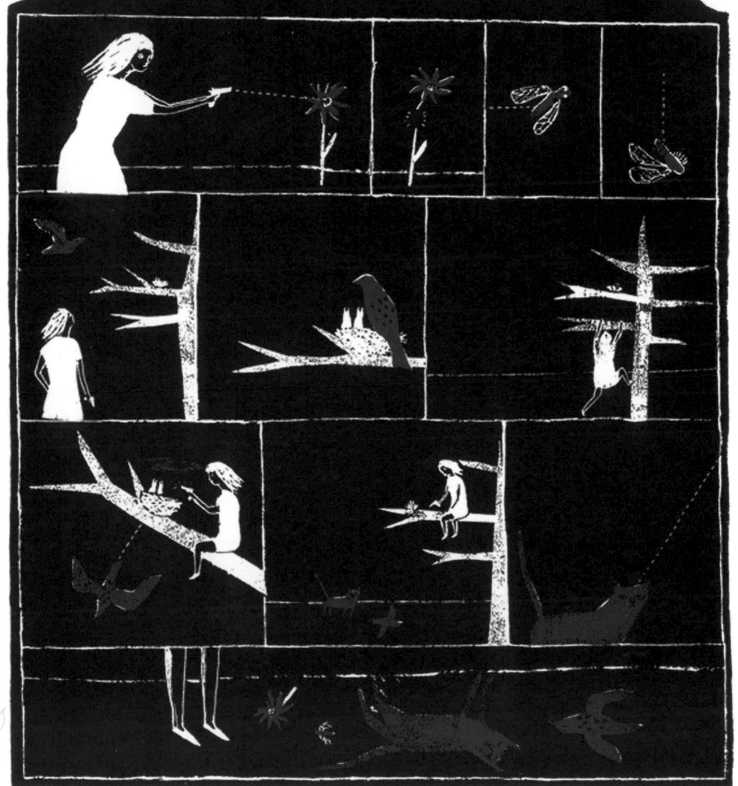

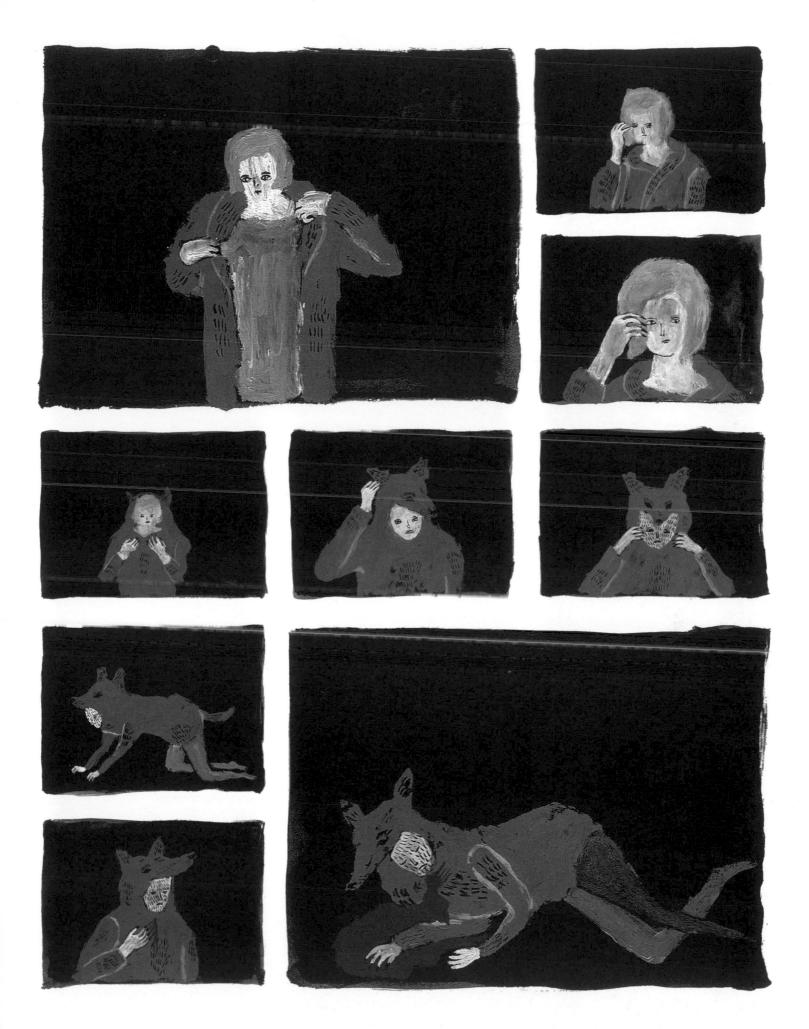

Peter Blegvad

"Sketches often record the struggle – they are palimpsests, with alternate stabs, mistakes, and corrections on top of one another," Peter Blegvad intones. "The mess can have an aesthetic appeal all its own. The drawing tends to be quick, a hieroglyphic scribble. This is how I REALLY draw (my ability hasn't evolved much since I was a kid), without references, and so on." The veteran comics artist and creator of *Leviathan* continues, "In a sketch, the drawing often has the honesty of a by-product. Then, when I do the final, I use references and generally agonize over trying to depict things 'right,' probably sacrificing a lot of 'character' in the process. Because my comic strips are often so verbose, so dense with text, sketches are required to help design a more legible layout."

Blegvad remarks that sketching is a continual process, which is essential to his creativity: "There are so many of them moldering in notebooks, going back forty years. And I consult them pretty often, still finding the germ of an idea here and there that proves useful all these years later."

The themes that frequently arise in his books are skepticism, fear, mystery, perversity, and, frequently, immaturity. In the comic strip *Leviathan*, which dates from 1991, "the faceless tot was the star of a weekly half-page newspaper strip I drew for more than seven years, so childhood is a big theme: innocence vs experience," he explains.

Surely I was too young to harbour such dark forebodings ...

My anxiety must therefore be inherited from my parents. It was true, they were furtive, suspicious of strangers — so was I.

friend or foe?

Foe for life! All I'd done was tear out a few of his whiskers — I vowed vengeance on the family cat.

I was not a good mixer

But there was one kid in the creche, a little older than the rest of us, who could already hold a spoon. I worshipped him from afar.

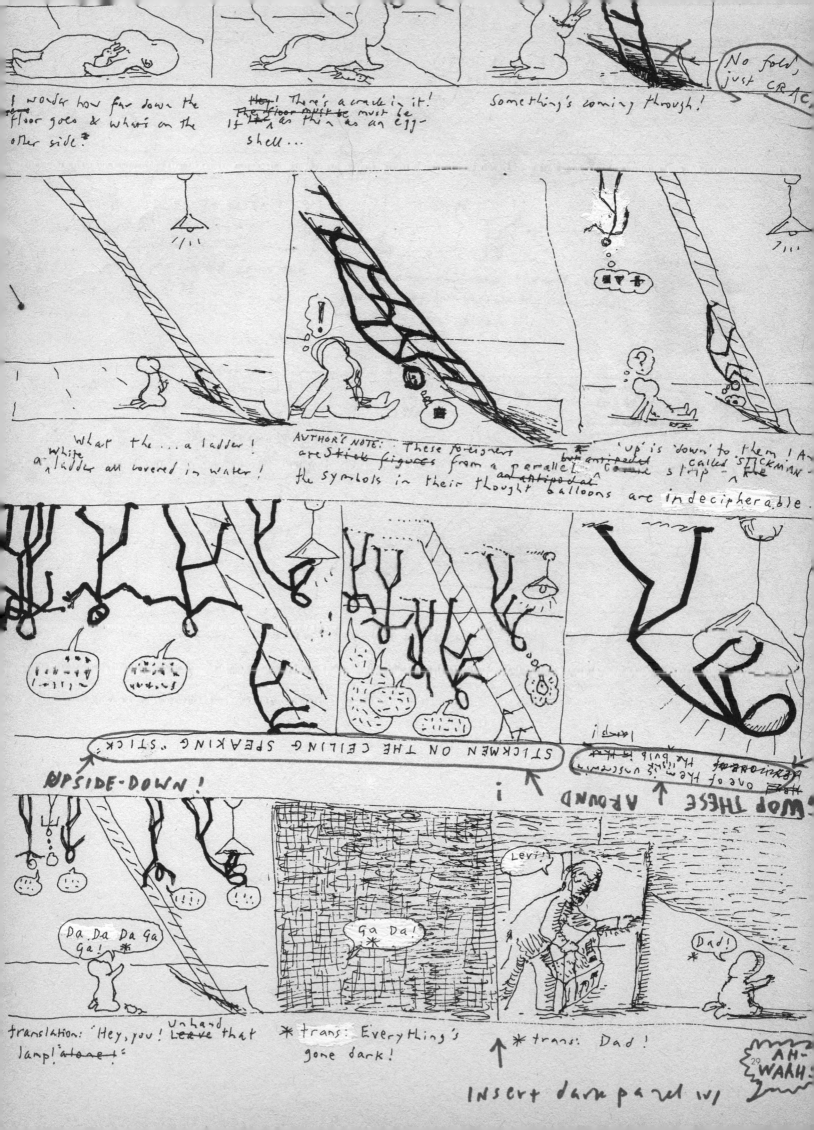

Russ Braun

Russ Braun (aka Java Monk) recalls that at one time his sketchbooks were "a
playground to work out ideas, create characters, and simply a convenient place to
practice becoming a better draftsman." He developed a sense of sequential storytelling
by drawing the same character a number of times, answering a different question each
time: "'What would happen next?' or, even more basically, 'What would he look like
from this angle?' Whole stories were told within a few pages this way, without fully
conscious intent; characters just came to life and dictated their own stories."

For years, Braun's portfolio was one of his sketchbooks. Then, "when I began
working in comics professionally, almost exclusively as a freelance 'hired gun' on
someone else's script, the sketchbook became the place to design characters and
settings and goof around; a retreat from the pressure of 'finished work' and official
comics pages. It was always a bit frustrating to be able to draw freely and well in
my sketches but not have that translate to the finished page. By comparison, characters
I'd draw on the comic page tended to feel a bit bland and stiff – accurate, but lifeless.
My characters sometimes appeared to be aware of the panel borders
and would hunch to fit within the frame. They had to be 'right,'
so they lost that fearless quality a sketch has." The main
distinction between the sketch and the finished
work is the loose and, as Braun suggests,
"fearless quality the sketch maintains – a
kinetic energy that I necessarily have to
contain when it comes to the finished
page. The sketch has a life and
purpose all its own."

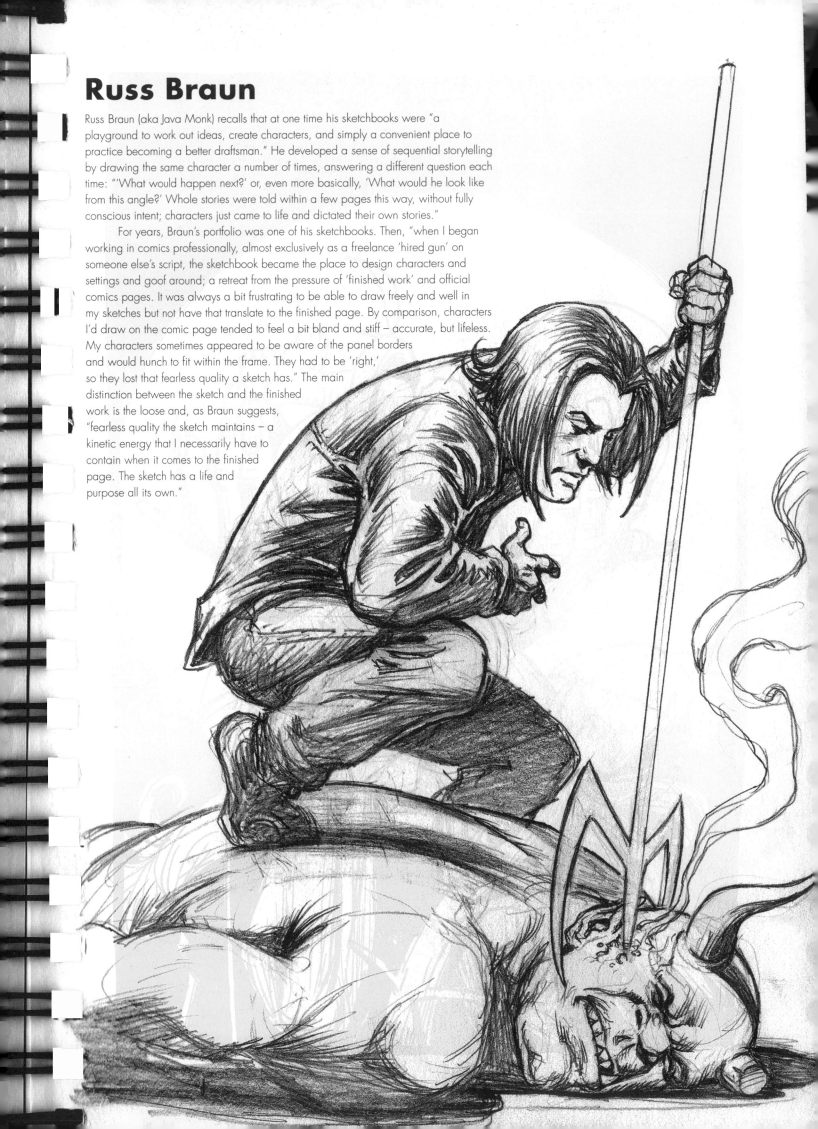

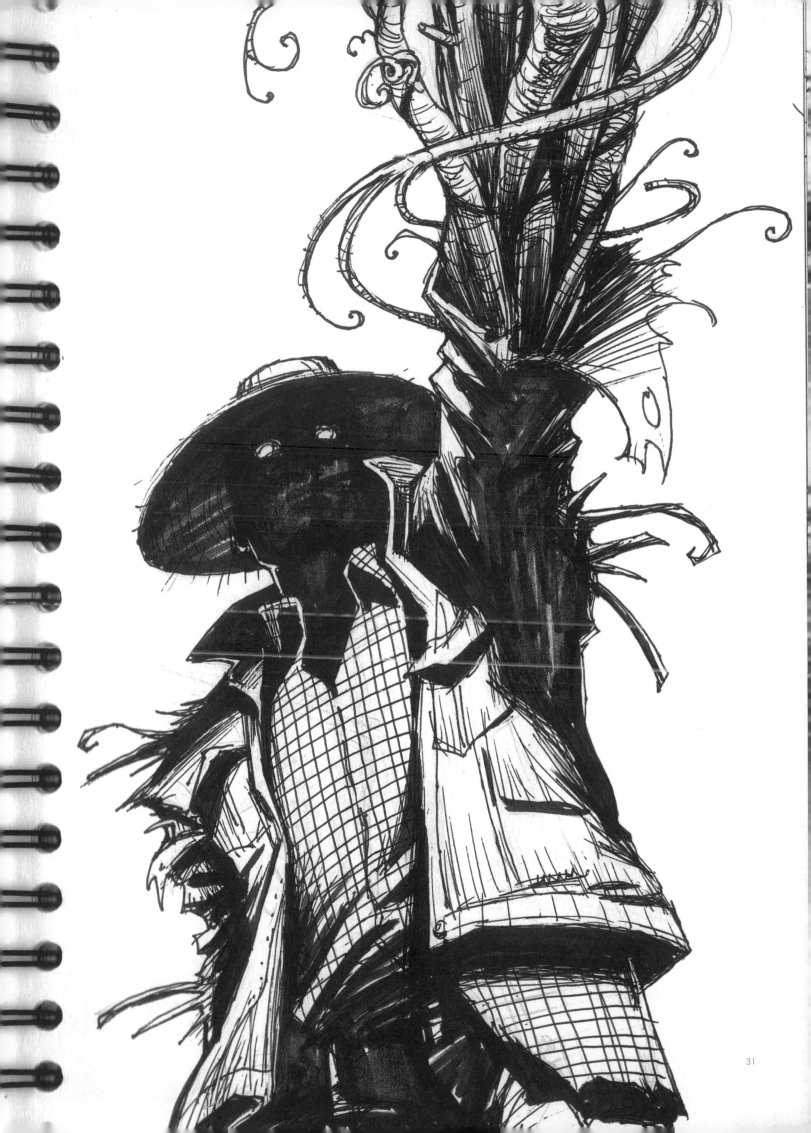

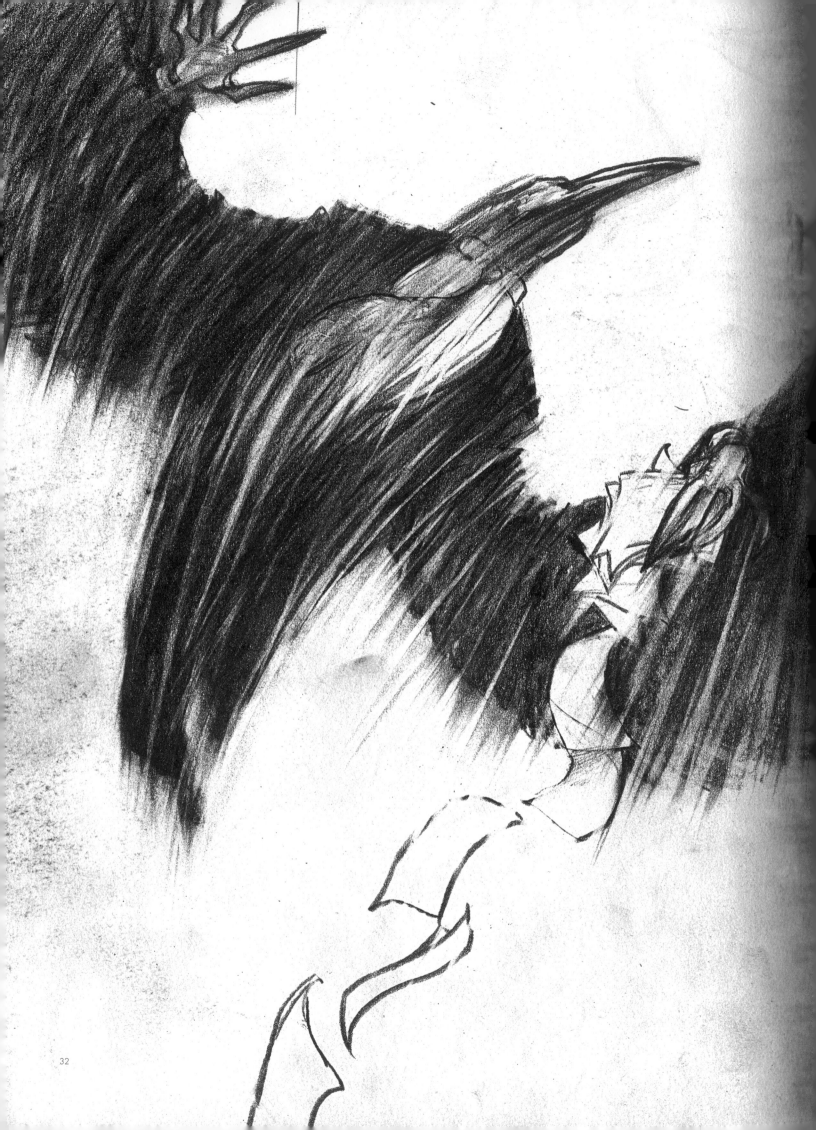

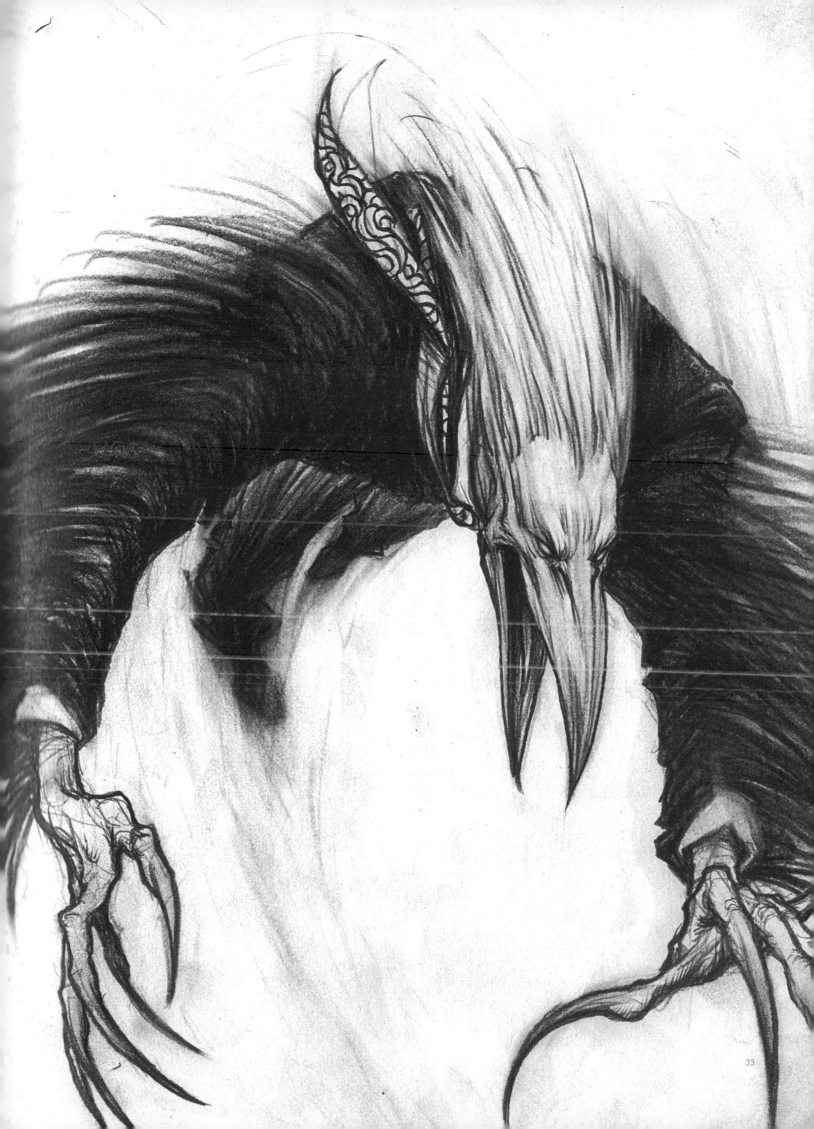

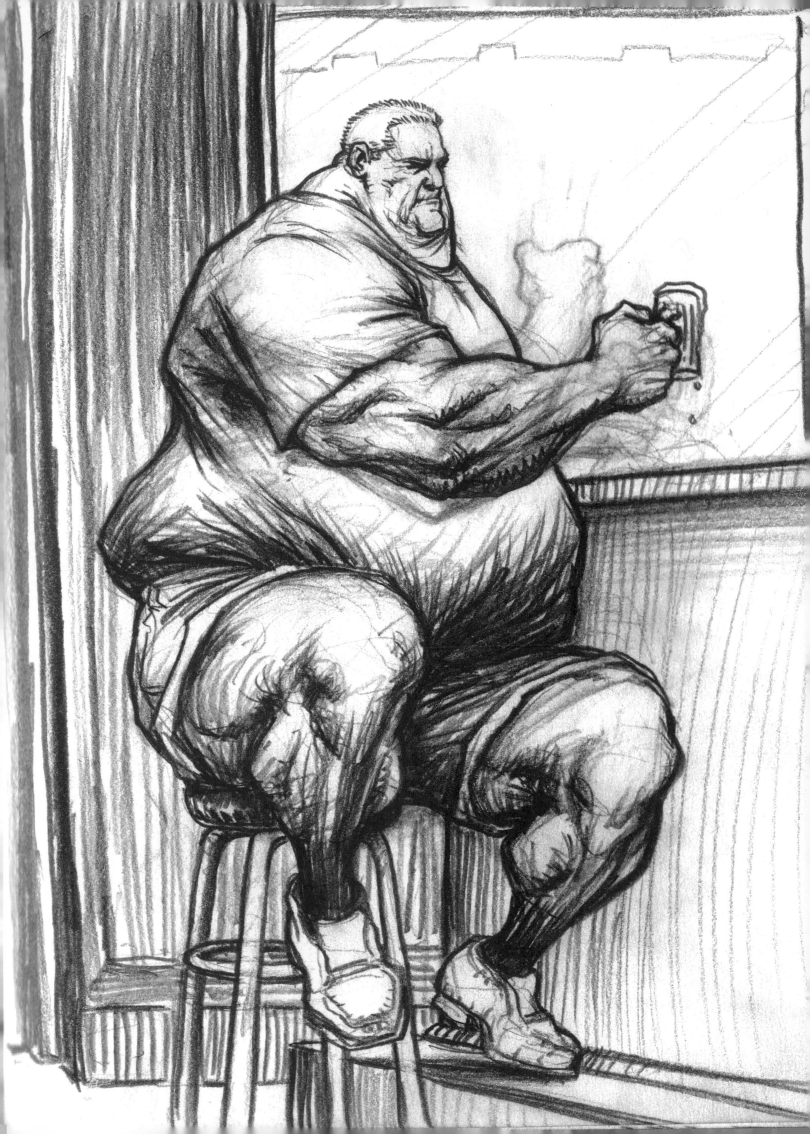

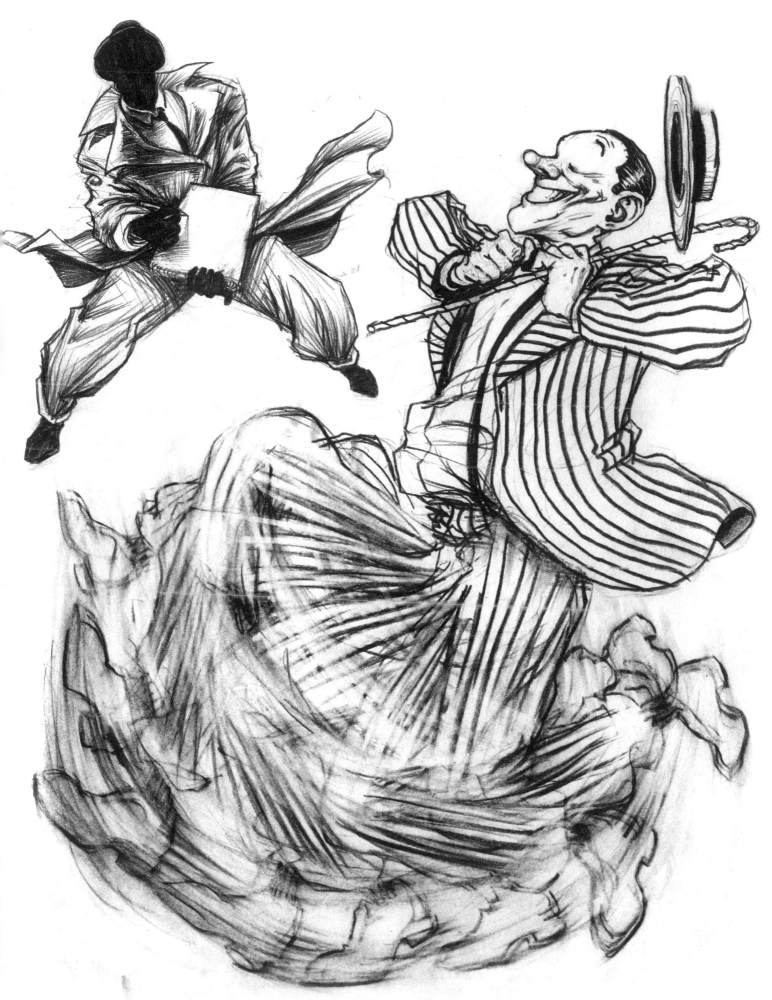

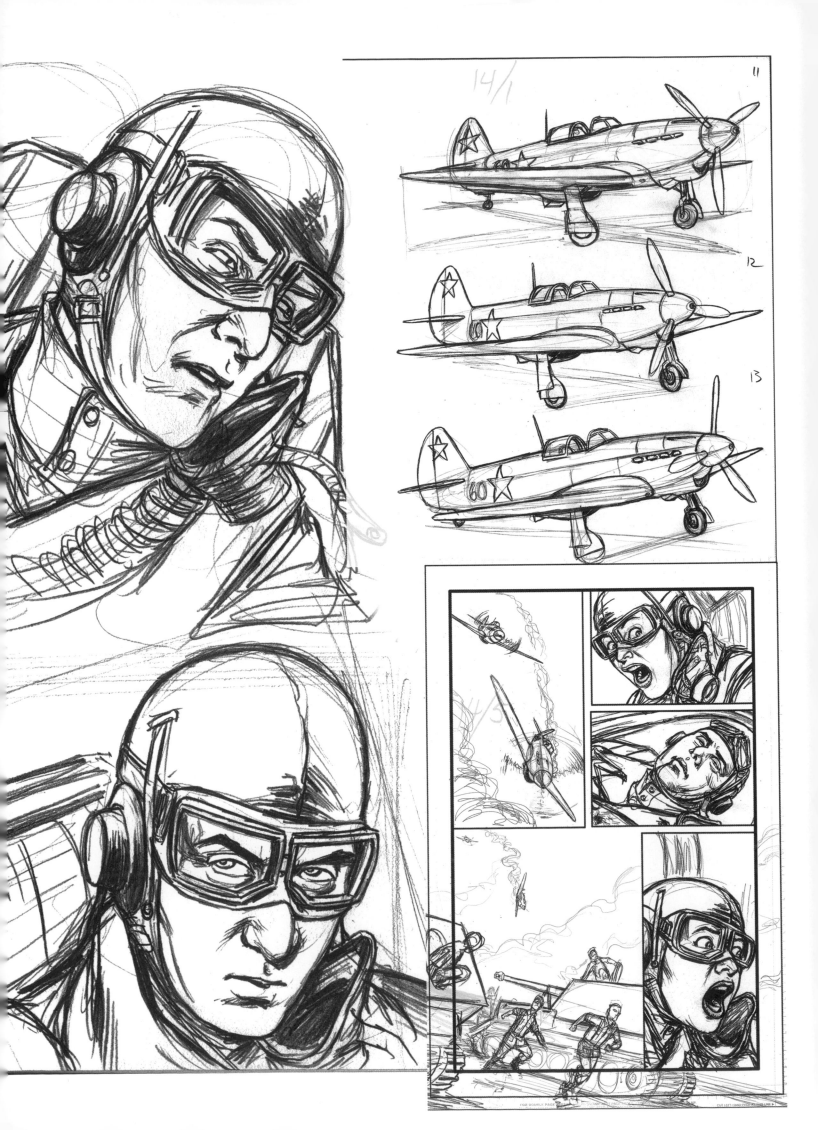

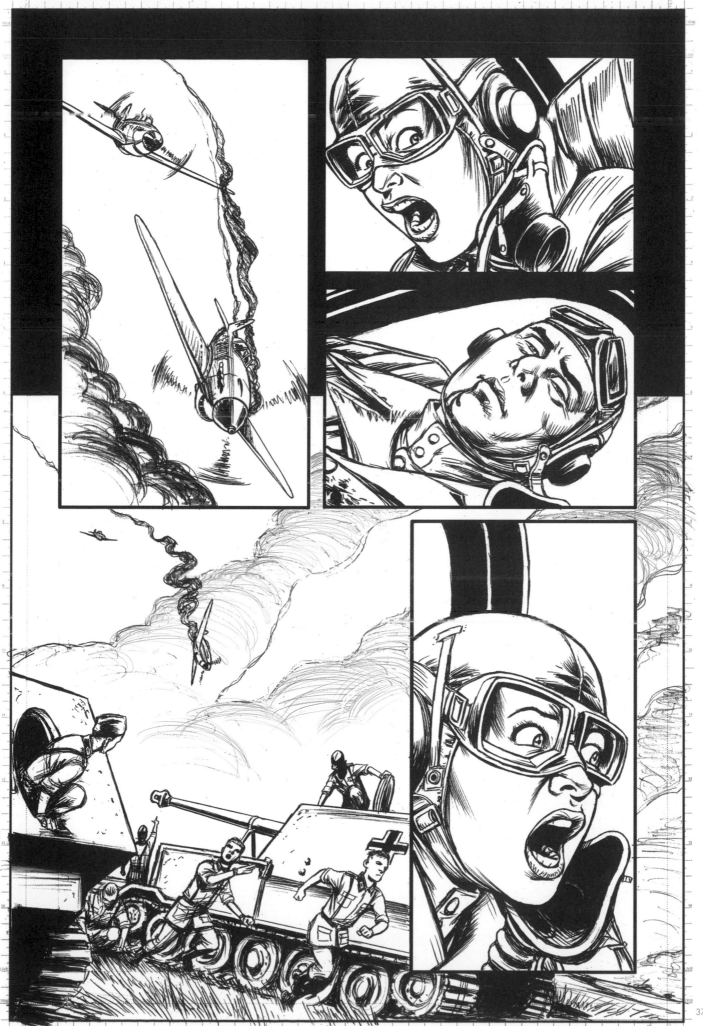

DYNAMITE ENTERTAINMENT BOOK Motherland ISSUE 3 PAGE 17 ARTIST(S) Russ Braun

ILLUSTRATION QUALITY PAPER FOR FULL BLEED AND REGULAR COMIC BOOK PAGES. FINISHED ART PRINTS AT 67%

FOR DOUBLE PAGE SPREAD: CUT AS SHOWN, ABUT PAGE EDGES, TAPE ON BACK. DO NOT OVERLAP.

CUT LEFT-HAND PAGE AT THIS LINE ▶

38

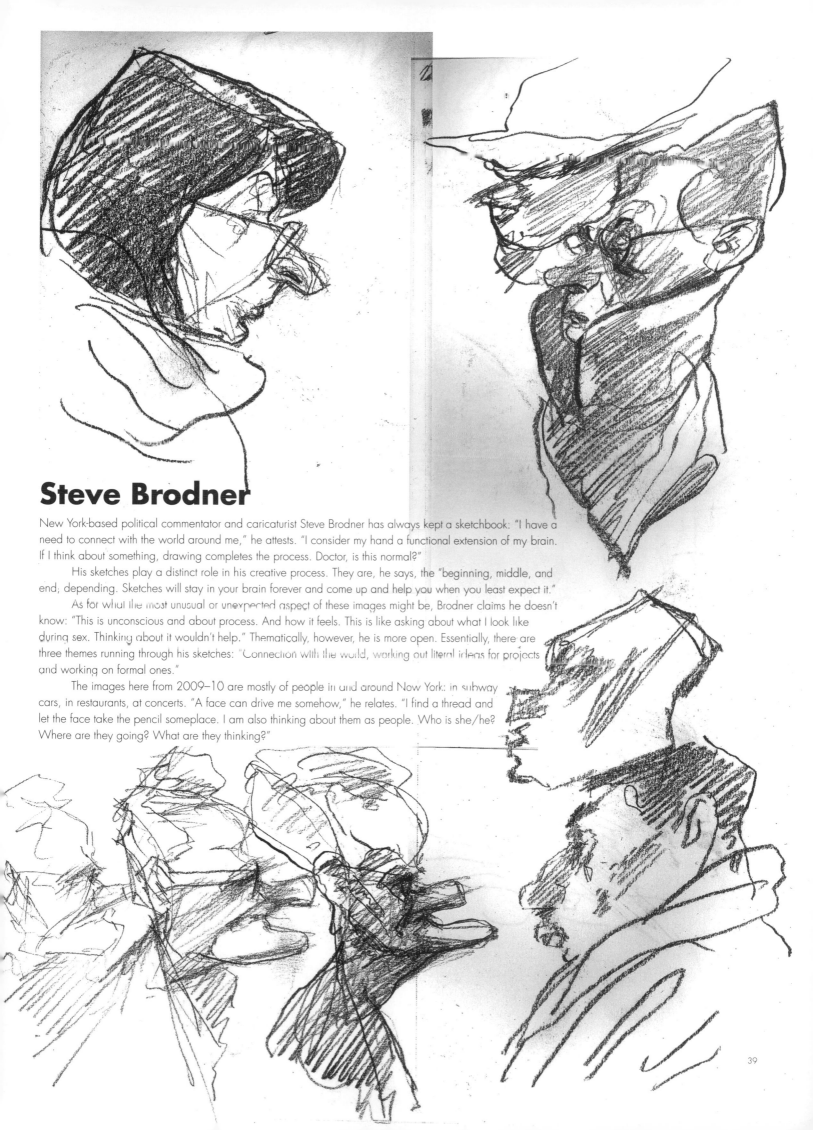

Steve Brodner

New York-based political commentator and caricaturist Steve Brodner has always kept a sketchbook: "I have a need to connect with the world around me," he attests. "I consider my hand a functional extension of my brain. If I think about something, drawing completes the process. Doctor, is this normal?"

His sketches play a distinct role in his creative process. They are, he says, the "beginning, middle, and end; depending. Sketches will stay in your brain forever and come up and help you when you least expect it."

As for what the most unusual or unexpected aspect of these images might be, Brodner claims he doesn't know: "This is unconscious and about process. And how it feels. This is like asking about what I look like during sex. Thinking about it wouldn't help." Thematically, however, he is more open. Essentially, there are three themes running through his sketches: "Connection with the world, working out literal ideas for projects and working on formal ones."

The images here from 2009–10 are mostly of people in and around New York: in subway cars, in restaurants, at concerts. "A face can drive me somehow," he relates. "I find a thread and let the face take the pencil someplace. I am also thinking about them as people. Who is she/he? Where are they going? What are they thinking?"

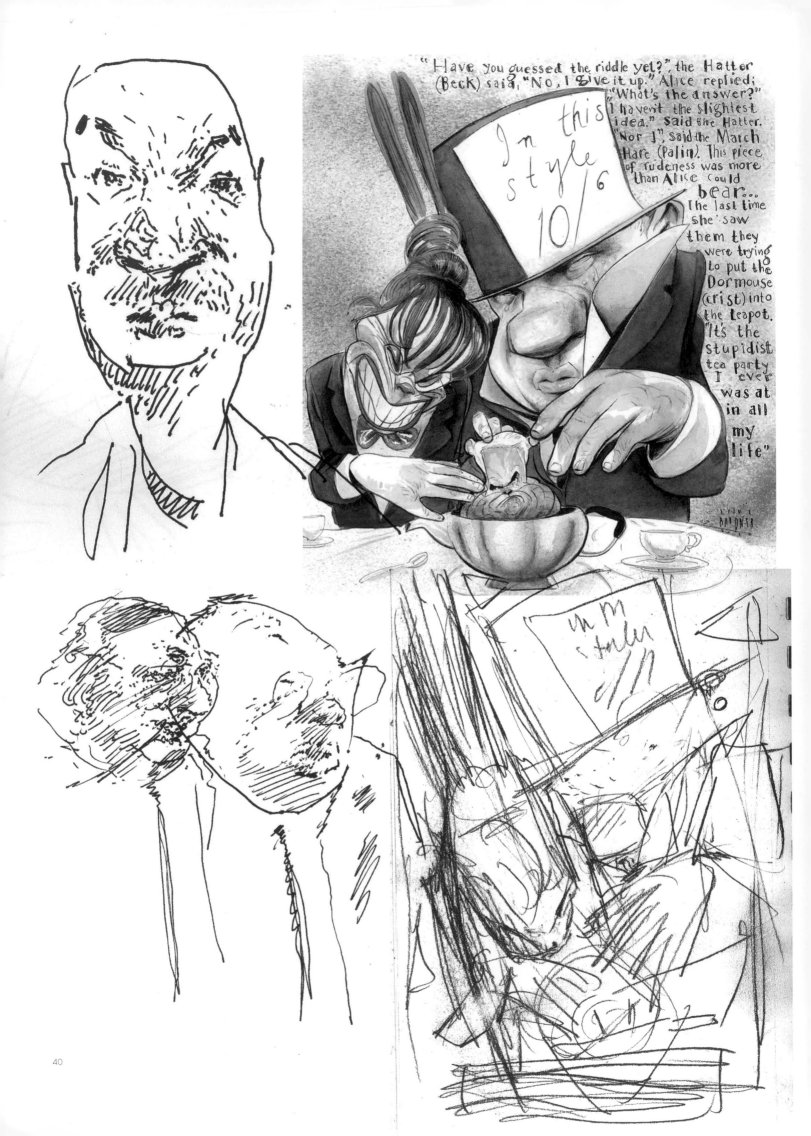

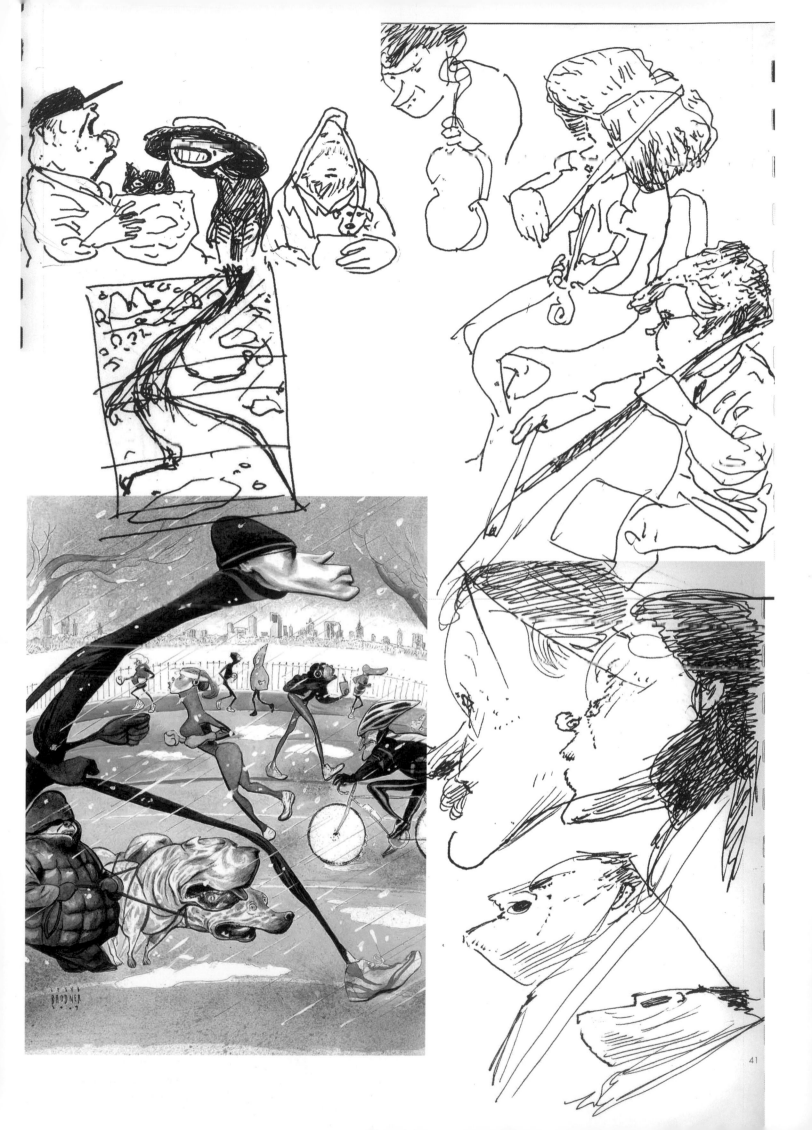

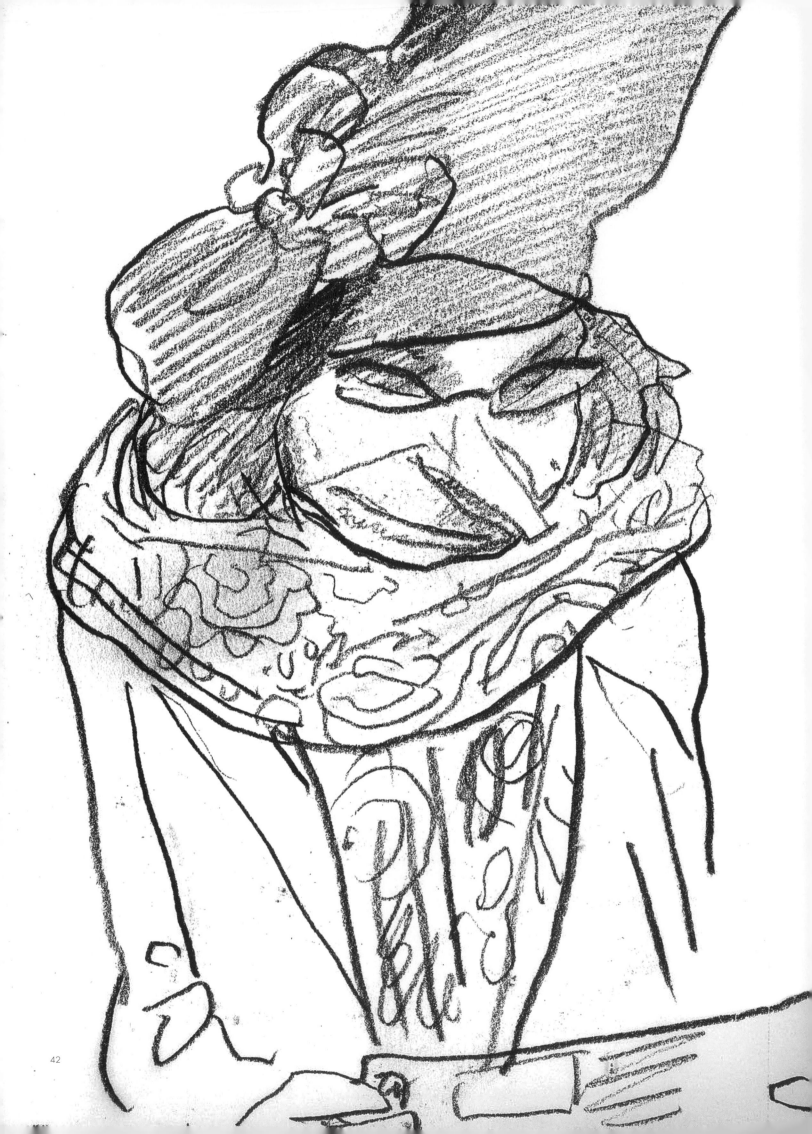

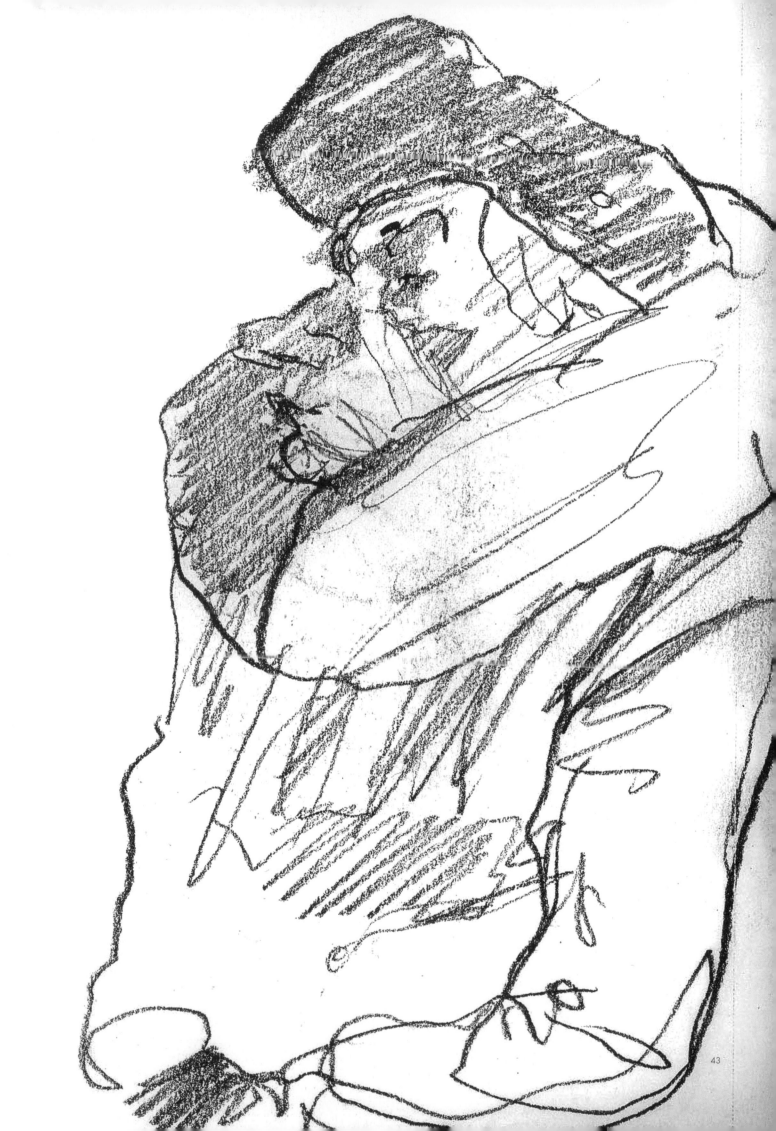

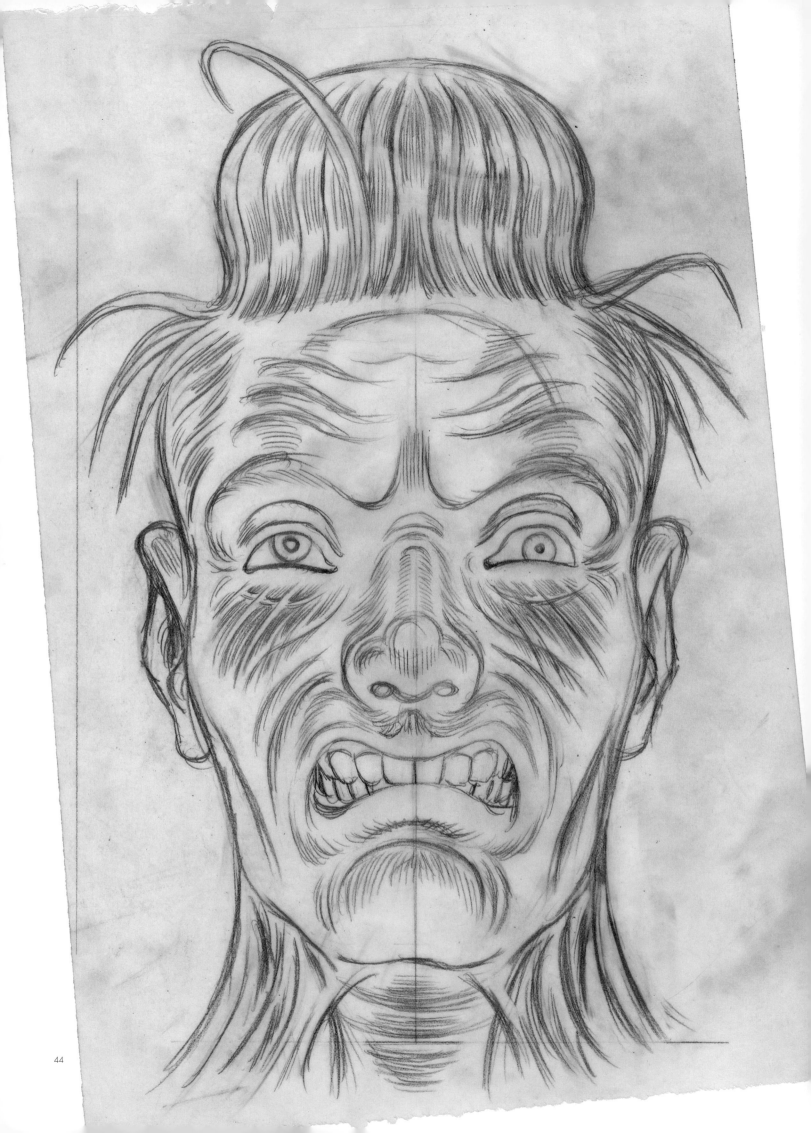

 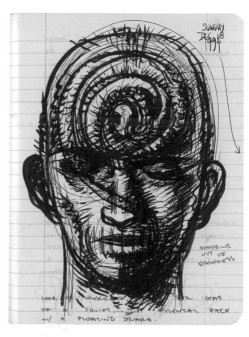

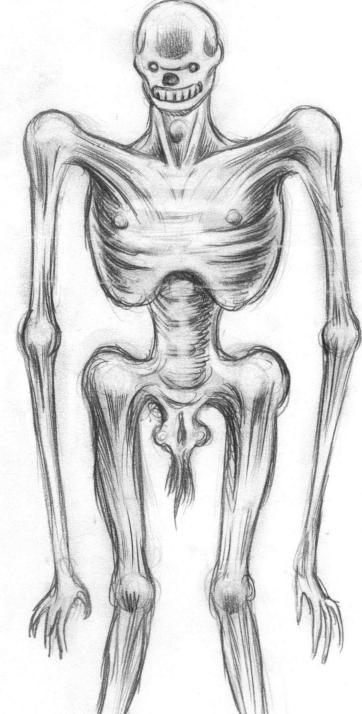

Charles Burns

Charles Burns, a master of both the funny and the creepy who exploded on the comics scene in *RAW* magazine and with *Big Baby in Curse of the Molemen* in 1986, says his books are filled with writing and occasional drawings that refer specifically to projects he is working on.

Explaining the sketches here, spanning the years 1980–2010, Burns says: "The Nitnit sketch [opposite] is a pencil drawing of my character done in a sort of 'funny animal' style. Meat puppet? The zombie sketch [this page]... kind of disturbing to look at – especially the genitals. What can I say? The naked girl with skin disease [p. 46] is from when I was working through ideas of a 'teen plague' – I 'stole' the pose from a *Spiderman* comic...all your favorite teen characters are hiding a dark, dark secret. I also simply copied one of Johnny Craig's amazing women from one of his EC comics [p. 47]. Once again, I was copying artists that I admire, trying to learn from the masters. The big head of a slobbering dog [p. 48] was a sketch of an older drawing that I guess has something to do with age and mortality (see my scribbled notes at the bottom of the page...'Have you run a good race?'). The dogs up on their hind legs [p. 49] was when I was designing a tattoo for a friend. I think I lifted the look of the dog from a *Dick Tracy* comic I was reading."

Burns concludes, "I'll probably burn most of them before I exit this planet – I don't want to inflict them on my daughters or anyone else once I'm gone."

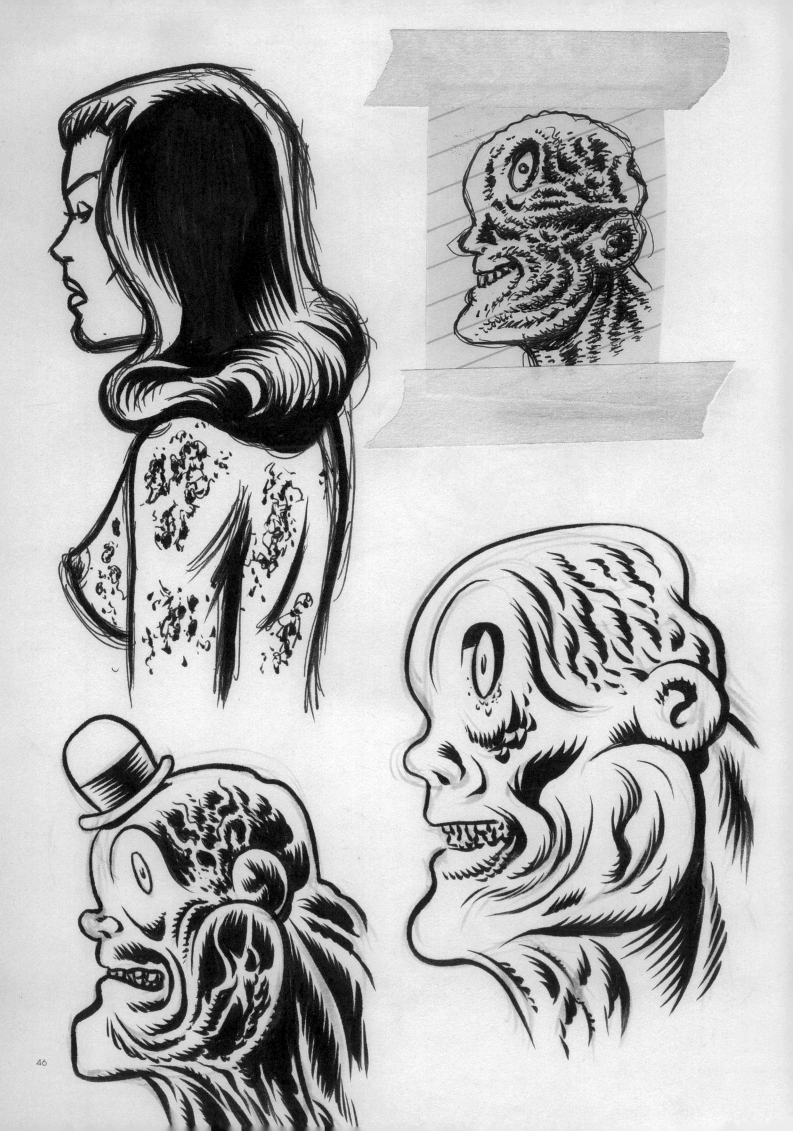

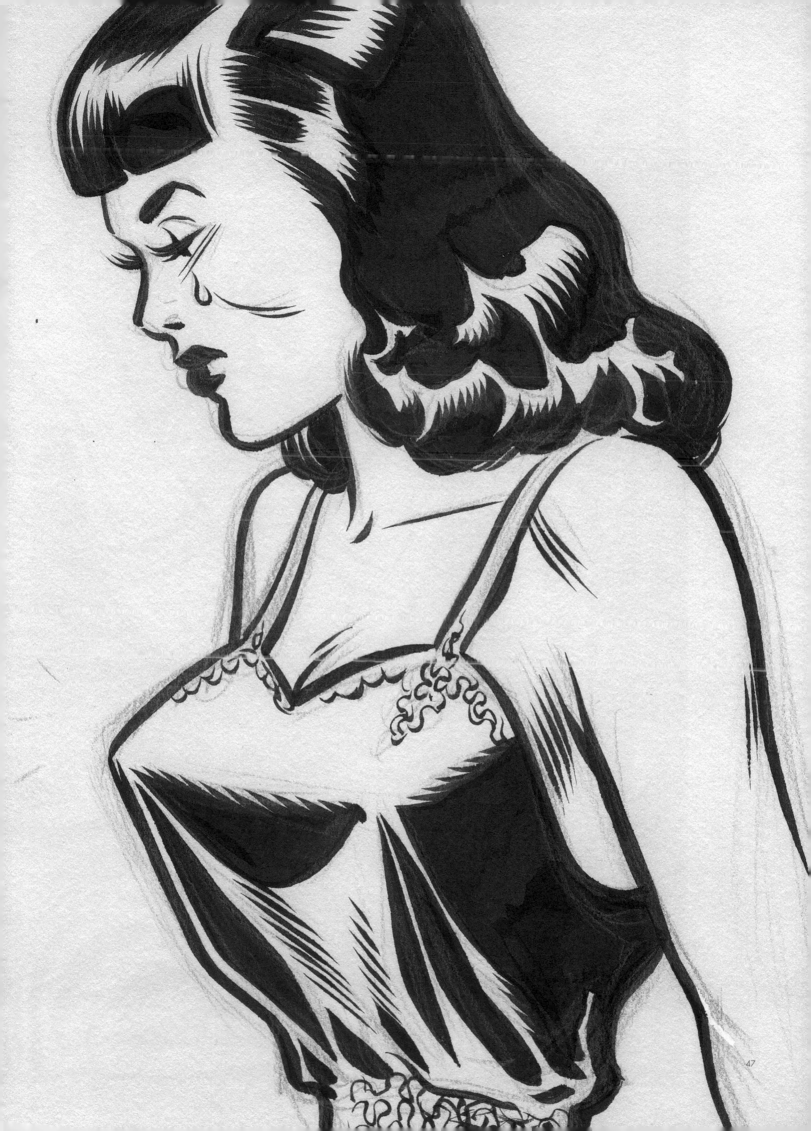

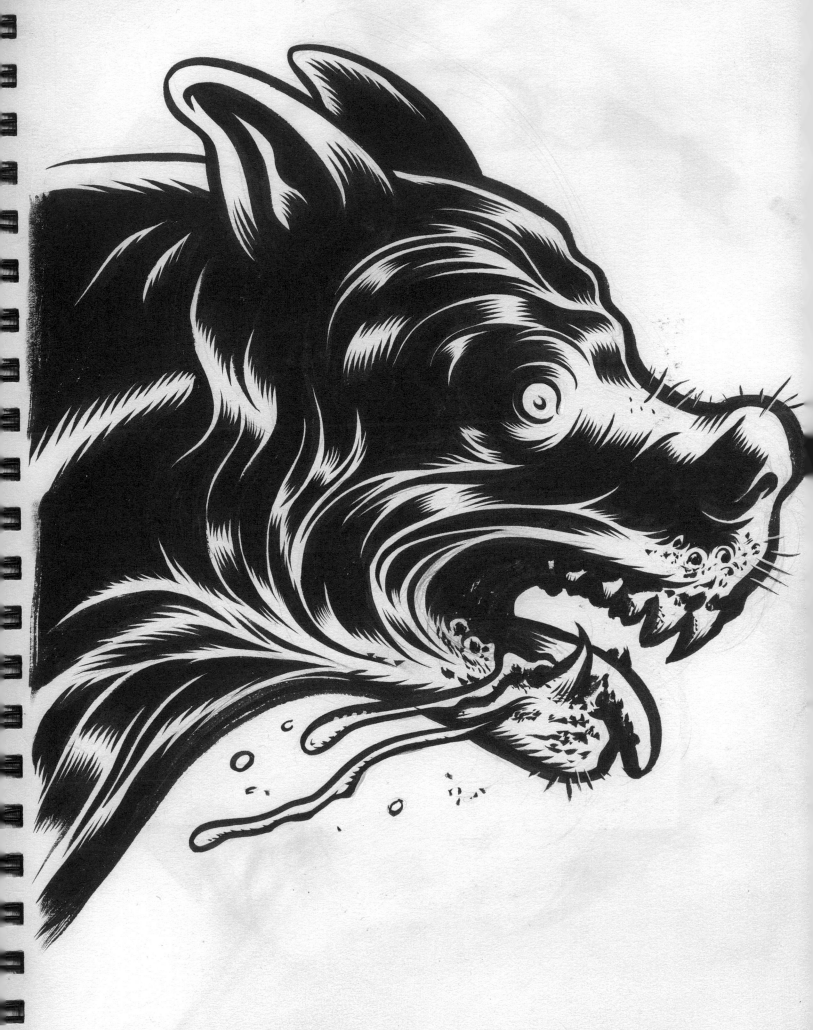

RUNNING HARD, THE END IN SIGHT, THE END IS NEAR
THE END IS COMIN'
HAVE YOU RUN A GOOD RACE?

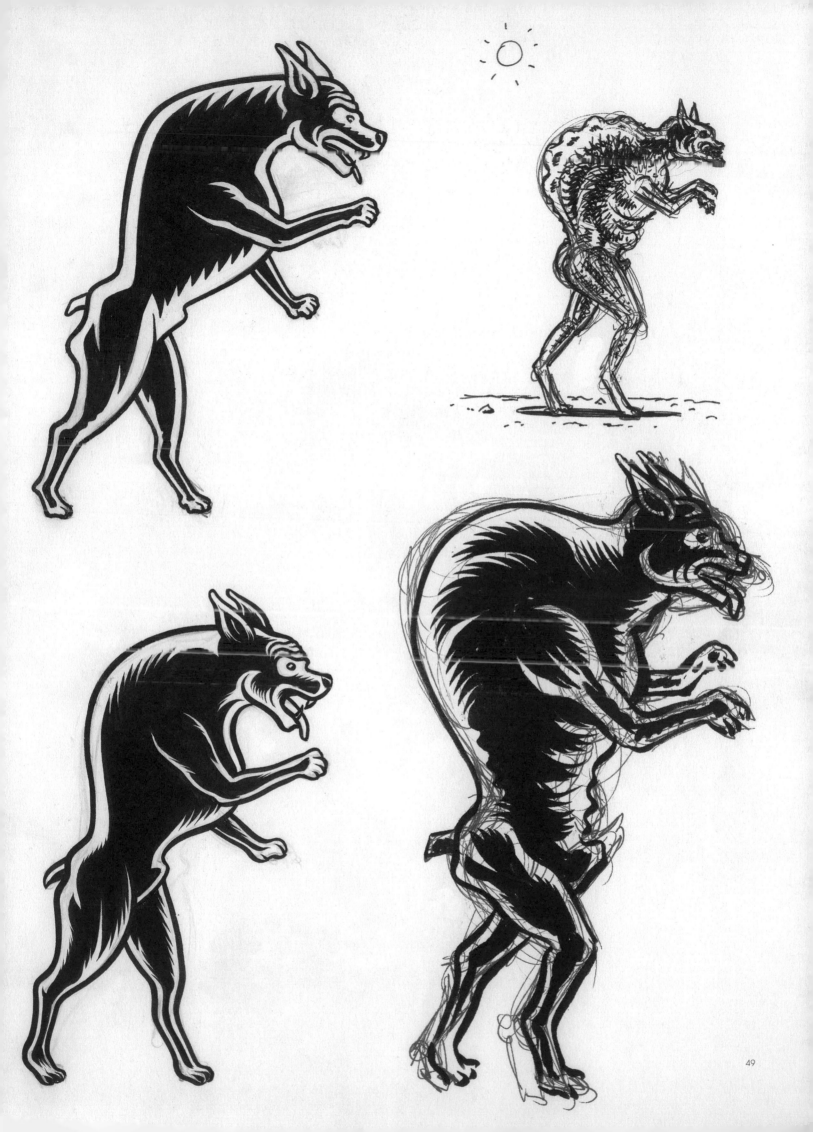

Chris Capuozzo

"I started keeping sketchbooks in high school and haven't stopped since," says Chris Capuozzo, a former tag-master who lives in New York State. "Some of the most intense were my graffiti sketchbooks. I went to the High School of Art & Design in New York from 1980–4, when it was a hotbed for graffiti artists," and where, he remembers, a black book (sketchbook) was essential: "A cool black book could give you status and would be passed on and embellished by other writers." Today he retains "a very strong relationship with my sketchbooks and have one with me practically all the time."

Capuozzo admits he uses a lot of paper when making comics: "If I'm working on a comic page based on sketchbook art, the art will be xeroxed and moved out onto loose paper, where I'll keep evolving and refining it. I also think of sketching as a way to keep my hand in proper shape," he continues, "like a musician who needs to practice every day…I always brighten up after I've spent some time in my sketchbook, so there's a therapeutic aspect as well. It's how I loosen up energy. I'll be testing out styles or looks. This is where I can be a spectator and discover things that I maybe never directly intended to."

Capuozzo is so relaxed working in his books, it follows that the imagery is looser; sketchbooks are "a place where I'm closer to recording my initial impulses of inspiration," he observes. "I relish the chance meetings on the pages – different styles are constantly smashing up against each other to spur on new ideas."

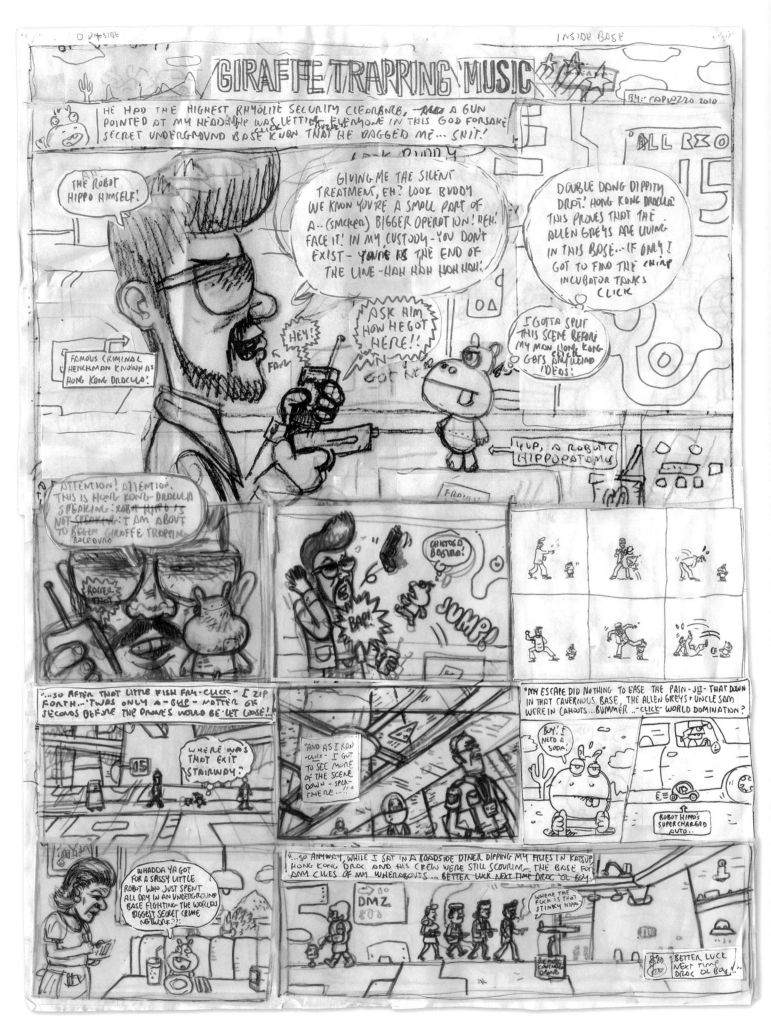

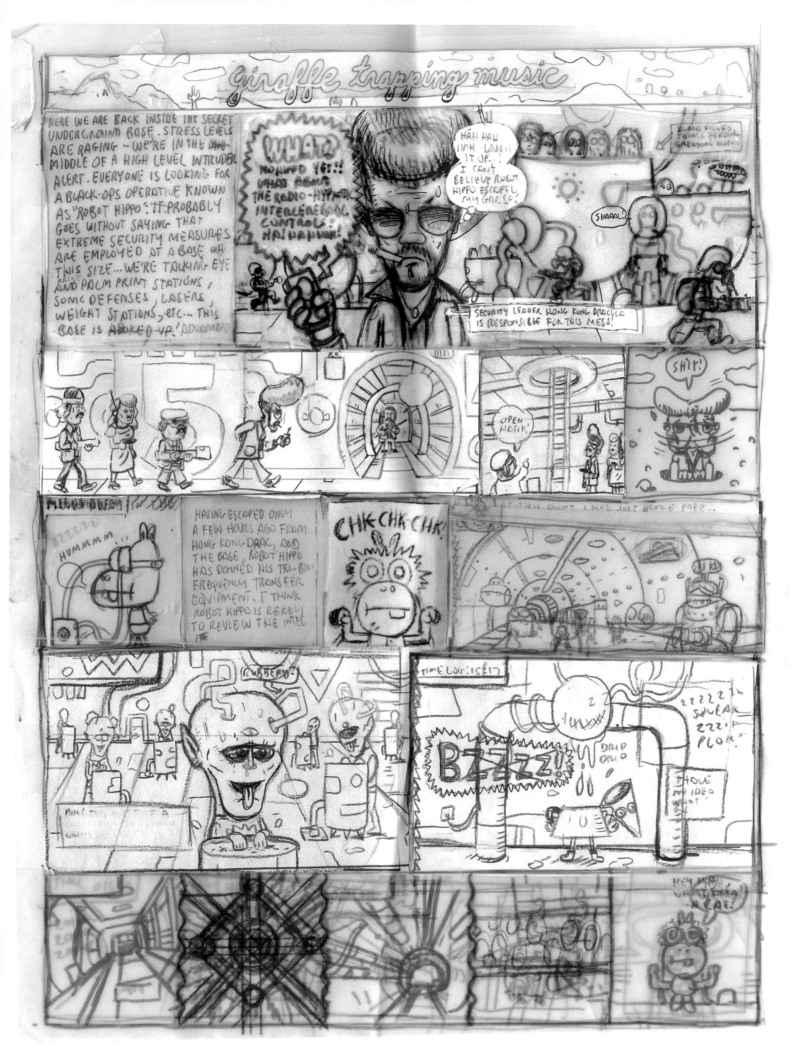

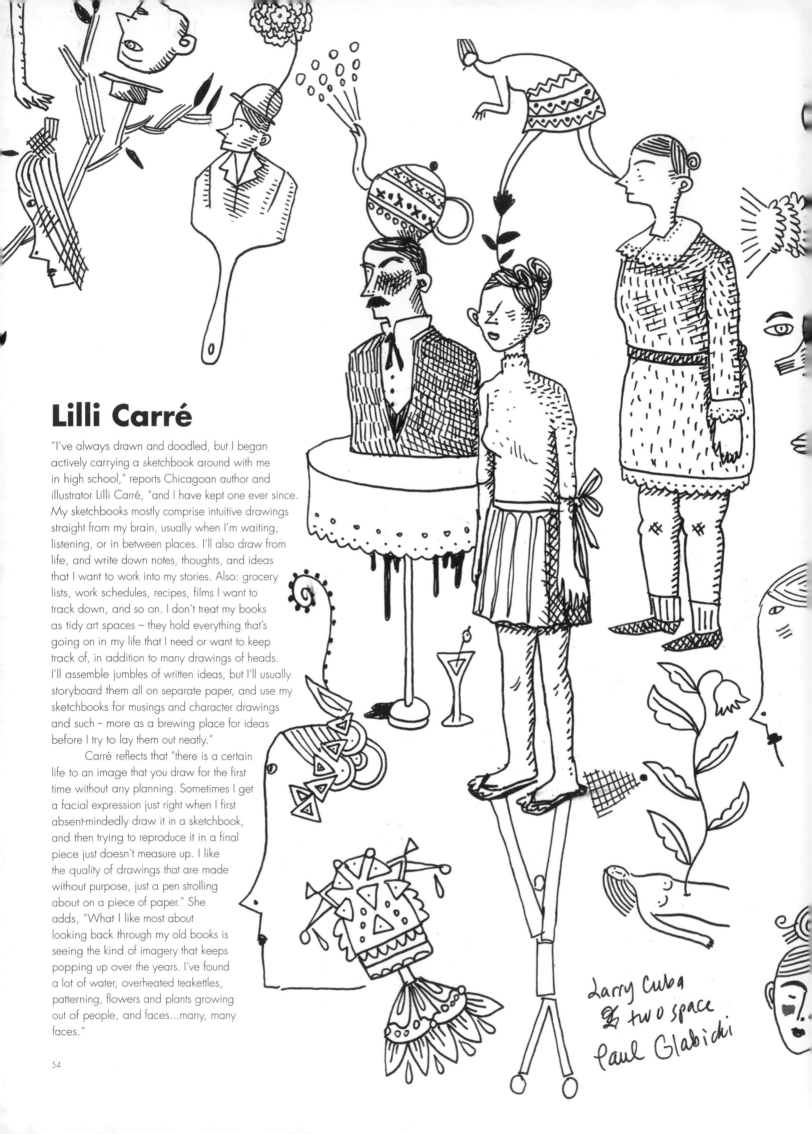

Lilli Carré

"I've always drawn and doodled, but I began actively carrying a sketchbook around with me in high school," reports Chicagoan author and illustrator Lilli Carré, "and I have kept one ever since. My sketchbooks mostly comprise intuitive drawings straight from my brain, usually when I'm waiting, listening, or in between places. I'll also draw from life, and write down notes, thoughts, and ideas that I want to work into my stories. Also: grocery lists, work schedules, recipes, films I want to track down, and so on. I don't treat my books as tidy art spaces – they hold everything that's going on in my life that I need or want to keep track of, in addition to many drawings of heads. I'll assemble jumbles of written ideas, but I'll usually storyboard them all on separate paper, and use my sketchbooks for musings and character drawings and such – more as a brewing place for ideas before I try to lay them out neatly."

Carré reflects that "there is a certain life to an image that you draw for the first time without any planning. Sometimes I get a facial expression just right when I first absent-mindedly draw it in a sketchbook, and then trying to reproduce it in a final piece just doesn't measure up. I like the quality of drawings that are made without purpose, just a pen strolling about on a piece of paper." She adds, "What I like most about looking back through my old books is seeing the kind of imagery that keeps popping up over the years. I've found a lot of water, overheated teakettles, patterning, flowers and plants growing out of people, and faces…many, many faces."

Larry Cuba
& two space
Paul Glabicki

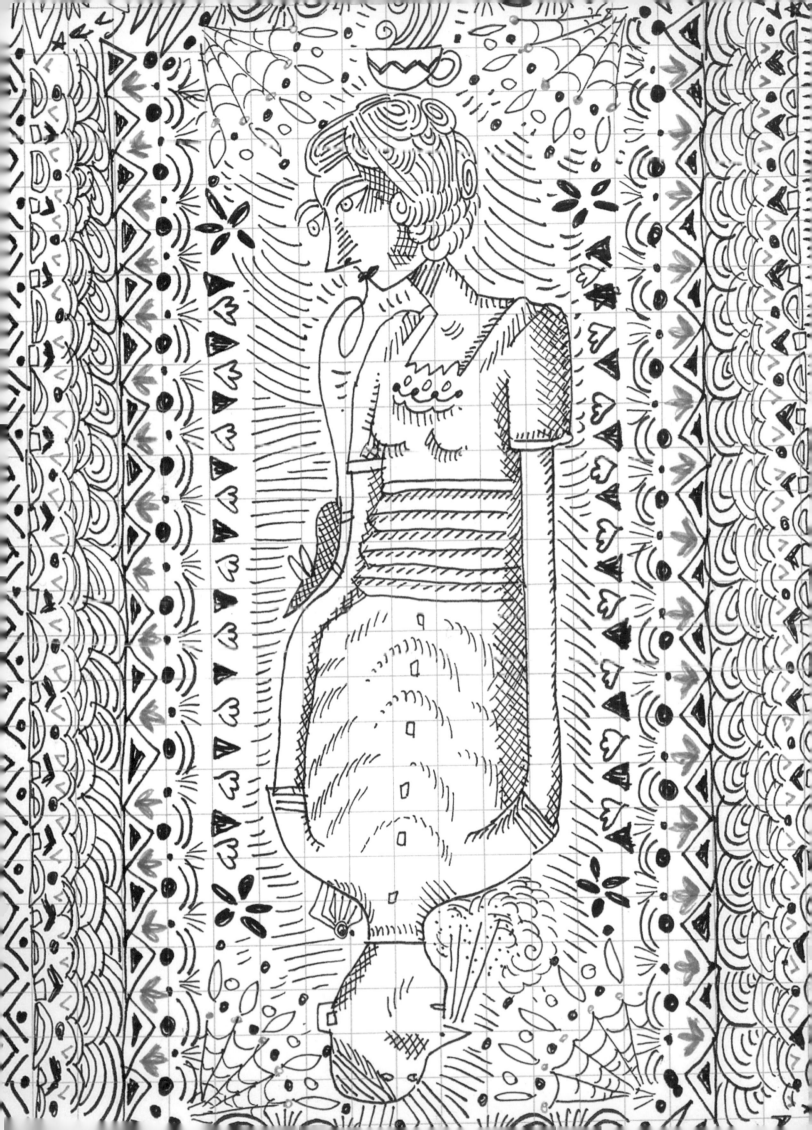

Seymour Chwast

The eighty-year-old and still prolific Seymour Chwast (who says he lives on "Cloud Nine"), co-founder of Push Pin Studios, has made sketches for a whopping sixty years. But the ones here, which are among the few that he's retained, are specifically kept as part of his process for producing his first three graphic novels, *Dante's Divine Comedy* (2010), *The Canterbury Tales* (2011), and *Homer's Odyssey* (2012). Although Chwast has made many comics over his lifetime (and was indeed influenced during his formative years by the Sunday Funnies), only in his seventy-eighth year did he start work on the books — making what he says he loves best. In the images shown here, he plays with unique ways of interpreting classic tales that others have illustrated before him.

The sketches are, of course, his prelude to the finished art, which itself often looks very sketch-like. Nonetheless, Chwast asserts, "Sketches are meant to be tentative." And because he regards them as unimportant in comparison to his finishes, the fate of almost all Chwast's sketch work is an inevitable endgame. "They are doomed to be dumped," he insists, defiantly adding, "There is too much paper anyway."

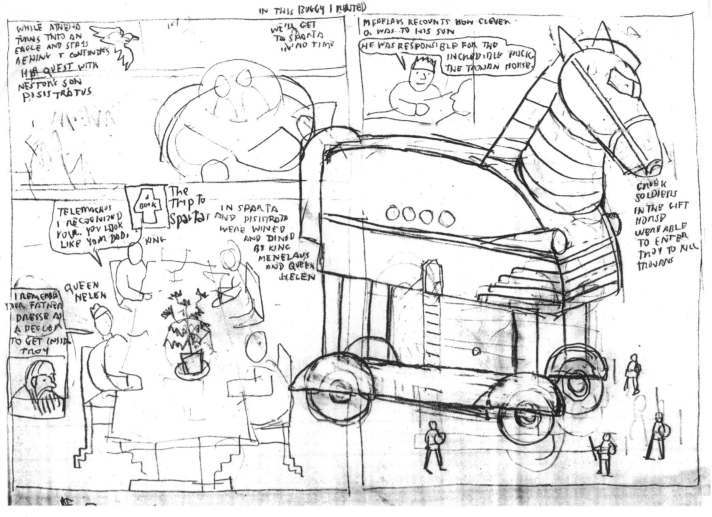

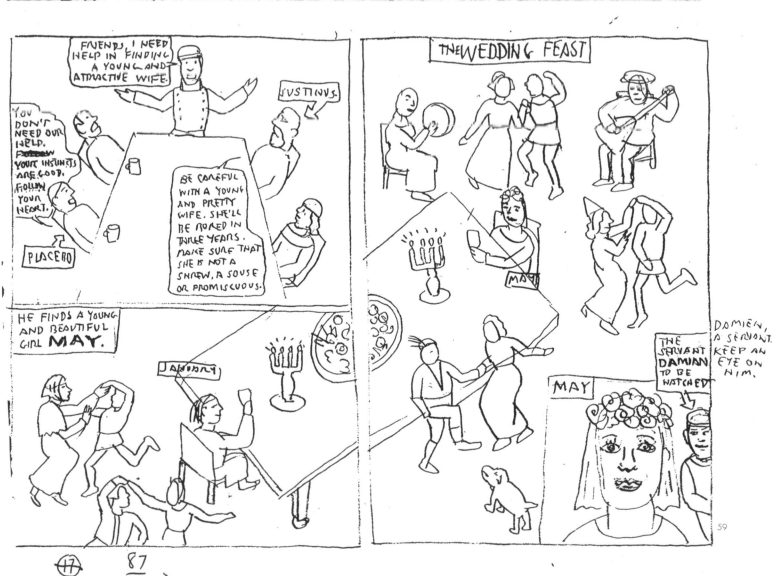

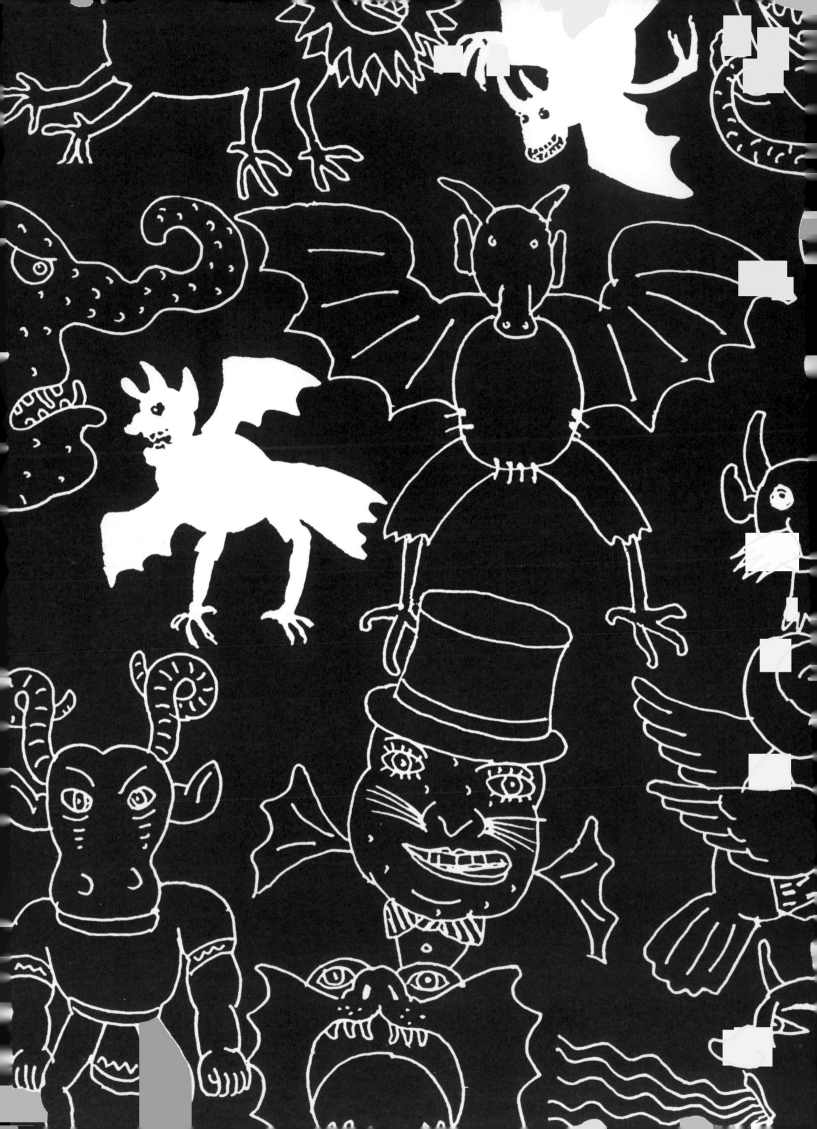

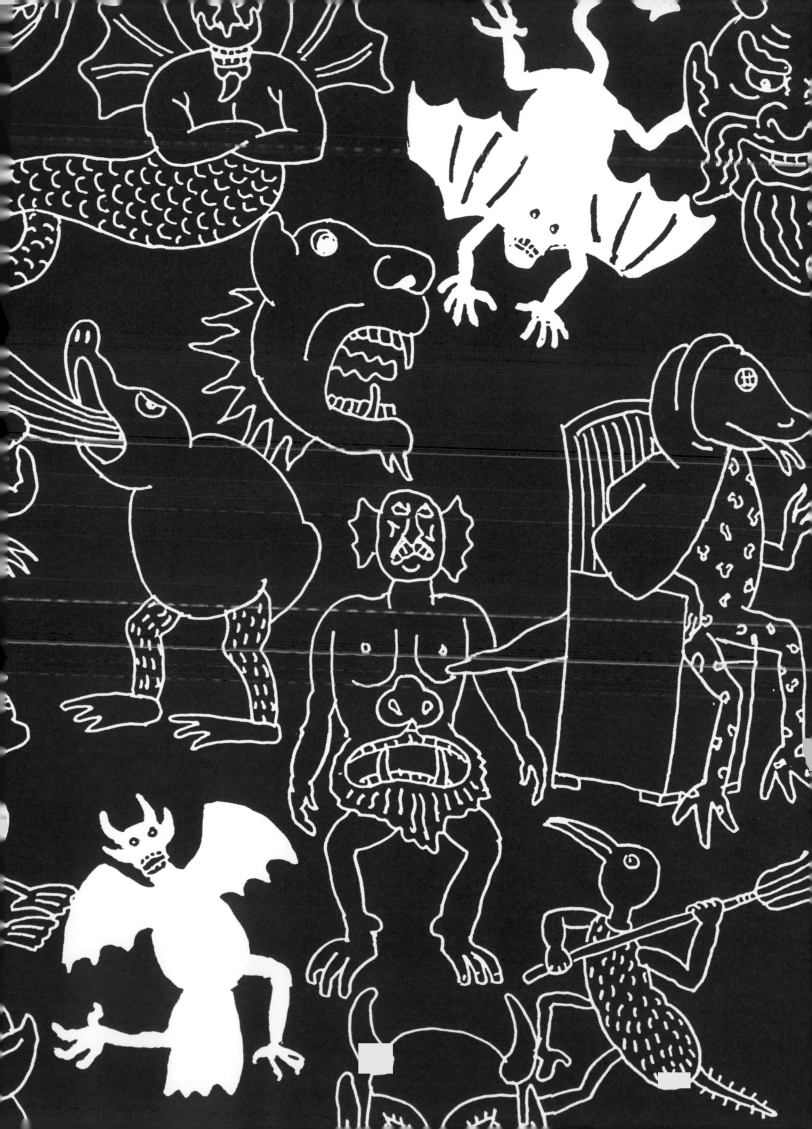

Colonel Moutarde

The enigmatically named Colonel Moutarde, from Paris, France, says she only works in a sketchbook "when I have a book project in my mind." The purpose of the sketches at that specific juncture is "to find a new way to draw my subject. They are mostly preludes to finished drawings." They also show the process of getting to the final piece – the dead ends, the trial and error, the finessing, the discarding and redrawing.

Of the sketches and character developments shown here, Colonel Moutarde reports that she wanted to do a comic book about cowgirls and boys. "These sketches were meant to give the writer some ways, some ideas. But we still haven't found [the best way] yet...." Nonetheless, she adds, "I like the mustaches of the men."

The difference between these seemingly finished drawings and her final pieces is, she says, that "My finished work is not so rough, generally with less charcoal and more colors."

R. Crumb

R. Crumb, whose underground comix defined the absurdist sensibility and cartoon aesthetic of the 1960s (and beyond), began publishing his sketches and sketchbooks in beautifully printed volumes as early as the 1970s – and there is no end in sight. His sketches are often complete entities and, like his final drawings, are either fantasies – sexual, mostly – or representational: one of his passions is blues and jazz musicians. These sketches, culled from *R. Crumb's Sex Obsessions* (Taschen, 2007), exhibit his devout, almost religious attention to detail – and therefore reveal the utter magic behind his craft. To shed more light, he shared some of his technical secrets with Ted Widmer in the *Paris Review*: "I use Pelikan black drawing ink, and the crow-quill pen nibs," Crumb explained: "you

stick them in a handle. They're getting harder to find, all these antique art instruments. The companies that have made them are dying off one by one."

Talking about his biblical extravaganza, a comics retelling of Genesis, Crumb told Widmer, "I would often make a sketch first on a piece of scrap paper, try and get it right before I started penciling on the drawing paper. How's this angle, his arm? And the guy's holding a tool, how does that look? I used Muybridge's *Animal Locomotion*, from the late 1800s. It includes hundreds of photos of naked people in action, really handy for any kind of cartoon work where you have to draw people realistically in different actions and poses."

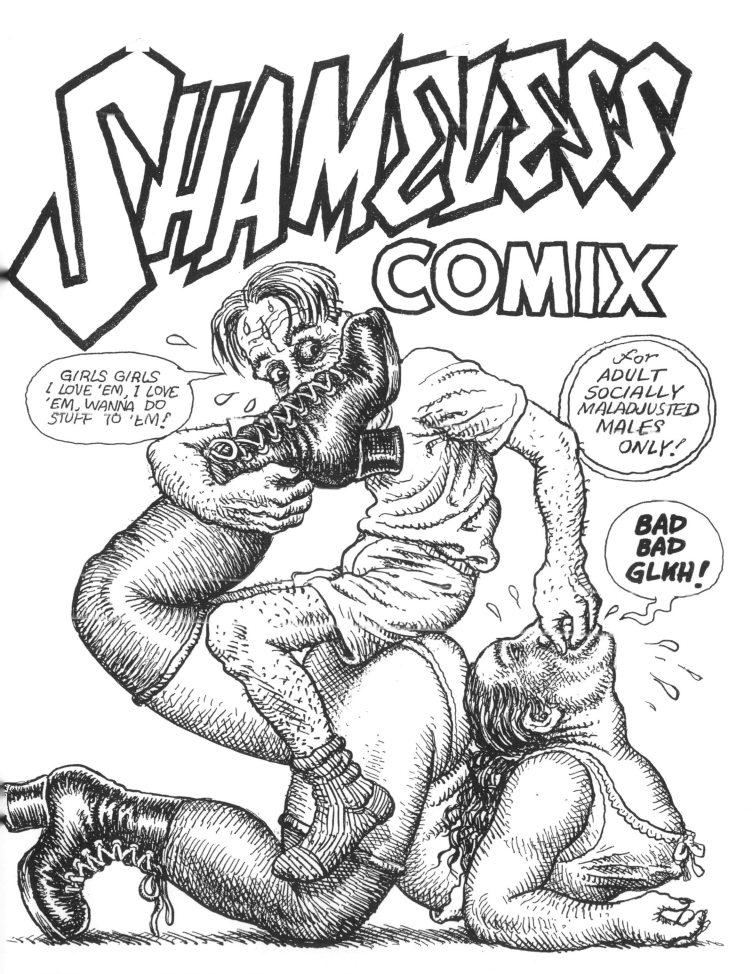

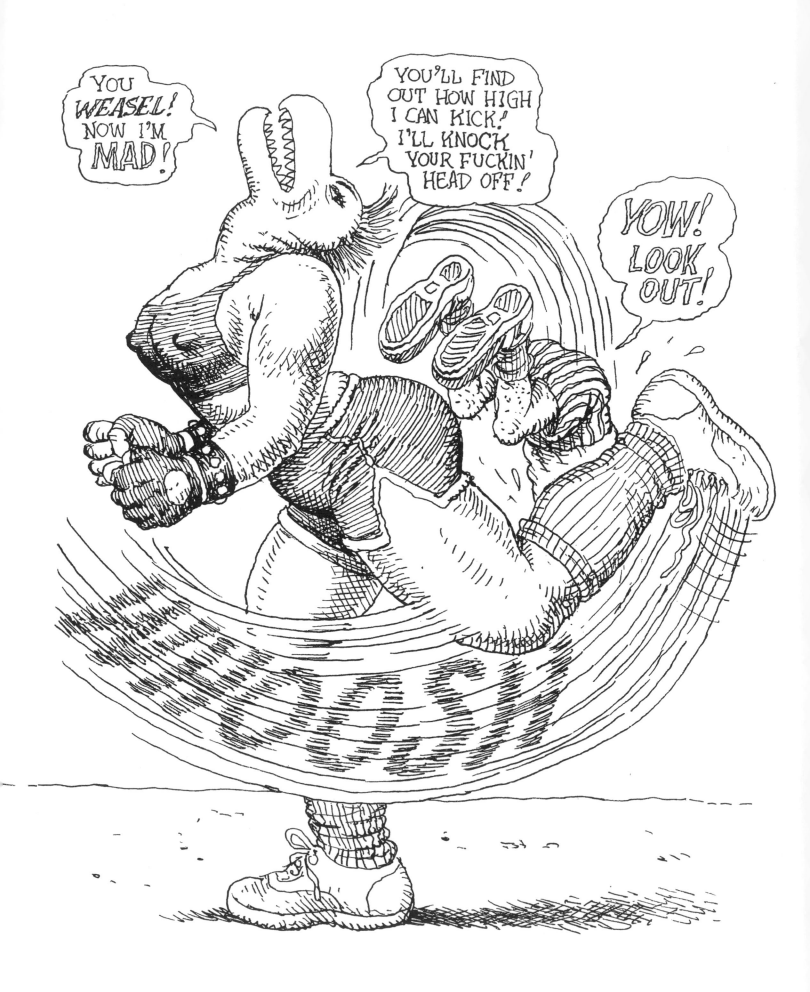

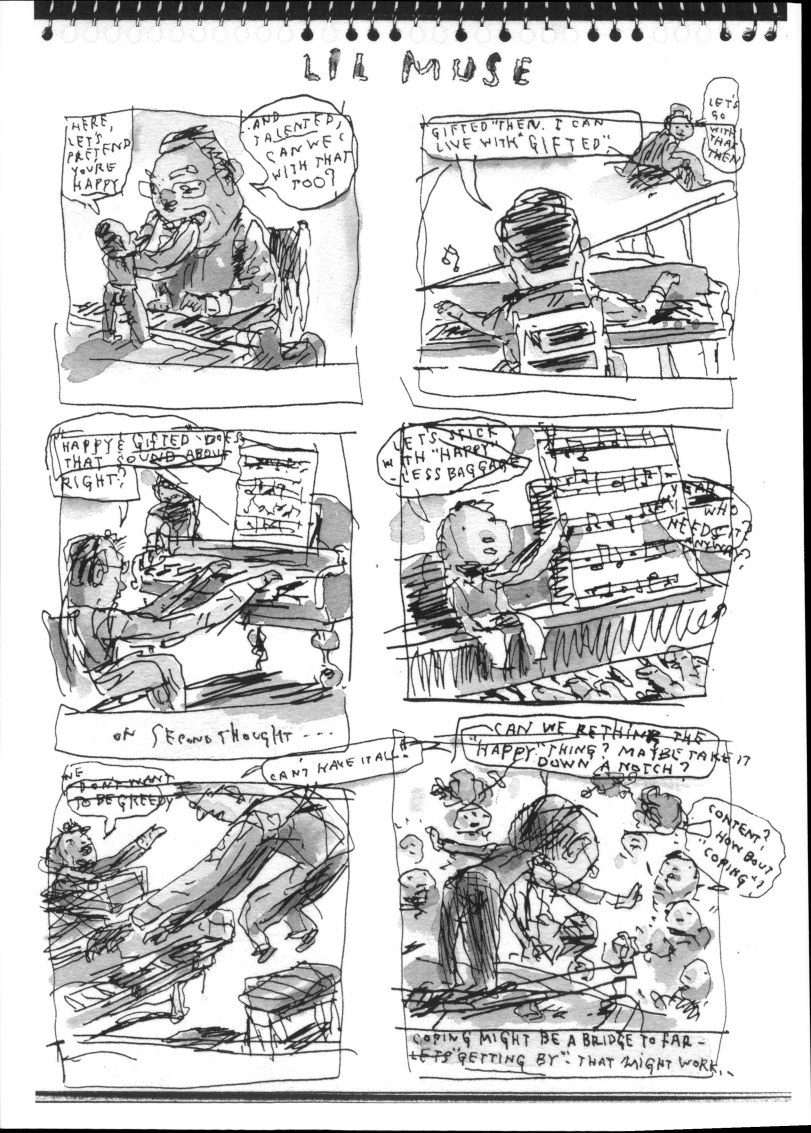

HITCHHIKING

John Cuneo

Illustrator John Cuneo has been drawing in sketchbooks since he was a teenager. "The motivation for these things shifts around," he declares. "I get into drawing ruts, have bouts of insecurity and go through OCD stages of manic repetition, and sketchbooks are good places to work some of that out. I like to pretend that there is discipline here, like a musician practicing scales – but that's probably a self-serving rationale." Sometimes doodles will morph into an idea for a strip, and "I try to follow up on those. I like to place characters on a page or in a panel and see if I can make them interact without getting too tripped up by logic or narrative."

Commissioned work, by definition, does not encourage this kind of "play," although, as Cuneo observes, "the best comics artists manage to integrate their personal themes and imagery into their assignments. But sometimes magazines will ask for a page of drawings on a certain theme, and occasionally I'll submit an unsolicited narrative page idea to a magazine art director with whom I have a working relationship."

Much of Cuneo's personal work is concerned with "managing certain adult appetites and with the guilt and self-loathing associated with them." These sketches were done between 2009 and 2011.

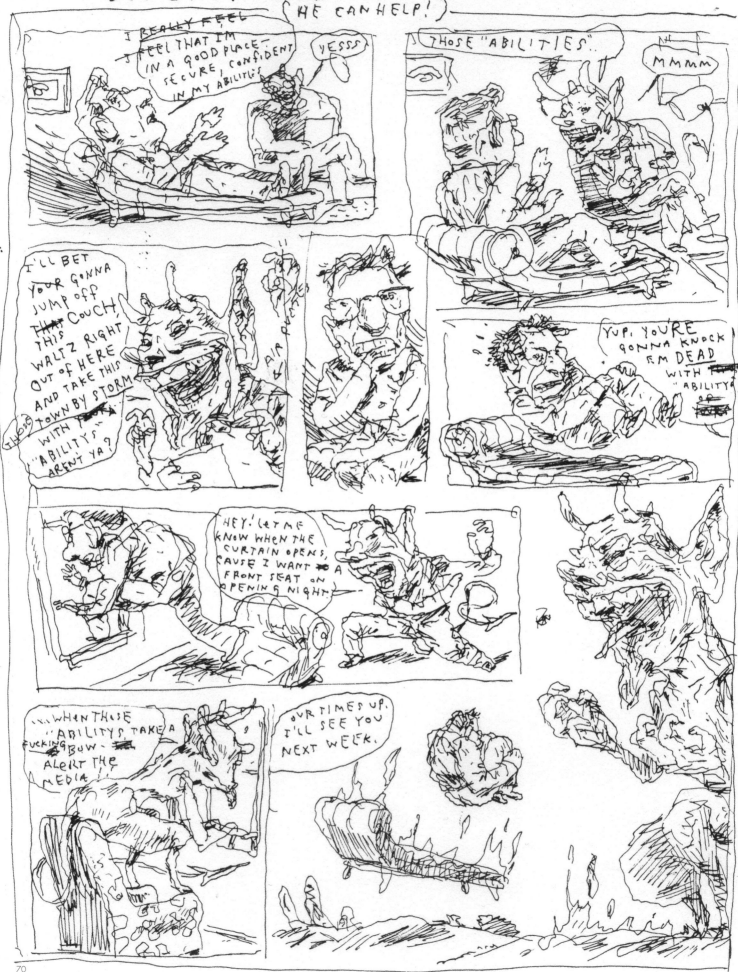

BREAK DANCING

THE CIVILIZED WAY to BREAK BAD NEWS

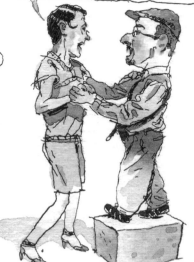

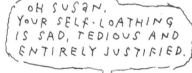

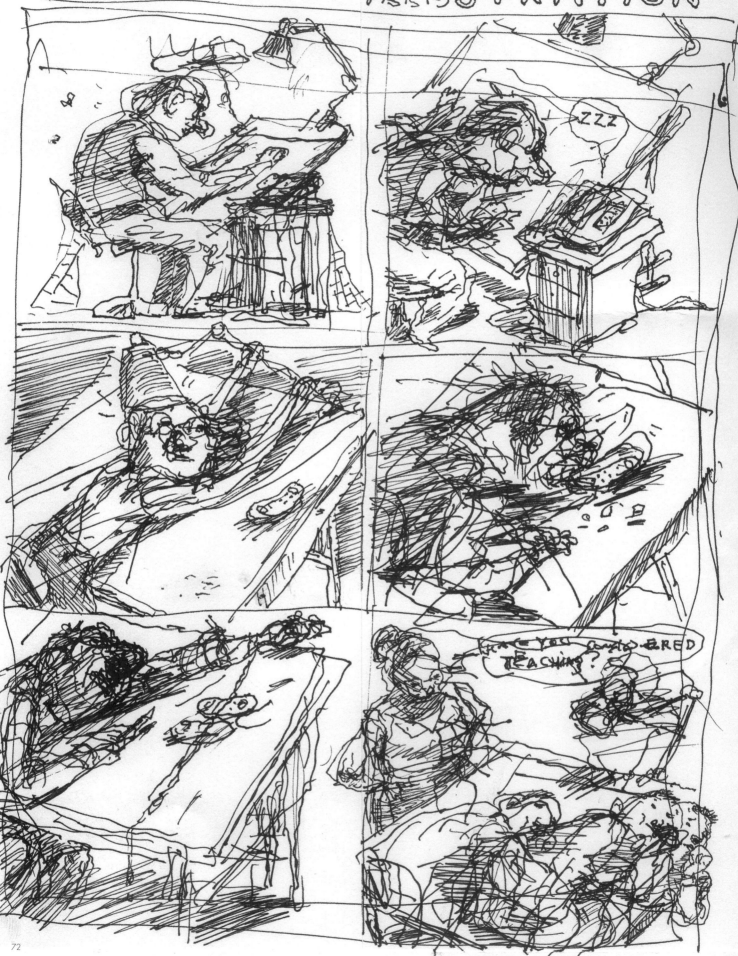

ADVENTURES in ILLUSTRATION!

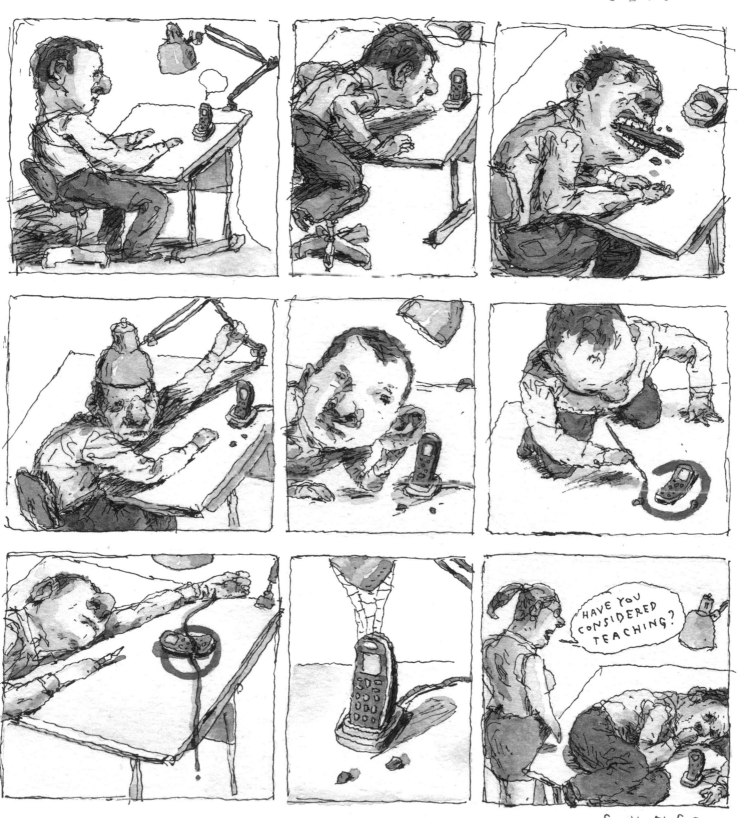

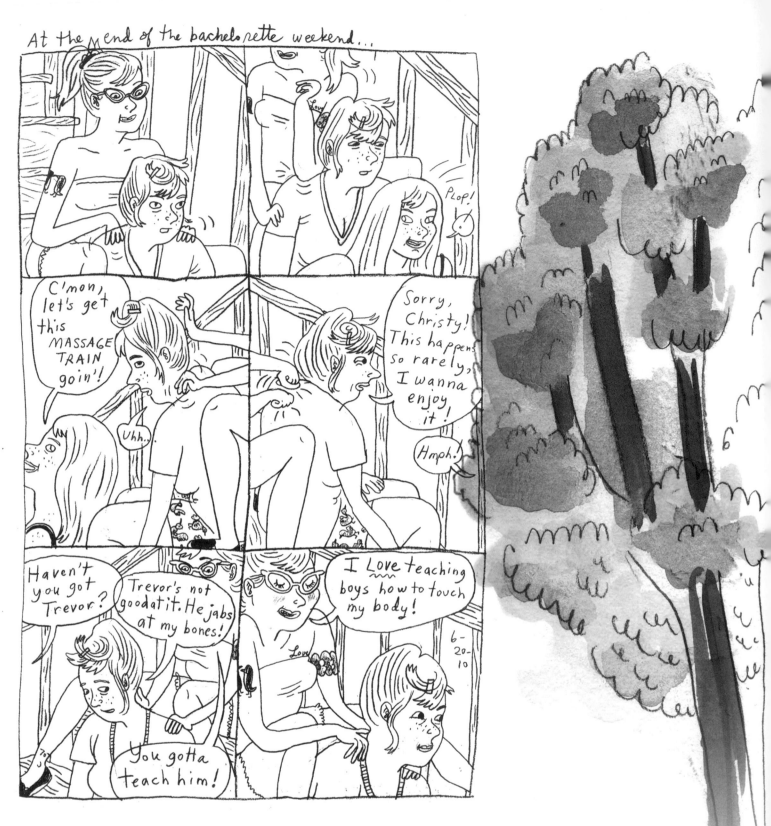

Vanessa Davis

Vanessa Davis, an illustrator and cartoonist based in Santa Rosa, California, confides she has worked in sketchbooks "probably since about seventh grade. I work out drawing problems in my book, see what ideas might look like once I draw them. Sometimes I'm just keeping busy, too."

Davis notes, "In my sketchbook I can fail, or choose not to show it to people. So I can do whatever I want. With my finished work, I think much more about the person looking at it, or reading it." Pondering the uniqueness of her sketches, she says, "Perhaps something unusual about most drawings in my sketchbook is that they overlap. I don't often think of the page as a whole. Sometimes I feel like my sketchbook is too expensive

just to treat as a doodle-pad. But if I didn't have it, I wouldn't get anything done. The sketchbook is always the first (and sometimes last) step."

About the sketches shown here, all from 2010, Davis explains, "The two pages with all the drawings of different objects were just from a day when I wanted to draw a bunch of fun things together. The sketches of hair metal rockstars are from when I started wanting to draw hair metal rockstars. The massage train comic is just a diary comic I did after a bachelorette party. And then the page with the faces and the watercolor is the first page of the sketchbook, and whenever I get a new sketchbook I get on a real sketching-from-life kick."

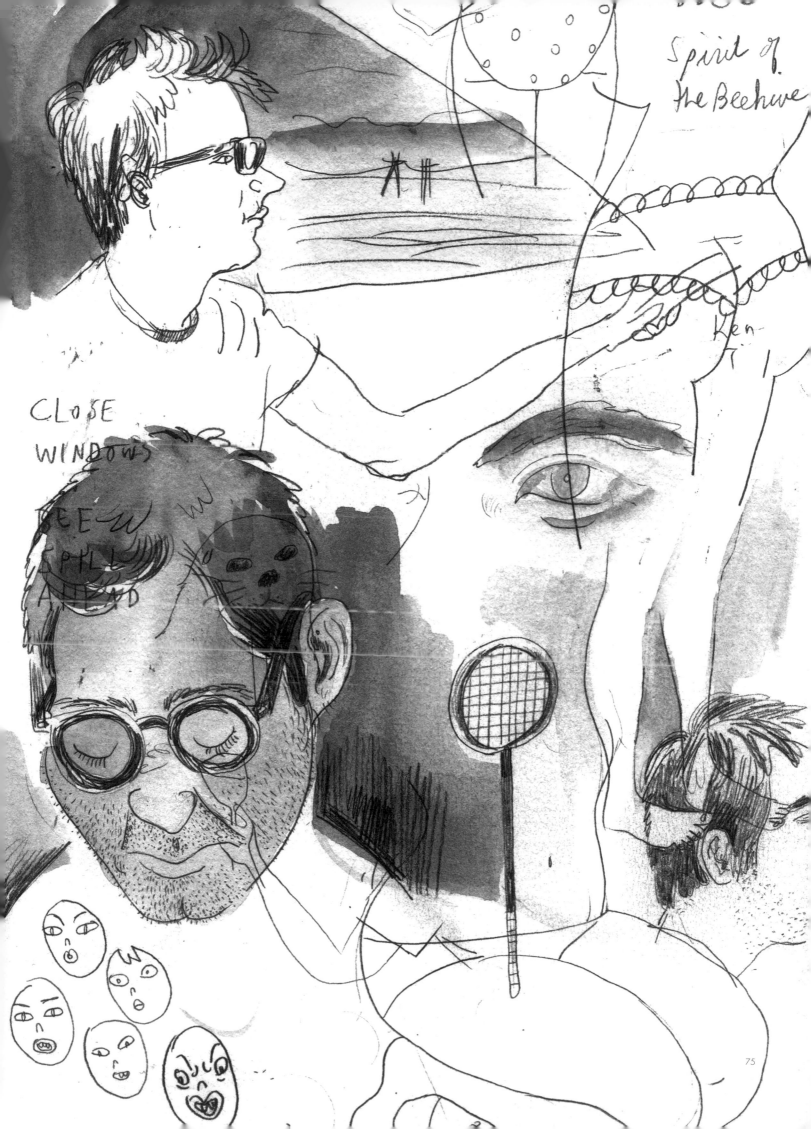

Spirit of.
the Beehive

Ken

CLOSE
WINDOWS

BEE
SPILL
AHEAD

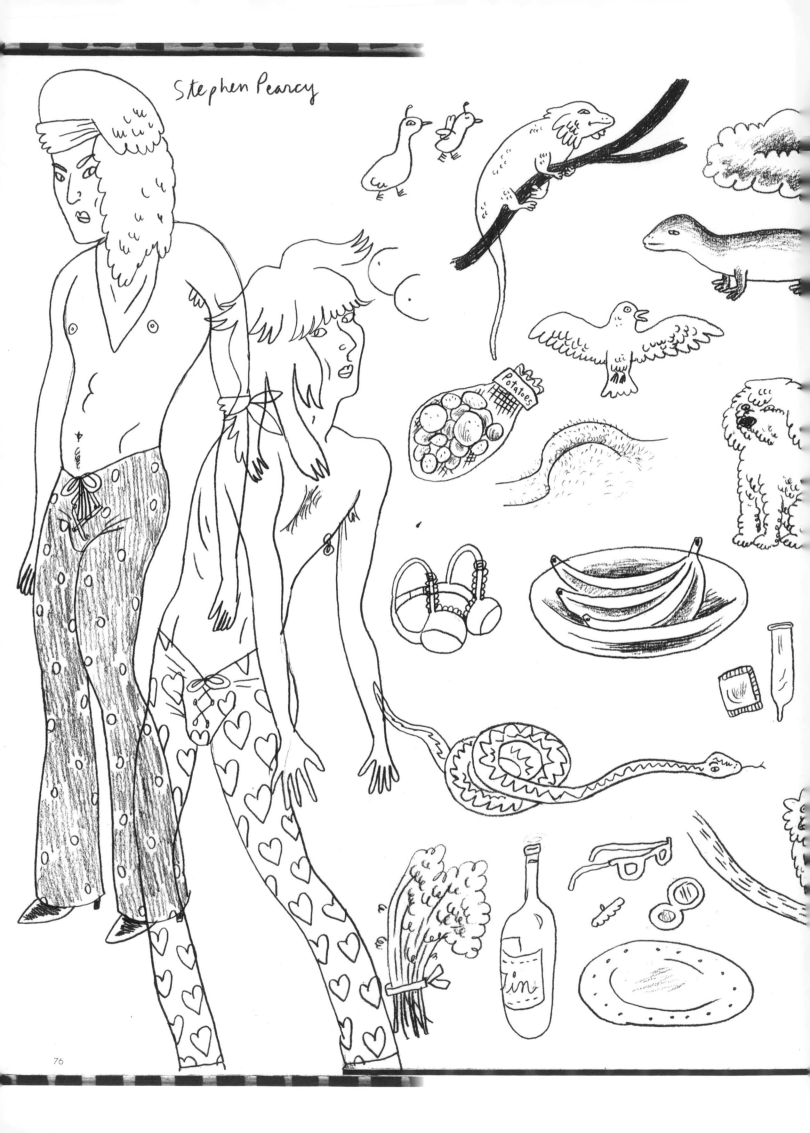

Stephen Pearcy

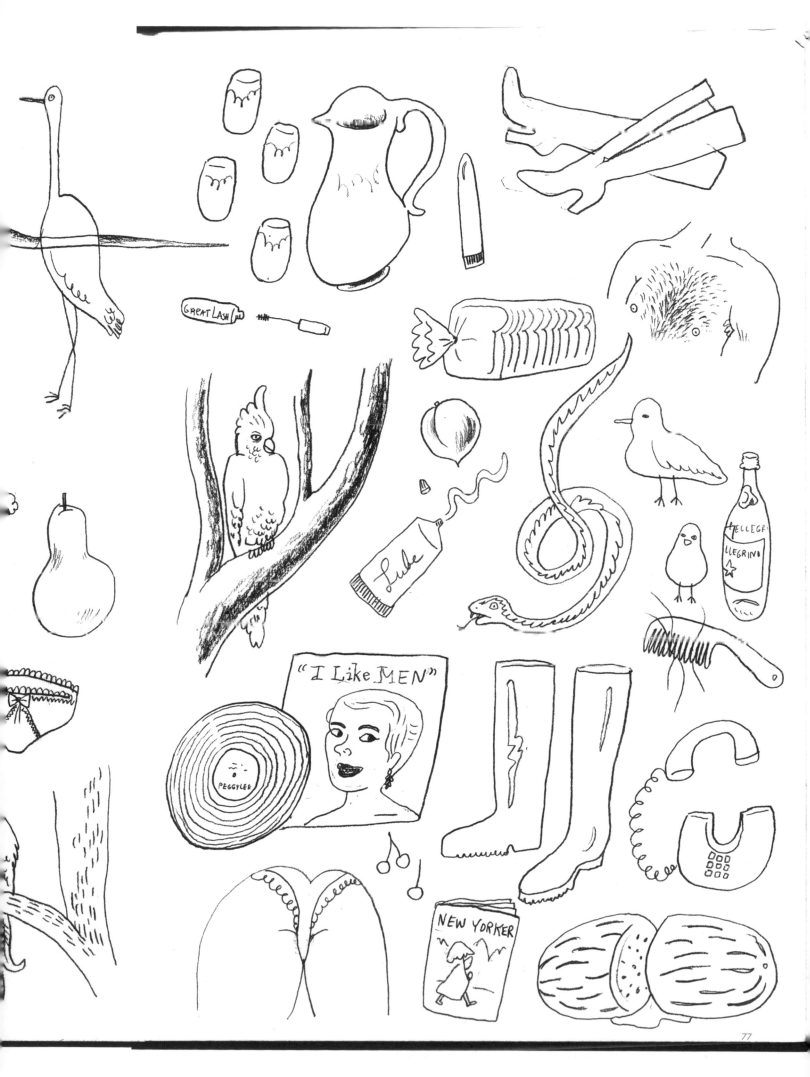

One last thing he mentioned before starting to read, was that he'd hired Allen Rollins to be my leading man! Mr Varnay told me that Rollins deeply regretted the accident that occured in Lumberton when he was with the Molly O'Dare crew, and went on to say that,

Allen deplored the sorded conditions that led to the accident which could so easily have maimed, or, God forbid, killed you!

Well! I certainly hoped so!

60

In the serial, Rollins played a fictional character loosely based on young Mr. Varnay. Mr. Varnay cast himself in the role of the mysterious stranger - seen here. who turns out to be the leader of a secret order known, (perhaps) as The Mystic Knights Of Enlightement.

They are the same men who daringly raided an ocean liner to capture the story's heroine,

...and, using a strange submarine managed to audaciously escape with her!

With her wig on straight and her make-up almost on, Molly begins to look like herself. Well, a yellow faced version of herself on a bad day.

In her cups

LISSEN HONEY, IF YOU DON'T STICK UP FOR YOURSELF, YOU'LL BE WALKING THE STREETS ALL YOUR LIFE! AND IF ABE PRICKSTEIN HERE AIN'T PAYING YOU THE GOING RATE, YOU JUST TELL HIM TO and etc...

Poor Molly. And poor Doc! He's got a fortune tied up in Molly O'Dare!

Abe! Can you bring that girl over here?

Okay kid, it all depends on you!

Kate's got a face and form that ought to be on a coin; or a stock certificate. She's money.

No. She's better than that.

⑪ Abe, on the other hand, hears opportunity knocking.

After a huddle with Ledicker, Abe signals for Kate to come over. This welcome reprieve renders her practically ecstatic.

LEDICKER ACTS early rescue?

Eleanor Whaley's husband was a former New York City fireman named Warren. Like Ellie, Warren was a born again Christian.

His death, while serving in Iraq, shakes Ellie's belief system to its very core.

① With Ellie's brother Sid, (The Crown cap King,) in 2003

Kim Deitch

"I have never kept an actual sketchbook," the underground comix artist Kim Deitch admits. "In the late 1960s, after meeting R. Crumb [see p. 64] and seeing how he used sketchbooks, I tried, but it didn't really take. But at some point after that, I made the happy discovery that there was something about the large 11 × 17 in. (28 × 42 cm) Xerox sheet that set me free to sketch. I'm left-handed and start at the far right and work my way left. This has been going on in this format in earnest, I'd say, for twenty to twenty-five years."

For Deitch, the purpose is essentially to help the writing process: "By the time I have a story together I have a corresponding pile of sketches, always in pencil. Since I am doing these in tandem with writing,

I often end up with scenes and situations at this level that are somewhat different from what is in the final story. Character designs tend to evolve and change as well," he attests. Sometimes Deitch will deliberately put his characters in situations that don't seem to fit into a story, "just to get to know a character better, or simply to get used to drawing certain characters."

His sketches could easily be finishes. "People often seem nonplussed that the sketches are so finished-looking, like entities unto themselves," he reflects. The sketches shown here are from the long story Deitch is now working on and were made between 2009 and 2010: "It is my longest story to date," he explains.

REISENWEBERS

Felton's Cafe Felton's

HAPPY'S Hottentot Novelty JASS BAND

One night we went over to Felton's cafe over on Columbus Circle to hear and dance to the new jazz music, which I thought was rather funny, but fun to dance to.
 Allen told me I'd really missed the great dancing days in New York city, which he told me had flourished in a series of dance clubs run by Vernon and Irene Castle.

because dancing was something he especially excelled at.

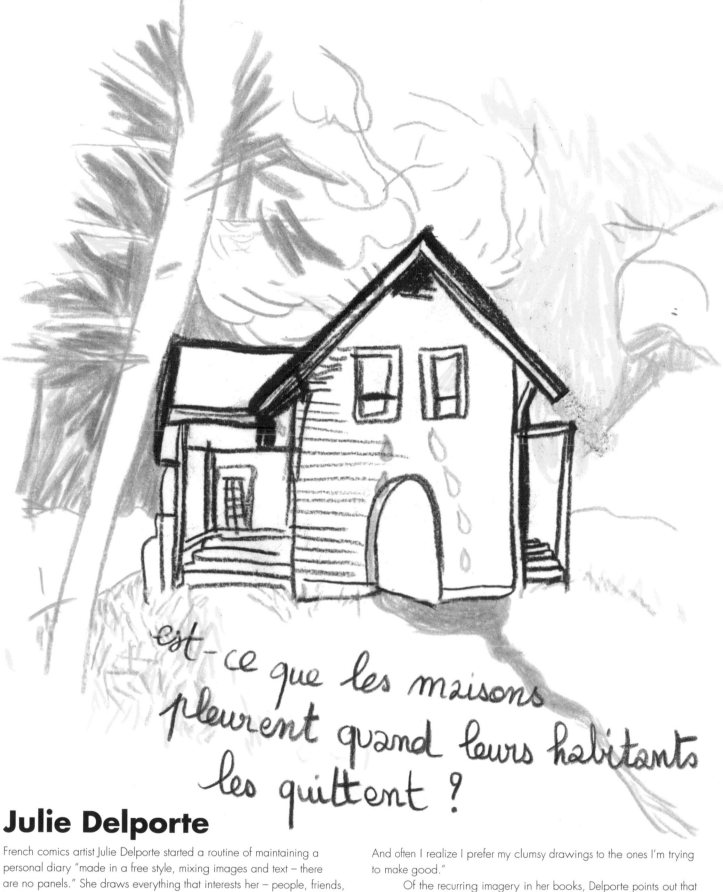

est-ce que les maisons pleurent quand leurs habitants les quittent ?

Julie Delporte

French comics artist Julie Delporte started a routine of maintaining a personal diary "made in a free style, mixing images and text – there are no panels." She draws everything that interests her – people, friends, landscapes, animals, buildings, images from films. "Since I've been doing that," she says, "I don't use a camera any more."

Her sketches are not so different from finishes. "When I like them, I cut them from my sketchbook and paste them with tape in my diary pages. For this diary, I don't pencil and then ink, I draw directly in colors. I think it's more a European style, maybe…" She also insists that her sketches are more free and casual – like children's drawings: "They can be clumsy, with bad perspective, for instance.

And often I realize I prefer my clumsy drawings to the ones I'm trying to make good."

Of the recurring imagery in her books, Delporte points out that hands appear frequently – "mine and other people's." Self-portraits are prevalent, too, "but I try not to draw myself as a codified character – I draw myself from mirrors or photobooths, so that my faces can change with time (it's important for a diary)."

Her sketches help her to be less self-consious about her work. "It's fun to sketch, less painful. Mostly because it's fast and in color. Sometimes, when I feel depressed, drawing sketches helps me to find my normal mood again."

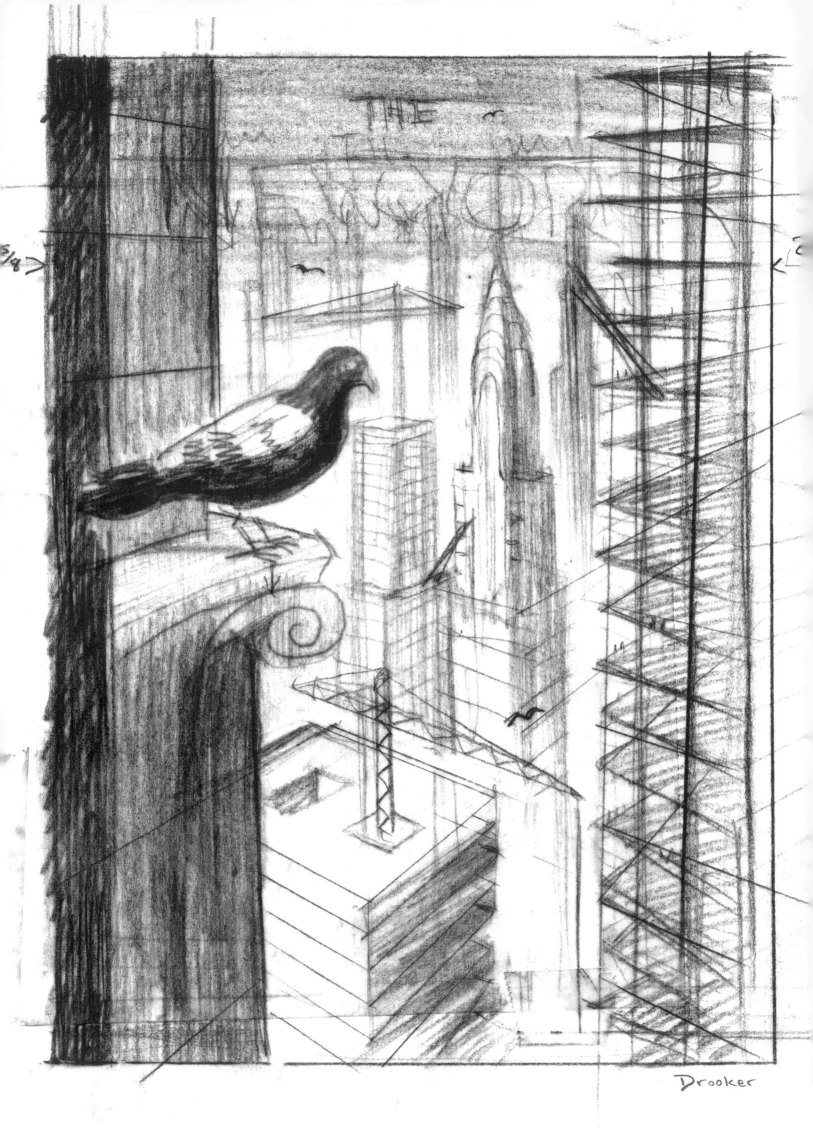

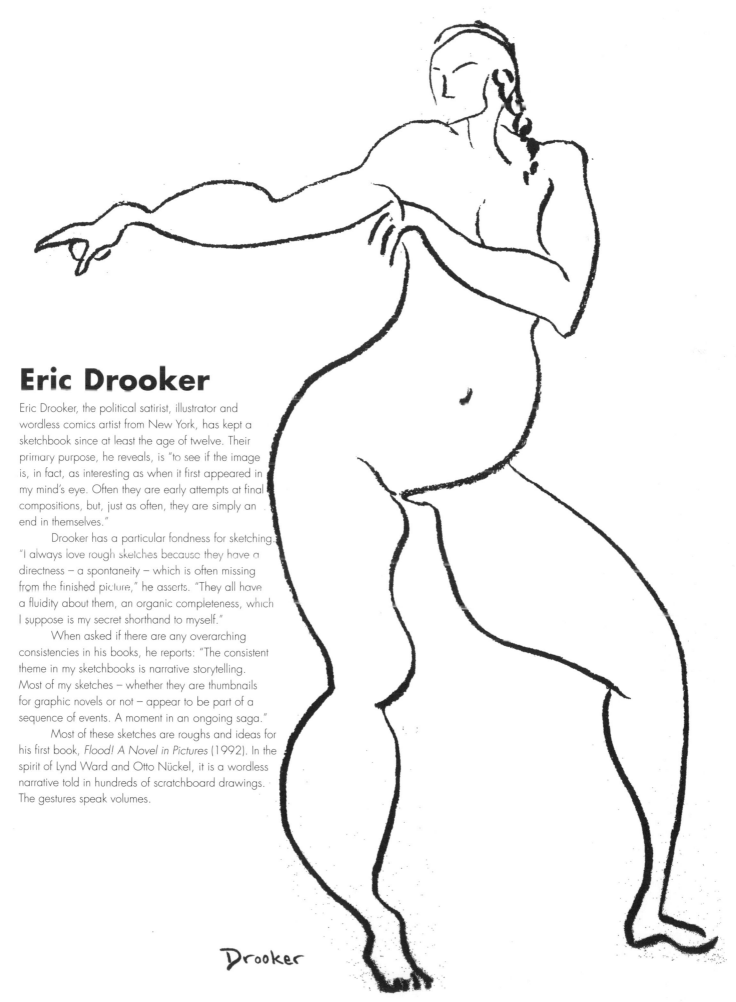

Eric Drooker

Eric Drooker, the political satirist, illustrator and
wordless comics artist from New York, has kept a
sketchbook since at least the age of twelve. Their
primary purpose, he reveals, is "to see if the image
is, in fact, as interesting as when it first appeared in
my mind's eye. Often they are early attempts at final
compositions, but, just as often, they are simply an
end in themselves."

Drooker has a particular fondness for sketching.
"I always love rough sketches because they have a
directness – a spontaneity – which is often missing
from the finished picture," he asserts. "They all have
a fluidity about them, an organic completeness, which
I suppose is my secret shorthand to myself."

When asked if there are any overarching
consistencies in his books, he reports: "The consistent
theme in my sketchbooks is narrative storytelling.
Most of my sketches – whether they are thumbnails
for graphic novels or not – appear to be part of a
sequence of events. A moment in an ongoing saga."

Most of these sketches are roughs and ideas for
his first book, *Flood! A Novel in Pictures* (1992). In the
spirit of Lynd Ward and Otto Nückel, it is a wordless
narrative told in hundreds of scratchboard drawings.
The gestures speak volumes.

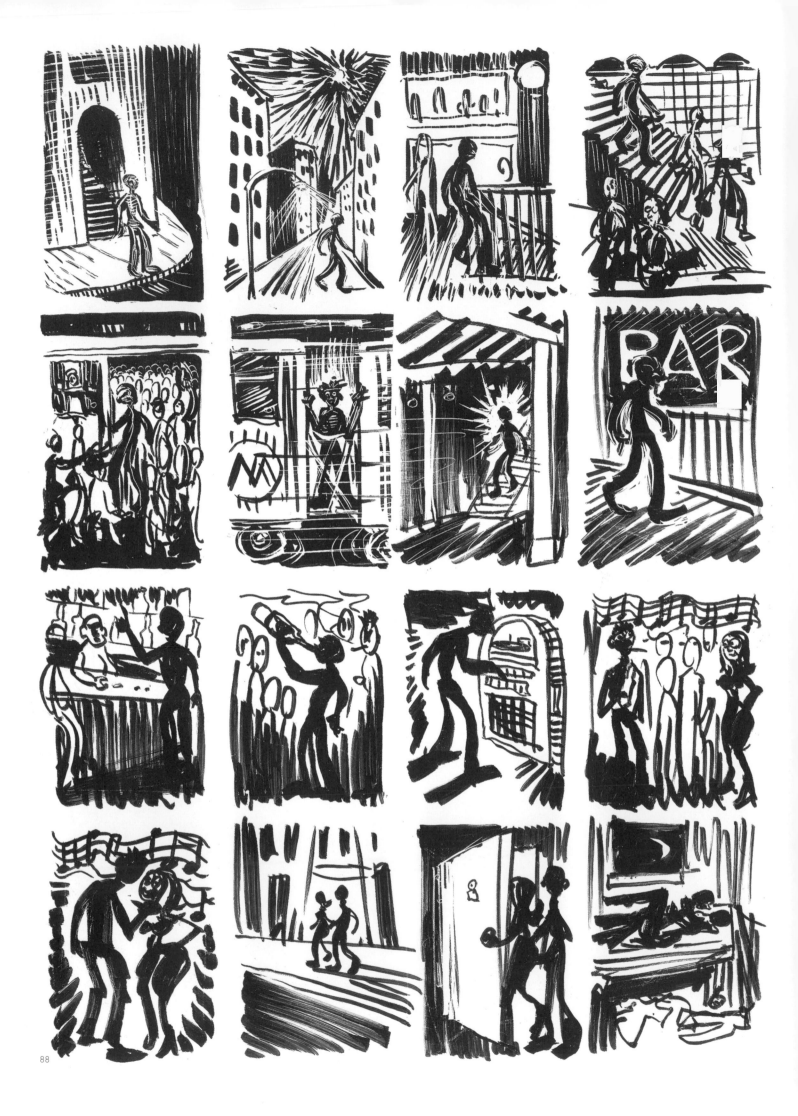

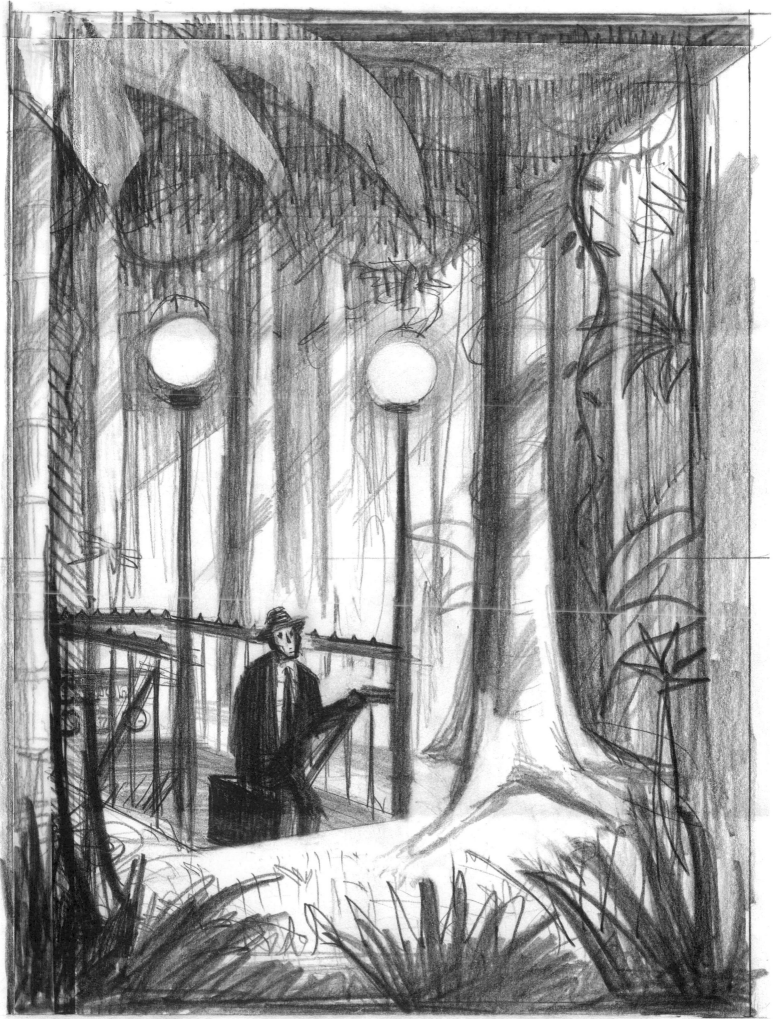

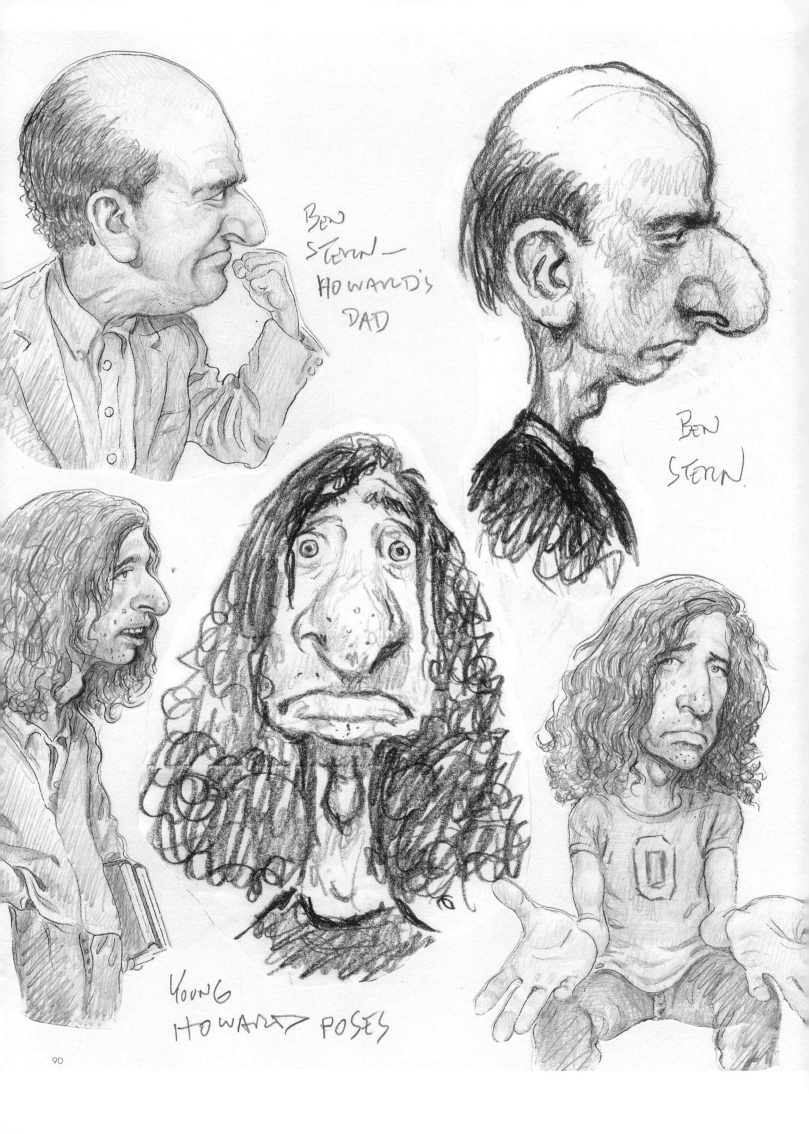

BEN
STERN—
HOWARD'S
DAD

BEN
STERN.

YOUNG
HOWARD POSES

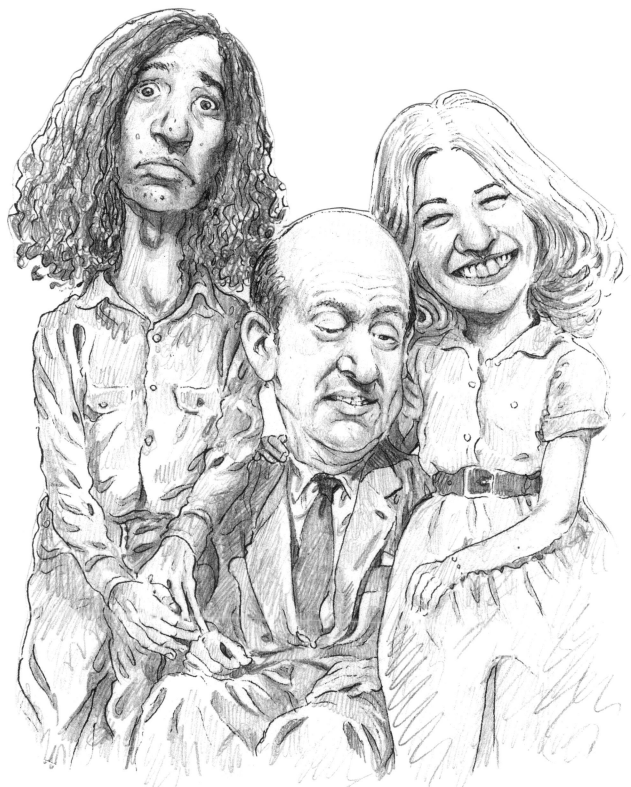

Drew Friedman

Caricaturist of classic comedians Drew Friedman says, "I sketch an idea if I'm inspired, usually with the intention of submitting it as a concept to a magazine. For instance, the Obama as George Washington image was quickly sketched on the day he was inaugurated. I mulled it over, showed it to my wife to get her thoughts, and then I decided to email it to the *New Yorker* as a possible cover." Of course, the sketches are loose, sometimes sloppy, and in pencil. His finishes are precise, tight and painted. Yet he acknowledges that "some of the pencil images are very tight, almost appearing to be the finished art (the Alan King). After the initial sketch, I tend to do a 'tight' pencil sketch, which I then paint over, leaving the pencil drawing underneath. In the case of the Alan King, I didn't

wind up taking it to a finish, so that's all that exists." His sketches are overwhelmingly to do with faces: "I love drawing faces," he proclaims, "either random faces or famous ones. But I hate drawing 'attractive' faces – too boring. I love character and lines in faces (old Jewish comedians)."

Of the examples above and opposite, he states, "The Howard Stern images are interesting because they show my more 'cartoony' side. Howard asked me to draw up a bunch of 'character designs,' including his family members, for a projected animated TV series about his teenage years. He actually encouraged me to make him as 'ugly and disgusting' as possible. My first sketches were a bit tight, then I loosened up and drew the more cartoony ones, which I feel are more effective."

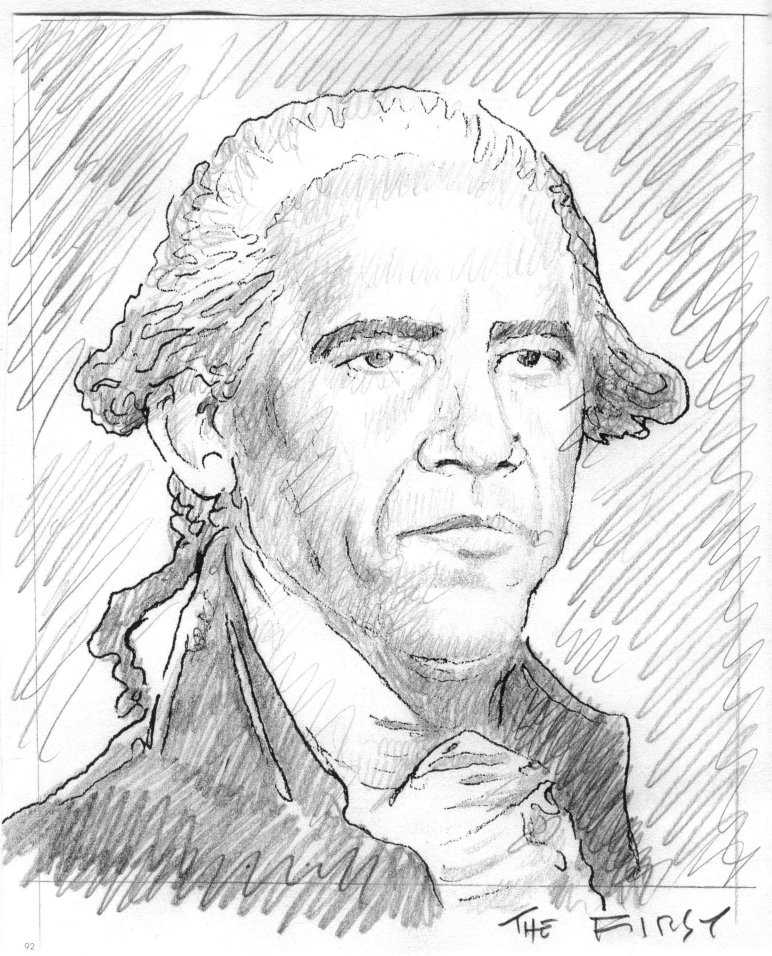

THE FIRST

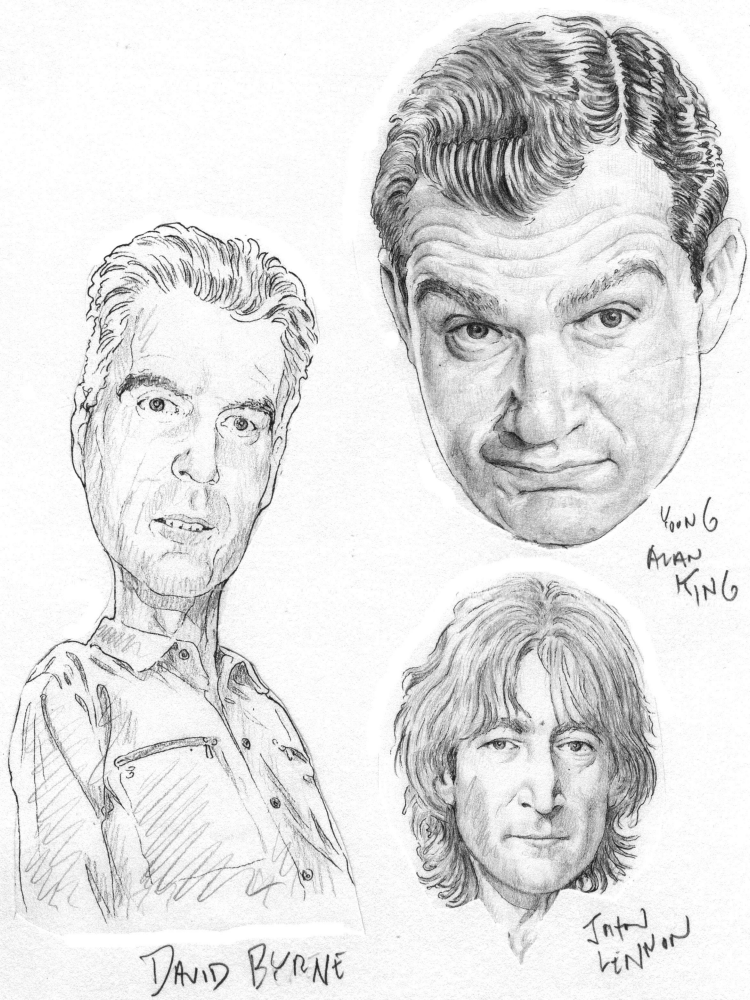

YOUNG ALAN KING

JOHN LENNON

DAVID BYRNE

93

"CLASS CARTOONIST"

FOUR EYES

BIG GLASSES

TOPPS
TOXIC
HIGH
SKETCHES

The Rocket

SEASON'S GREETINGS

FALES

COVER
CONCEPT
SKETCH

DEFACED GEORGE M. STATUE

Manuel Gómez Burns

Peruvian illustrator Manuel Gómez Burns's sketchbooks were, at first, mostly studies from magazines, old pictures, or postcards – "then I could draw people I saw on the streets or in cafés, and also do drawings of locations – all with the purpose of developing my style," he recalls. Over the years, he has progressed from realistic to more cartoony drawings: "I like to draw my own characters and ideas in sketchbooks. Even if I use pictures as a reference, or draw other well-known characters, I like to do it in my own style. Also, I like the idea of the sketchbook as an art object; I see the sketching as art itself."

Most of Gómez Burns's sketches are musings. "I develop characters in my books, which I later use in comics," he declares, "but I never discard the possibility of making bigger paintings based on those sketches in the future." The images here, made between 2009 and 2011, are from sketchbooks that "I'm still filling up." They are drawn with various media, sometimes gouache and sometimes ballpoint pen. "Each one has a different treatment in which I explore possibilities: the use of color or texture. I have some characters that I like to draw in different ways – they may look the same, but I try something new every time, especially those with many faces in one head. The idea of creating those characters came from looking at some sketchbook drawings by Gary Panter [see p. 242], in which he combined many faces of well-known cartoon characters in one head, making it look like something abstract Cubist," he explains.

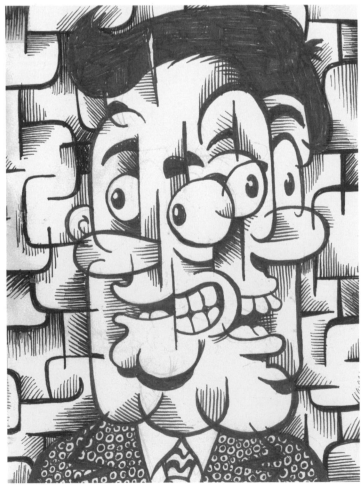

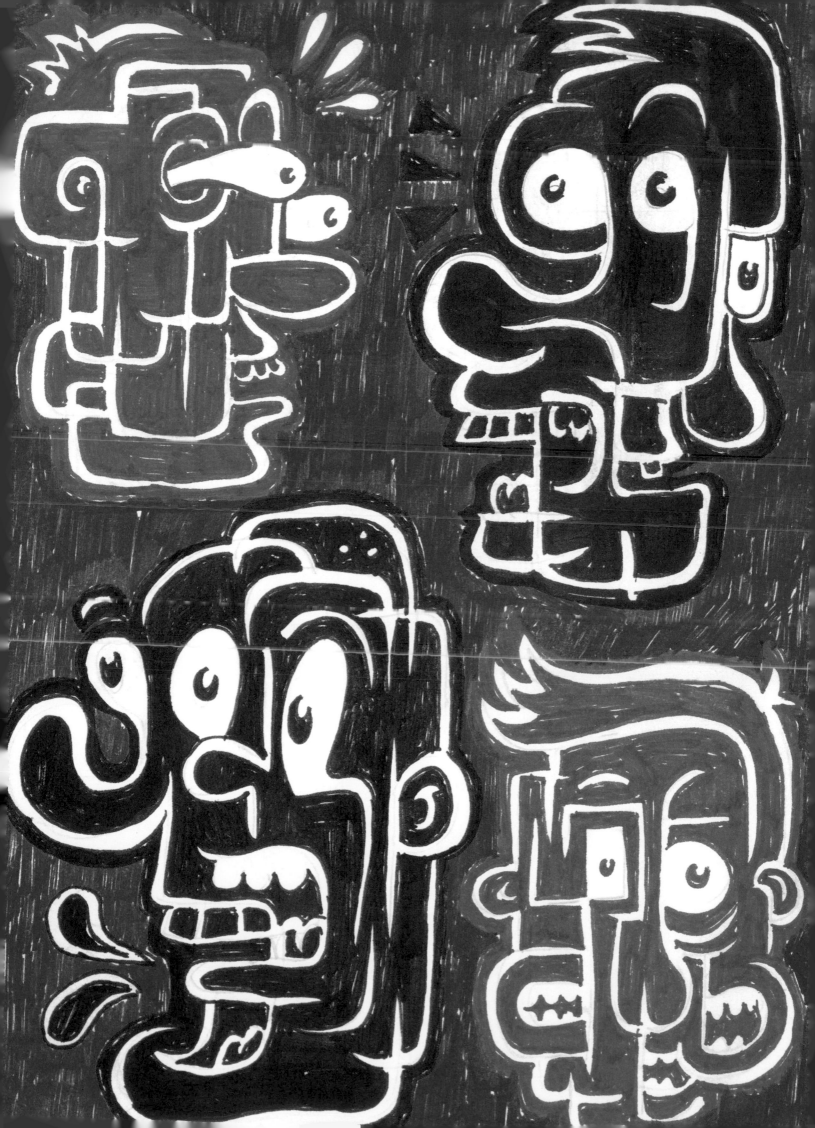

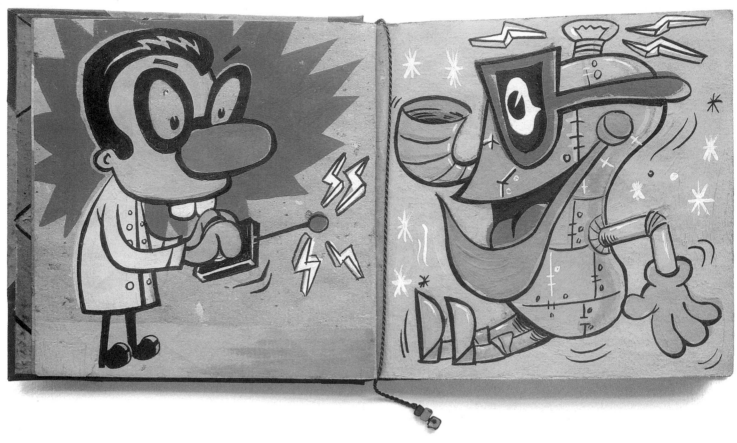
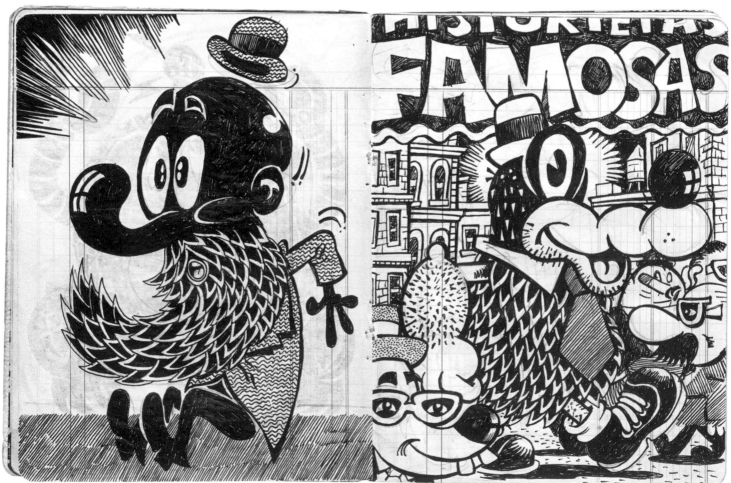

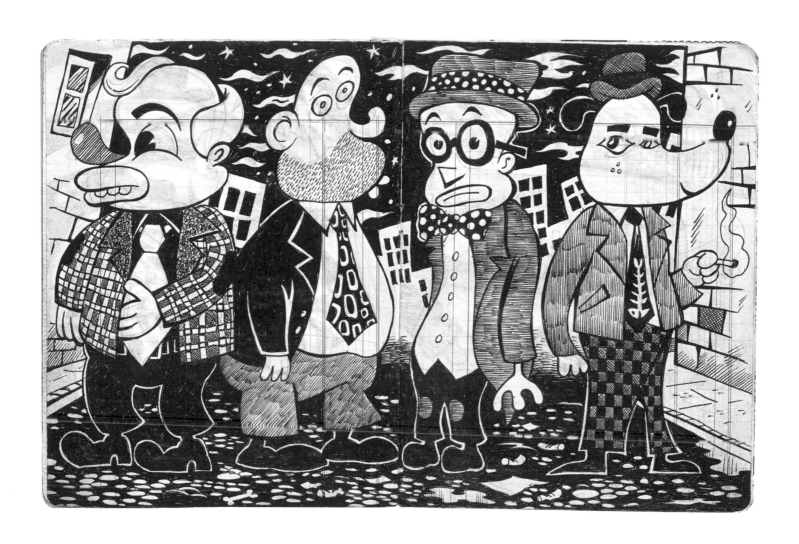

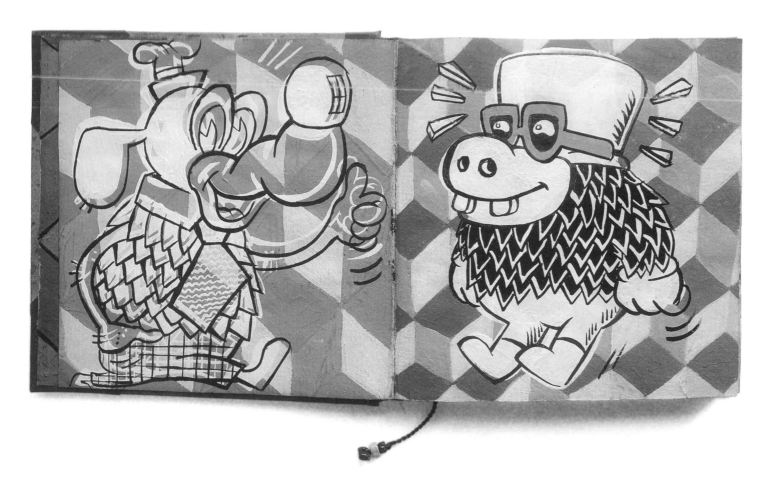

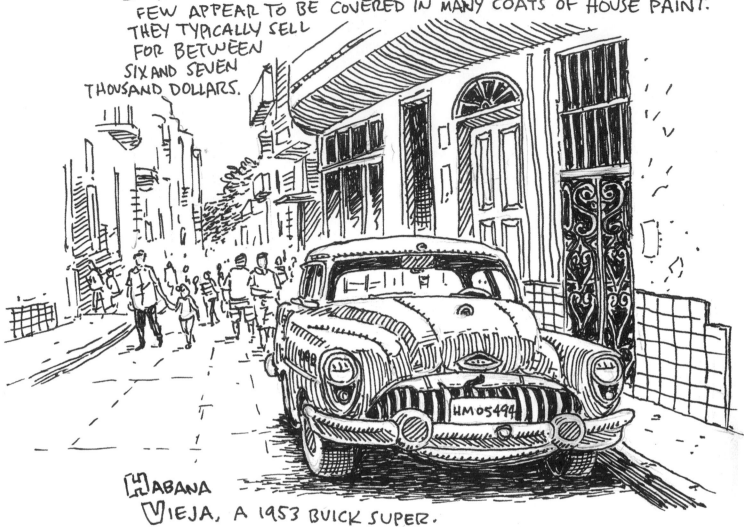

AMERICAN CARS FROM the 1950'S ABOUND IN HAVANA. FOR the MOST PART THEY'RE KEPT IN GOOD SHAPE, THOUGH QUITE A FEW APPEAR TO BE COVERED IN MANY COATS OF HOUSE PAINT. THEY TYPICALLY SELL FOR BETWEEN SIX AND SEVEN THOUSAND DOLLARS.

HABANA VIEJA, A 1953 BUICK SUPER.

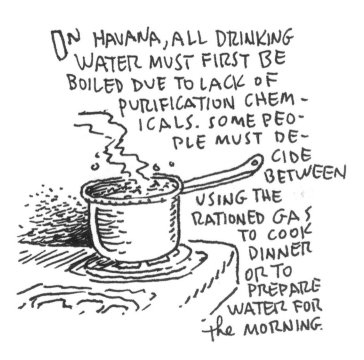

IN HAVANA, ALL DRINKING WATER MUST FIRST BE BOILED DUE TO LACK OF PURIFICATION CHEMICALS. SOME PEOPLE MUST DECIDE BETWEEN USING THE RATIONED GAS TO COOK DINNER OR TO PREPARE WATER FOR the MORNING.

Bill Griffith

The creator of *Zippy the Pinhead* and many other comics over the past forty years, Bill Griffith has kept sketchbooks "off and on since 1971." Most of his sketching is done on travels around the US and abroad: "My book serves as a kind of diary in that sense. My purpose is to record the people and places I encounter, and to relieve the itch I have to keep drawing even when I'm away from my studio. Often, snippets of overheard conversation ('Get me a table without flies, Harry') will wind up in my *Zippy* strips, as will inspirations for new characters."

When he's sketching, Griffith never thinks of an end purpose beyond capturing what he is seeing or thinking about. "I just have a compulsive need to record what I see, perhaps in the hope of making sense of all the input. Or to get a strip idea down on paper before it evaporates. I turn off the 'Little Man' inside my head and just go with what seems interesting. None of the dialogue in my sketches is invented. It's all as I heard it," he claims – so he always attempts to stay alert to the humor and grotesqueness of the everyday world.

About the work shown here, from the mid-1990s to early 2000s, he says, "My sketches are of observations I've made in various places like Cuba, Vancouver, Calistoga, CA, Monument Valley, several US airport waiting rooms, Tucson, AZ, New York City and Lake Tahoe."

THE BELLMAN SHOWING OFF the *MEYER LANSKY* SUITE ON the TOP FLOOR OF HAVANA'S RIVIERA HOTEL CAREFULLY EXPLAINED THAT the FADED PRINT ON the WALL WAS "A REPRODUCTION OF the ORIGINAL PAINTING" WHICH ONCE HUNG THERE. NO WAY. IT'S RENOIR'S FAMOUS "*Le Moulin de la Galette*" AND IT'S BEEN HANGING IN the *LOUVRE* FOR MANY DECADES.

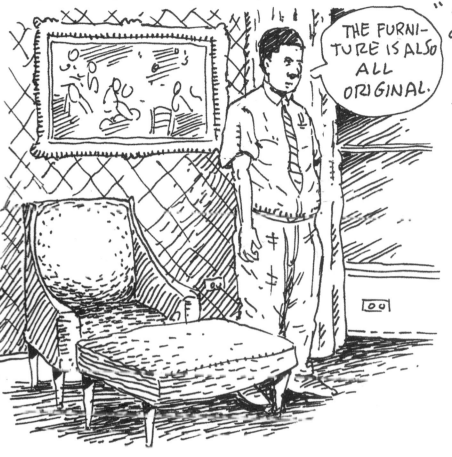

THE FURNITURE IS ALSO ALL ORIGINAL.

THE RUSSIAN EMBASSY LOOKS LIKE A *ROBOT* ABOUT TO WREAK HAVOC ON HAVANA. THE SOVIET ARCHITECT CLEARLY DID NOT DESIGN THE EDIFICE TO *BLEND IN* WITH THE LOCAL URBAN LANDSCAPE. IT IS NOT, SHALL WE SAY, *CARIBBEAN* IN FLAVOR.

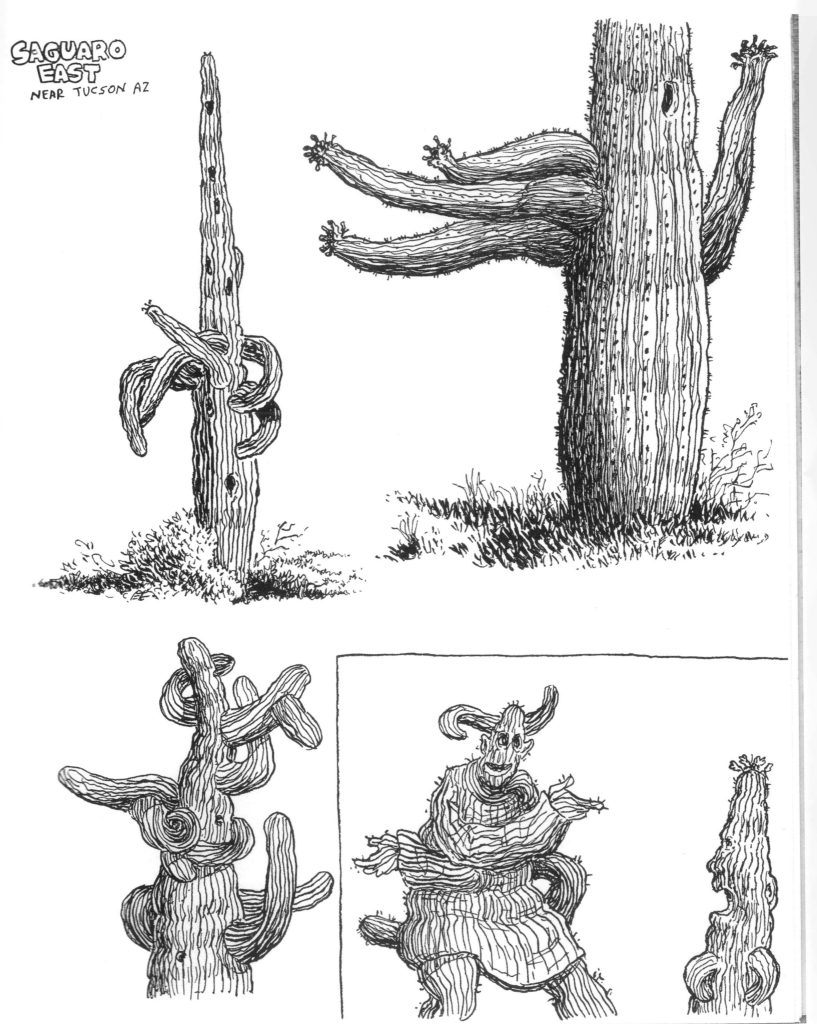

SAGUARO EAST
NEAR TUCSON AZ

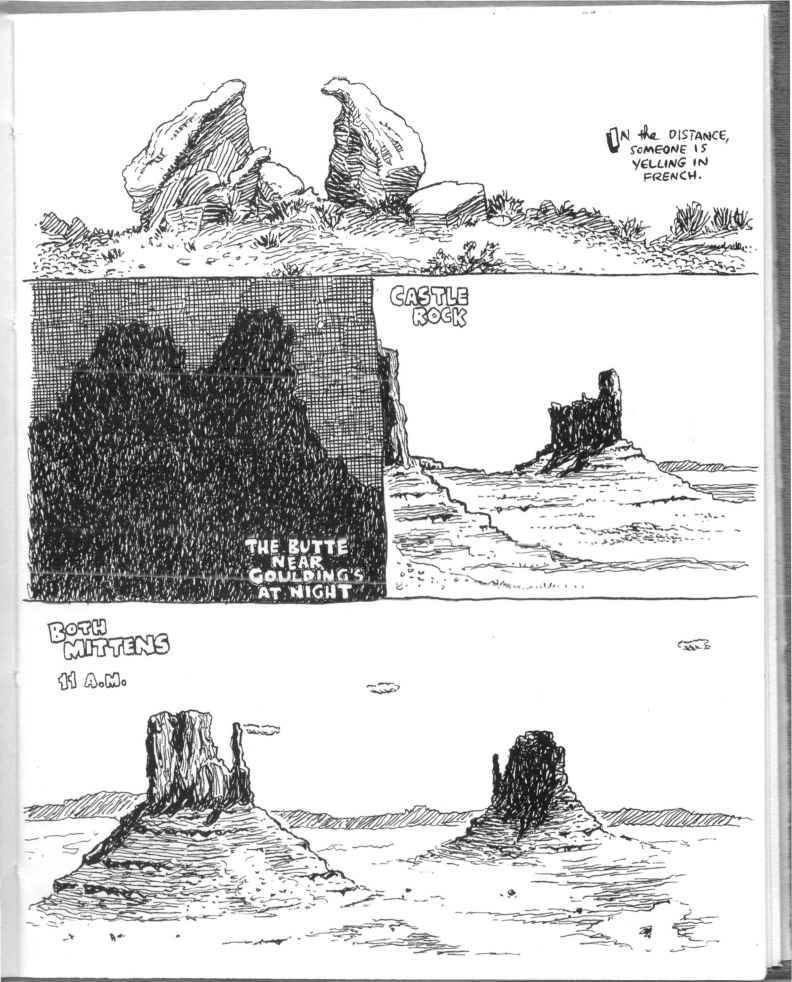

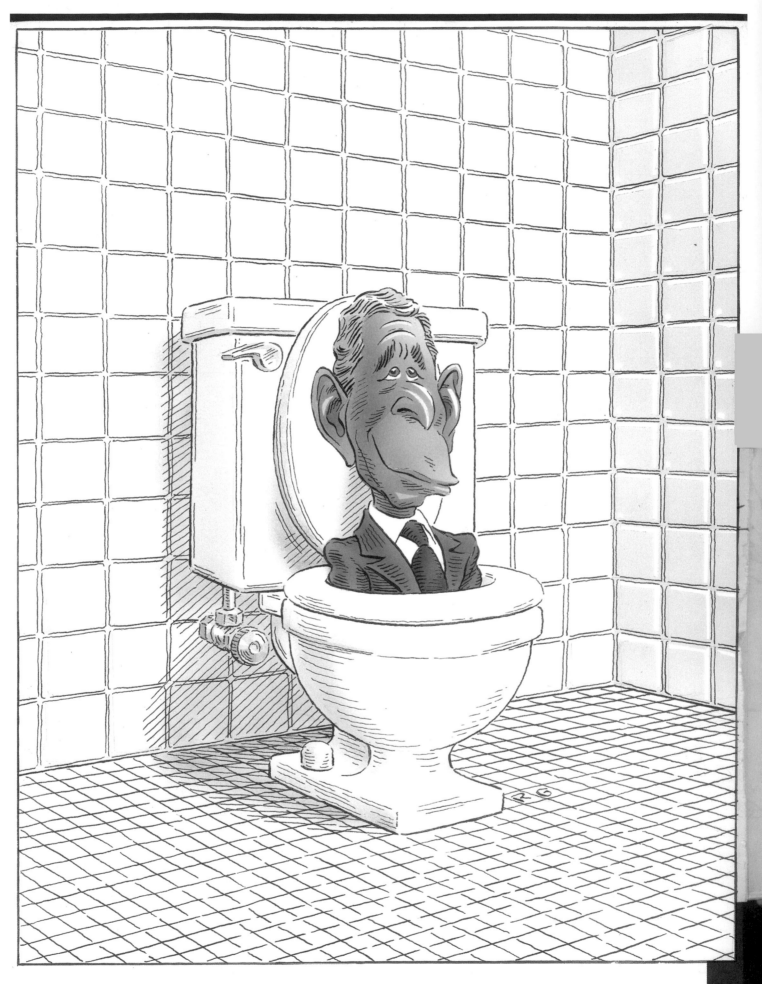

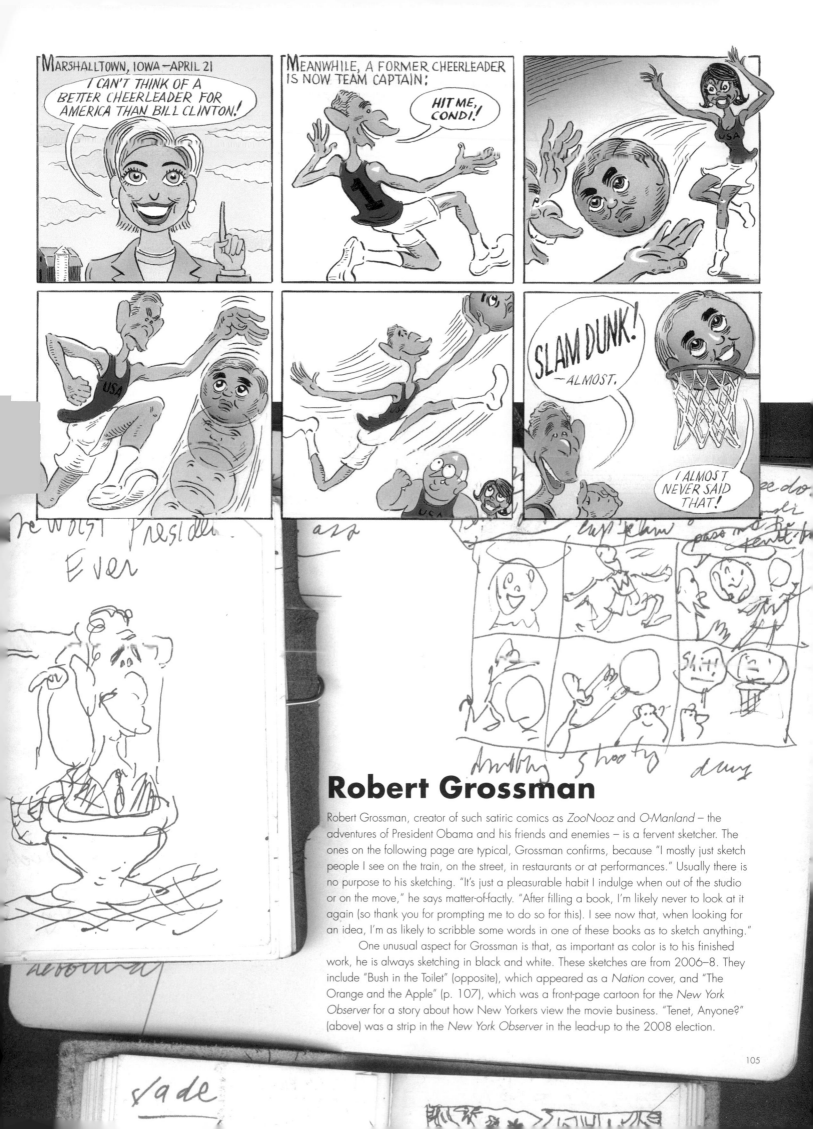

Robert Grossman

Robert Grossman, creator of such satiric comics as *ZooNooz* and *O-Manland* – the adventures of President Obama and his friends and enemies – is a fervent sketcher. The ones on the following page are typical, Grossman confirms, because "I mostly just sketch people I see on the train, on the street, in restaurants or at performances." Usually there is no purpose to his sketching. "It's just a pleasurable habit I indulge when out of the studio or on the move," he says matter-of-factly. "After filling a book, I'm likely never to look at it again (so thank you for prompting me to do so for this). I see now that, when looking for an idea, I'm as likely to scribble some words in one of these books as to sketch anything."

One unusual aspect for Grossman is that, as important as color is to his finished work, he is always sketching in black and white. These sketches are from 2006–8. They include "Bush in the Toilet" (opposite), which appeared as a *Nation* cover, and "The Orange and the Apple" (p. 107), which was a front-page cartoon for the *New York Observer* for a story about how New Yorkers view the movie business. "Tenet, Anyone?" (above) was a strip in the *New York Observer* in the lead-up to the 2008 election.

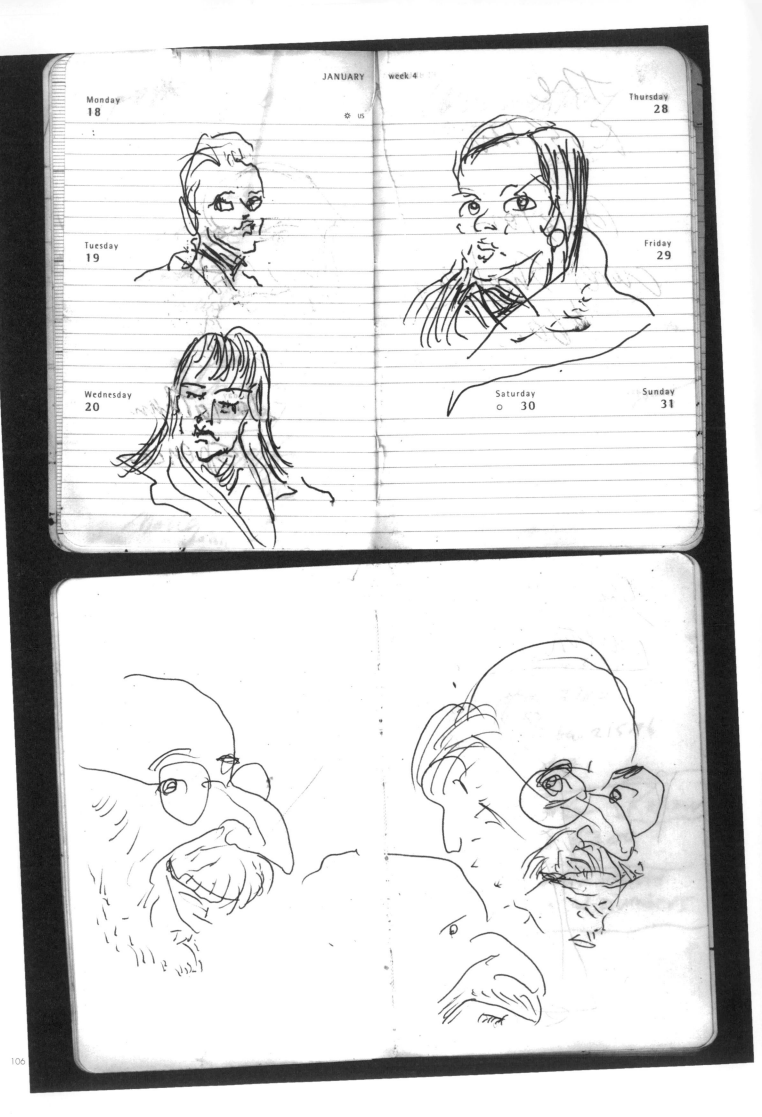

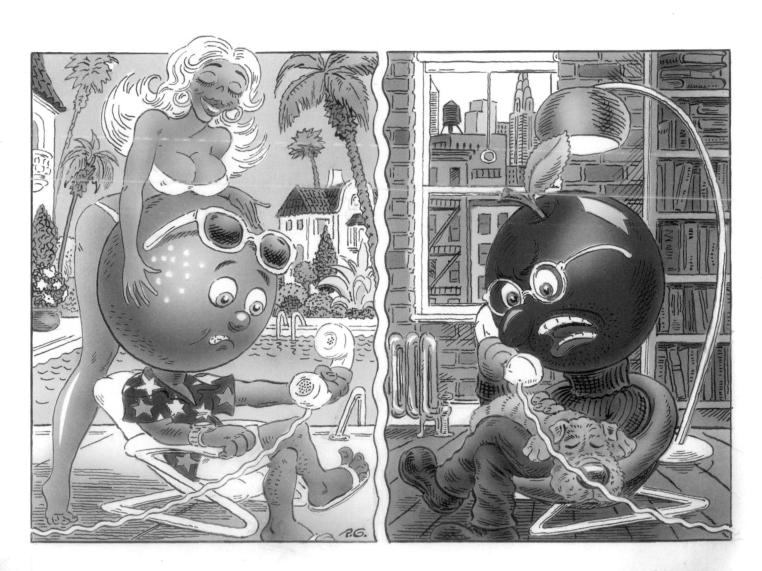

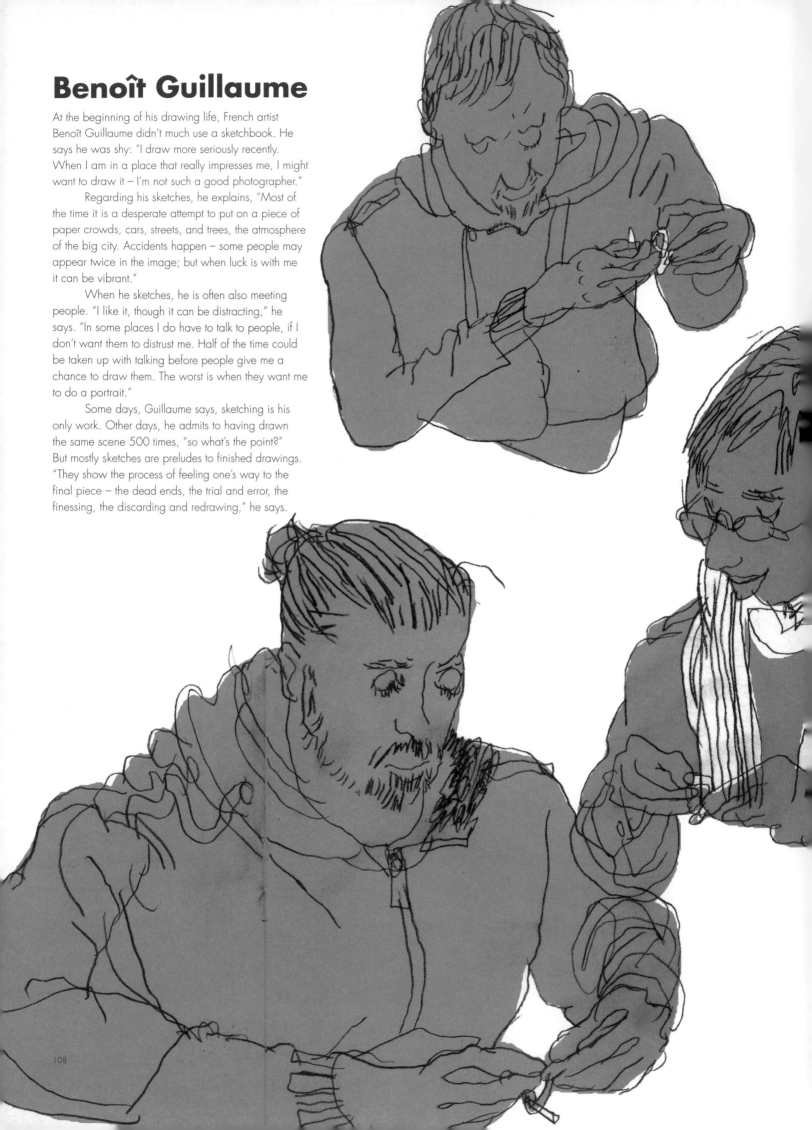

Benoît Guillaume

At the beginning of his drawing life, French artist
Benoît Guillaume didn't much use a sketchbook. He
says he was shy: "I draw more seriously recently.
When I am in a place that really impresses me, I might
want to draw it – I'm not such a good photographer."

Regarding his sketches, he explains, "Most of
the time it is a desperate attempt to put on a piece of
paper crowds, cars, streets, and trees, the atmosphere
of the big city. Accidents happen – some people may
appear twice in the image; but when luck is with me
it can be vibrant."

When he sketches, he is often also meeting
people. "I like it, though it can be distracting," he
says. "In some places I do have to talk to people, if I
don't want them to distrust me. Half of the time could
be taken up with talking before people give me a
chance to draw them. The worst is when they want me
to do a portrait."

Some days, Guillaume says, sketching is his
only work. Other days, he admits to having drawn
the same scene 500 times, "so what's the point?"
But mostly sketches are preludes to finished drawings.
"They show the process of feeling one's way to the
final piece – the dead ends, the trial and error, the
finessing, the discarding and redrawing," he says.

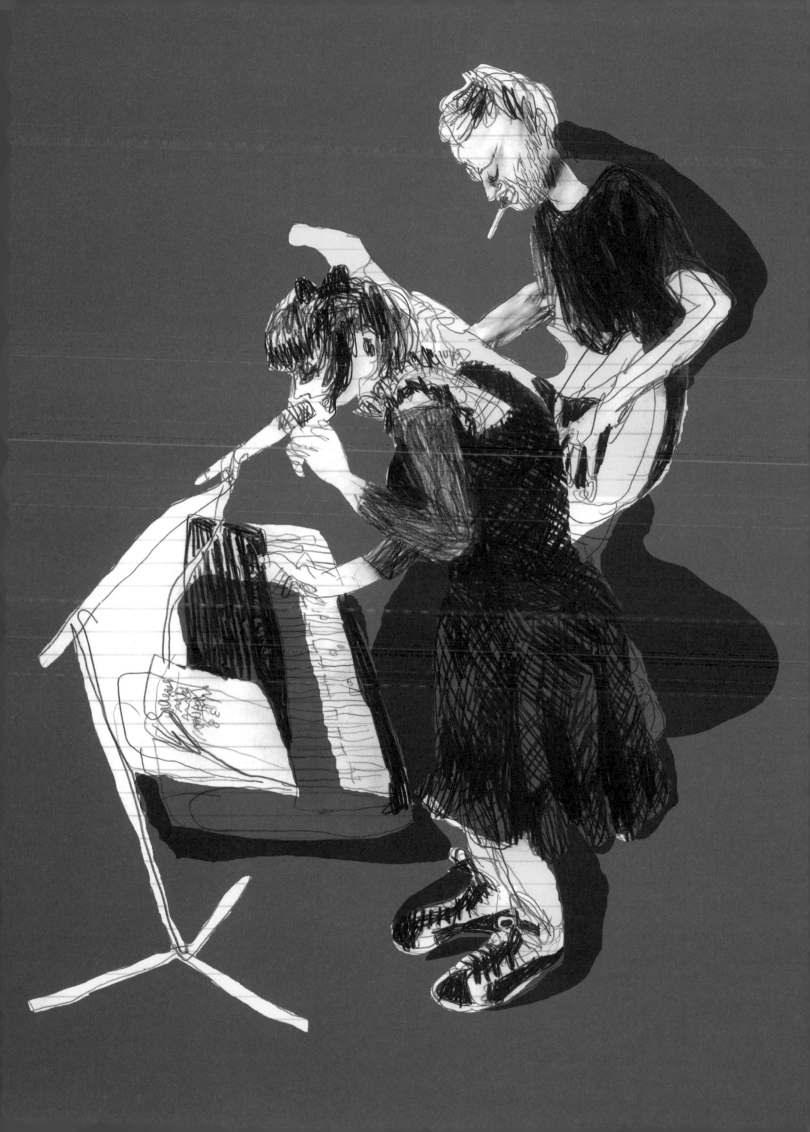

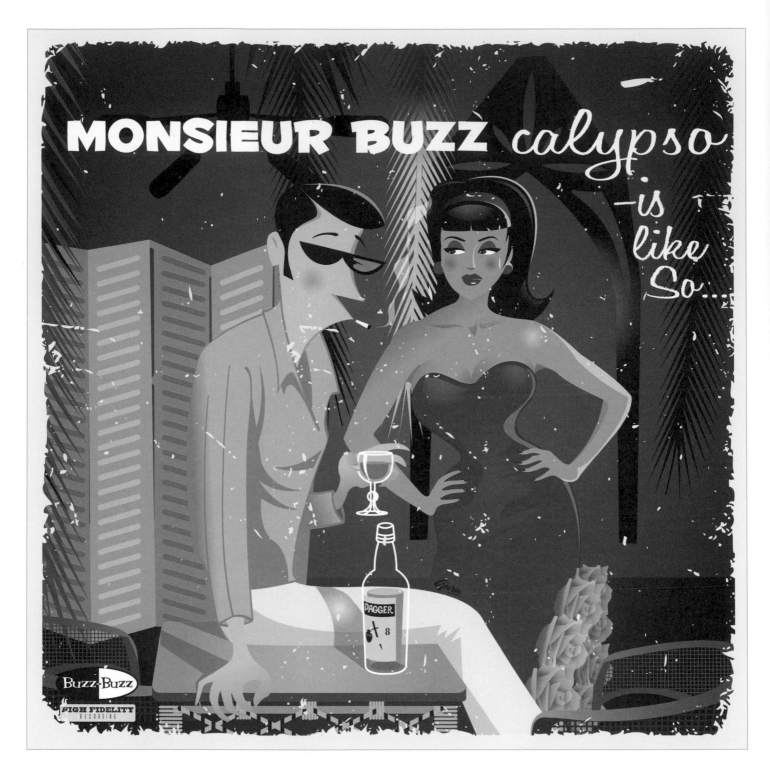

Cyril Guru

Frenchman Cyril Guru, the character creator who lives in a village called Aiglemont next to Charleville-Mézières (birthplace of the poet Arthur Rimbaud) in France, reveals, "The sketch for me is how I make my characters; for example, I draw hands and I save a file of 'hands' and when I draw Mr. Buzz for a particular project, I will try to find a hand that I have drawn before, and that can match the position of the character."

It is the same process for the backgrounds: "If I need a tree I remember that for another poster I drew trees, so I'll look for that tree and copy and paste it in my new background, like in cartoons – I read an interview where the designer said they used the same objects (trash, lamppost, building) in different cartoons, and in different scenes. That is

like a doll concept, where you have a base and you change the clothes and accessories."

For Guru, vector graphics all important, as the sketch is replaced by the creation of a "library:" having these libraries avoids hours and hours of work. Otherwise, he says, there is "no context in my sketches, it's just things that I tried to draw prettily." Nonetheless, there is a recurring theme: Guru's character, Mr. Buzz, "and unusual situations for a cartoon character in a traditional world." The images shown here are part of an exhibition and future book called *Mr. Buzz Adversities*. They are parodies of films, record covers, and paintings of the "great masters who have touched me, graphically or emotionally," he explains.

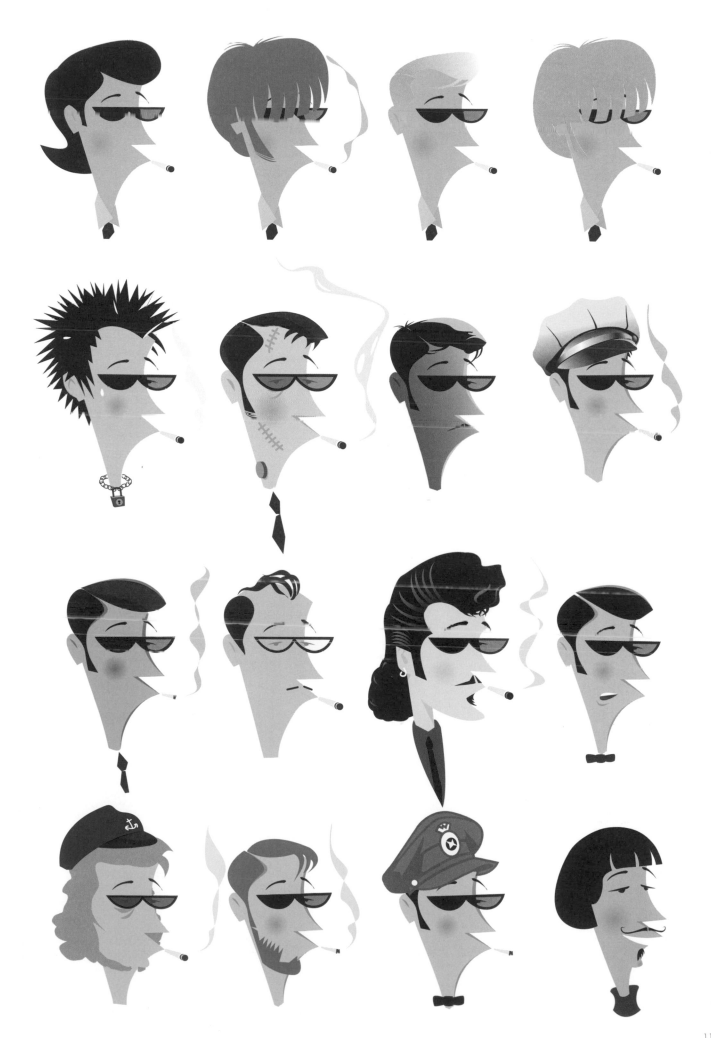

111

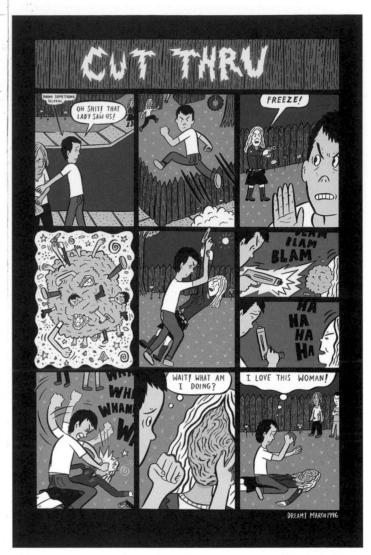

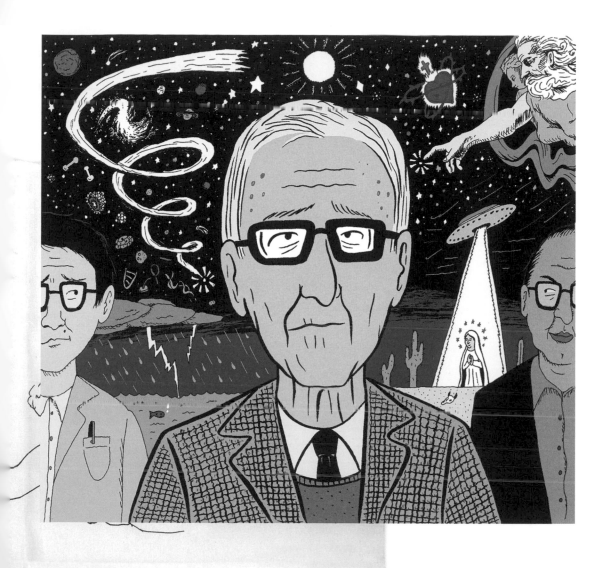

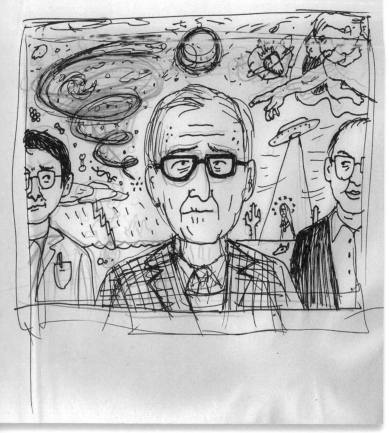

David Heatley

Sex. Longing. Childhood. God. Those are David Heatley's recurring sketchbook themes, although they were not when he first started. "I used to draw my own picture books as far back as five years old," reports Heatley. But now, "More often, I sketch as part of work I'm doing, either for my art or for a client. I'm trying to solve a visual problem that I have a vague sense about in my head."

In 2003, Heatley experienced a revelation after looking at the sketches he had made for "Sex History" (a part of his autobiographical book *My Brain Is Hanging Upside Down*, 2008) and saw real excitement in the lines: "I got the energy right with the thumbnail sketches, the first stab at translating my notes into cartoons. My process used to be that I'd take those thumbnails and re-draw them in pencil and then ink them. But once you do that, the original spark is kind of dead. So I've stripped out those steps in my process. I usually try to work out the mechanics of how a page will function, but try to save the drawing so it happens just once. I want the tentative, unsure lines to be part of the finished art." He adds: "When I'm drawing a sketch, I'm feeling shaky and unsure about where it's leading. I'm feeling out how things should be. But I'm struck by how confident the lines look in retrospect. There's something very mysterious about that to me. That there's a deeper (younger?) self in charge when I make art and I can only see afterward that I was being led to what I've created."

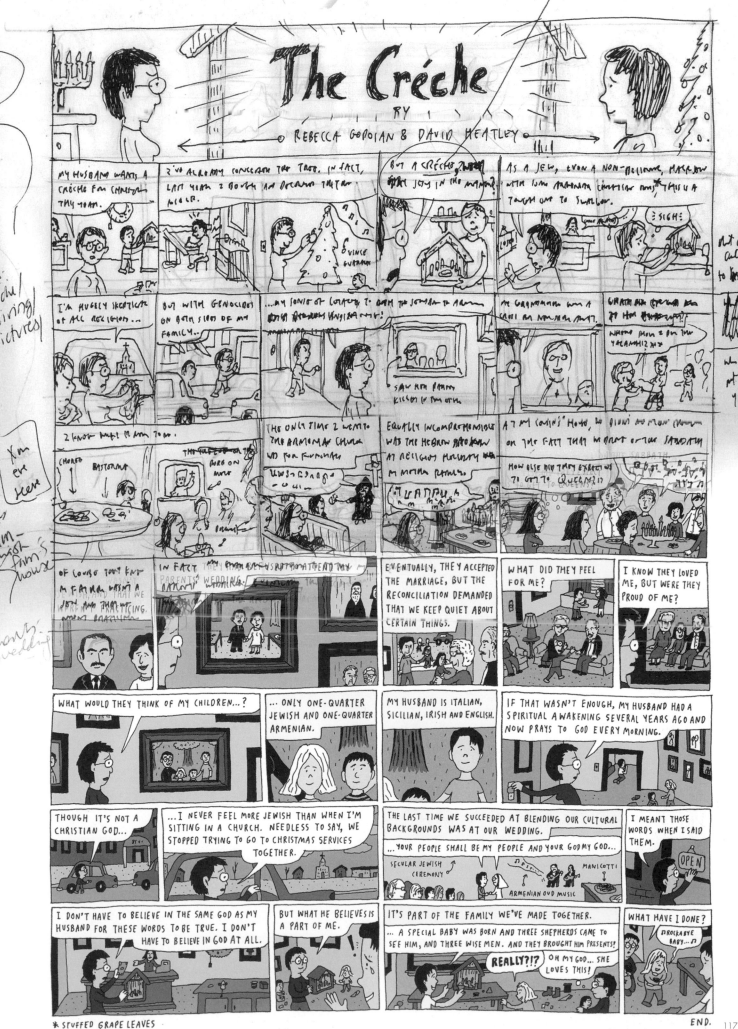

*STUFFED GRAPE LEAVES

Rian Hughes

The incredibly prolific illustrator and typographer Rian Hughes, based in London, uses sketching to get ideas down, "Not to produce nice drawings as such," he clarifies. "Generally, they are a prelude to a commercial job – exploring possibilities, jotting down directions and concepts, feeling out technical challenges (the figure drawing aspects, for example) and attempting to solve them."

"Sometimes my sketches don't have a specific application, but will end up leading somewhere interesting – the notes for my book CULT-URE [2011], for example, built over ten or more years before they coalesced into the final book. They are rarely an end in themselves or intended to be objects of beauty for their own sake," he says.

Hughes proudly asserts, "I drew (and designed) for many years as a professional before the Mac made serious inroads, so I'm a member of the generation that has a foot in both the analog and digital realms – and that will only ever happen once in history. I've seen how the crossover opened up so many new creative possibilites – Adobe Illustrator, for example, revolutionized my drawing style and enabled me to create the strong graphic illustration images I'd always wished that I could. The sketches, being made with something called a pencil, return me to Eden – that is, to life before the Apple. There's something cathartic in getting your hands covered in carbon dust. Illustration Unplugged."

VENTURE INTO THE UNCANNY

I OFTEN IMAGINE YOUR UNIVERSE AS THE PERFECT POCKET-WATCH.

SEVEN DAYS IN EVERY WEEK, FOUR WEEKS IN EVERY MONTH, TWELVE MONTHS IN EVERY YEAR.

MOVING AND TICKING IN PERFECT SYNCHRONICITY.

SCRIPT: MARK MILLAR
ART: RIAN HUGHES
LTG: ELLIE DE VILLE

BUT THIS WASN'T ALWAYS THE CASE, DEAR READER.

THANK YOU, GRAHAM.

SQUAAWK!

COME WITH ME, IF YOU WILL, ON A JOURNEY OF ARCANE KNOWLEDGE.

A TRIP DOWN BAD MEMORY LANE TO A SMALL COUNCIL HOUSE ON A NORTHAMPTON ESTATE.

TO THE CELLAR OF AMADEUS DUNNE.

AN OLD MAN WHO GUARDS THE SECRET OF THE MISSING MONTH OF ARACHNE.

DOES GRAN KNOW YOU KEEP ALL THIS WEIRD STUFF DOWN HERE, GRANPA?

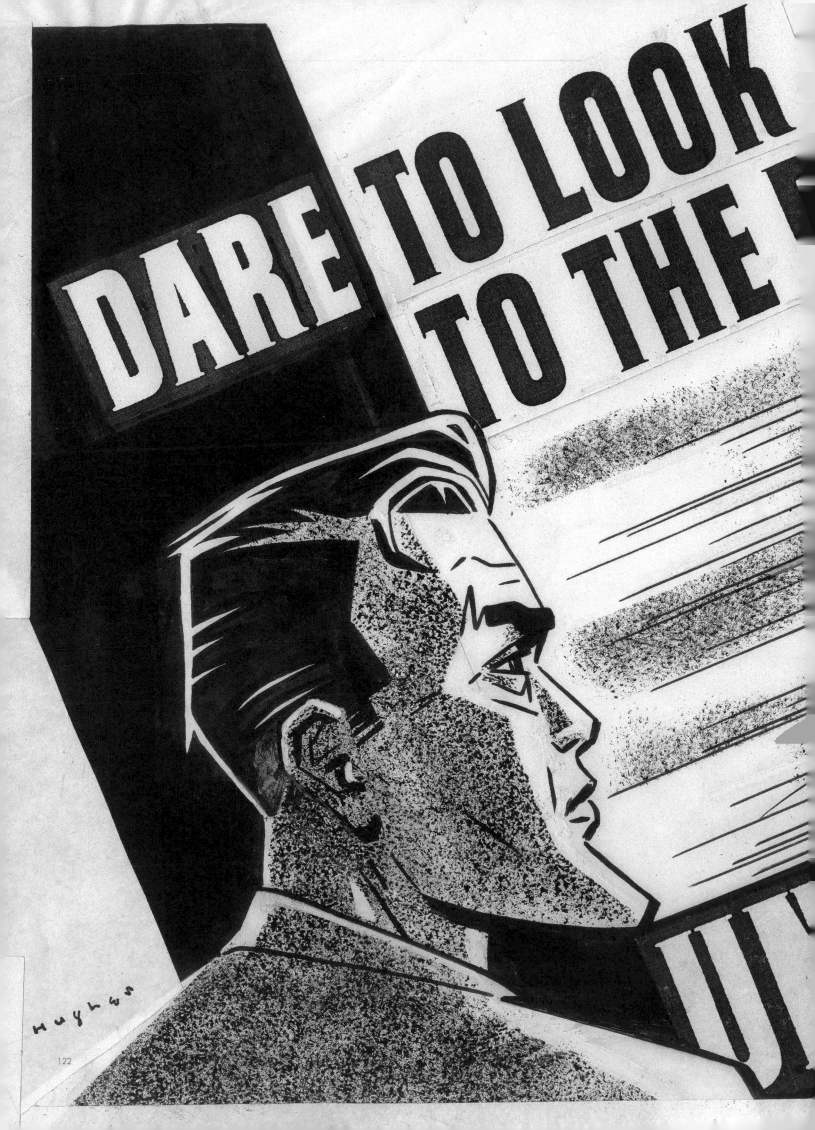

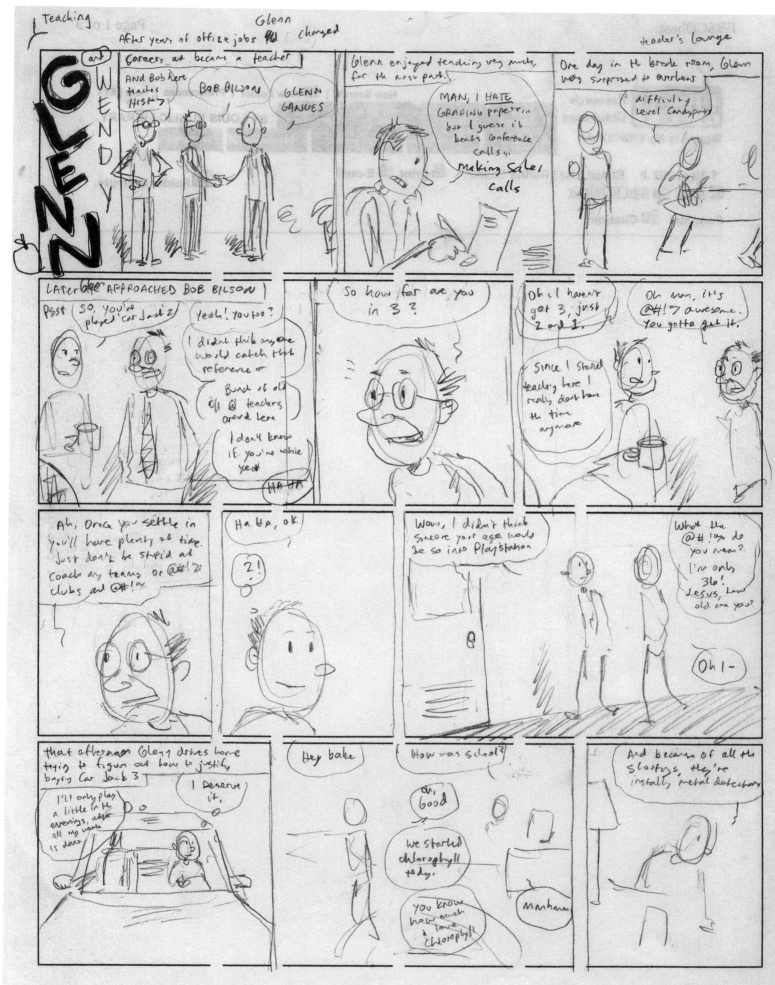

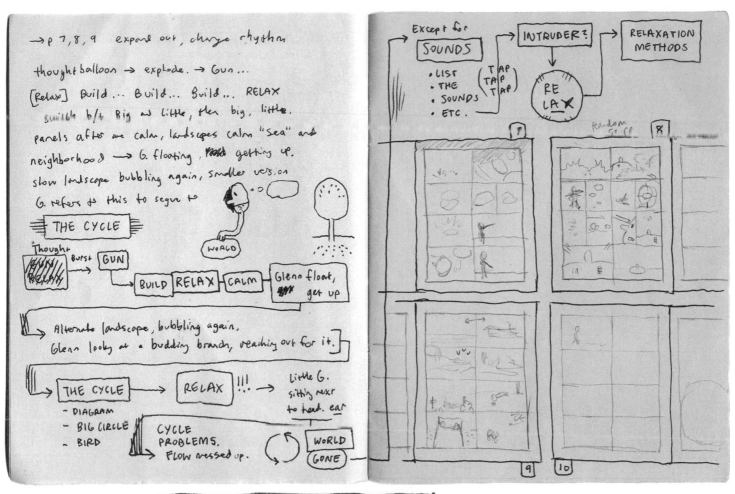

Kevin Huizenga

Kevin Huizenga started using sketchbooks after seeing the *Crumb* movie in high school. "Up until that point I made drawings and kept them in a folder," he says, "but after seeing how Crumb [see p. 64] worked, I started thinking about a sketchbook as a special thing. For a few years I tried to use them the way he does, but I eventually realized I don't like to draw for no reason all that much – I get bored and antsy – and now they mostly just function as a support system for making comics. I'll sometimes try to learn from something by copying it, but sadly I seem to forget that as soon I'm done with it, and I'm not sure I end up learning anything."

Huizenga feels his books have three purposes: "First, to write and doodle until I'm in some kind of peaceful state of mind, where I don't feel overwhelmed and paralyzed; second, to record ideas and things to remember; and third, to work out some visual problem. Separate from the sketchbooks are sheets of paper onto which I pre-print rows of panels, and I use those to work out stories."

He confesses that "the thing which strikes me, looking through them, is how many ideas for projects I have that will probably never appear in any finished form, and I get that feeling again of being paralyzed by all that there is to do and how little time there is to do it."

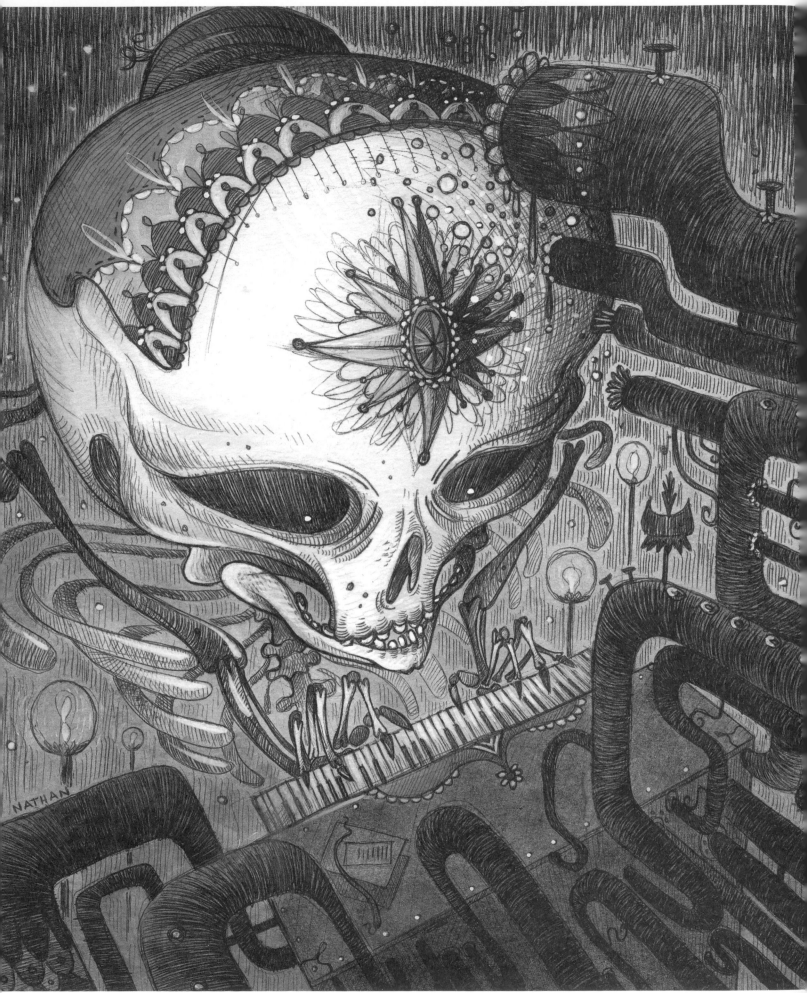

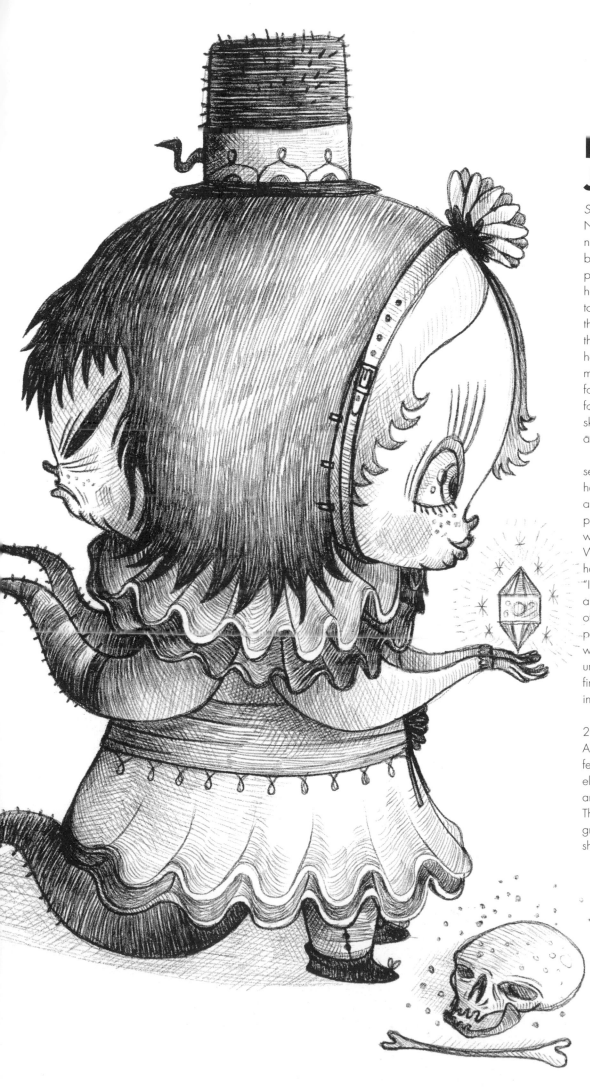

Nathan Jurevicius

Scarygirl creator and toy maven Nathan Jurevicius, an Australian native based in Canada, has been keeping sketches for the past twenty years. "Sometimes I'll have to assess whether some need to be discarded and then keep the best ones. I generally keep them on loose sheets of paper," he says. "It's the foundation of all my work…as an approval image for clients but also as a database for ideas. Sometimes I like the sketches more than the finished artwork, and value both equally."

His sketches almost always serve a functional purpose: "Most have a final outcome, but there are times where they are work in progress or just a flow of thoughts without an end," he declares. What's more, Jurevicius lets his hair down with his sketchbook: "It's a lot looser and not concerned about color (which is a big part of my work)," he continues. "The pen sketches are directly drawn with ballpoint. There's no pencil underlay and no erasing – the final result is what you see, drawn in one go."

Most of these images from 2007–9 are character-based. About 90 percent of his sketches feature figurative work. He elaborates, "Most of the pieces are linked to my brand 'Scarygirl.' They are either images from my graphic novel or sketches for art shows based around her."

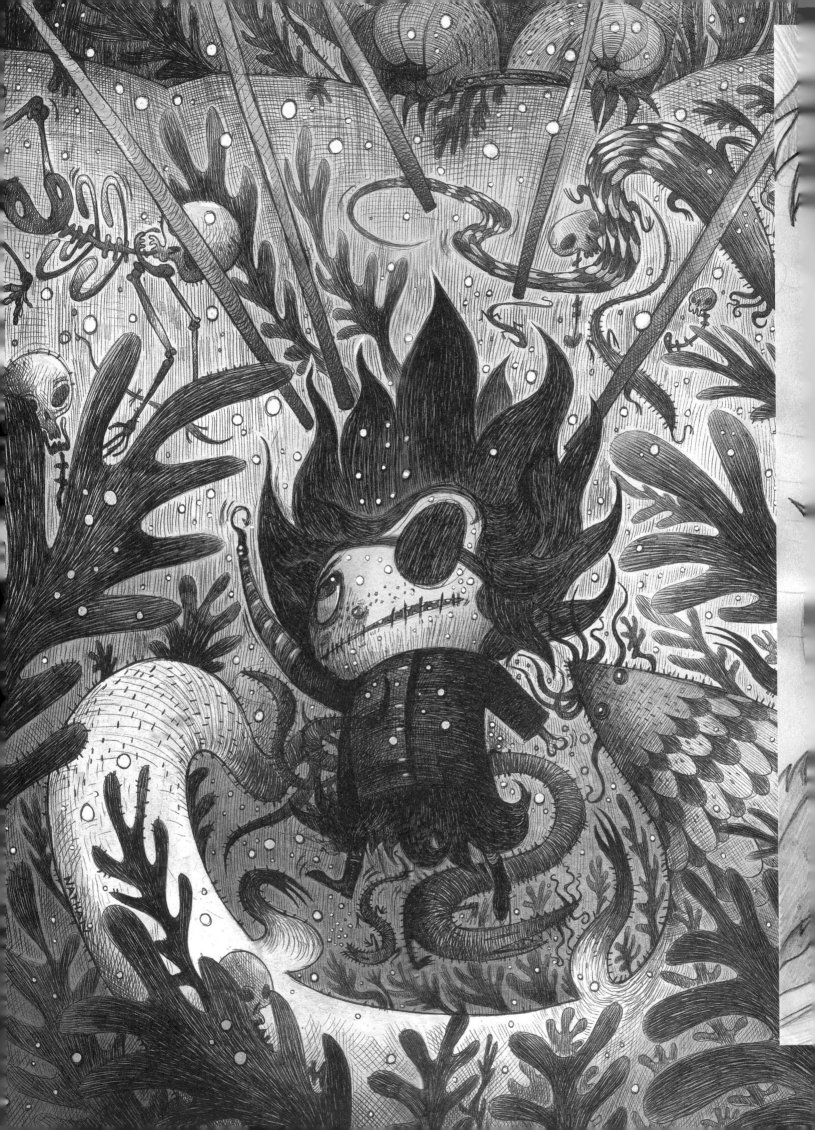

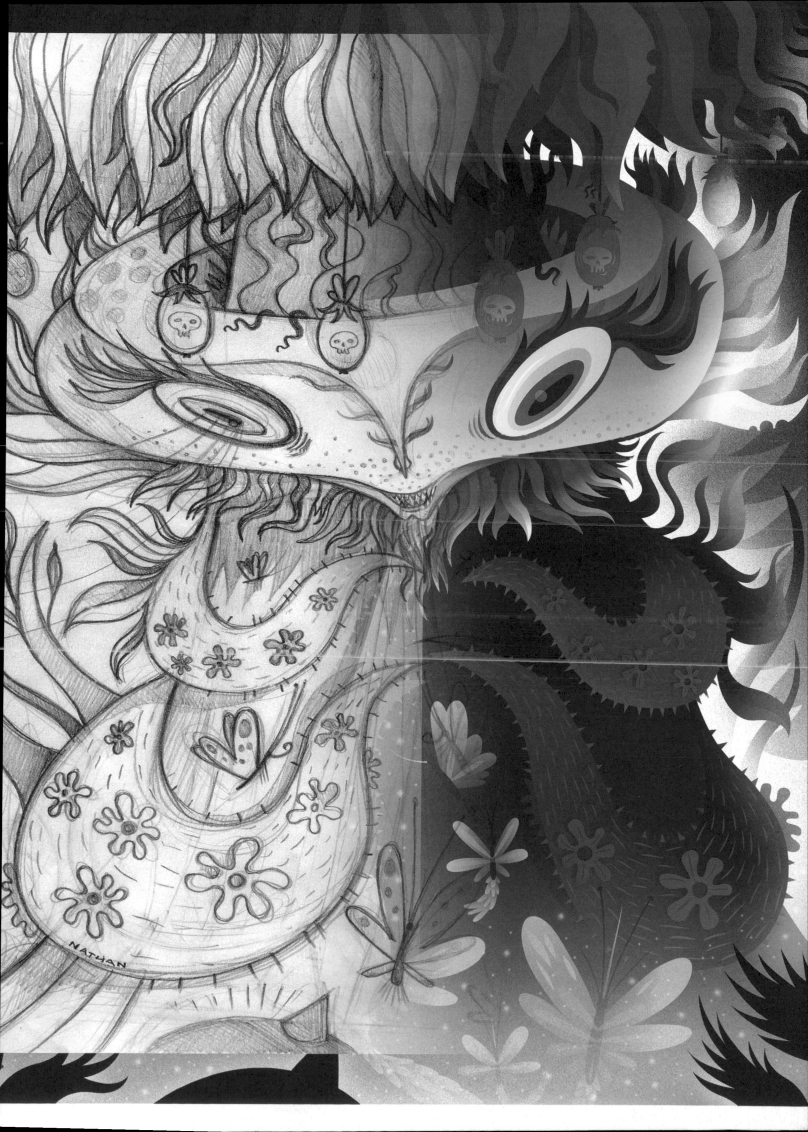

Ben Katchor

Ben Katchor, whose emotionally somber comics conjure a restive, bygone, early twentieth-century New York City of immigrants and reprobates, confesses that he has not kept a sketchbook since he was in school: "I draw directly in ink (and now digitally) and everything I draw is for the purpose of a finished strip," he reports.

The images shown here, from 1999, were done as part of a commission to make a drawing of an off-Broadway show. "I drew in the dark, and from these notations I put together the finished drawing," he explains; "I was mostly concerned with the reportage aspect of this drawing," and he recorded colors and the actors' postures. He was also given 10 × 8 in. (20 × 15 cm) photos of the actors' faces. The finished drawing was done directly in ink with watercolor. "There is no compositional logic to the notations," he reveals. "Otherwise, in my own work, there's more invention. I get the sketch feeling alive in the final drawings by working directly in ink."

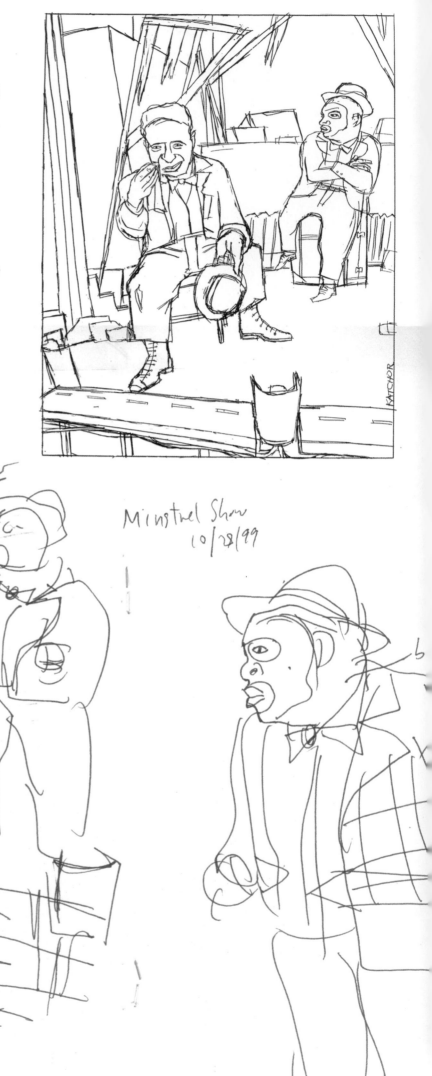

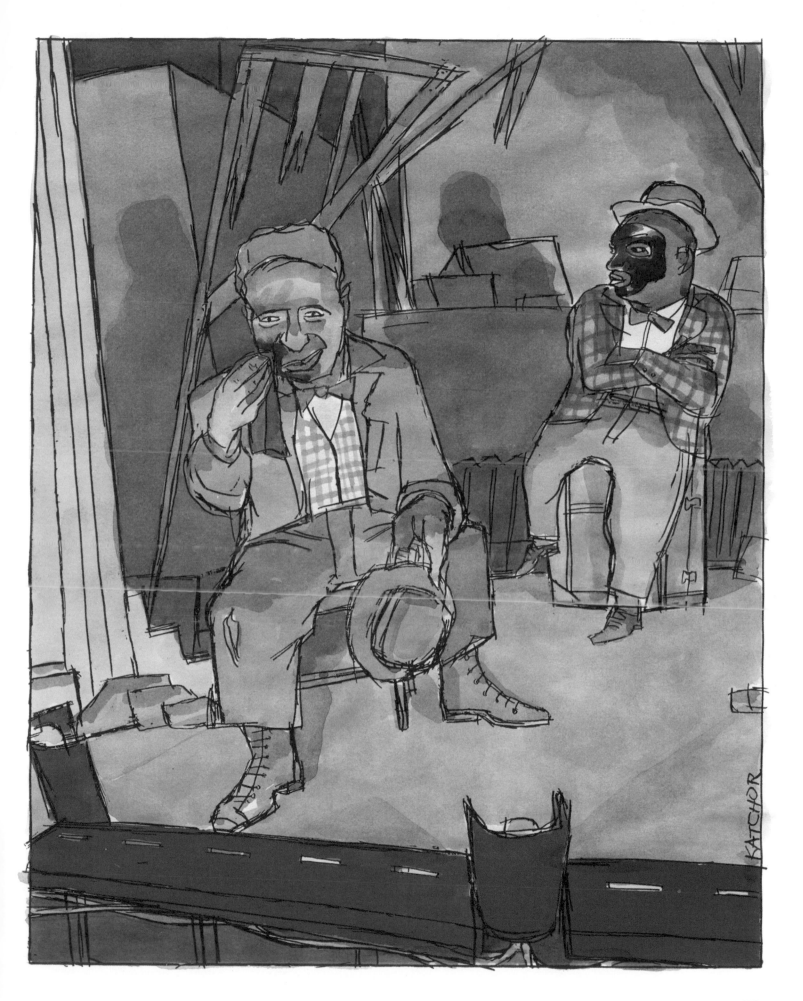

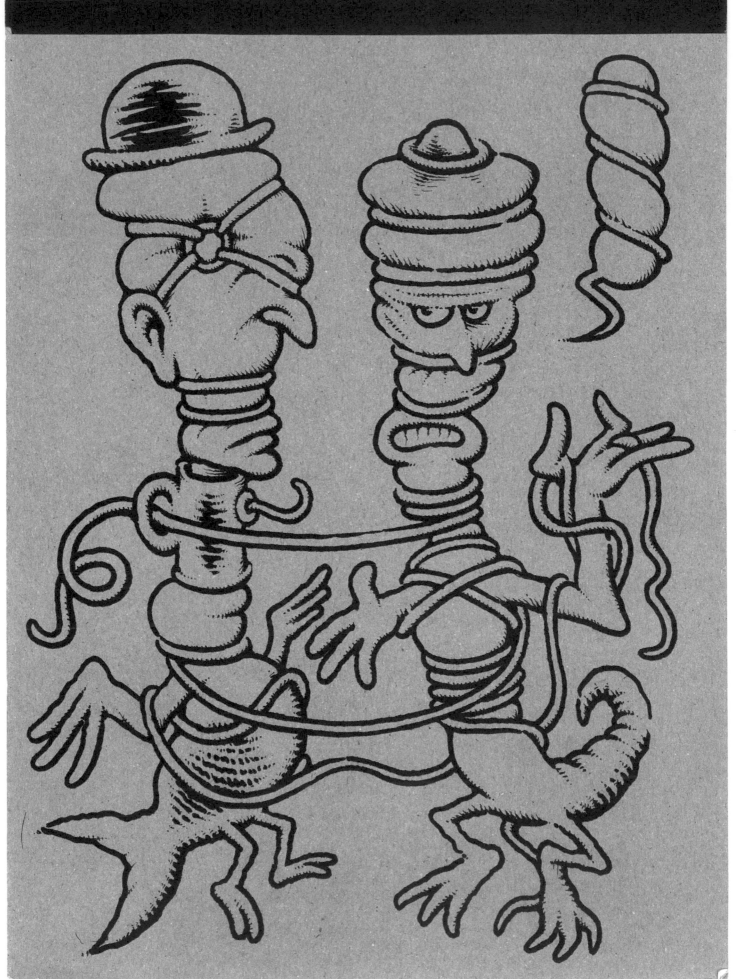

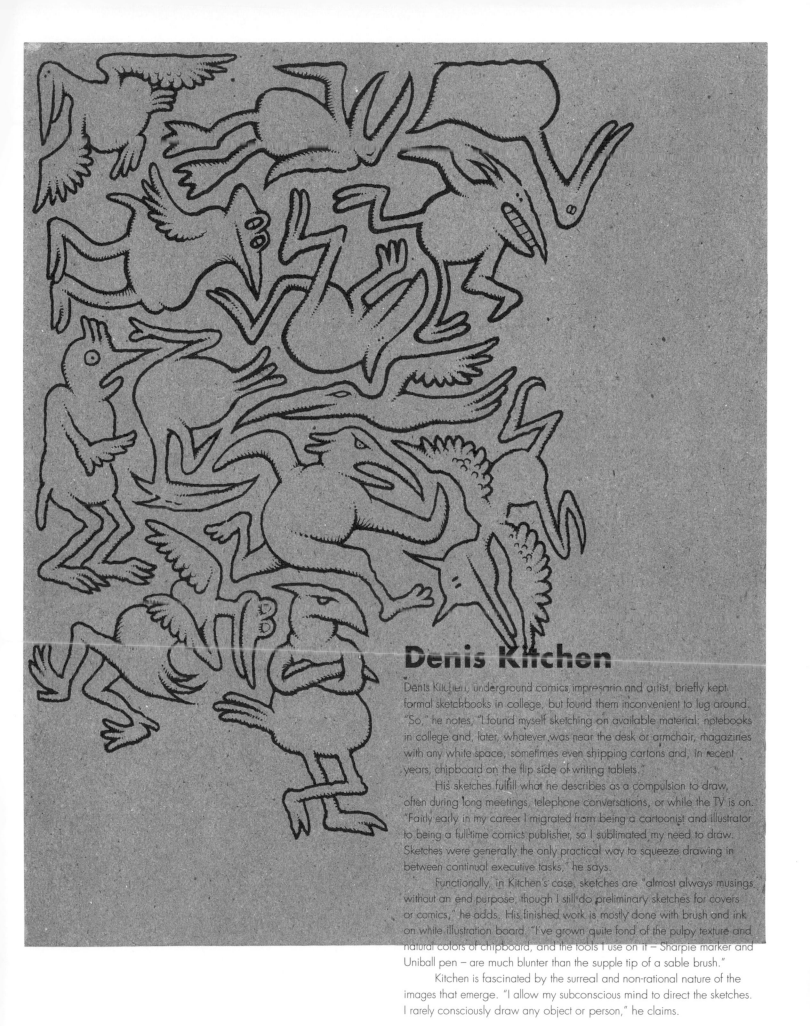

Denis Kitchen

Denis Kitchen, underground comics impresario and artist, briefly kept formal sketchbooks in college, but found them inconvenient to lug around. "So," he notes, "I found myself sketching on available material: notebooks in college and, later, whatever was near the desk or armchair, magazines with any white space, sometimes even shipping cartons and, in recent years, chipboard on the flip side of writing tablets."

His sketches fulfill what he describes as a compulsion to draw, often during long meetings, telephone conversations, or while the TV is on. "Fairly early in my career I migrated from being a cartoonist and illustrator to being a full-time comics publisher, so I sublimated my need to draw. Sketches were generally the only practical way to squeeze drawing in between continual executive tasks," he says.

Functionally, in Kitchen's case, sketches are "almost always musings without an end purpose, though I still do preliminary sketches for covers or comics," he adds. His finished work is mostly done with brush and ink on white illustration board. "I've grown quite fond of the pulpy texture and natural colors of chipboard, and the tools I use on it – Sharpie marker and Uniball pen – are much blunter than the supple tip of a sable brush."

Kitchen is fascinated by the surreal and non-rational nature of the images that emerge. "I allow my subconscious mind to direct the sketches. I rarely consciously draw any object or person," he claims.

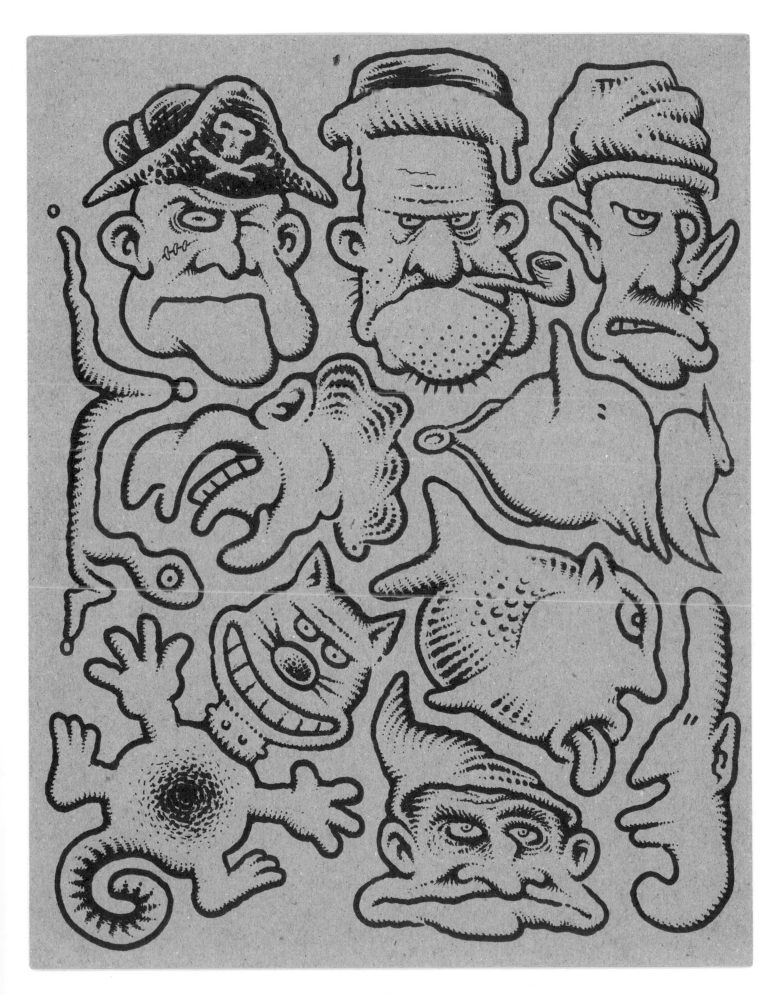

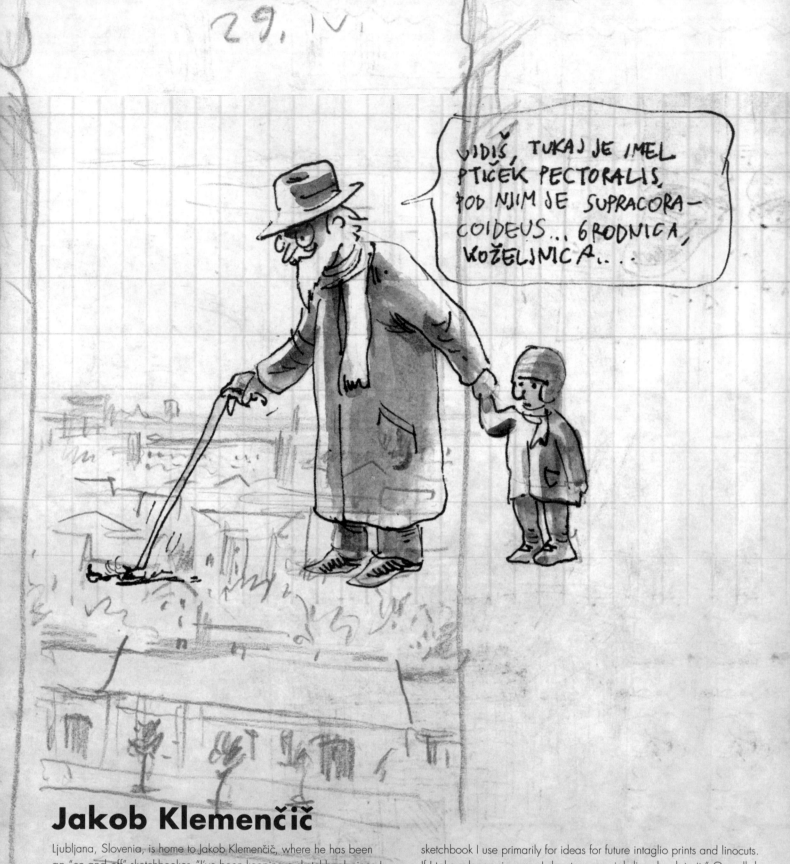

Jakob Klemenčič

Ljubljana, Slovenia, is home to Jakob Klemenčič, where he has been an "on and off" sketchbooker. "I've been keeping a sketchbook since I found a German edition of R. Crumb's [see p. 64] sketchbook excerpts twenty years ago in a bookshop in Vienna," he recalls. "Another decisive moment was seeing my pal Marcel Ruijters's colorful sketchbooks a couple of years later, and yet another big impetus was learning the essentials of bookbinding in the summer of 2009."

Currently he maintains "a small 'everyday' sketchbook that I carry around and fill with idea embryos, random thoughts, surreptitious sketches of interesting (to be used in comics) physiognomies, architecture, sights from museum visits." But that's just one of his books – "There's a

sketchbook I use primarily for ideas for future intaglio prints and linocuts. If I take a longer journey, I devote a special diary book to it." Overall, he continues, "I'd classify sketches under 'musings that will hopefully develop into something some day.'" Yet every once in a while, "sometimes (but not very often), things that surprise me come out. Often drawings that I once found well done now look rather unexciting, and vice versa." Perhaps most surprising are "various strange artifacts from my museum visits (but also imagined museum objects). When I draw comics sequences, it's mostly dreams, remembered as faithfully as possible." Overleaf is what he calls "a two-page dream: I travel very much in my dreams and this one takes place 'somewhere in northeastern Germany,'" he says.

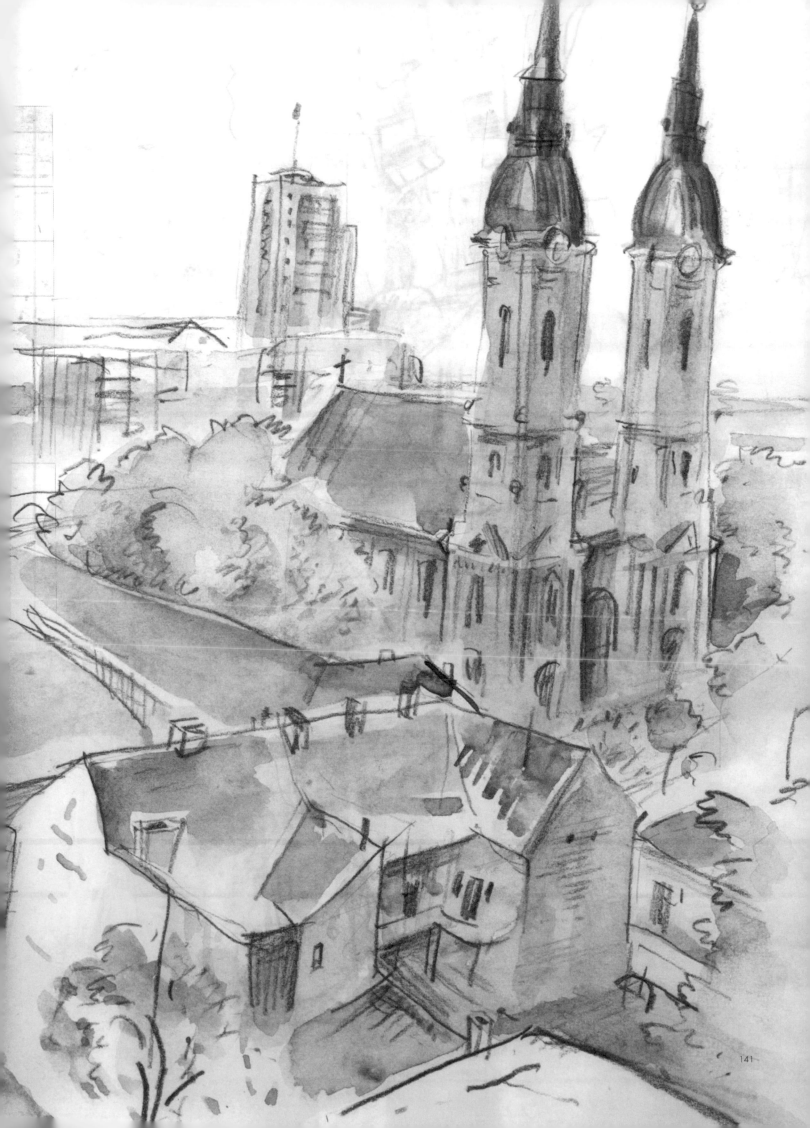

141

NEKJE V SEVEROVZHODNI NEMČIJI. SMO NA ENEM FESTIVALU ALI KAJ IN R. JE NA VRAT NA NOS ODSEL S TRAJEKTOM V HELSINKE. ZAKAJ NE BI TUDI JAZ ŠEL KAM? KAKŠNIH FINIH DESTINACIJ TU BLIZU NI; AMPAK, SAJ ŠE CENTRA NISEM VIDEL! KAJ SE ČAKAM?!

ZEMLJEVIDEK IMAM ŽE OD PREJ... ...IN AUTOBUS (TRAMVAJ?) JE TUDI ŽE TUKAJ!

IN TAKOJ ZA VOGALOM SE ONSTRAN REKE POKAŽE ZGODOVINSKI CENTER V VSEM SIJAJU!

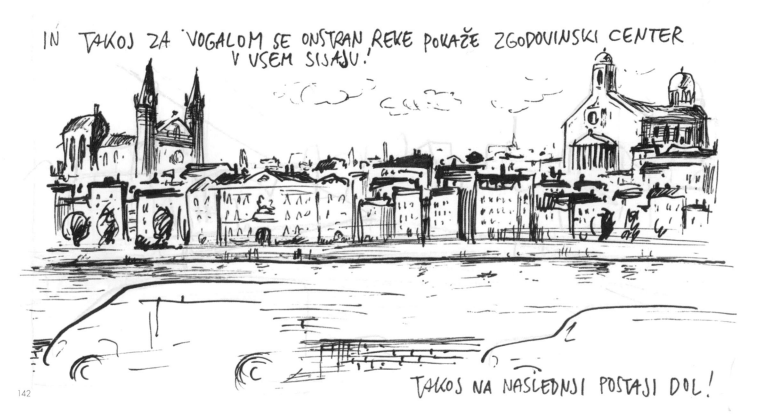

TAKOS NA NASLEDNJI POSTAJI DOL!

VELIKO JIH JE ŠLO DOL NA TEJ POSTAJI IN VSI GREJO PO ŠTENGAH ČEZ EN GRABEN. JE SKOZI LUKNJO KAKŠEN MOST V CENTER? AMPAK NAJPREJ PAR FOTK.

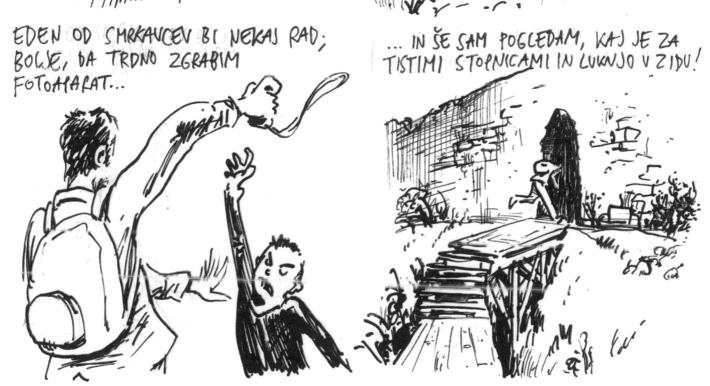

EDEN OD SMRKAVCEV BI NEKAJ RAD; BOLJE, DA TRDNO ZGRABIM FOTOAPARAT...

... IN ŠE SAM POGLEDAM, KAJ JE ZA TISTIMI STOPNICAMI IN LUKNJO V ZIDU!

IN KAJ NAJDEM: VODA JE PLECEJ ŠIRŠA IN JE BOLJ MOČVIRJE KOT REKA. TUDI MOSTU NI NOBENEGA, LE NA POL POTOPLJENA CEV. SO PO NJEJ ŠLI TISTI STARCKI IN STARKE? JAZ SI NE UPAM IN SE RAJE OBRNEM.

Thomas Knowler

"I never commit to a sketchbook," affirms animation maven and Londoner Thomas Knowler. "I'm too proud to have bad drawings permanently attached to good, and I create lots of bad drawings! A sketch is a failed final piece. I always aim to get it perfect first time, and fail. I keep doing this until I get closer. Sometimes I'll make a 'bare-bones' drawing to plan perspective, but these are far from pretty. When animating, each frame is a kind of sketch of the one that follows – though they aren't technically the same image, as there's been an increment of time."

Knowler draws a lot, but he is not a doodler: "I want results! Maybe I have too high expectations. Animation is perfect, as it requires masses of drawing and the results are moving, emotive, engaging." The images here, he confirms, "show that my sketches are very close to the end product. I want my drawings to be complete." These are also backgrounds, and so look quiet and uninhabited, he adds: "They are crying out for something to live in them. Unlike illustration, the animation background has to be adaptable to change: panning, the redistribution of characters, manipulation." Another unique element is that "I live for the details," he remarks. "I read an interesting observation by an animation historian: some artists draw holistically, others draw details that eventually become a whole. I live squarely in the latter. At first my drawings look disjointed, but over the years I've managed to compensate. I hope to get better."

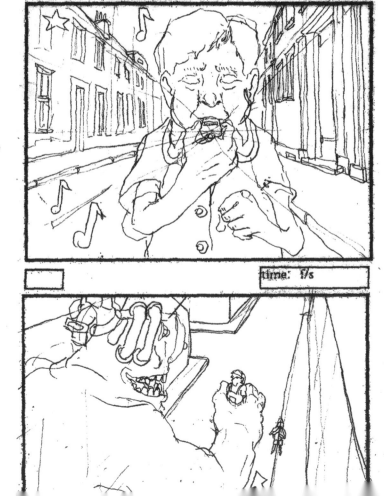

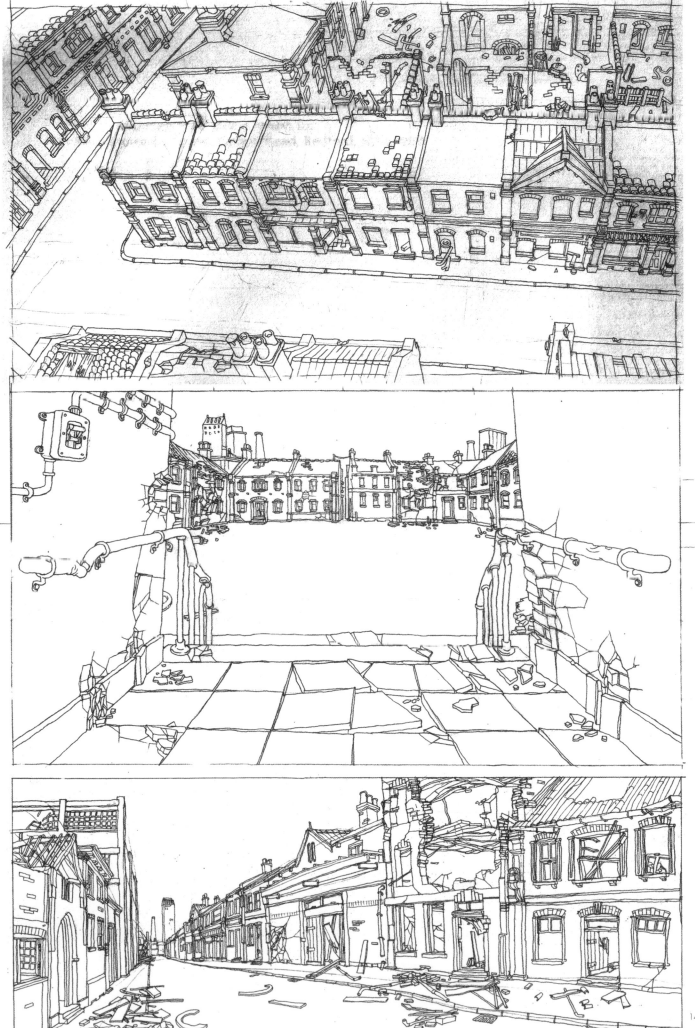

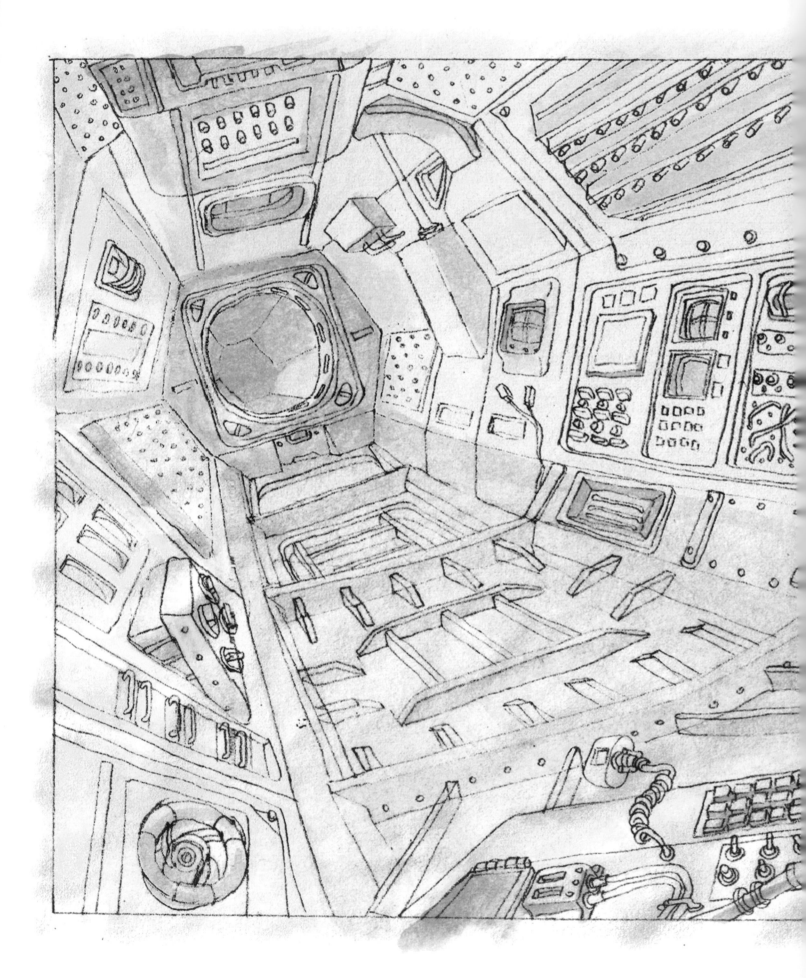

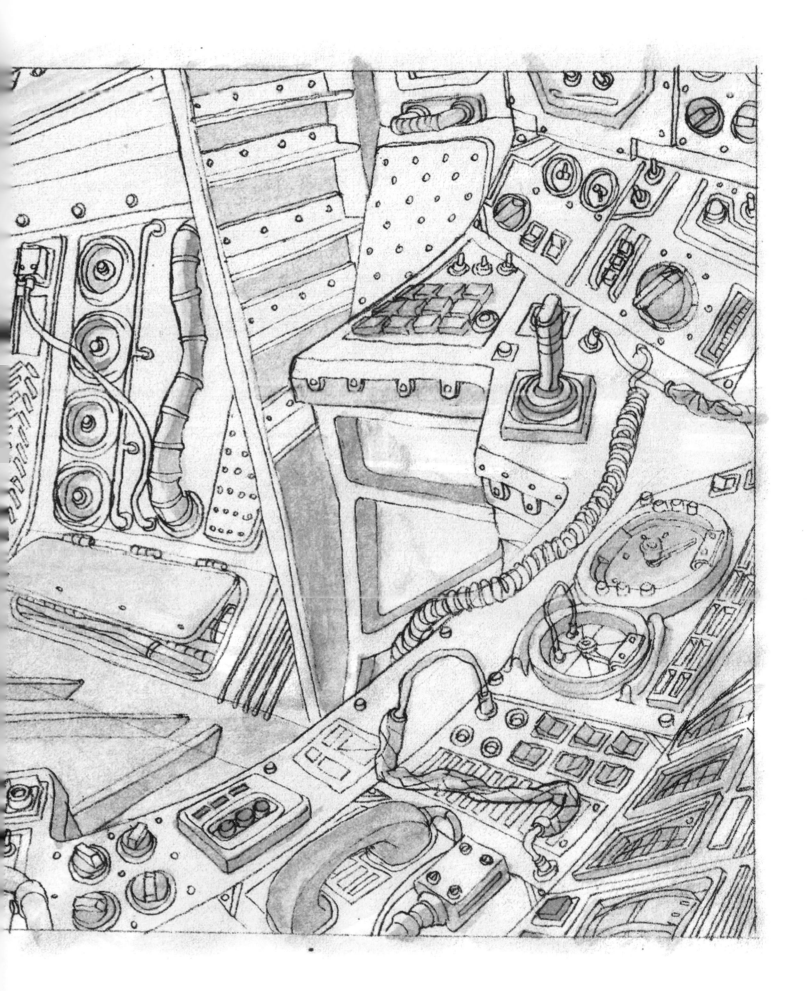

148

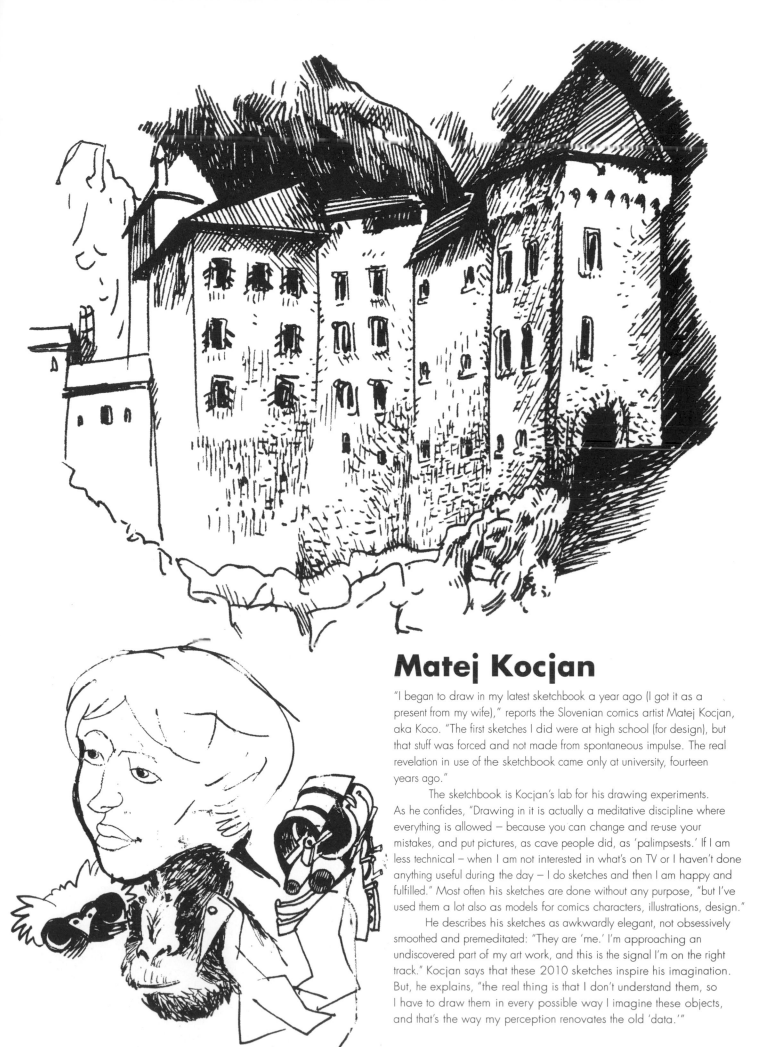

Matej Kocjan

"I began to draw in my latest sketchbook a year ago (I got it as a present from my wife)," reports the Slovenian comics artist Matej Kocjan, aka Koco. "The first sketches I did were at high school (for design), but that stuff was forced and not made from spontaneous impulse. The real revelation in use of the sketchbook came only at university, fourteen years ago."

The sketchbook is Kocjan's lab for his drawing experiments. As he confides, "Drawing in it is actually a meditative discipline where everything is allowed — because you can change and re-use your mistakes, and put pictures, as cave people did, as 'palimpsests.' If I am less technical — when I am not interested in what's on TV or I haven't done anything useful during the day — I do sketches and then I am happy and fulfilled." Most often his sketches are done without any purpose, "but I've used them a lot also as models for comics characters, illustrations, design."

He describes his sketches as awkwardly elegant, not obsessively smoothed and premeditated: "They are 'me.' I'm approaching an undiscovered part of my art work, and this is the signal I'm on the right track." Kocjan says that these 2010 sketches inspire his imagination. But, he explains, "the real thing is that I don't understand them, so I have to draw them in every possible way I imagine these objects, and that's the way my perception renovates the old 'data.'"

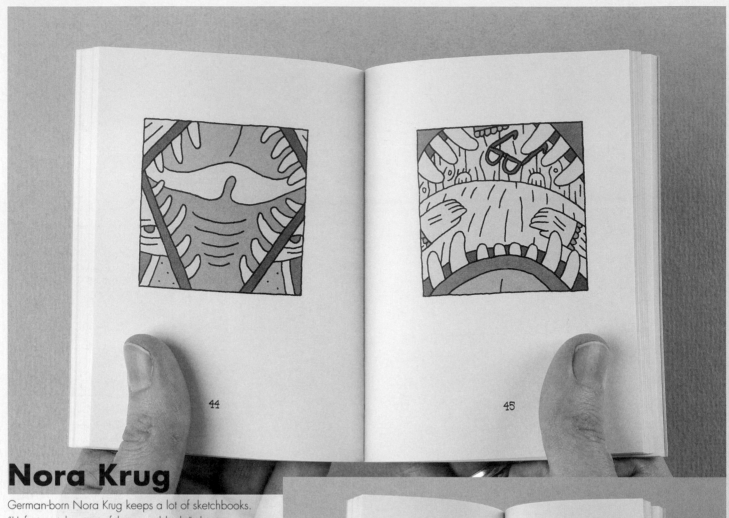

Nora Krug

German-born Nora Krug keeps a lot of sketchbooks. "Unfortunately, most of them are blank," she says, "with a few isolated sketches inside. I don't carry a sketchbook around with me, because I'm afraid of blank pages. My sketches are never musings. I don't have the desire to doodle, because I'm very critical with my drawings. My work is always first driven by an idea, never by the mere desire to experience the physical sensation of drawing as a process. When I draw, I struggle." Struggle or not, through her sketches Krug is always looking for the best possible way to create a particular atmosphere or emotion, or to present a character within a scene, which, she notes, can be an excruciating experience. "When I draw, I never know how the drawing is going to look in advance," she explains. "It more or less makes itself visible in front of my eyes. I like the idea of going over the paper again and again. I get obsessed by filling every little corner to eliminate the innocence of the white surface. It feels like during that process, the paper becomes part of me. Sketching is like a dialogue between my brain and my hand."

Krug has been working on biographical comics about people whose lives have been affected by war: "In this 2010 ten-page comic called *Kamikaze* I'm telling the story of a Japanese WWII kamikaze pilot who survived his mission due to an unexpected crash. I'm interested in how coincidences or brief moments in time can change or even completely determine our lives."

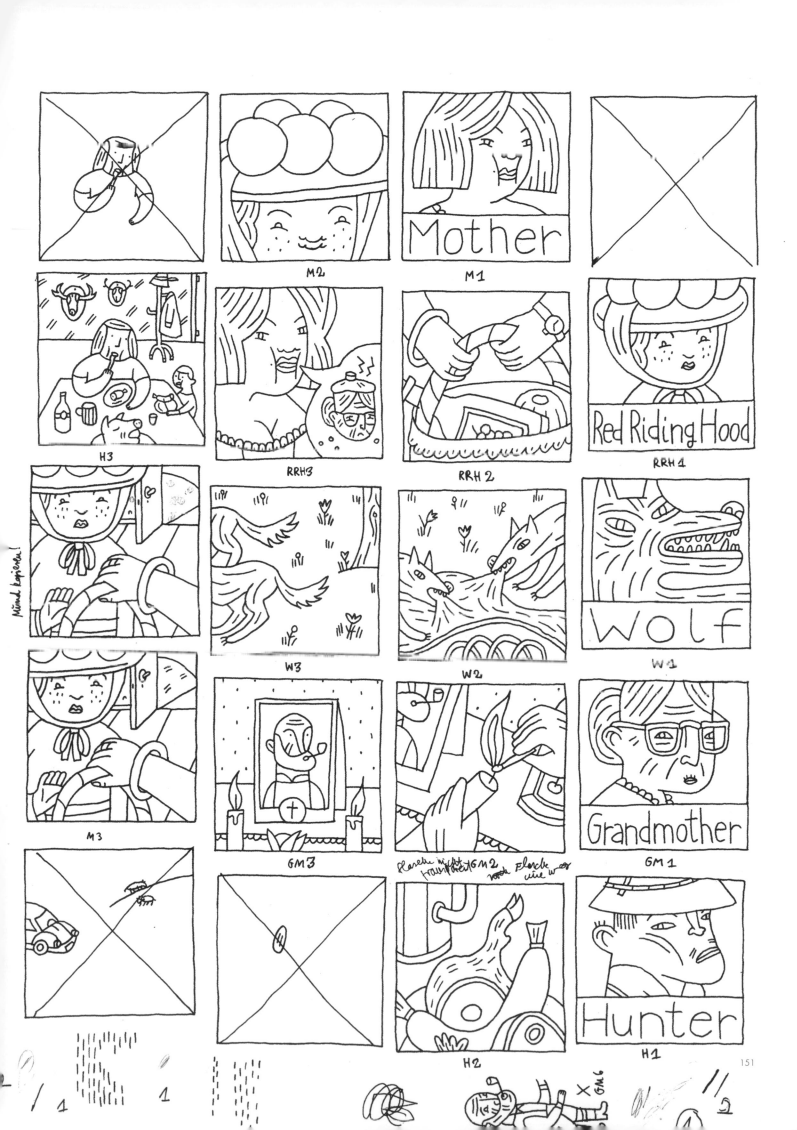

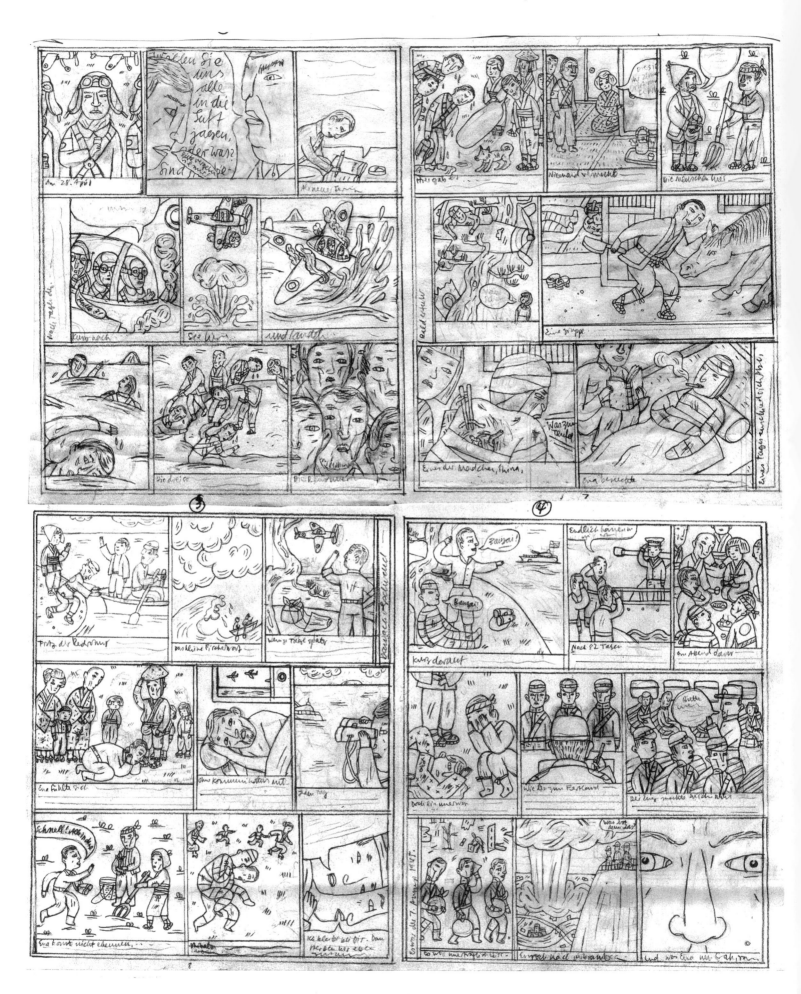

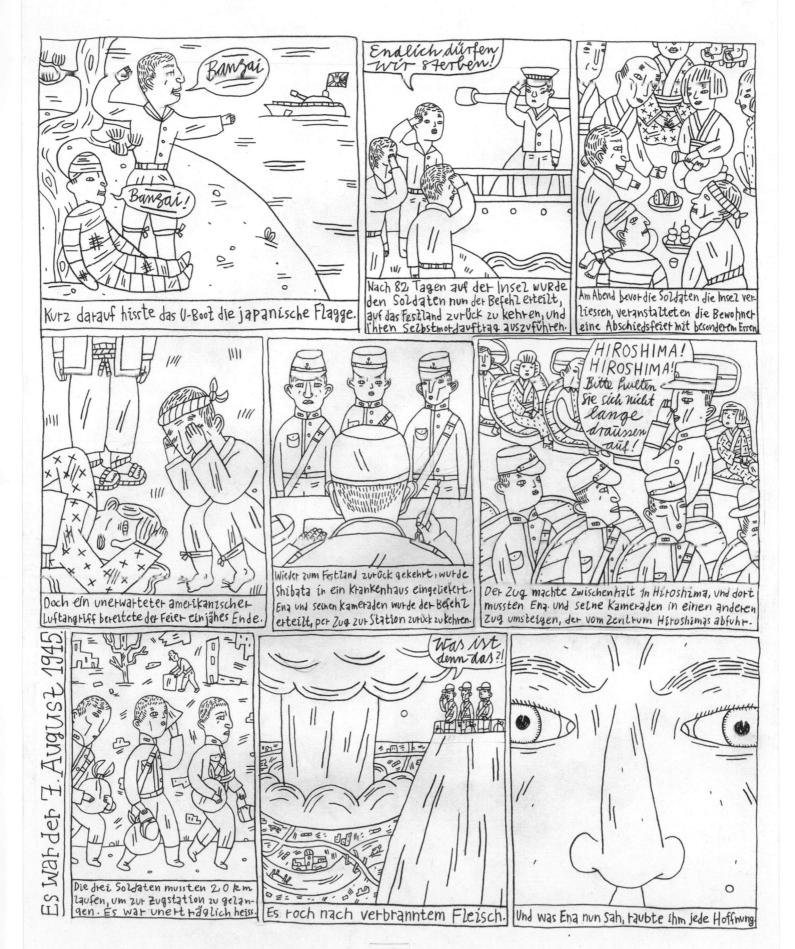

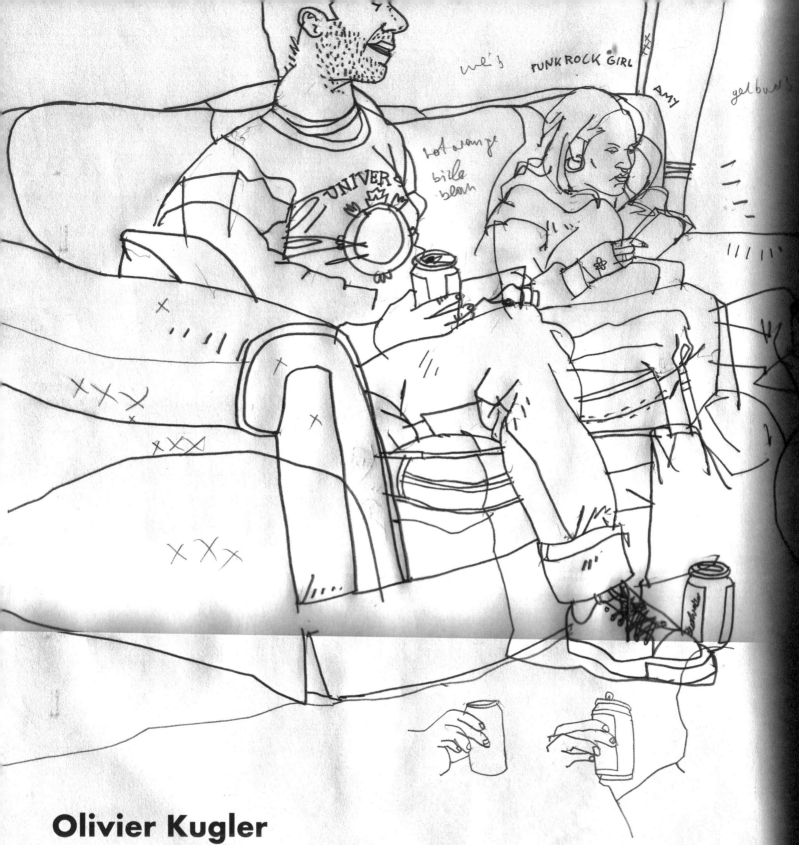

Olivier Kugler

London-based illustrator Olivier Kugler, originally from Germany, started sketching more or less seriously when he was fifteen or sixteen years old. He explains, "At the beginning sketching was just a practice for me to become a good draftsman. For me to draw in my sketchbooks was maybe comparable with an athlete doing his daily exercises...sometimes I had to force myself to draw. After a while it became second nature for me to draw and record what was around and what inspired me."

Today the sketches are the drawings that "I use in the final artwork. I add color on the computer," he clarifies. "They are just pencil (HB, Faber–Castell) line drawings, without color. Sometimes I leave lines out,

so not all the details are shown, but I guess I leave enough for the viewer to perceive the image. I also usually like to add short written observations into the drawings like, for example, a quote from an overheard conversation." These drawings from 2000–2 were all done on location "while doing my MFA [Illustration as Visual Essay at the School of Visual Arts in New York]. I loved to draw in the bars and coffee shops of the Lower East Side and in Williamsburg, a junk yard in the Bronx, a parking lot and an Italian barber shop in Spanish Harlem. But probably my favorite location to draw in was the interior of the "Frying Pan," a derelict lighthouse ship docked at New York's Chelsea Piers," he recalls.

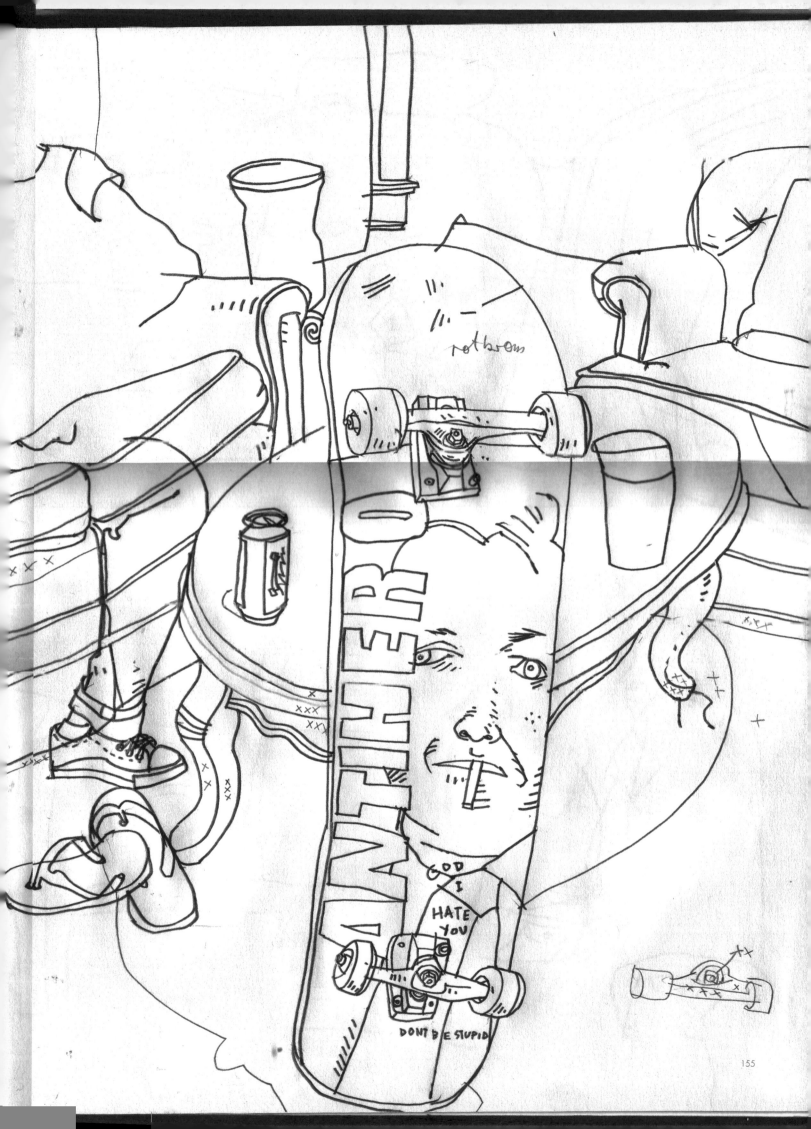

155

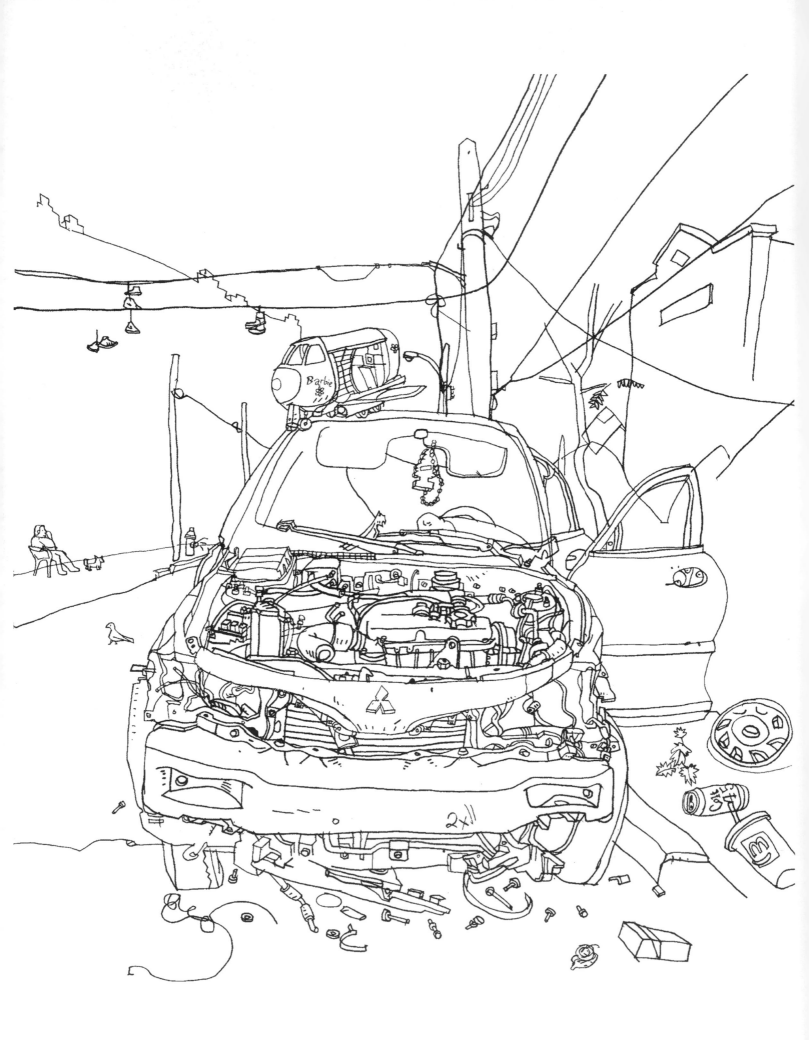

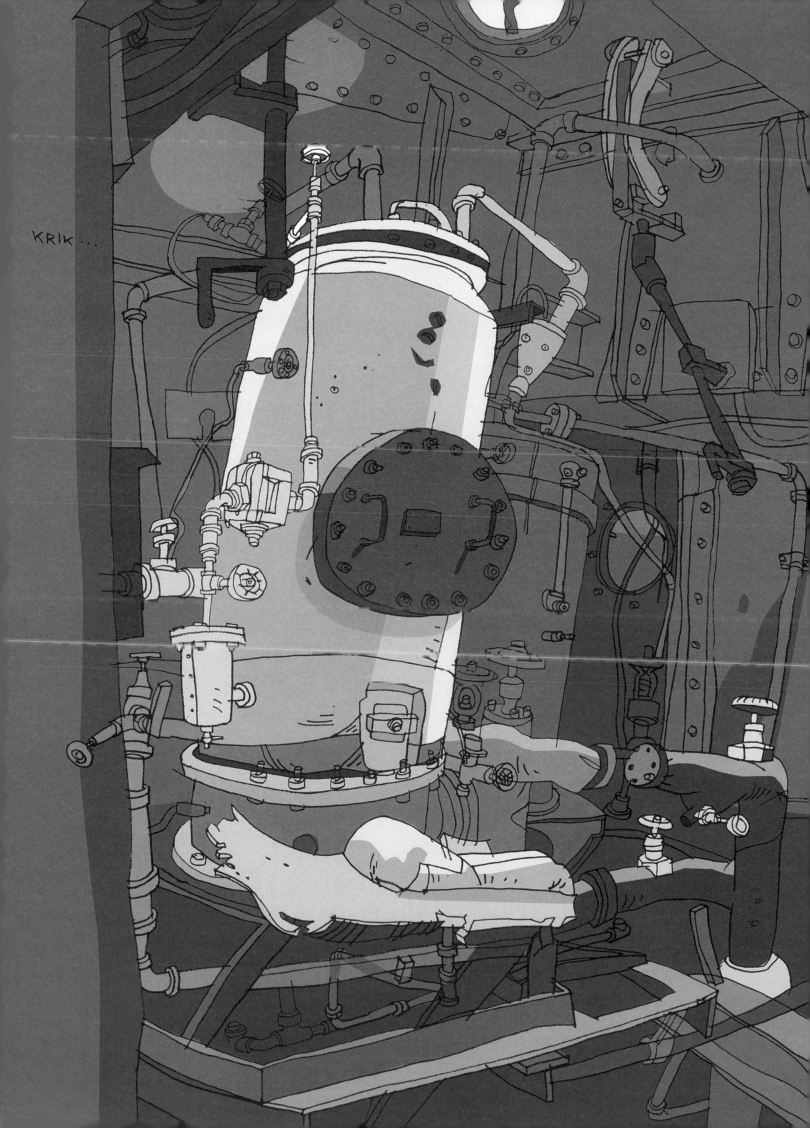

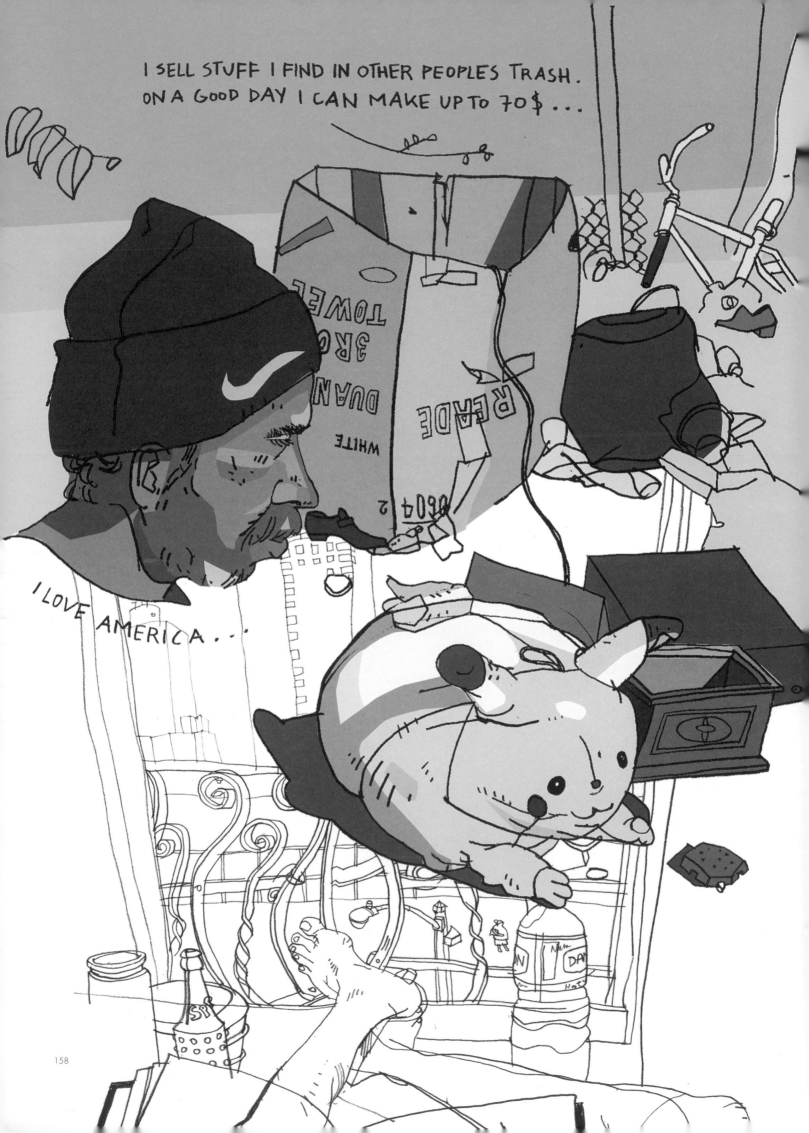

My day

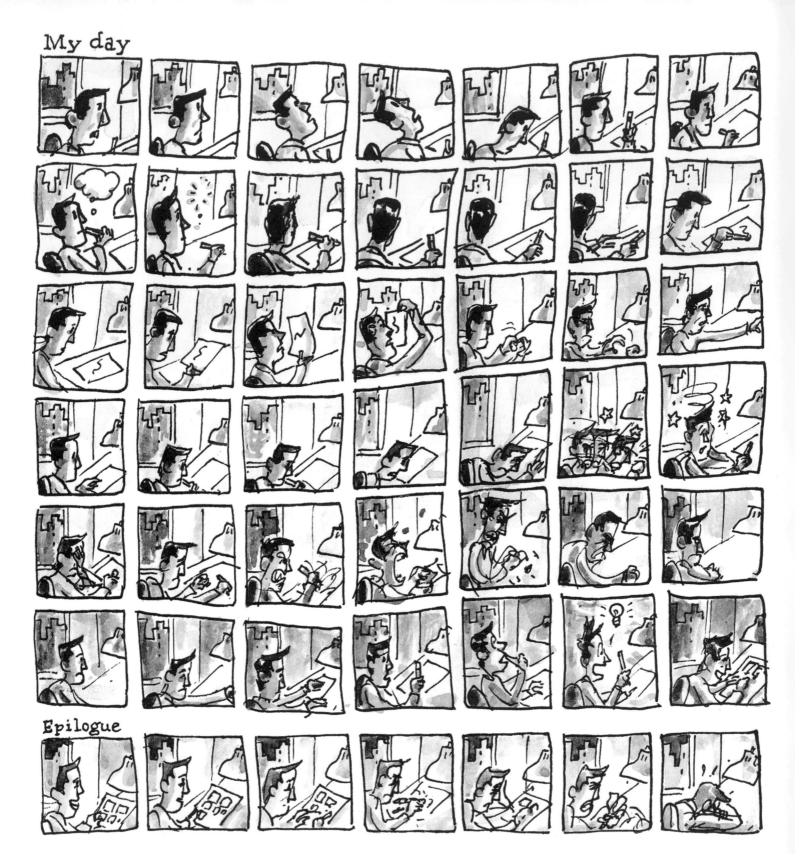

Epilogue

Peter Kuper

"Sketchbooks have been many things for me over the years," declares the New York-based peripetetic Peter Kuper. "They have been a place to experiment stylistically and capture ideas. When I travel they serve as a document of the trip and a way to absorb the flavor of the different places I've visited. They are also the best communication tool I can carry in a foreign country." His sketches have gotten him food, gotten him out of some close scrapes, gotten him through closed doors, and entertained and interpreted for him when he couldn't speak a word of the language. "At this point they are my most important resource for developing new

directions in my work," he adds. "Ultimately they serve as a historical document of time periods and mental states in my life."

Recently, Kuper reflects, "they have become more like unplanned murals with images from different locations and different times merging into a whole. I spent two years in Mexico and the environment nudged me in this direction. There is a simultaneity there with the ancient world butted up against the modern. It seemed appropriate to let the images bleed into one another and across the spread. I am very interested in recording the things I see, but much to my surprise I'm becoming more of a surrealist."

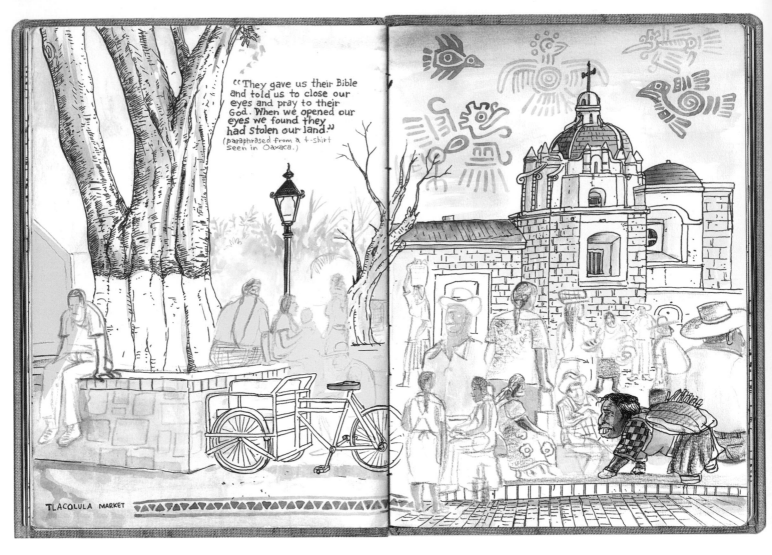

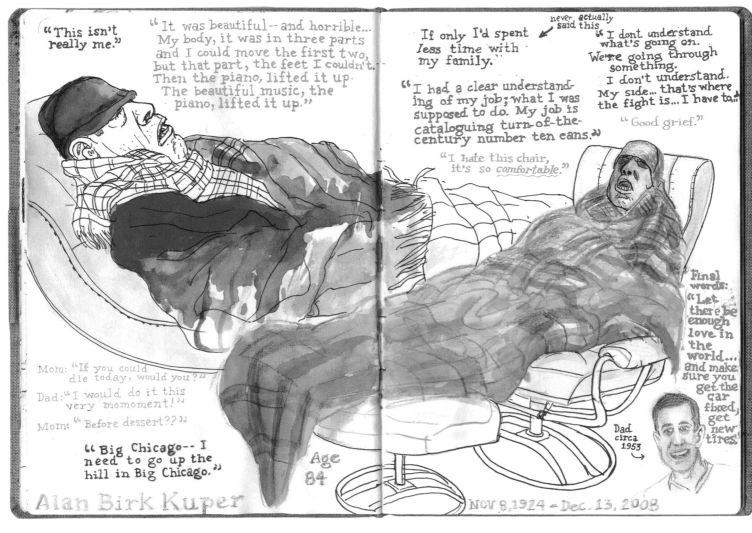

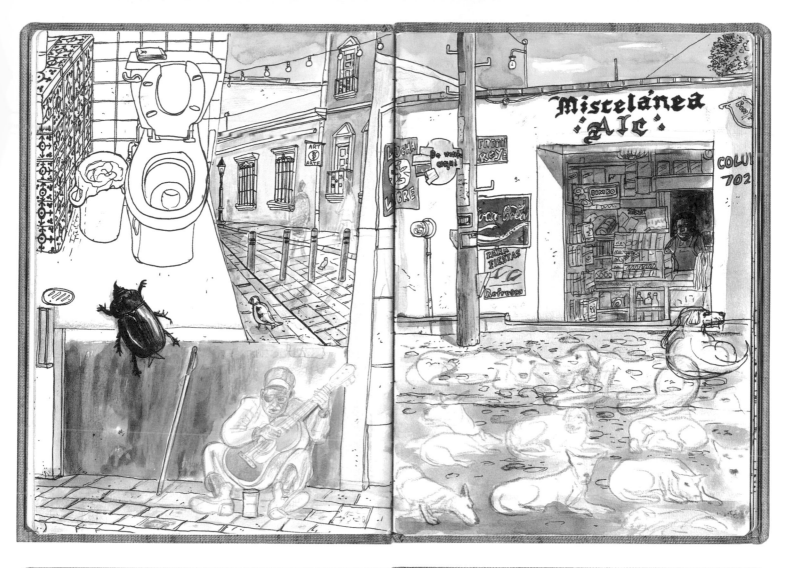

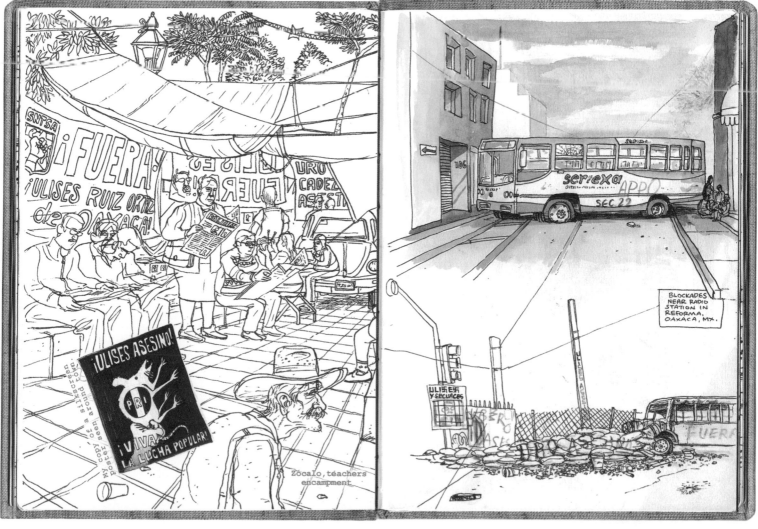

Zócalo, teachers encampment

BLOCKADES NEAR RADIO STATION IN REFORMA, OAXACA, MX.

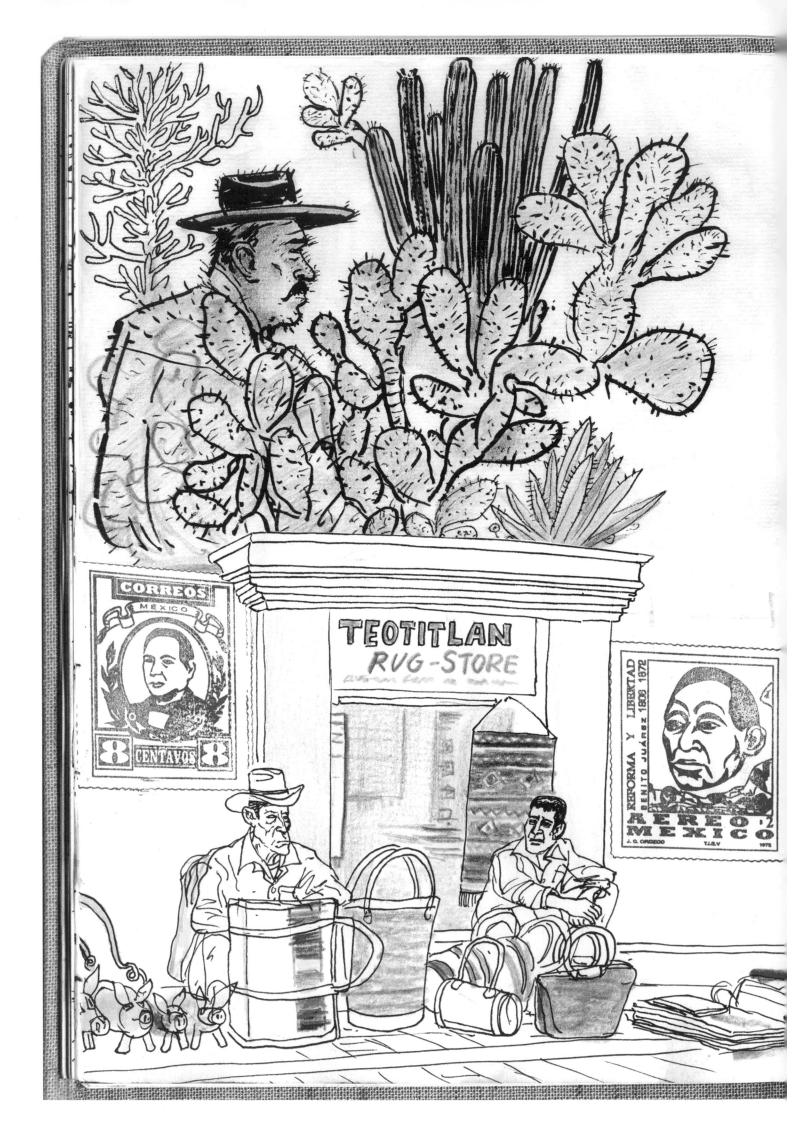

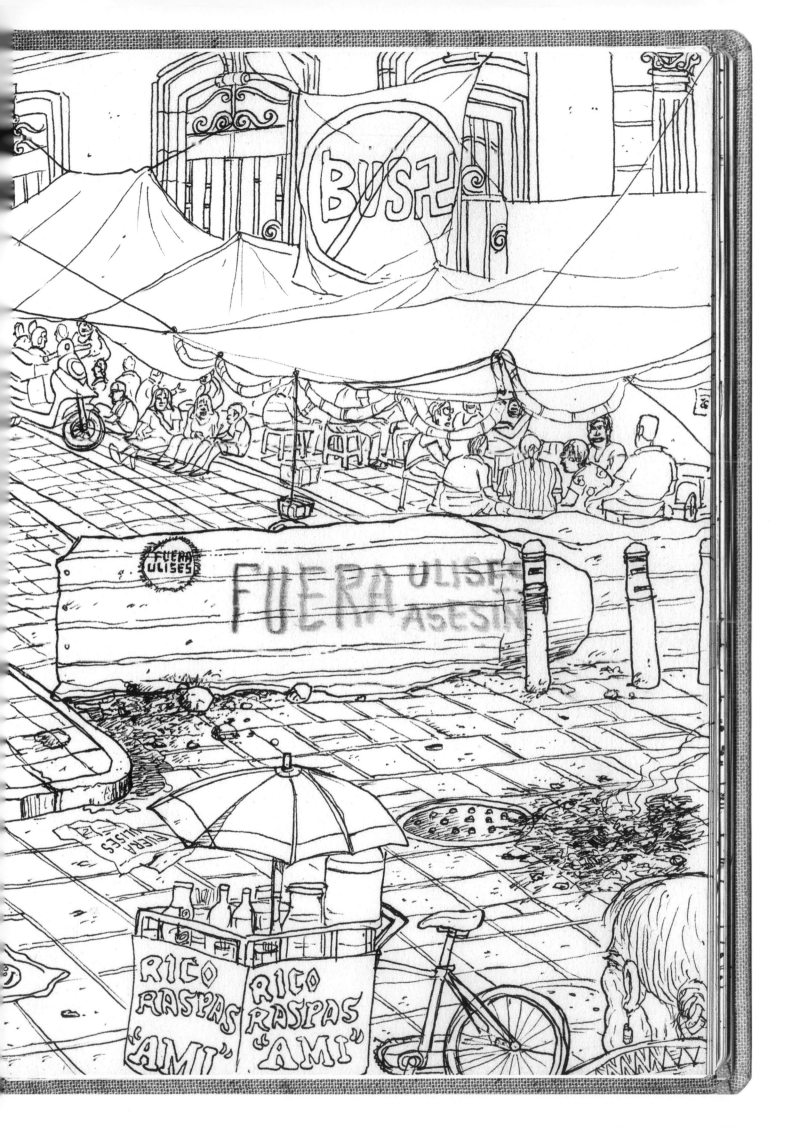

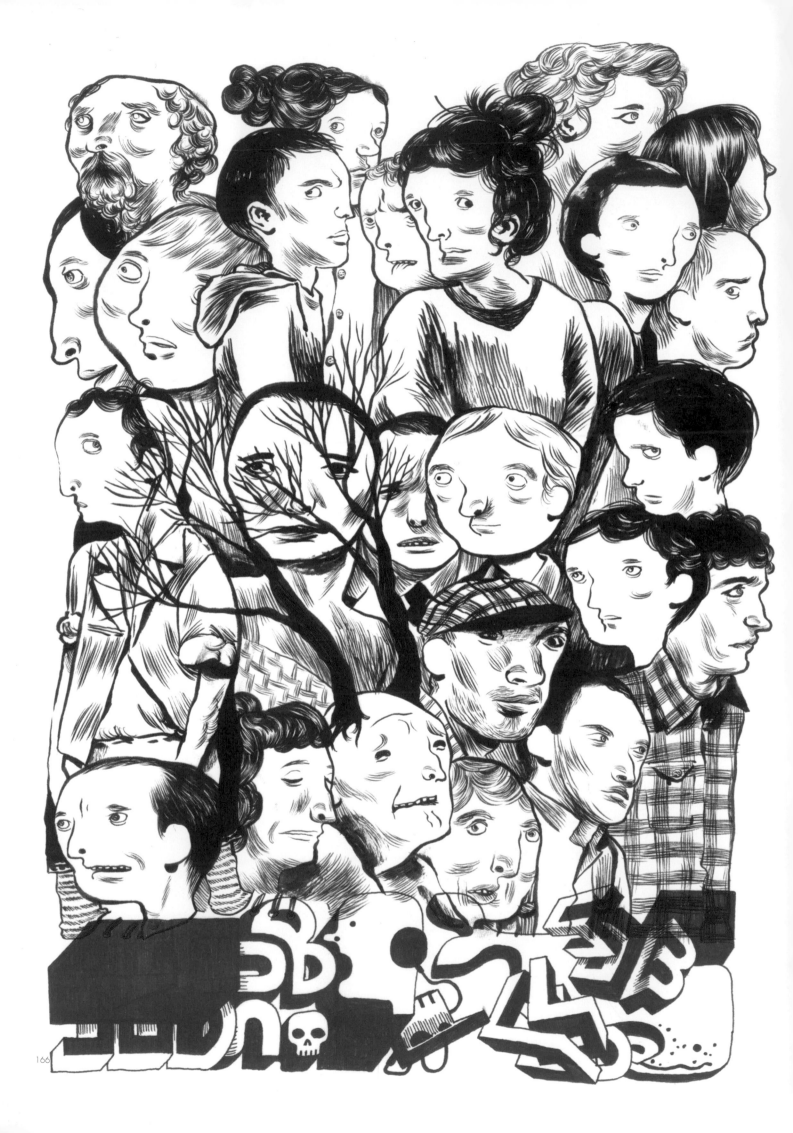

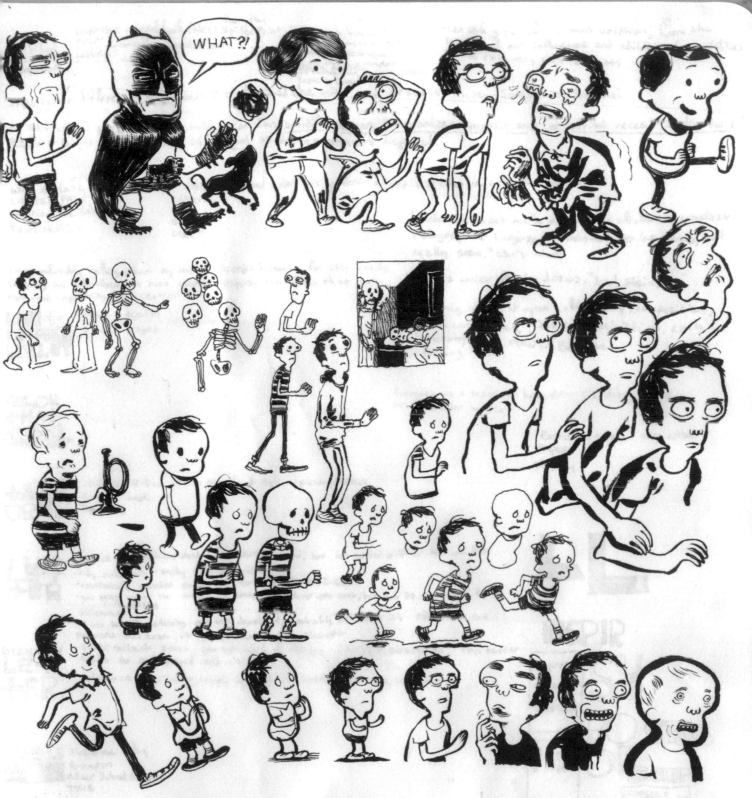

Joseph Lambert

Sketching keeps cartoonist Joseph Lambert's hand and mind loose. About the process, he says, "If a project I'm working on calls for a specific kind of drawing or stroke, I will spend some space in the sketchbook practicing. That's why a lot of my pages are full of repeated images. I try to get all of the bad or stiff drawing out of my system before I get to the final page. I have a tendency to overdraw things, so I like to get that mark-making exorcized before I start the final drawing."

But there is another side: "I like to doodle mindlessly whenever possible. It's kind of like visual free association without having to be responsible for the results." Lambert adds, "My sketches are drawn straight in ink or color, and there's a freshness which comes with sketching that I haven't figured out how to express in my finished work." Indeed, the most unusual aspect of his current sketchbooks is that the pages are full: "When I was younger I used to scribble out images and leave a page mostly blank if it was too ugly, because it would bum me out to look at the drawings. Nowadays I'll leave the ugliness and learn from it, or whatever. If the individual drawings aren't bearing fruit then I'll treat the page as an exercise in design by trying to make it interesting as a composition. There is a lot to learn from sketching, but it should also be a comfortable place to play in – it took me a long time to treat my sketchbook that way."

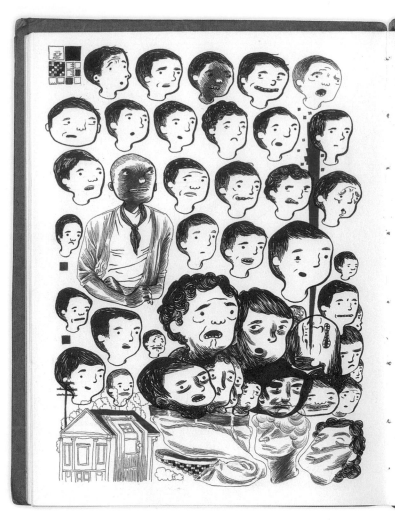
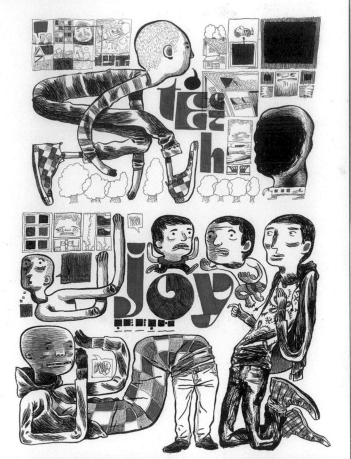
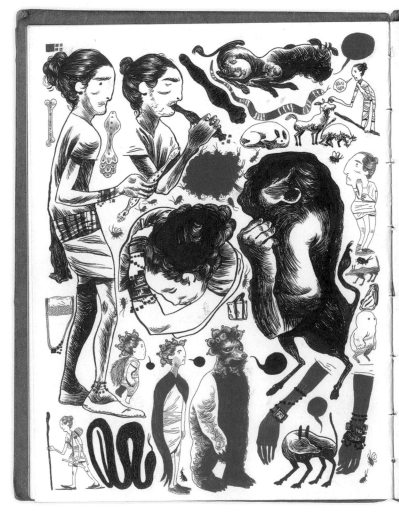
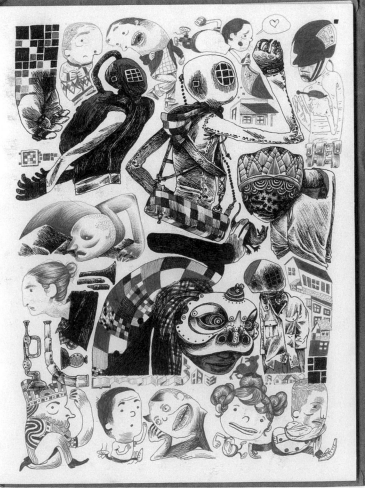

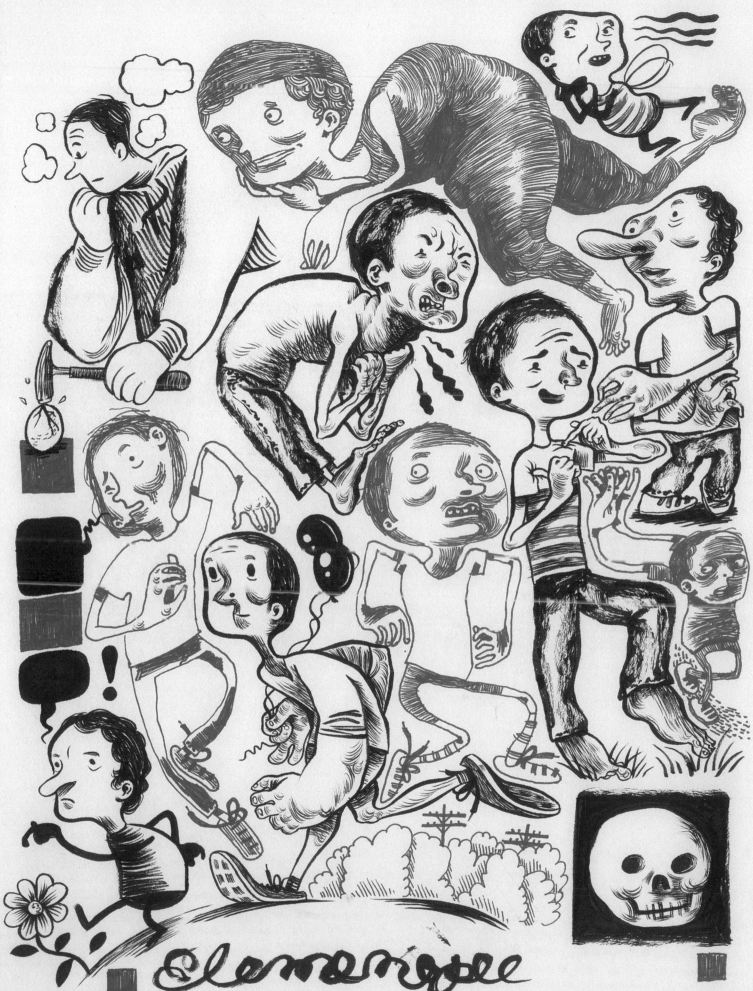

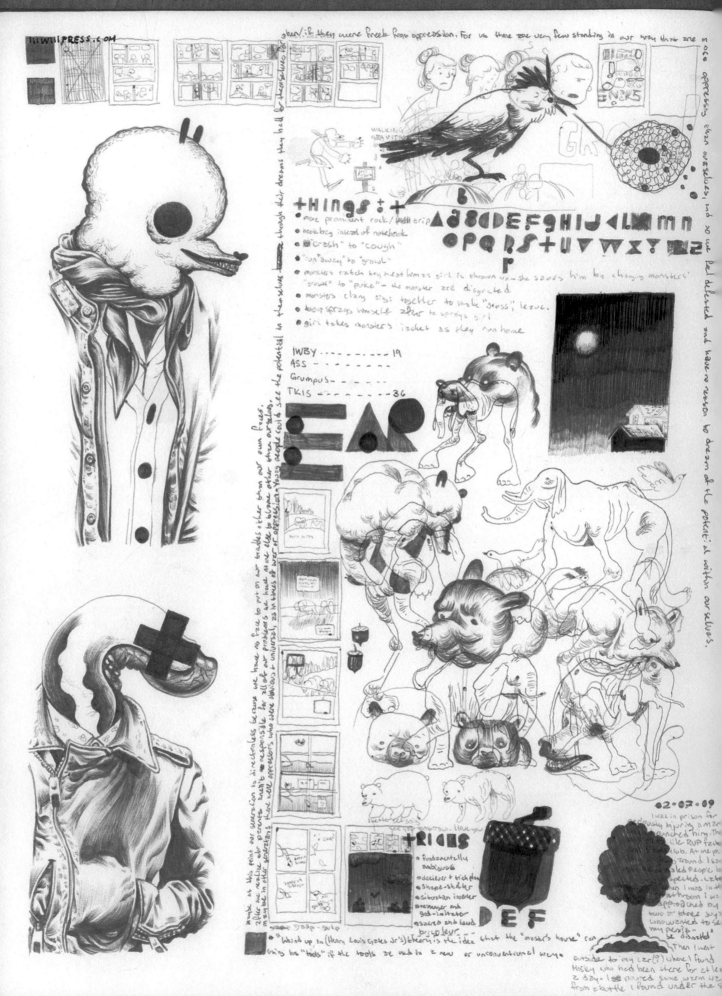

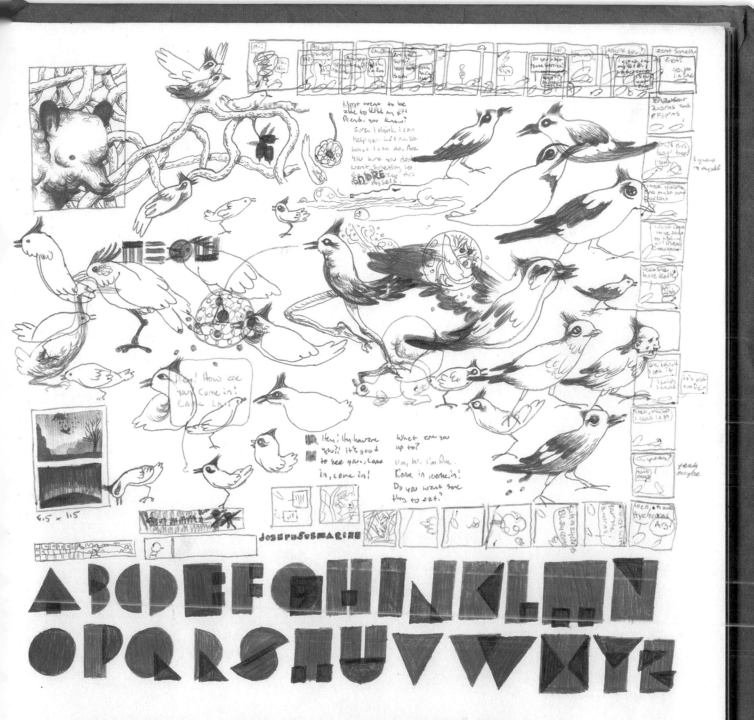

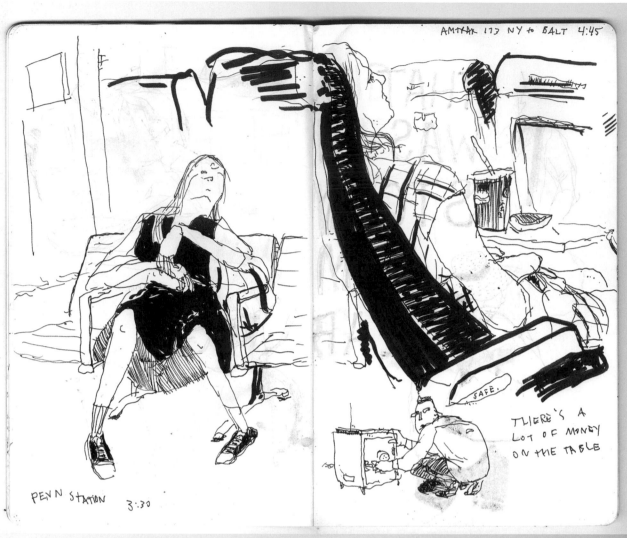

Brendan Leach

Brooklyn-based artist Brendan Leach has worked in sketchbooks for as long as he's been drawing. He says he's fond of keeping all his work in one place. This is also where he can put all the "dumb ideas and bad drawings," he admits, adding, "That way they don't end up in the final comics." The sketchbooks are almost entirely free association and stream of consciousness: "If I hear something said that sticks with me I'll write it down. Or if I see something I like, I will try to draw it. Sometimes bigger ideas get sparked that way. Sometimes not."

At times he goes through periods when he doesn't work in the sketchbooks all that much – and then there are "stretches of time where I'm filling them up as fast as I can."

Some of Leach's drawings will lead to finished work, or at least inform the ideas that become finished pages, but mostly the drawings in the sketchbooks are done without thoughts of final or polished images. "I am far less uptight in the sketchbooks – there is no editing process. In my final comics I try to consider every little aspect of the drawing and stories. In the sketchbooks, it's more open," he acknowledges.

What's unusual about his sketchbooks? "On the one hand, I feel there is nothing unusual here. But sometimes if I look back at older pages, I'm really surprised at what seemed important enough to put down in the book. Sometimes I have no idea what I was thinking or trying to accomplish with these drawings," he confesses. Those shown here were all made during a six-month period in 2010.

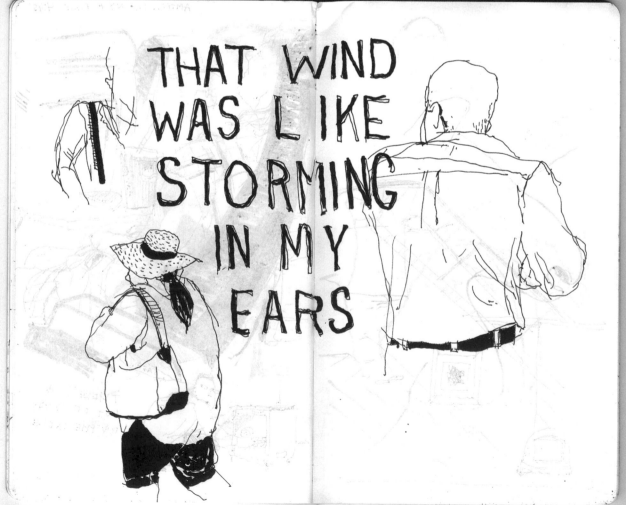

THAT WIND
WAS LIKE
STORMING
IN MY
EARS

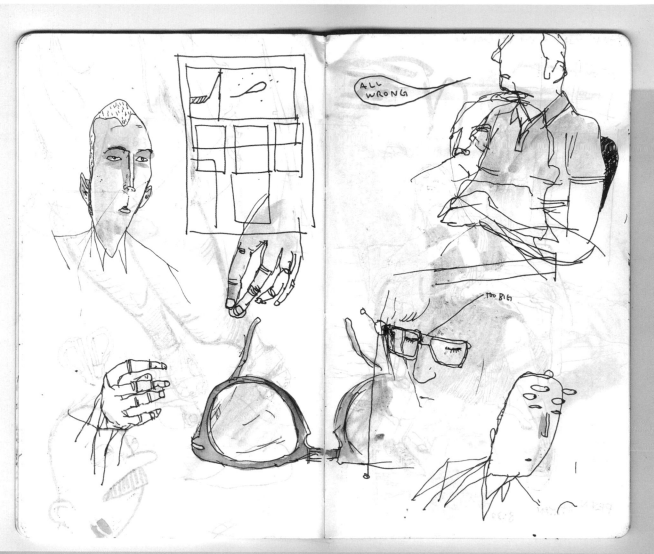
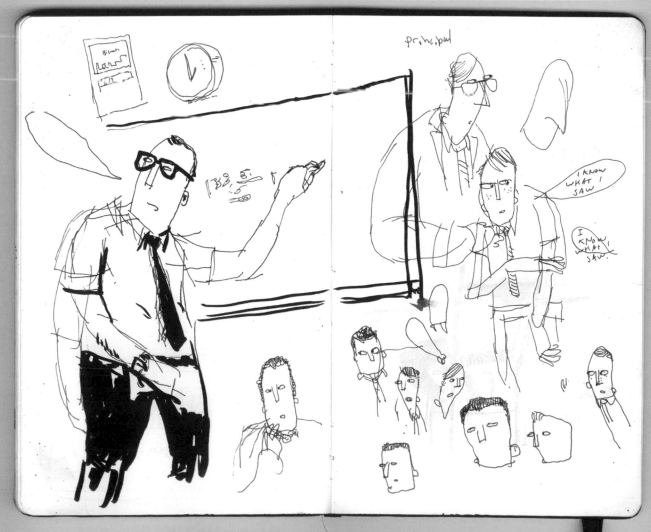

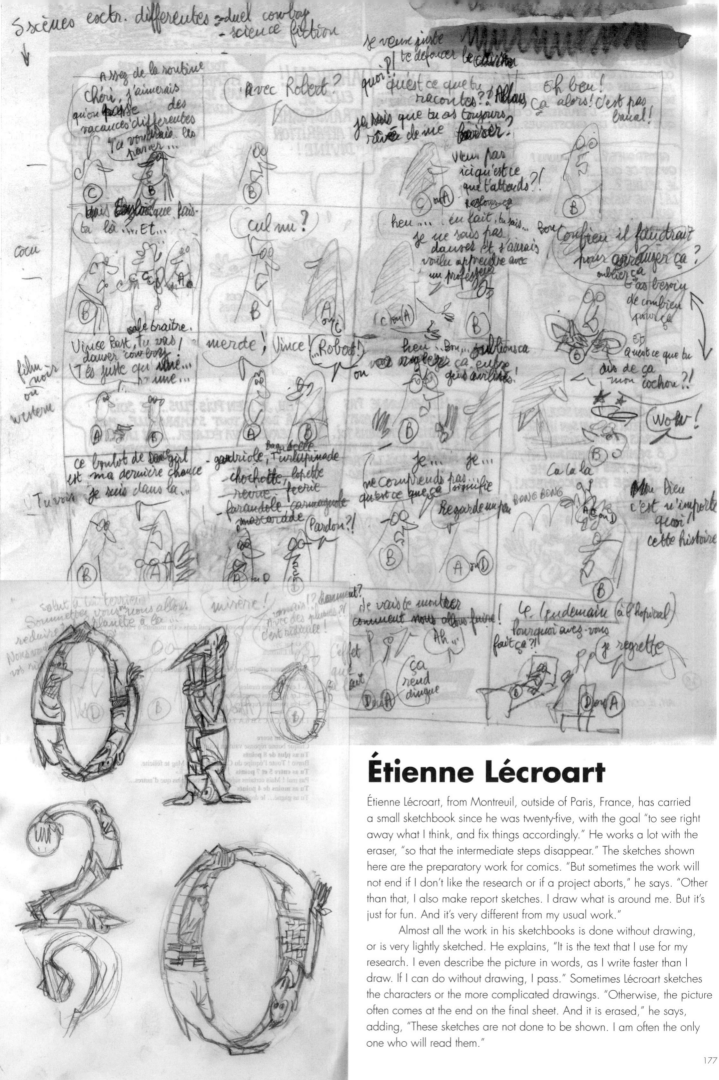

Étienne Lécroart

Étienne Lécroart, from Montreuil, outside of Paris, France, has carried a small sketchbook since he was twenty-five, with the goal "to see right away what I think, and fix things accordingly." He works a lot with the eraser, "so that the intermediate steps disappear." The sketches shown here are the preparatory work for comics. "But sometimes the work will not end if I don't like the research or if a project aborts," he says. "Other than that, I also make report sketches. I draw what is around me. But it's just for fun. And it's very different from my usual work."

Almost all the work in his sketchbooks is done without drawing, or is very lightly sketched. He explains, "It is the text that I use for my research. I even describe the picture in words, as I write faster than I draw. If I can do without drawing, I pass." Sometimes Lécroart sketches the characters or the more complicated drawings. "Otherwise, the picture often comes at the end on the final sheet. And it is erased," he says, adding, "These sketches are not done to be shown. I am often the only one who will read them."

A L'amour. Encore et toujours "C'est ce qui fait"	B qu'on reste jeune Mais c'est de	C L'illusion. On s'imagine avoir tout compris, tout ce qui t'interesse c'est	D Perdre ton temps avec des conneries c'est ça t'as raison	E Tu n'es qu'un vieux radoteur pontifiant.	F Je vais te dire: le drame de la vieillesse c'est...					
G Le sexe. Tu sais c'est pitoyable Tu veux juste faire	A L'amour Encore et tjrs. C'est ce qui fait.	B qu'on reste jeune Mais c'est de	C L'illusion on s'imagine avoir tout compris Tout ce qui t'interesse c'est	D Perdre ton temps avec des conneries	E	F				
H la bêtise. On devient vite seule, hanté par	G Le sexe Tu sais c'est pitoyable Tu veux juste faire	A L'amour Encore et tjrs C'est ce qui fait	B qu'on reste jeune.	C	D	E	F			
i qu'on répète sans cesse comme un cercle vicieux Là est	H La bêtise. On devient vite seule, hanté par	G Le sexe ... Tu veux juste faire ...	A L'amour	B	C	D	E	F		
J ton bonheur... c'est nul Mais c'est comme ça. On fait des erreurs.	i qu'on répète sans cesse. Un cercle vicieux. Là est	H La bêtise. On devient seule hanté par	G Le sexe. Tu sais c'est pitoyable	A	B	C	D	E	F	
	J Ton bonheur... c'est nul Mais c'est comme ça. On commet des erreurs		H La bêtise	G	A	B	C	D	E	F
K Mais tais-toi Laisse-moi	K	i qu'on répète sans cesse!...	H	G	A					
		J ton bonheur		H	G					
		K			H					

Heu qu'est ce que je disais?...

Ecoute Bibiche, ce n'est pas le moment je resouds le paradoxe de la somme du grand duc de Toscane

Enfin chéri, nous voyons plus! tes peuvent atteindre nou?

nous ne sommes

Ton peuple est à ge 2 rouge et tu m'as avec tes bavardages!

Ferme-

Ca ne te diraitpas u petite partie x'intersection de os ensembles hein?

Mais..!? mais. dis-tu? Faut pas ser! Ne sois pas gros jet'en prie!

Que pous sieve

Nez rouge sait la fleur de paix se à la lisié du bois du conflit

C'est ça Va la brouter tout seul ta paquere

178

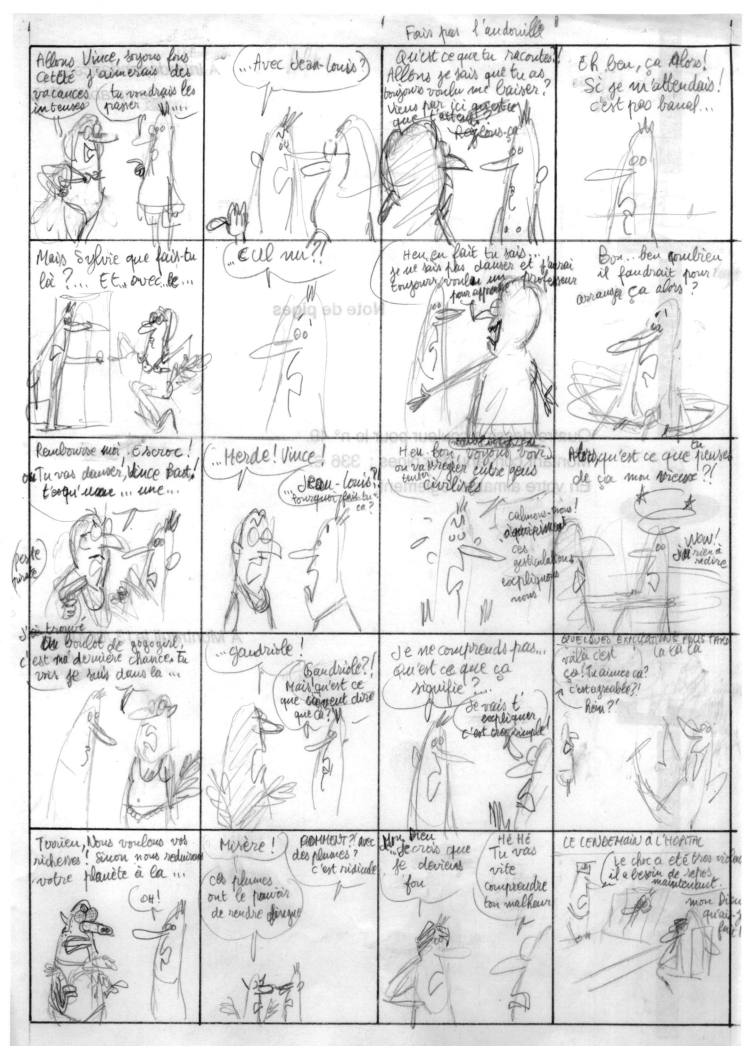

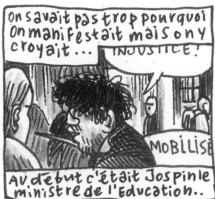
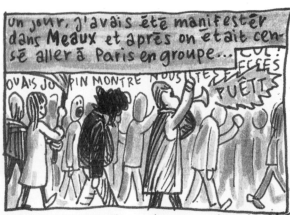
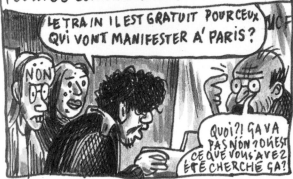

Matthias Lehmann

Parisian comics artist Matthias Lehmann reveals that he always writes "the date of the beginning and the end of each sketchbook on the first and last pages of the book, and sometimes two years or more pass between those two dates. But I use several sketchbooks at the same time." The images shown here are from 2004–11.

His books are a receptacle for many things. "Sometimes, they contain only doodles that I do to find ideas, or just to waste time," he states. "Sometimes they are studies for future illustrations, drawings, paintings or comics stories, and sometimes it's a finished drawing (it can be a sketch from the street, too, but I haven't done that in years)."

For Lehmann, the fundamental joy of the sketchbook is "a feeling of freedom – no penciling, for instance. My finished work is usually more sophisticated (which is not always a good thing)." The books, he explains, offer a sense of intimacy, and "maybe they also have a childish aspect that's not necessary in my other works."

Thematically, everything can be addressed, and "that's the best part of having a sketchbook – although there is a good proportion of material that consists of reproductions of engravings," he admits. "I hope I'm not being too cheesy, but they're kind of precious (to me, of course)."

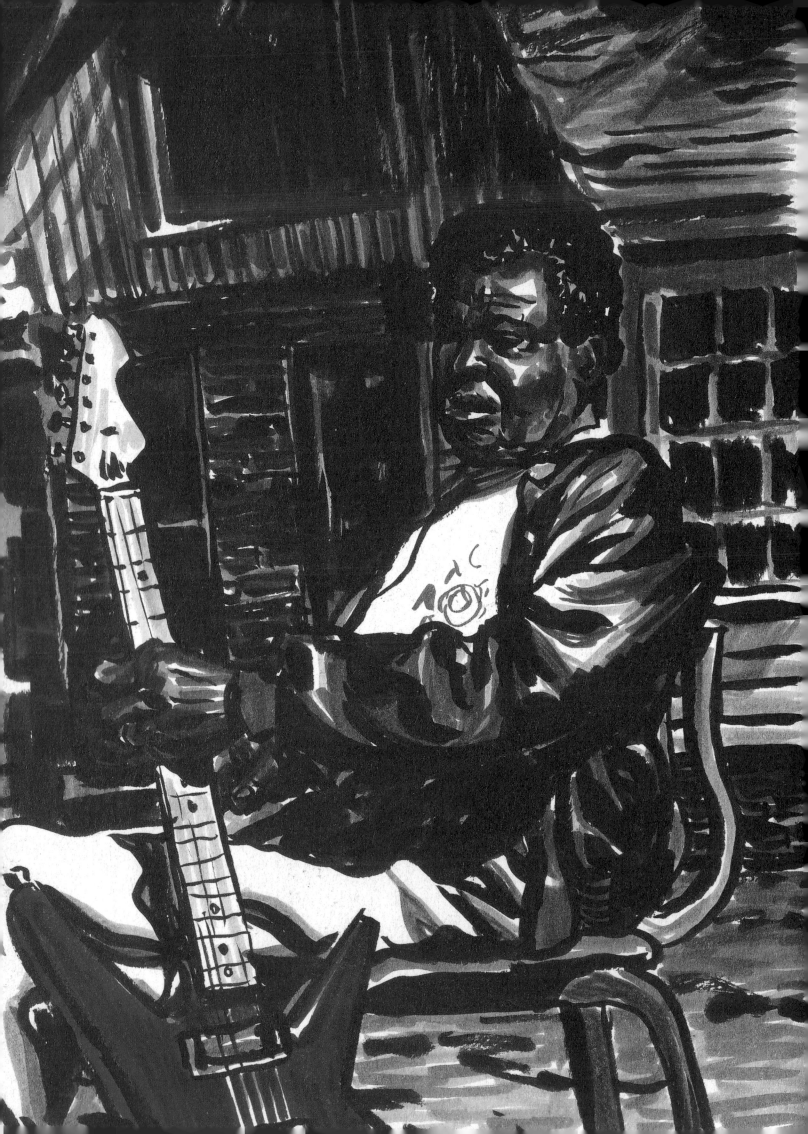

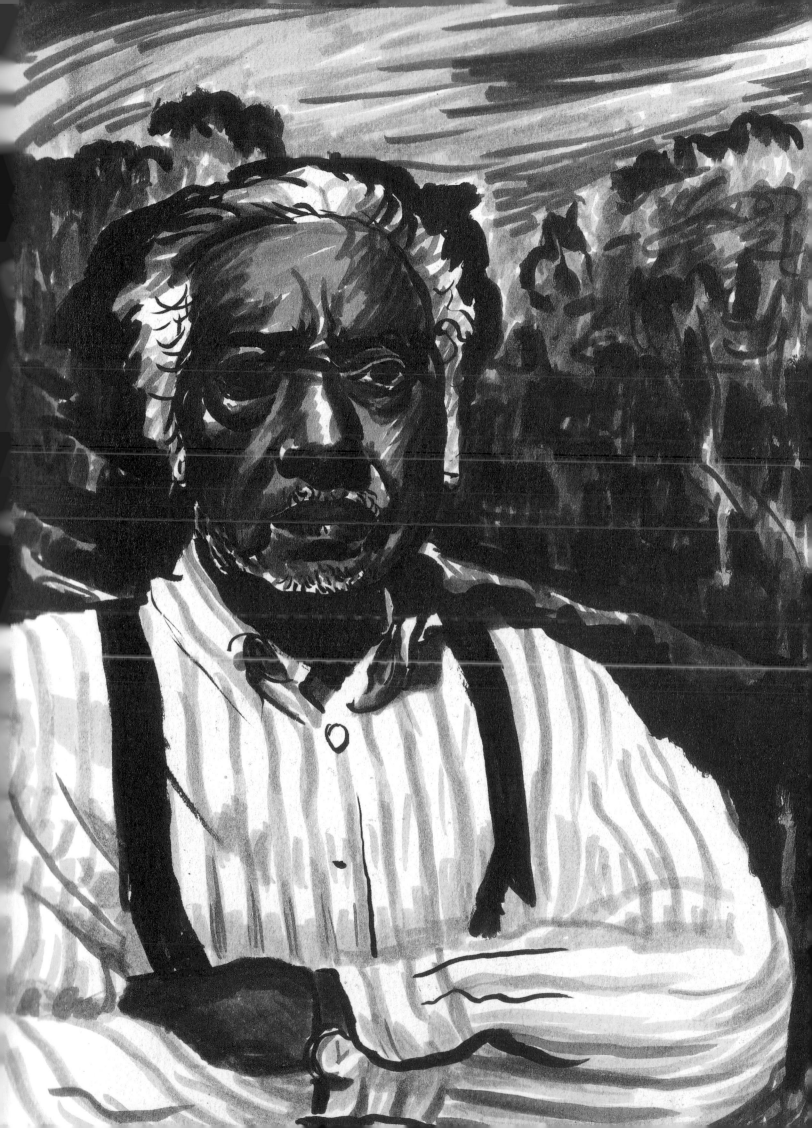

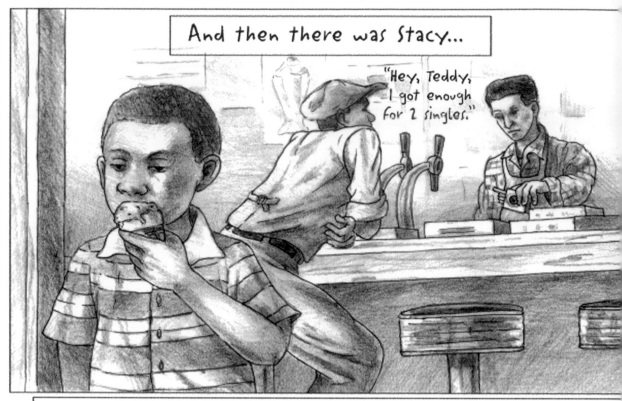

And then there was Stacy...

"Hey, Teddy, I got enough for 2 singles."

He came in to get his "smokes" and shoot the breeze with Daddy.

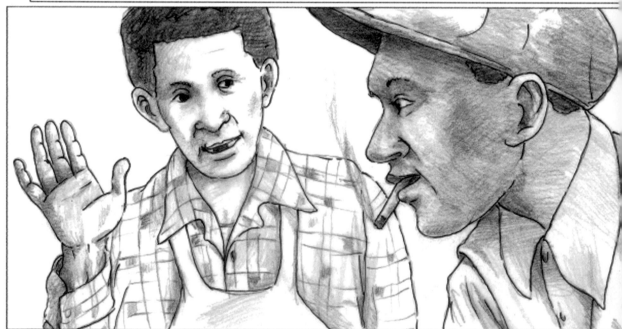

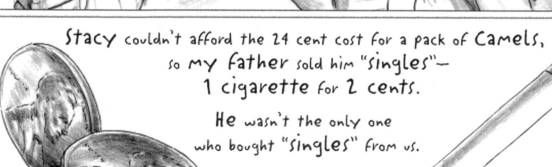

Stacy couldn't afford the 24 cent cost for a pack of Camels, so my father sold him "singles"— 1 cigarette for 2 cents.

He wasn't the only one who bought "singles" from us.

It was a poor neighborhood.

Martin Lemelman

"When I was six years old, I uncovered a cache of old art supplies in my father's candy store," recalls Martin Lemelman from Allentown, Pennsylvania. "It was a treasure trove of broken brushes, school tempera paints, cakes of watercolor, model airplane colors and oils from an incomplete Paint-by-Numbers set. Finding this was transformative. I started to paint in a frenzy. The floors were littered with dozens of paintings. Needless to say, my mother was not happy tiptoeing over my art. So, after a few days, she gave me this advice: 'Mattaleh,' she said, 'if you want to make a nice picture, don't finish in a day. Take your time. It will be better.' She never realized what an impact her words had on me. For over fifty years now, I plan and sketch before I go to final art. Good advice for anyone."

Putting pen to paper seems to loosen Lemelman's brain: "Preliminaries are drawn on napkins, cheap pads, cardboard – anything available. In the next stage I draw on successive sheets of tracing vellum. These become more refined with each sheet, until I'm ready to go to final art." The sketches here are "from my graphic memoir, *Two Cents Plain: My Brooklyn Boyhood* [2010] – the story of growing up in Teddy's Candy Store in Brownsville. My parents were Holocaust survivors in a neighborhood of survivors. I have fewer than twenty photos of my family and the store in the 1950s and 1960s – my mother saved more photographs through World War II than I have of my childhood. The art is my attempt to recreate this lost world of Brownsville."

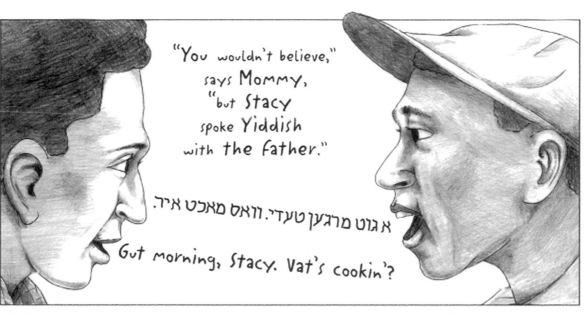

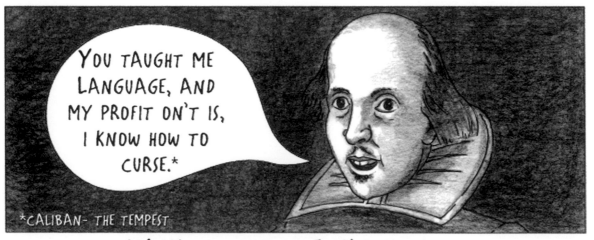

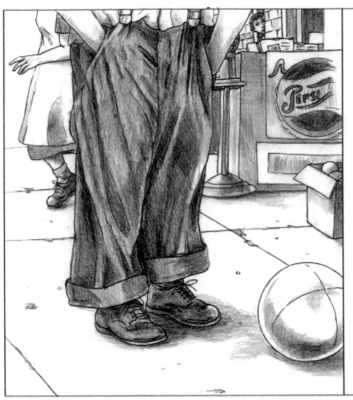

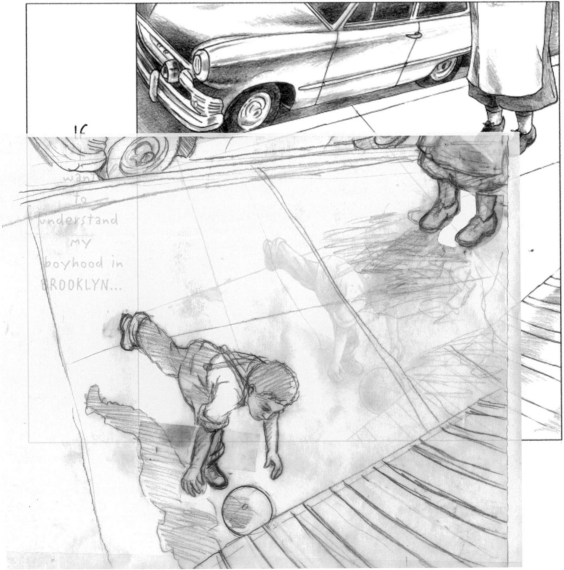

We climbed a hill outside my town.

"Here the Germans shot all the Jews from Radziwill and the villages around," the neighbor man said.

Here and there, I found bones on the ground.

THE EARTH SPIT THEM OUT.

This I saw with my own eyes.

In my heart, I knew, I was finished with Poland.

I HAD ENOUGH.

I went out from Radziwill and walked west to the American Zone.

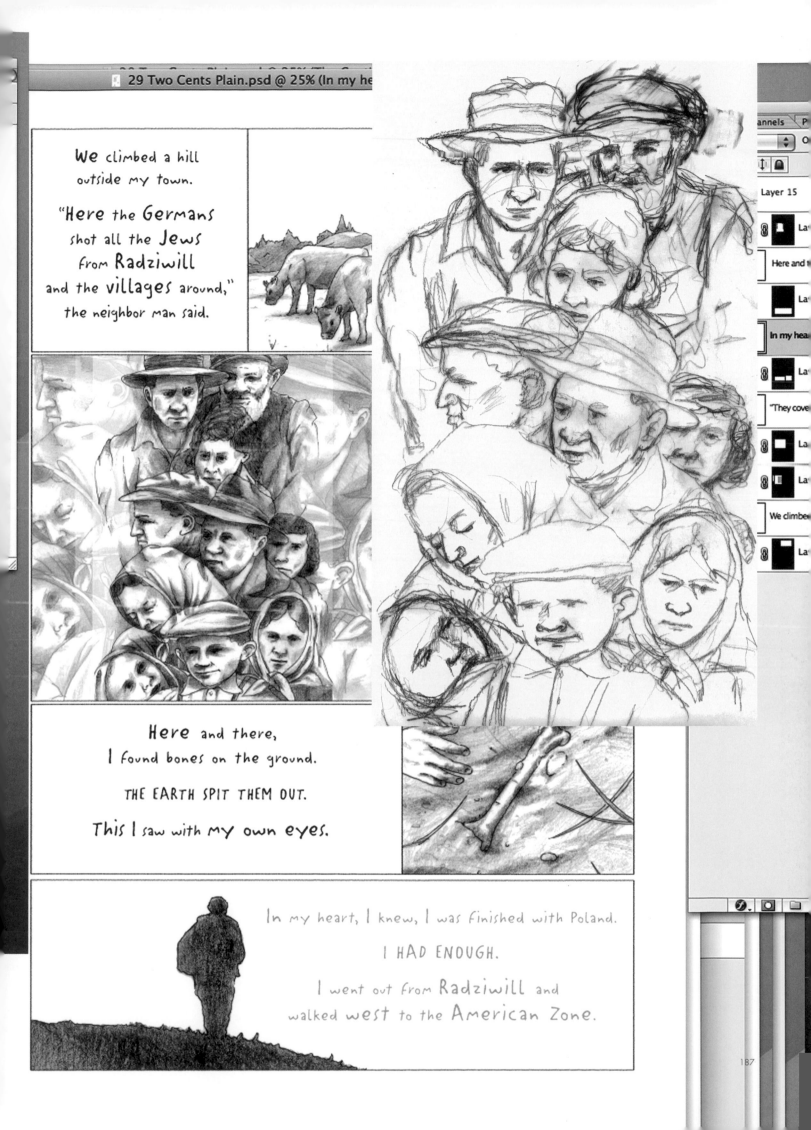

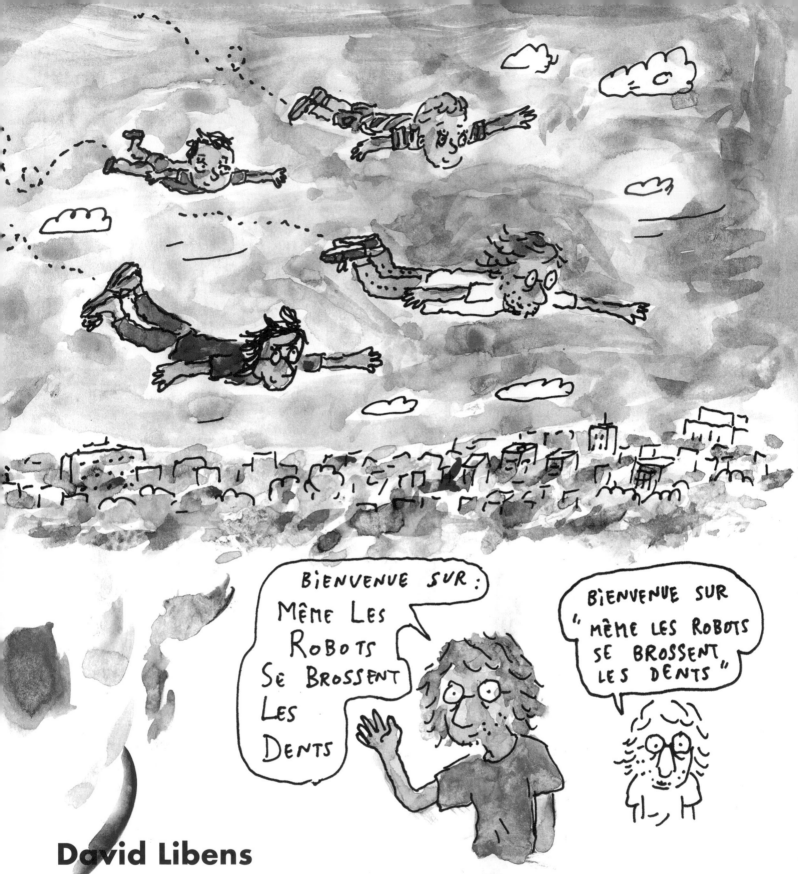

David Libens

"I draw my comics pages directly in my sketchbooks," explains Belgian David Libens. "I rarely 'doodle' or draw traditional sketches. I don't give myself the time to work that way. Although, since I'm a fellow this year at the Center for Cartoon Studies in White River Junction, Vermont, I have a lot more time on my hands. So my approach to drawing in sketchbooks might change over the course of the year. I might use my sketches more to 'doodle.'" For now, however, the sketchbooks, which he started in 1992, are practical. "I don't lose pages and I can draw wherever I want. Back in Brussels," he claims proudly, "I would draw standing up in the subway, or on my lap during my lunch break from my boring office job."

The sketches shown here are mostly autobiographical. "They cover my recent past and the last few months of my life in Europe," he remarks. "They deal with the fact that my family was about to move to the States for a year. The end of 2009 and beginning of 2010 were pretty intense. We were deciding if we were going to move. Our second kid was born around that time and the birth triggered a lot of questions in me about my own childhood. I had to dig deeper inside of me and get some form of therapeutic help to get through the past six months. More than ever, I questioned my autobiographical work during that time," he confides.

13 JUILLET

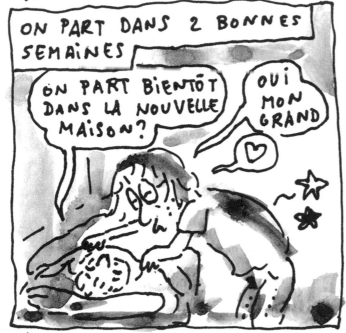

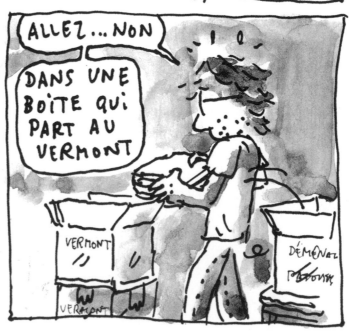

JANUARY 5th 2010

(THIS HAPPENED THE WEEK-END OF DECEMBER 19th)

I KEEP ON CHECKING MYSELF

LET'S SEE HOW DO I FEEL TODAY? PAT = PAT = PAT

THAT'S WHAT I DO SINCE FOREVER

(ALTHOUGH... ...IT WOULD BE NICE TO FIND OUT EXACTLY SINCE WHEN)

BUT EVERSINCE MY "FAMILY CONSTELLATION" WHATEVER I FIND ON ME AFTER CHECKING IS NOW DIFFERENT

WHAT IS THIS? THIS IS NEW!

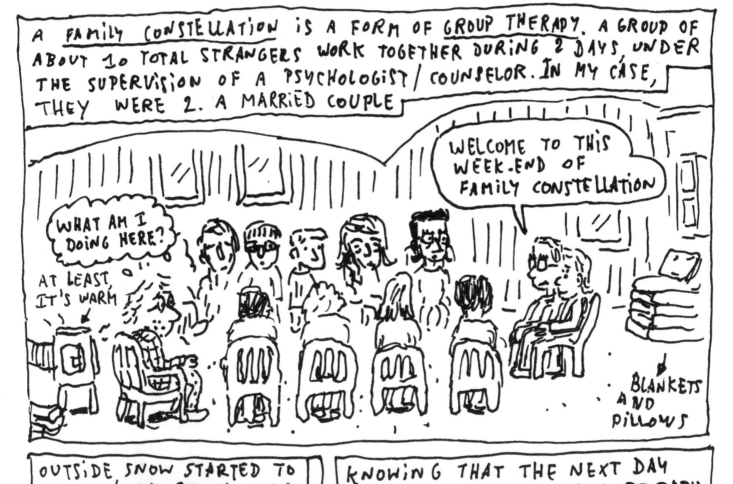

A FAMILY CONSTELLATION IS A FORM OF GROUP THERAPY. A GROUP OF ABOUT 10 TOTAL STRANGERS WORK TOGETHER DURING 2 DAYS UNDER THE SUPERVISION OF A PSYCHOLOGIST / COUNSELOR. IN MY CASE, THEY WERE 2. A MARRIED COUPLE

WELCOME TO THIS WEEK-END OF FAMILY CONSTELLATION

WHAT AM I DOING HERE?

AT LEAST, IT'S WARM

BLANKETS AND PILLOWS

OUTSIDE SNOW STARTED TO FALL. IT WAS REALLY COLD AND MY BIRTHDAY WAS RIGHT AROUND THE CORNER.

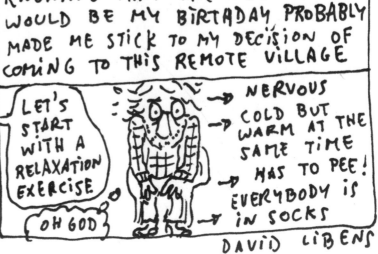

KNOWING THAT THE NEXT DAY WOULD BE MY BIRTHDAY PROBABLY MADE ME STICK TO MY DECISION OF COMING TO THIS REMOTE VILLAGE

LET'S START WITH A RELAXATION EXERCISE

OH GOD

→ NERVOUS
→ COLD BUT WARM AT THE SAME TIME
→ HAS TO PEE!
→ EVERYBODY IS IN SOCKS

DAVID LIBENS

14 JUILLET

3 NOV. 2008

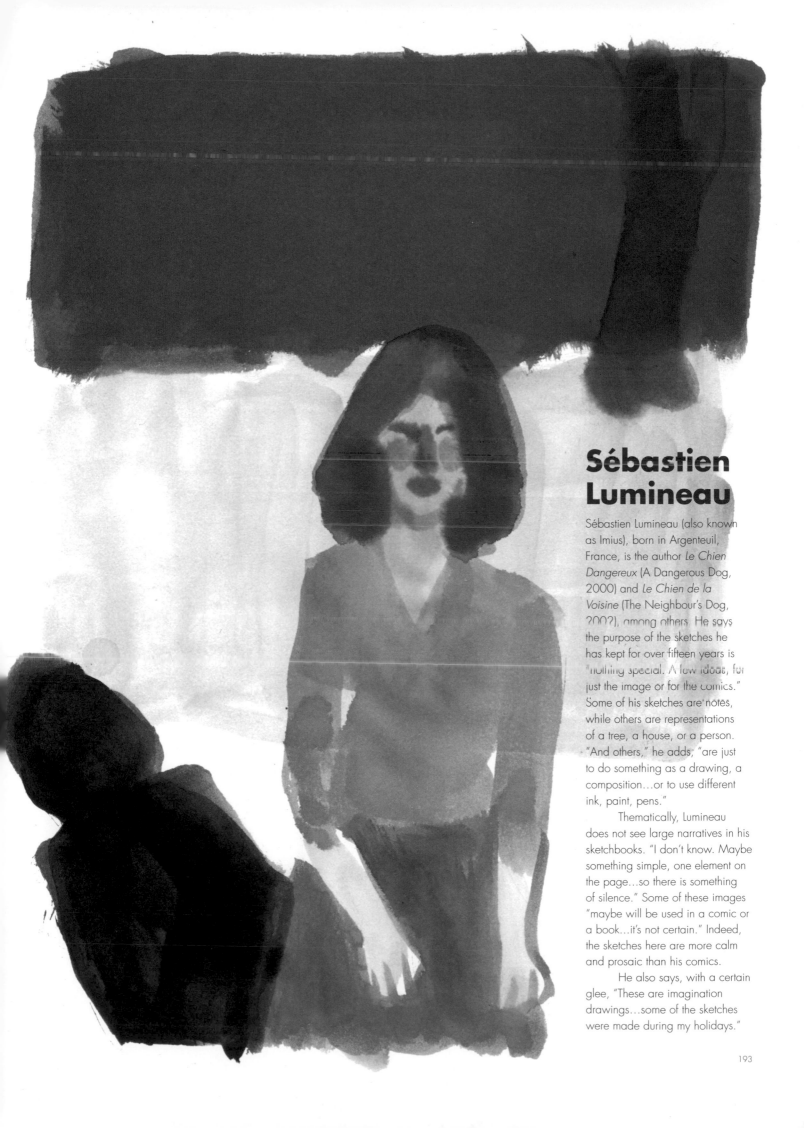

Sébastien Lumineau

Sébastien Lumineau (also known as Imius), born in Argenteuil, France, is the author *Le Chien Dangereux* (A Dangerous Dog, 2000) and *Le Chien de la Voisine* (The Neighbour's Dog, 2002), among others. He says the purpose of the sketches he has kept for over fifteen years is "nothing special. A few ideas, for just the image or for the comics." Some of his sketches are notes, while others are representations of a tree, a house, or a person. "And others," he adds, "are just to do something as a drawing, a composition…or to use different ink, paint, pens."

Thematically, Lumineau does not see large narratives in his sketchbooks. "I don't know. Maybe something simple, one element on the page…so there is something of silence." Some of these images "maybe will be used in a comic or a book…it's not certain." Indeed, the sketches here are more calm and prosaic than his comics.

He also says, with a certain glee, "These are imagination drawings…some of the sketches were made during my holidays."

193

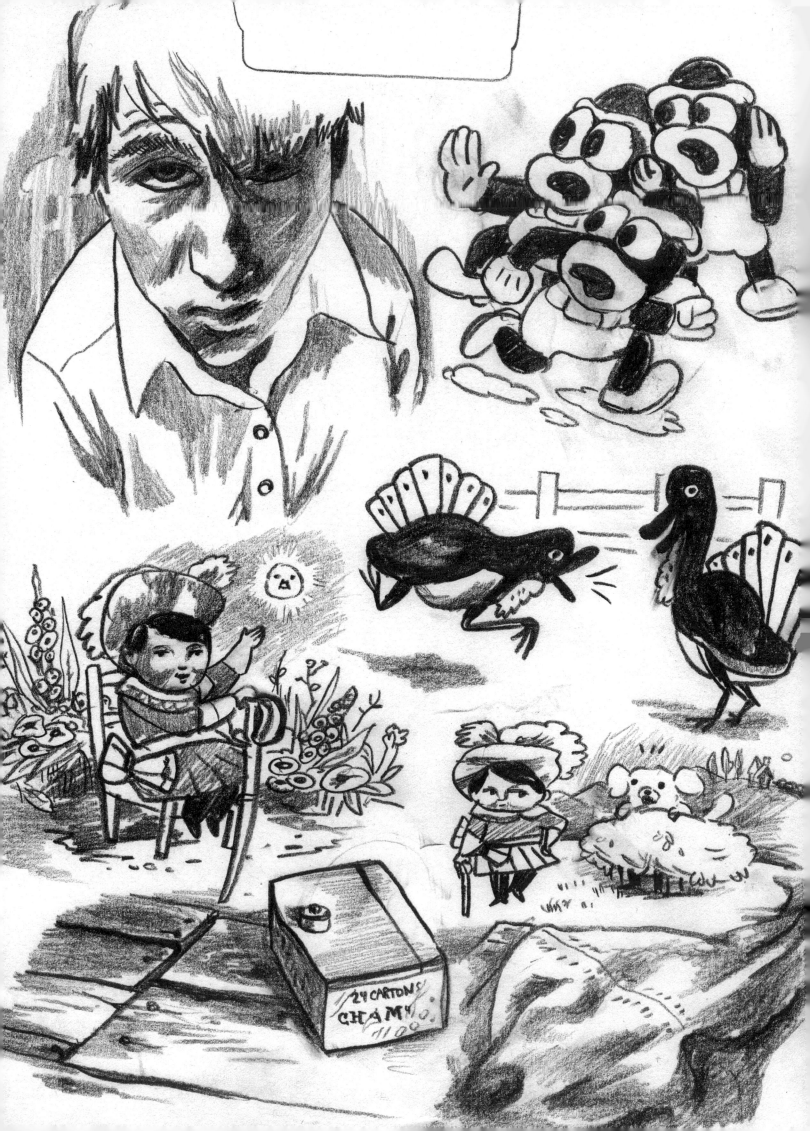

MY HOUSE

Patrick McHale

Animator Patrick McHale, from Galway, New York, insists he is bad at keeping a sketchbook: "I think it's because it feels so permanent. I'm confronted with the bad drawings every time I open it, which makes me eventually rip out the pages and throw them away." Instead, he carries a clipboard with a stack of paper. "That way it feels disposable – I don't worry so much about good drawings. I can also quickly hide pages on the bottom of the stack if anyone comes snooping around," he divulges.

McHale's sketch pages often have a theme: "I'll do a page of hands, or trees. But those are boring. The interesting ones are when I'm brainstorming or working out ideas. Still, even my purposeless musings can have a purpose if I accidentally draw something I really like."

For McHale, the key difference between these and finishes is that "sketches are missing the story – they're missing a perspective. When you make something for an audience, you have to guide them so they're entertained (or inspired, or whatever). My sketches are a jumble of stuff all over the place. It's like a dog without a leash. That's why I don't like to show people my sketches. It's also the reason why it's fun to look at other people's sketchbooks." Sketches also allow him the freedom to do what he does not usually do. He explains, "I don't draw necks very often. I try to, but it always looks weird. I like necks a lot! I just can't draw 'em right. I draw pretty vague hands, too, no matter how much I practice. And for some reason almost everything I draw looks really squishy."

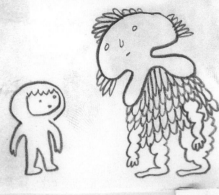
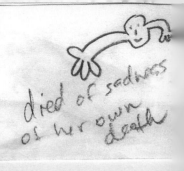

died of sadness of her own death

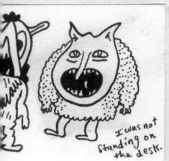

I was not standing on the desk.

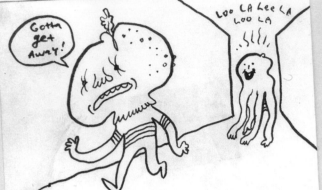

Gotta get away!

Loo La Lee La Loo La

The Darkness shall take you

Love

HATE

I'll touch that.

Johnny little-bit-ago.

Johnny on the fence.

Lady Tucker.

Gregory and Polly wee.

TRUE STORYS FROM LIFE
TRUE STORYS FROM
THE DARK

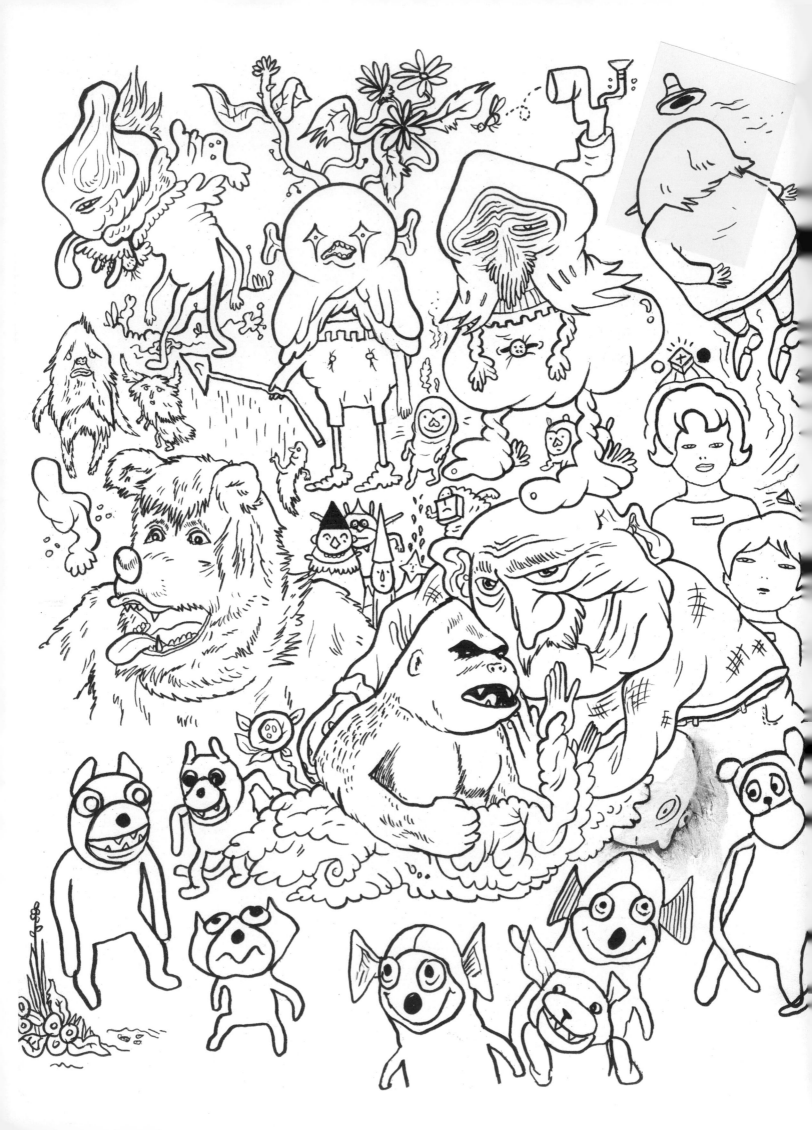

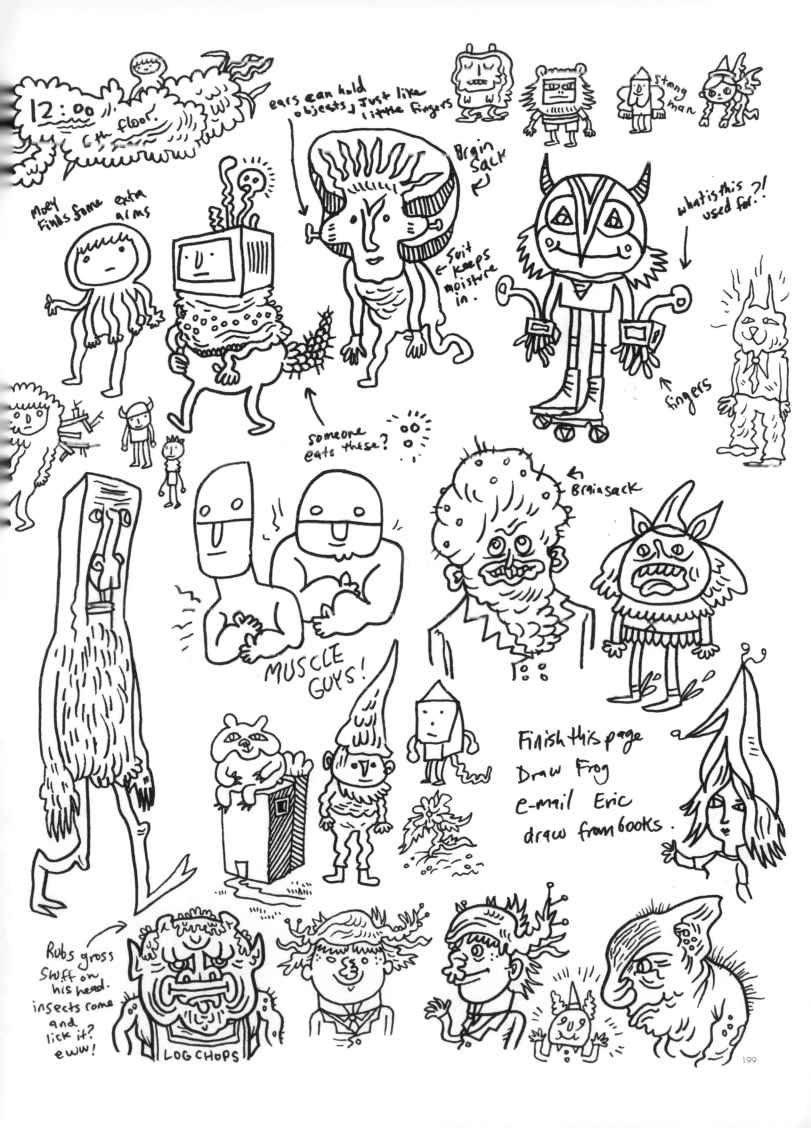

12:00
6th floor.

ears can hold objects just like little fingers

Brain sack

Moey finds some extra arms

Suit keeps moisture in.

what is this used for?!

fingers

someone eats these?

Brainsack

MUSCLE GUYS!

Finish this page
Draw Frog
e-mail Eric
draw from books.

strong man

Rubs gross stuff on his head. insects come and lick it? eww!

LOG CHOPS

Matt Madden

Matt Madden, comics artist and author of *99 Ways to Tell a Story: Exercises in Style* (2005) purports to have over fifty books of various sizes dating back to college, a large percentage of which "I wouldn't care to show anyone."

"The stuff I'm happy with, or find useful, or learned from falls in a number of categories: copying other artists' drawings; trying out different tools and techniques; studies and notes for comics; doodles (though a lot less than most people, I find); life sketches from around NYC and from my travels; abstract studies, and so on," he reveals.

Of the images shown here, there are "a few examples of drawings done in preparation for my comic *The Six Treasures of the Spiral* [this page and opposite]. I was practicing the nib drawing style as well as how to draw a whirlpool. When I'm working on a comic I'll try to do a warm-up drawing to get in the mood, and this [p. 202] is from a sketchbook I dedicated to that purpose a few years ago. And, recently, I've made a habit of doing thumbnail sketches from memory after seeing movies [p. 203]. It's an exercise in drawing from memory, film criticism, and compositional study that I can do in a café or bar."

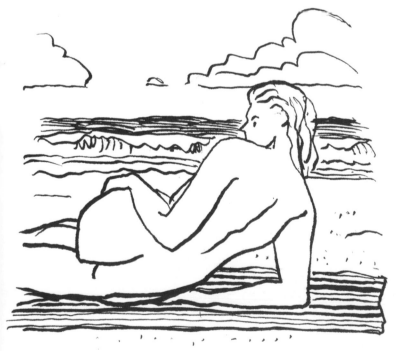

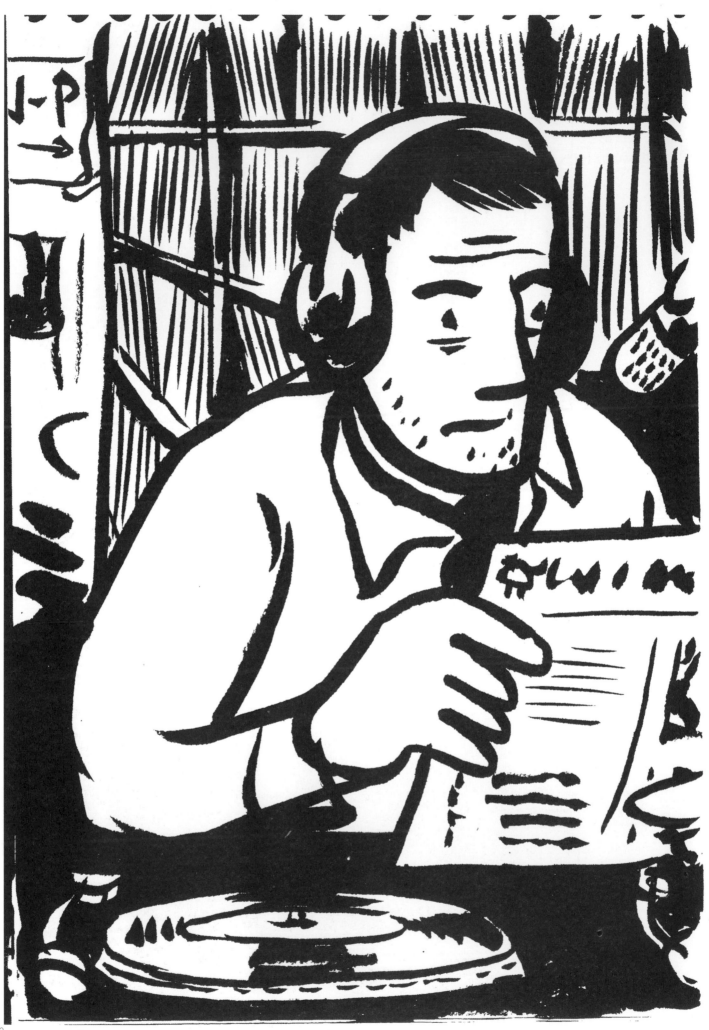

2 stills recalled from Dante v. el Rey del Crimen

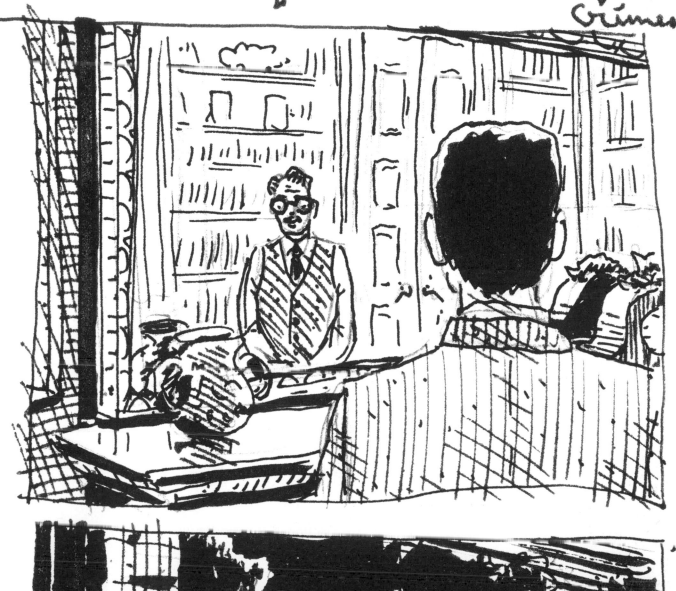

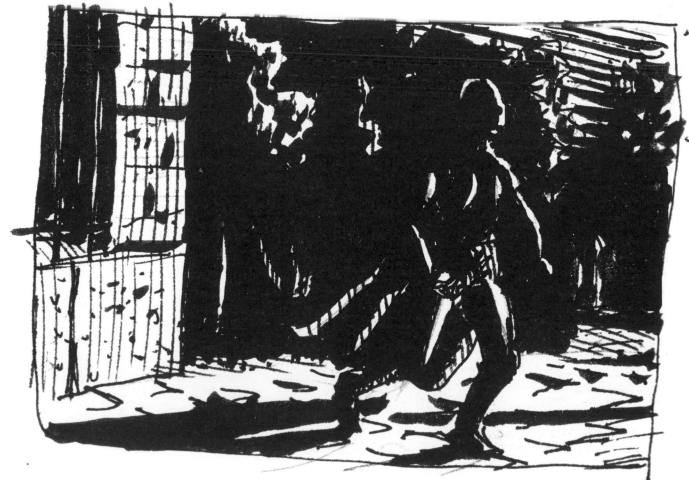

Javier Mariscal

Barcelona-based artist Javier Mariscal claims that he cannot precisely remember when he started keeping sketchbooks, but he hazards a guess: "Maybe 1972–6, when I was twenty-two or twenty-four years old." The comics artist, graphic designer, and interior designer has filled them avidly ever since. A book of his sketches was also published in 2010.

"The purpose for me in sketching," he says, "is to try to understand better the world that is around me, to amuse myself, to enjoy watching and observing; and to draw. The sketches often come from drawing

something you like and that you have in front of you; occasionally these sketches are for a specific piece of work.". Mariscal's work in general already appears instinctive and unfettered, but he says about sketching, "These are automatic drawings, immediates – I don't think about them, I only draw them."

As for the books themselves, represented here by excerpts from the 1970s through the 1990s, he comments, "Some of my books are unfinished. I start, but sometimes these just end up as blank pages."

205

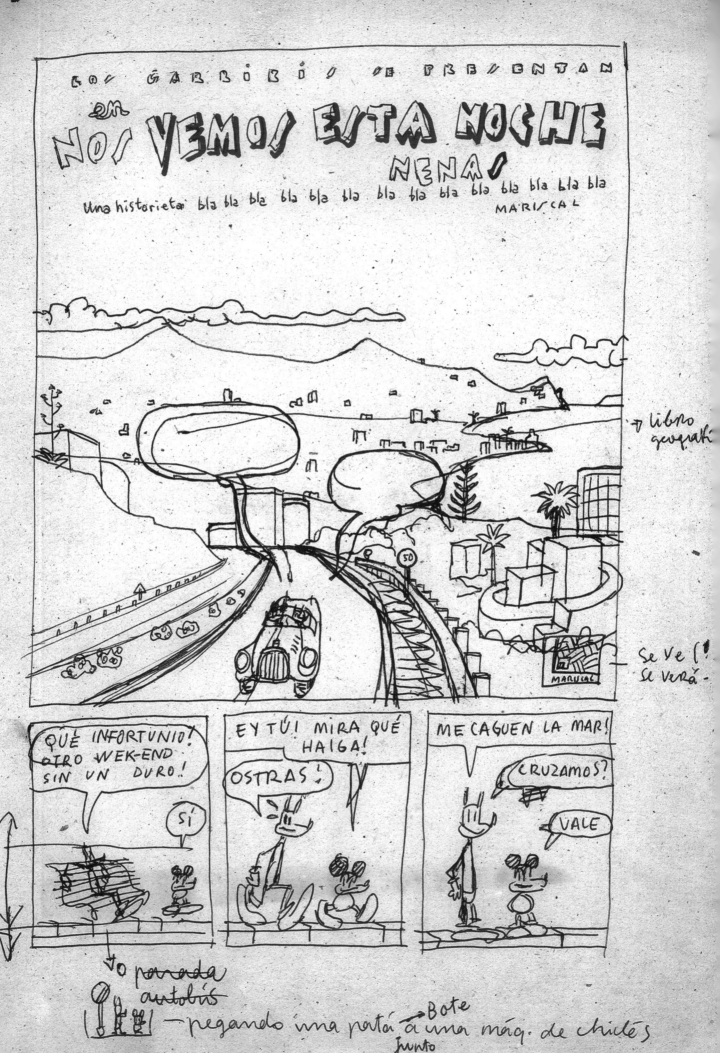

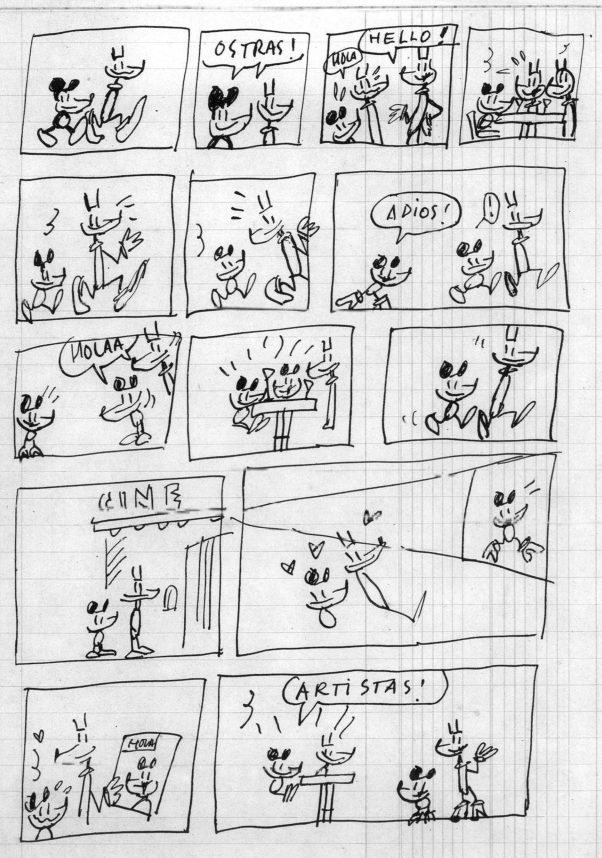

1

2

Insects develop by metamorphosis — that is they have different forms during their life cycle. In the grasshopper it is gradual. An egg hatches into a nymph [1] which molts several times [2] before adulthood [3].

Lubber grasshopper

3

grasshopper

harvester ant

Tiger Beetle

David Mazzucchelli

Prolific comics artist David Mazzucchelli makes reams of sketches for any project he is working on, "although, especially in the early stages, the sketches may not seem to have much to do with the project at hand. I tend to work more on loose sheets than in books, because I always have so much 'scrap' paper around, and drawing on it makes the piles smaller," he admits.

Usually he sketches to try to visualize a vague idea or test out a composition or arrangement, "but sometimes I'll start making marks and see what that leads to," he explains. "My sketching is a kind of thinking on paper, and often displays more a sense of play and

abstraction than may be evident in my finished work, which ends up employing some of the results of this wandering and exploring on the page."

The images opposite, from 2002–7, "are sketches directly related to [the 2009 graphic novel] *Asterios Polyp*, some working out a specific idea or image, some just loosening up." The images on this page were done earlier: "The insects came about from me spending more and more time looking at trees and grass and various creatures, and getting kind of excited about nature in general," he says.

Rutu Modan

Tel Aviv-born Rutu Modan, who has drawn comic strips for the Israeli newspapers *Yedioth Ahronoth* and *Maariv* and authored the graphic novel *Exit Wounds* (2007), has kept all her sketchbooks since she started at Bezalel Academy of Arts and Design in Jerusalem twenty-two years ago.

Modan's sketchbooks "are for everything I do," she declares, adding, "I do not have a separate planner. In the sketchbook I sketch, I write meetings, phone numbers, grocery lists, ideas for stories and quote from strangers I eavesdropped on the bus."

The books are for finishes as well as jotting: "Sometimes, if it is a sketchbook with the right kind of paper, it can be for finals as well."

These sketches span 2003–8. A few were done simply as doodles, others while working on *Exit Wounds*. About her deeply emotional book she notes: "I wrote what I thought might generally be the main theme." *Exit Wounds* tells the story of Koby Franco, a Tel Aviv cabbie in his twenties. Franco's life is critically altered when a female Israeli soldier tells him his estranged father was killed by a suicide bomber at a train station. It appears the soldier was having an affair with Franco's father, so together they try to find out if he is dead or alive.

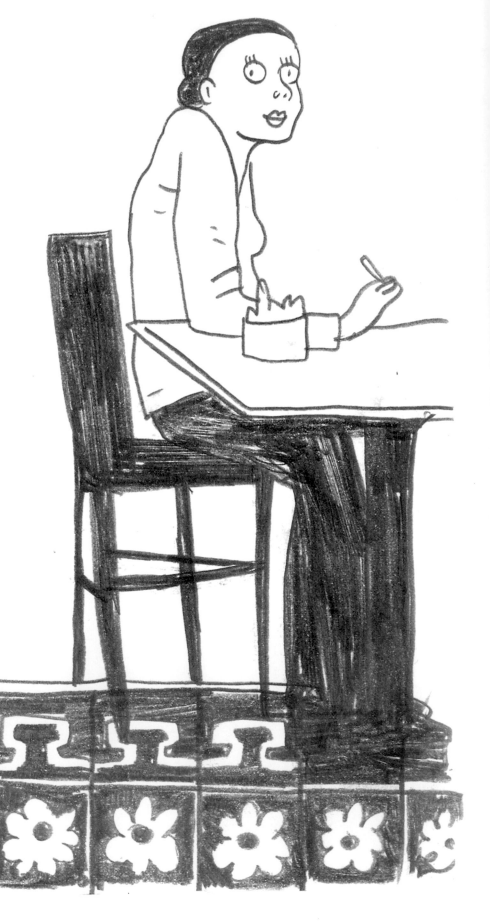

ISHAIMISHORY@yahoo.com

WE LL BE

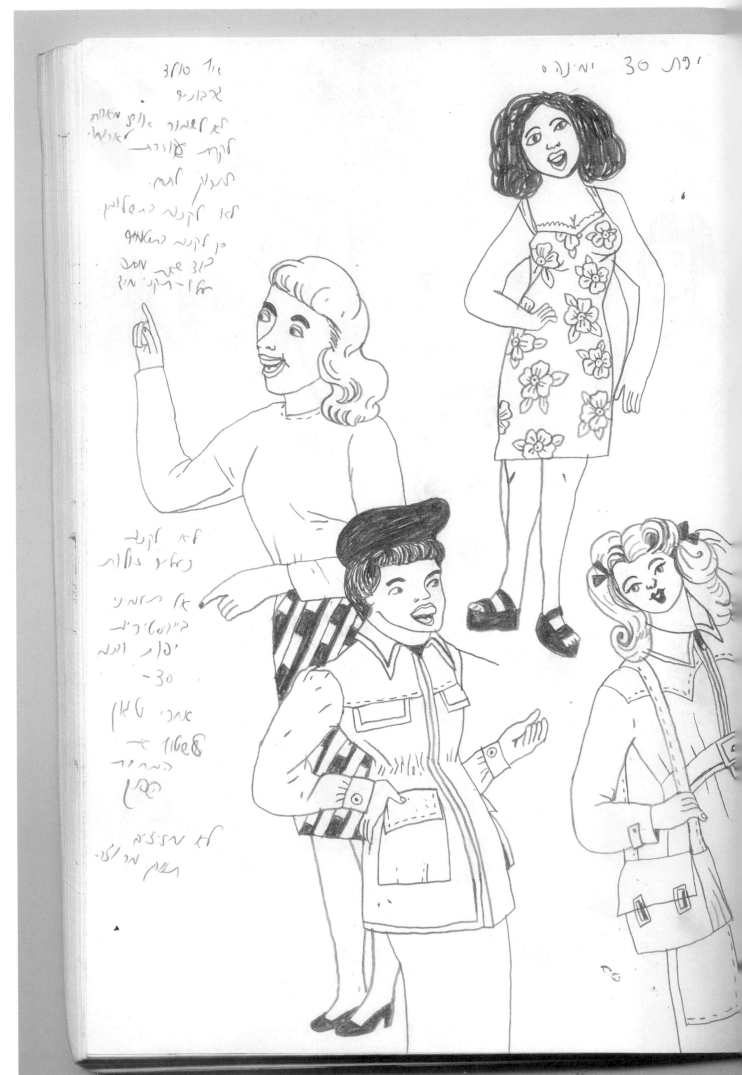

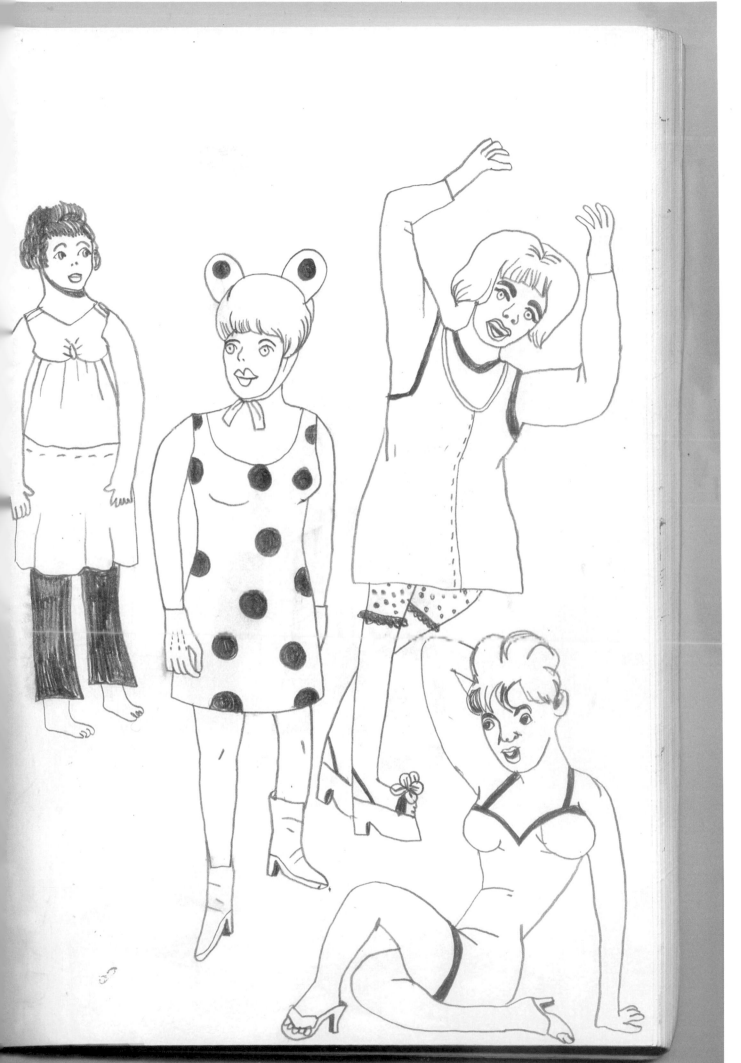

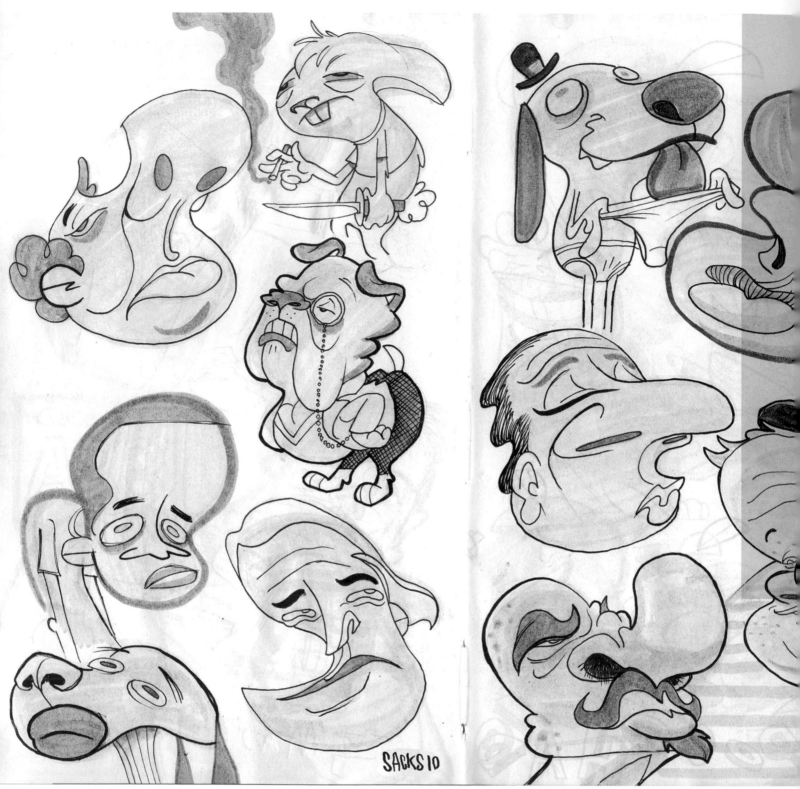

Saxton Moore

Virginian animator and illustrator Saxton Moore says he bought his first sketchbook in his senior year in high school: "I think I have, like, twelve now. I never finish up a book before moving on to another. For some reason my first instinct is to grab whatever is closest to me, be that sticky note, flyer, and so on. I usually cut and paste them into my books later."

Moore's sketchbooks are used, he announces, "mostly for bringing the characters in my head to life. I have an idea of what they look like, so I try a few variations in my sketches and then put them in different poses to find out more about their personality. Nowadays, I scan my sketches or photograph them on my webcam to fine-tune them in Photoshop or Illustrator. Nearly all of my sketches have a purpose."

Moore's books have a distinct personality because, among other things, "I like using random shapes, then drawing a character subject into them, if that makes any sense. If my character is a cat, for example, I use a light-colored marker to make random and awkward cat-like shapes. I then design as many different cat characters into those shapes as I can. That process is always the fun part, because it challenges me. It's like a puzzle or a game. Once I see a few that stand out, I take them to finish on the computer. Someone once told me that the first thing you sketch out is usually the best, because it's the first image that stems from your brain. It may not be the final, but the first image has the most soul in it," he suggests.

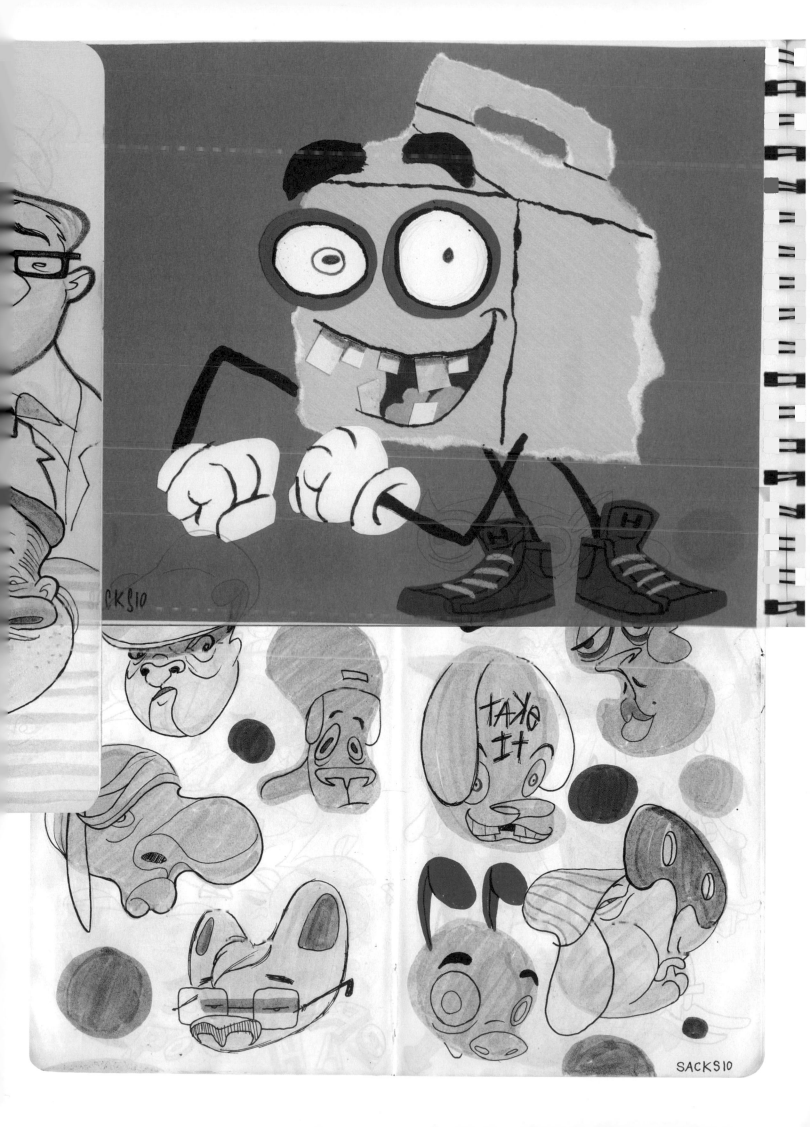

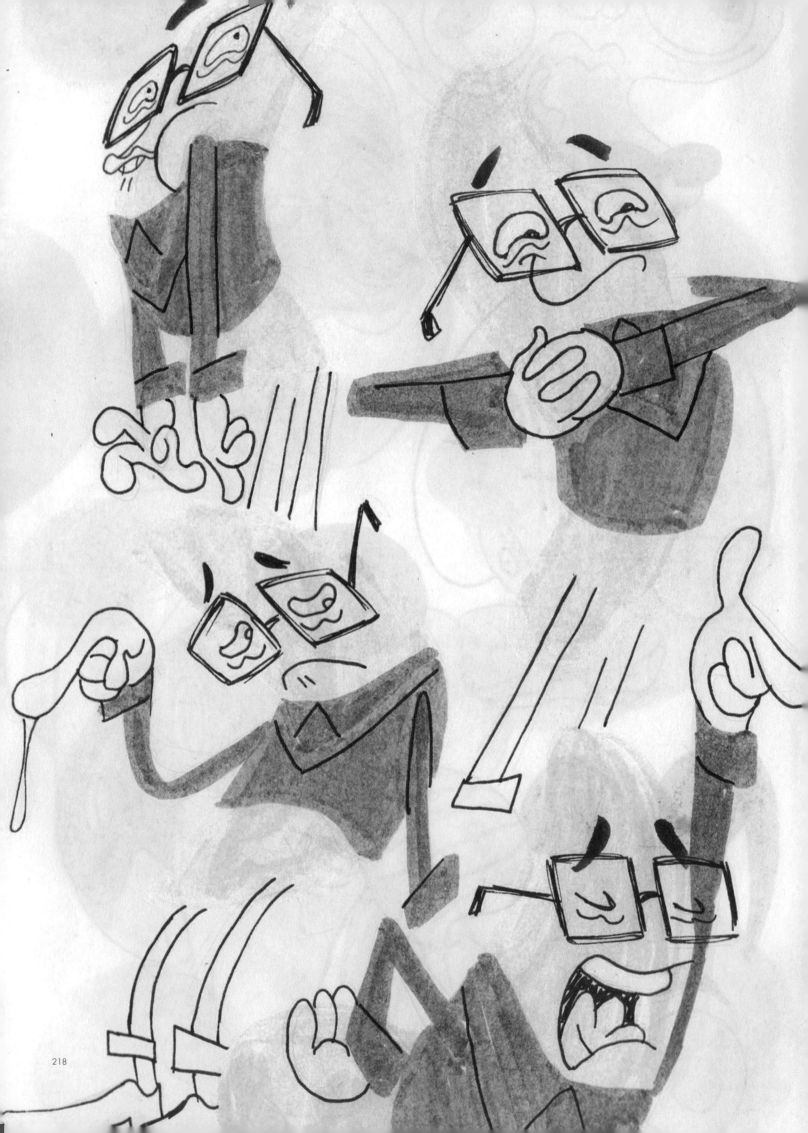

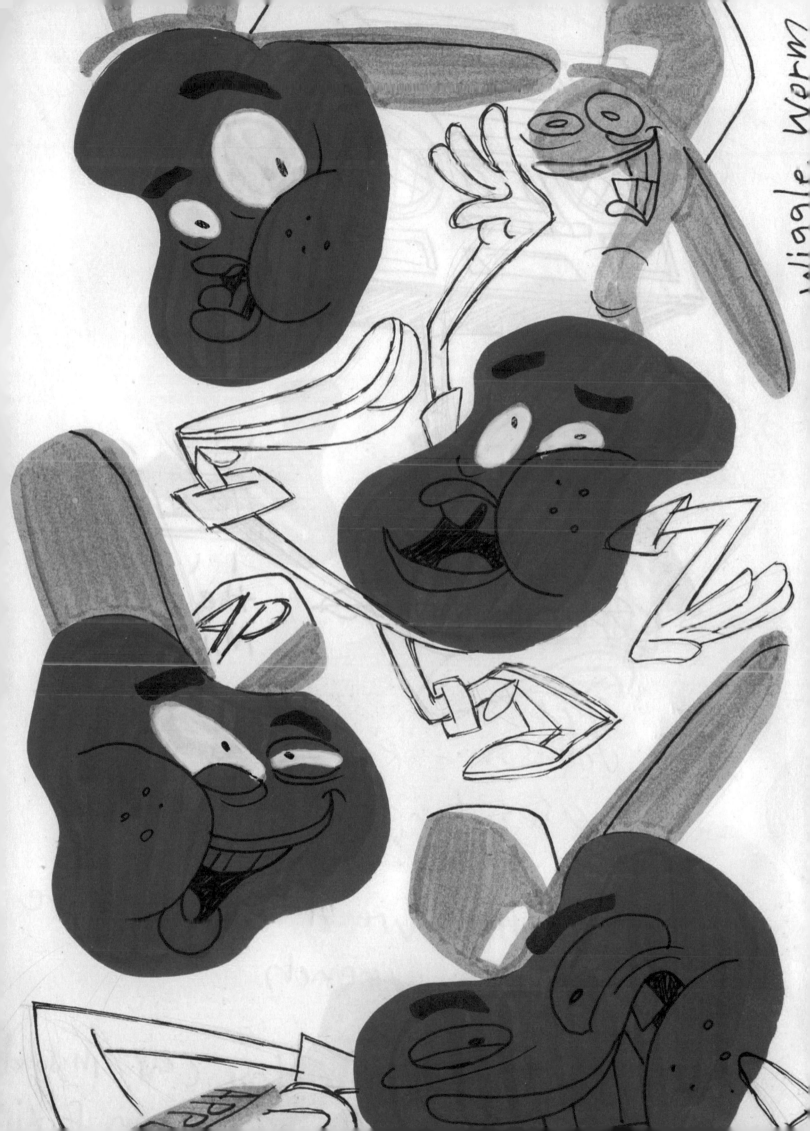

Wiggle Worm

Victor Moscoso

Victor Moscoso is best known for his psychedelic posters, which did for graphic design what bands like the Grateful Dead, Jefferson Airplane, and Big Brother and the Holding Company did for rock music: they turned up the juice, unlocked inhibitions, and broke all the rules.

Spanish-born, Brooklyn-raised Moscoso stumbled into this milieu, yet became a contributing force in this distinctly American design genre, characterized by illegible typefaces, vibrating colors, and antique illustrations. But what he must truly be known for is the painstaking precision that made these timely works so timeless. This same sensibility – indeed, his responsibility to his art – is what makes his kinetic comics so enduring. Much of the same energy that is evidenced in his posters comes through in comics created for *Zap*, which he co-founded 1968, and is vividly clear in the sketches here.

As in the works of Leonardo Da Vinci, every sketch is a "cartoon" or fragment for Moscoso's own Sistine Chapels. Each contains the detail in various evolutionary stages that will ultimately evolve into the finished piece. And yet Moscoso was a reluctant comics artist, believing that his posters had staying power and comics were too ephemeral. He once said: "These things should have gone by the wayside a long time ago, by all logical standards. But there are people who still read this crap! Not bad for a piece of trash. Really."

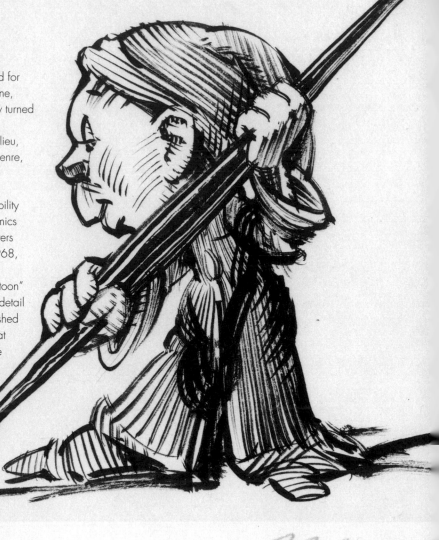

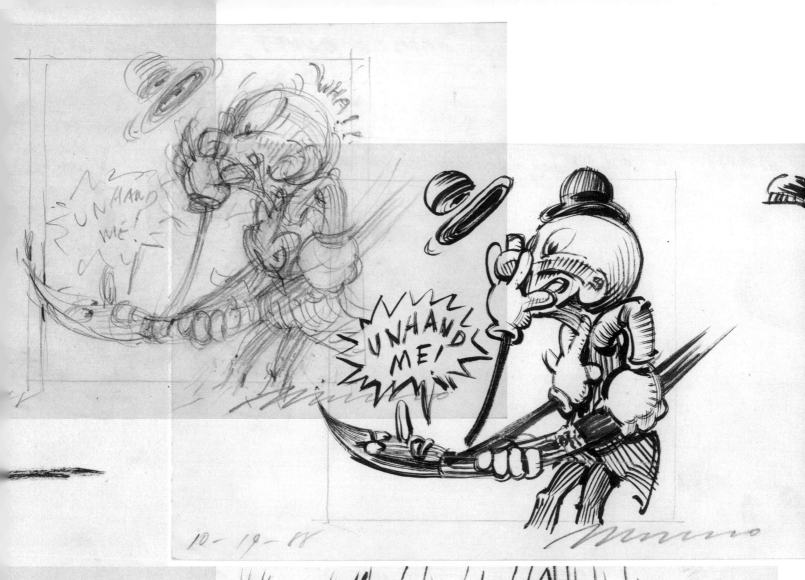

10-19-88

10-26-88

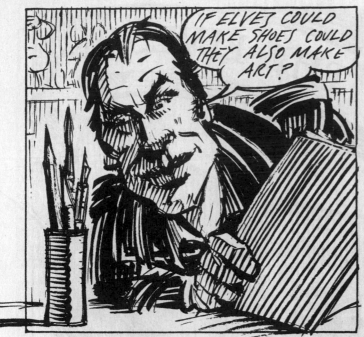

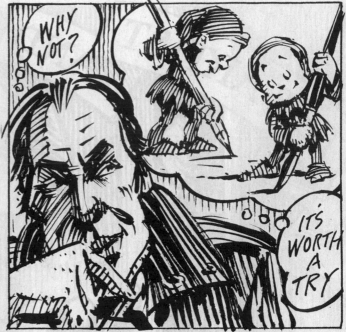

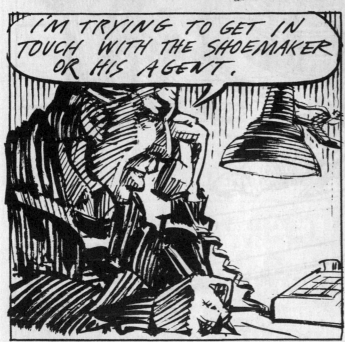

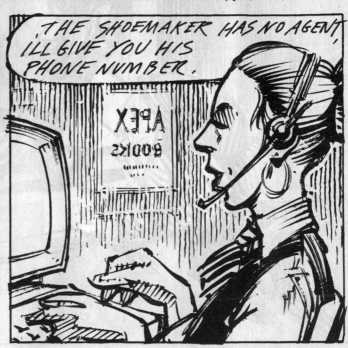

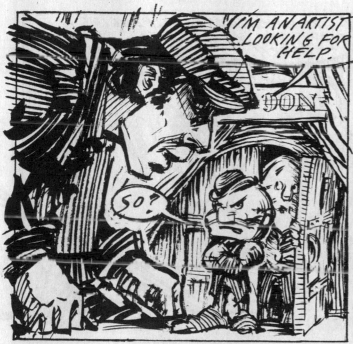

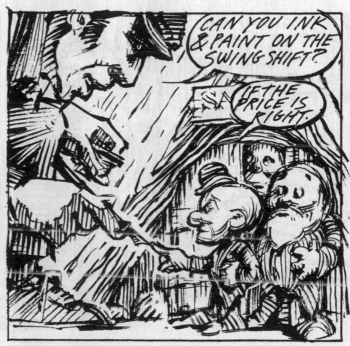

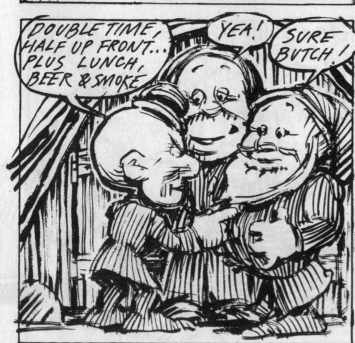

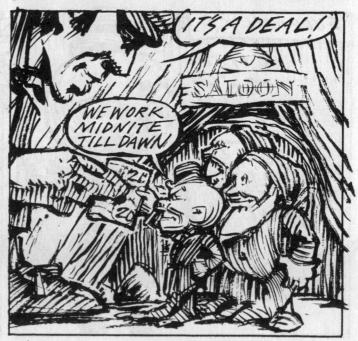

223

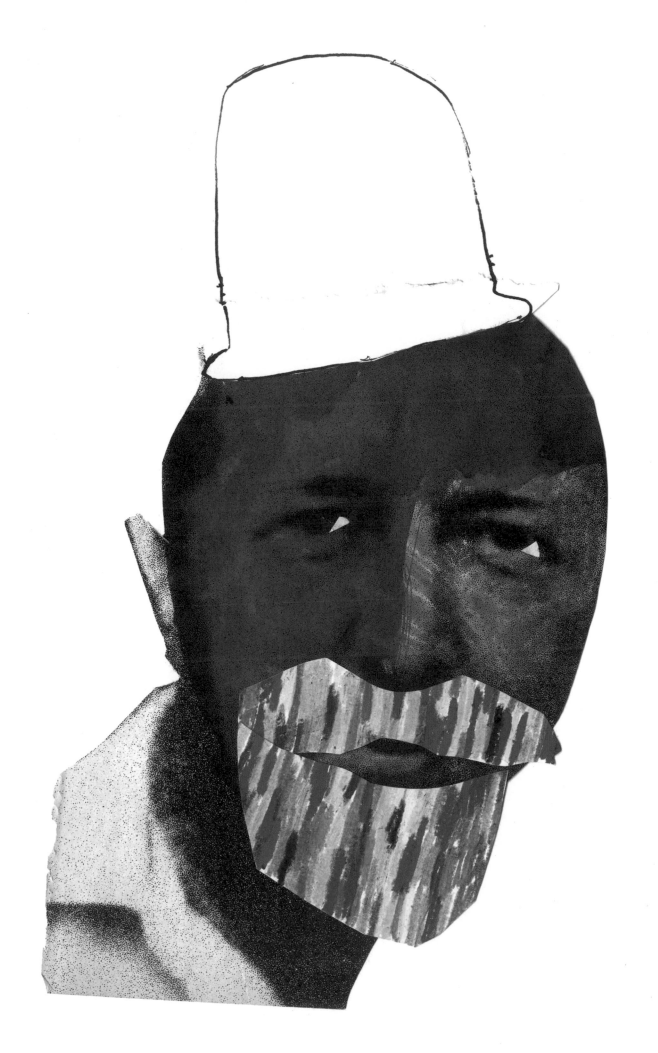

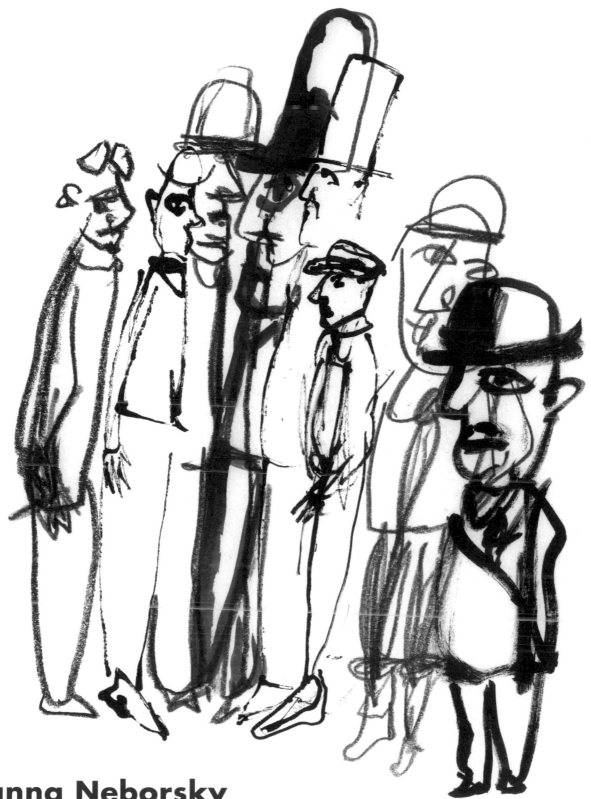

Joanna Neborsky

"I've been doodling in the margins since junior high, when record levels of boredom were observed in the children of suburban San Diego," quips Brooklyn-based illustrator and author Joanna Neborsky. "Eighty-seven percent of my early work was scrawled on the back of French homework. I made do with scraps of paper, and when those ran out, the backs of those scraps of paper. Still do."

Neborsky claims she finds aimless mark-making the only way to begin work. "Rarely does a crystalline vision guide me to my studio desk; usually it's a combination of guilt, restlessness, and Internet fatigue," she confesses. "You start to drag materials across the page to wake up the fogged brain and remind yourself how to illustrate. The illustrator Marshall

Arisman says that when you begin to make something, you start out deep in ego (thinking, 'What Will They Think?,' or the always problematic 'Look, I'm a Genius') until you discover yourself in that rarer state of unselfconscious creation. Then it's just gravy." Neborsky anticipates that her sketches will contain the germ of a final, "but sometimes they're just ugly smears that you try to shield from your studio-mate when he walks by and offers you a snack. Sketching is a kind of purposeful wandering; maybe you light on to one good idea, one pretty pattern, one smart line – maybe you don't. Regardless, I save them all. For collage I regularly cannibalize old failed experiments, which makes them less failed." But, she says, "like undergarments, they had hoped never to be seen."

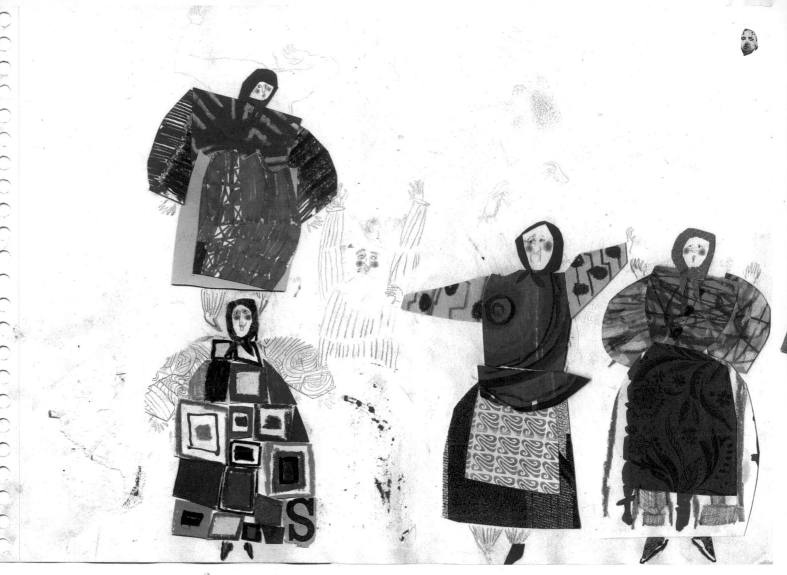

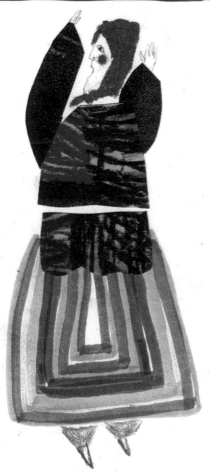

226

229

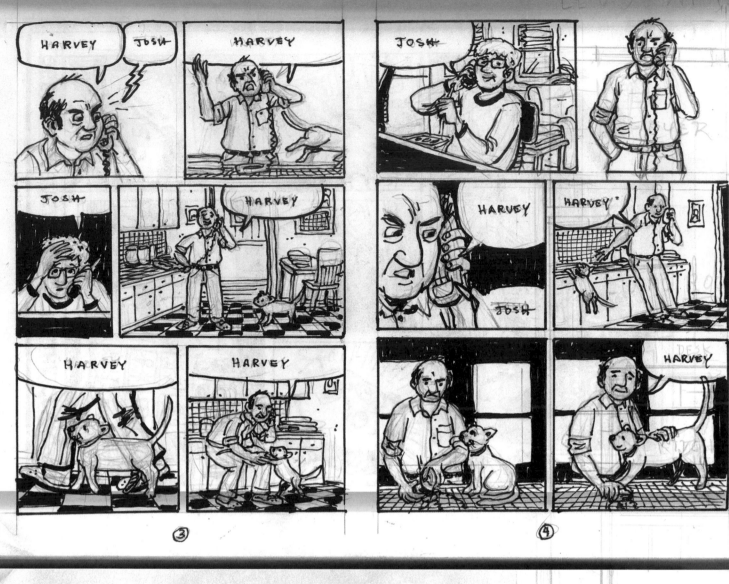

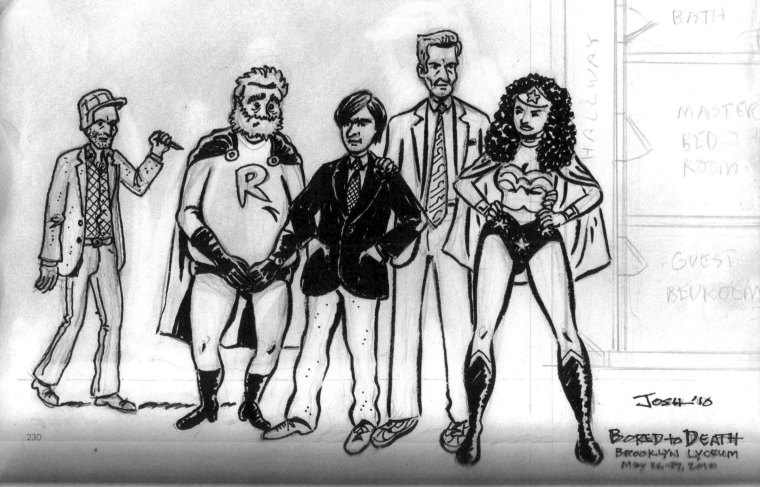

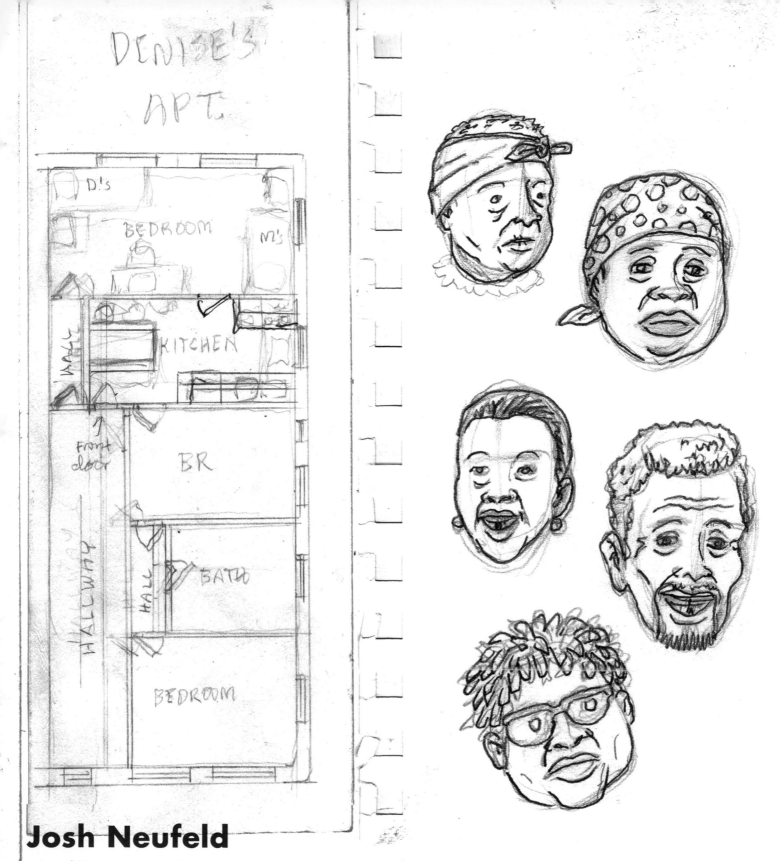

Josh Neufeld

Josh Neufeld, an artist based in Brooklyn, started sketching at New York's Music & Art High School when, he says, "I kept a book to draw character ideas for various superheroes I created, or to do full-color 'pin-ups' of some of my favorite Marvel or DC heroes. My friends and I would also trade and draw in each other's books – they were ways of having samples of each other's work for posterity."

He also kept a sketchbook at his day job at *The Nation* magazine, "just to keep my skills fresh. That was the first time I really used it for doodling and sketching," he continues, "and as a record of the world around me. I was losing interest in superhero comics and was casting about for another way to express my artistic impulses."

Later, Neufeld embarked on a round-the-world backpacking trip. "Upon returning to the States," he recalls, "my girlfriend and I ended up in Chicago, where I got hooked into the cartooning scene. I happened to get to know Chris Ware, and he gave me a very useful bit of advice. He recommended that I use my sketchbook to write and draw open-ended comics stories, to just go ahead with Panel One and see where it led me." Nowadays, Neufeld's sketches are highly directed, either character studies or thumbnail layouts for scripts: "I still use my sketchbook to work out concepts, such as the floor plans I drew up for characters in my book *A.D.: New Orleans After the Deluge* [2009] to understand how the different scenes, taking place in different rooms, connected to each other."

SKRITCH
SKRITCH

SKR

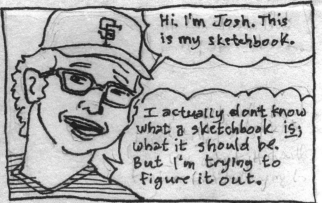

Hi. I'm Josh. This is my sketchbook.

I actually don't know what a sketchbook is; what it should be. But I'm trying to figure it out.

"I mean, should it just be full of sketches...?"

"or should it be more of a journal?"

"My Friend Dean thinks a sketchbook is:"

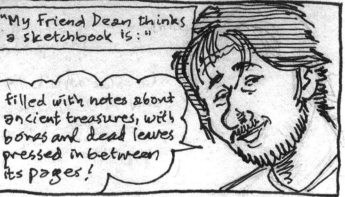

filled with notes about ancient treasures, with bones and dead leaves pressed in between its pages!

The comic book artists' sketchbooks I've seen are always full of perfect little drawings, not like sketches at all.

That's very intimidating for me, because I've always been terrible at cute little "gesture" drawings, caricatures and other quickie drawings...

≥sigh≤

That's it, though! I want this sketchbook to be a comics' book, like a comics notebook, where I can write down ideas, observations, experiment, practice layouts and so on!

And it can still be a regular sketchbook — for sketching!

I'm glad that's been sorted out!

Now if you'll excuse me...

SKRITCH

Josh 8.8.54

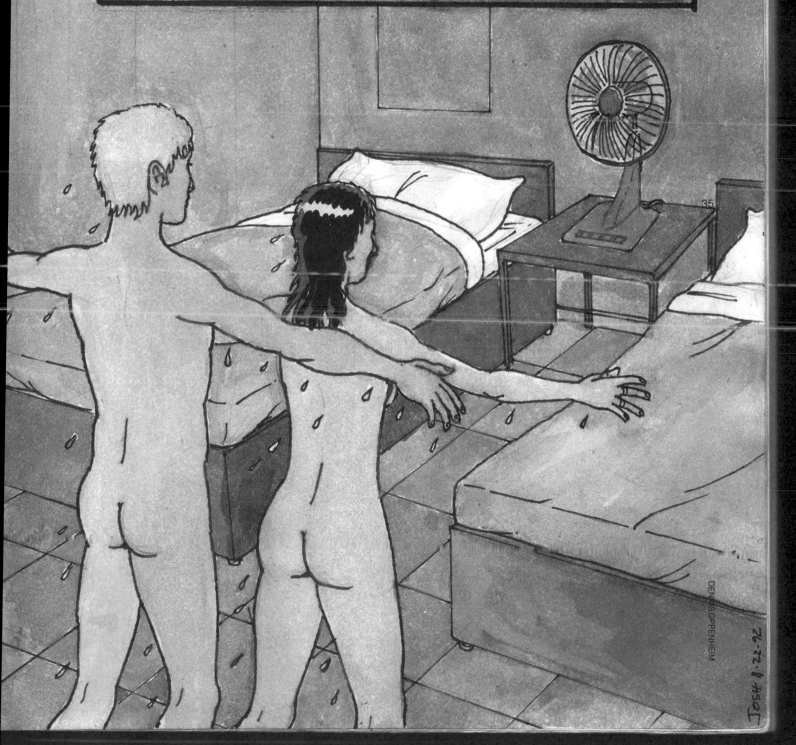

"They kept stealing all my million dollar ideas, so I just stopped having them."

Mark Newgarden

"I've been decorating loose sheets of typing paper with my scribbles since early childhood, but I keep proper sketchbooks rarely, and only under duress," admits Mark Newgarden. "I guess I was taught at an early age never to draw in books. Maintaining a sketchbook feels like too much pressure. And sort of precious. I like the ease and disposability of loose sheets." Newgarden's sketches are generally a lot more reckless than the final result: "It's always been a struggle for me to translate and temper that kind of spontaneity in a finished piece, which generally needs to cover other bases as well. I prefer most artists' roughs as drawings, and finished pieces as ideas – which, I guess, is the opposite of how they traditionally function." He loves novelties and gags, so his thematic focus includes "recombinant cartoon characters, slapstick gestures, funny hats, exploding cigars, half-empty wine bottles, big noses, bird poop."

Shown here are some of "the forty-odd idea sketches I developed for the cover of the (late) Nickelodeon magazine *Comic Book*. These were done quickly in soft colored pencil and just for myself as I tried to work out where I wanted to go." Newgarden also writes scores of gag cartoon captions at a sitting, which he cuts into strips before composing rapid, almost arbitrary sketches to mix and match with the dialogue. As he explains, "At other times my process may be far more deliberate, but I like attacking this particular form from completely different angles. The sad toilet clown is a rejected sketch for a book cover (which shall remain nameless)."

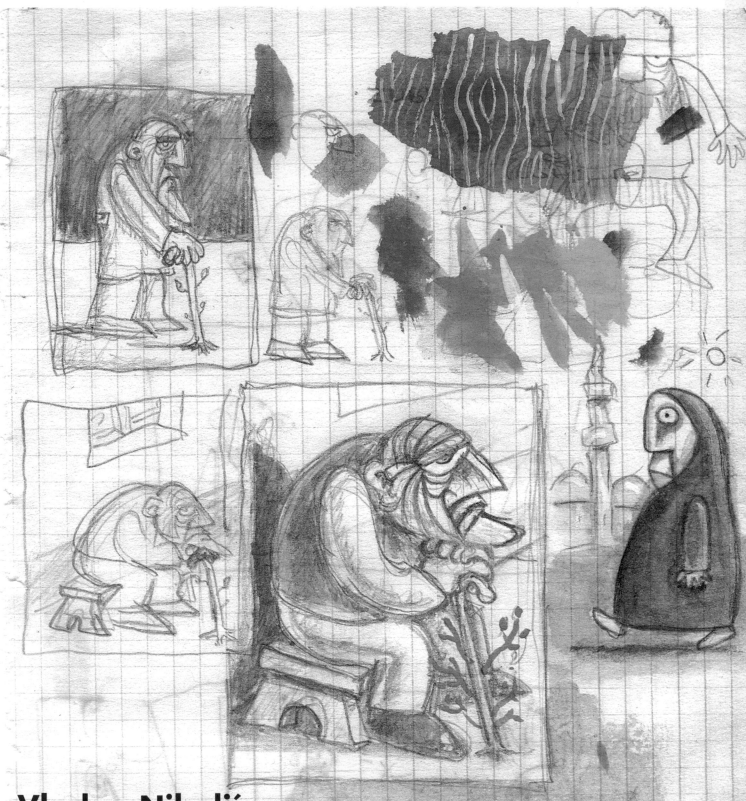

Vladan Nikolić

"My sketches are usually drawn on pieces of paper torn from notebooks or different paper blocks, or even on small pieces that can serve a purpose," Serbian Vladan Nikolić reports. His oldest ones date back twenty years. He does not "have a policy on keeping the sketches," he adds. "It's mostly a matter of circumstances that some of them are left hanging around while others are thrown away right after I finalize my work."

Nonetheless, a sketch is a reminder of an idea. "Mostly it's a rough sketch with few pointers and notes," he volunteers. "Then I move on to layouts and drawing the panels without too much detail but with notes, character sketches, exteriors and interiors." He further notes, "Sketches are mostly preludes to a final work but they could also be doodles. Often

there are drawings on the same pages where I do my sketches that aren't connected directly with the specific work. These are rooted in a spontaneous approach," or, he observes, "incompleteness.... Which may seem the opposite, at a first glance, of my finished work, which technically is minutely drawn."

Nikolić is currently working on comic books for kids, funnies and so-called "alternative" comics with various themes. The sketches here from 2004–9 are mostly preparations for finished work, including character studies and a poster for the "Comics Behind the Iron Curtain" project (opposite). "I would say that these are my thoughts on paper prior to realization," he explains.

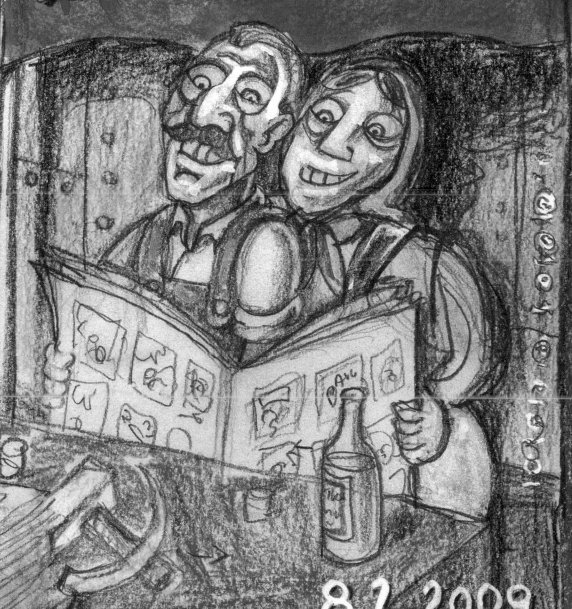

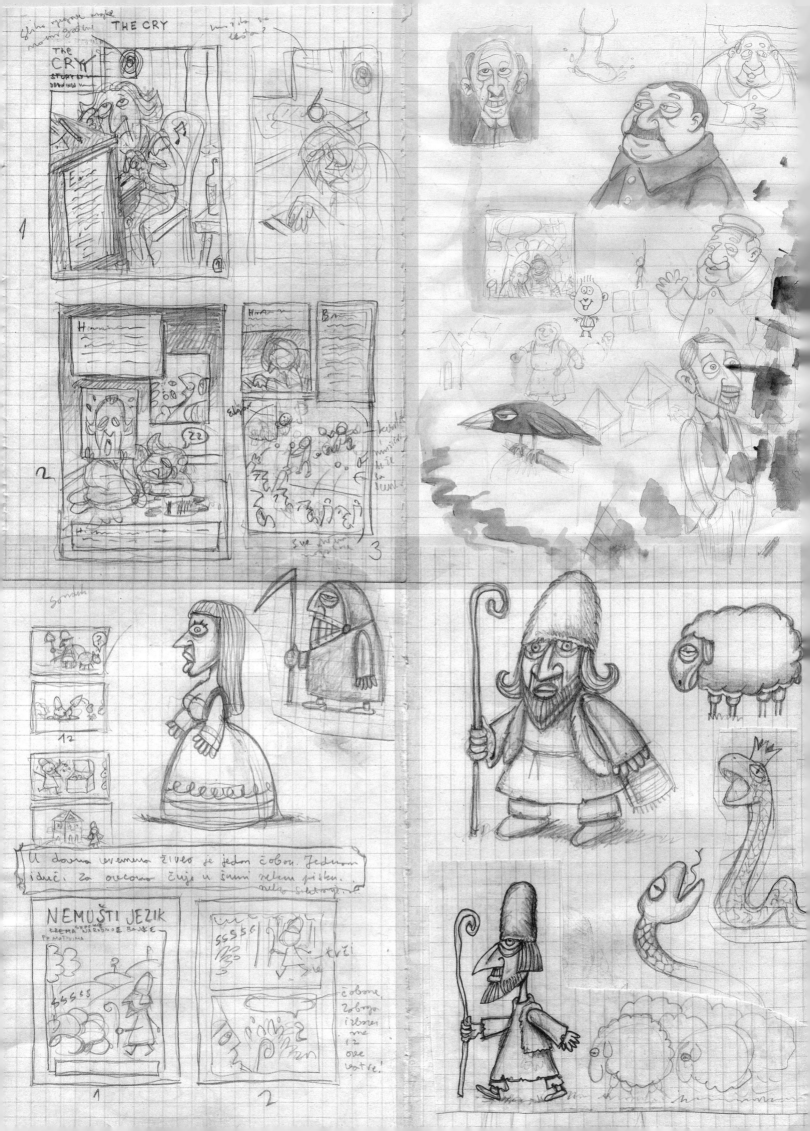

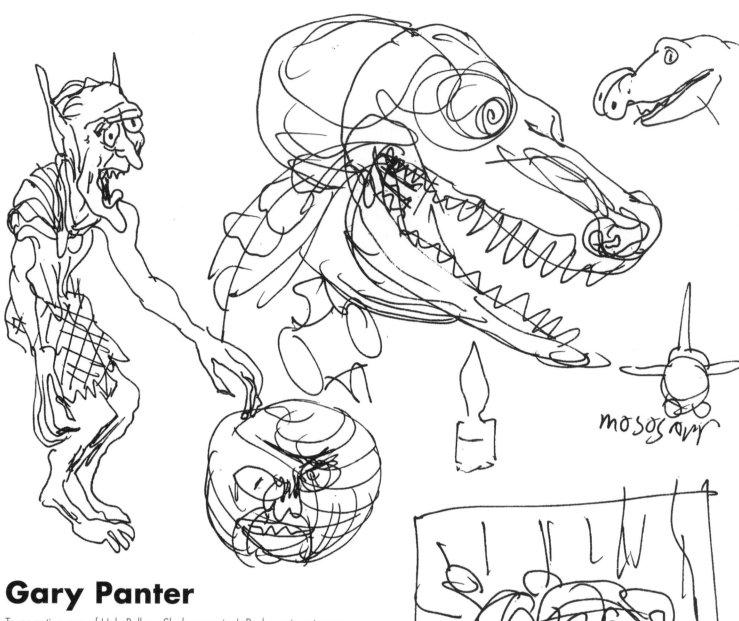

Gary Panter

Texas native, son of Holy Rollers, *Slash* magazine's Punk comics pioneer and creator of the alter-ego Jimbo, Gary Panter started drawing on pads in grade school, "discovered my first empty book in 1969 and have kept sketchbooks since then."

The slow and soothing talker admits the sketches are used "to get images out of my mind and onto paper, where I can have a look at them," adding, "They are a simple thing of themselves, but contain a lot of notes and attempts toward things beyond the sketchbooks." His finished work looks loose but, he insists, "I have drawn and erased it many times before inking. Almost all of my sketchbook work is direct to the page in ink."

The uniquely wonderful thing about sketches, he announces, is that "I am alive to do them and no one stops me." His bountiful sketchbooks serve as receptacles for a slew of Panteresque themes and ideas.

"I have many themes that return and many ongoing projects that I am exploring in the books," he says before listing them. "Some recurrent themes are: Robotic warfare. Compounds or campgrounds. Small building ideas. Silly comic characters that I draw to get going. Song chords. Lists. Thumbnail story attempts. Ideas for paintings. Ideas for sculptures or installations. Type ideas and designs. Drawings of places I visit. And, on a slightly new topic, model-building or prototyping is another sketchbook-like activity.

These images are from one week in 2011.

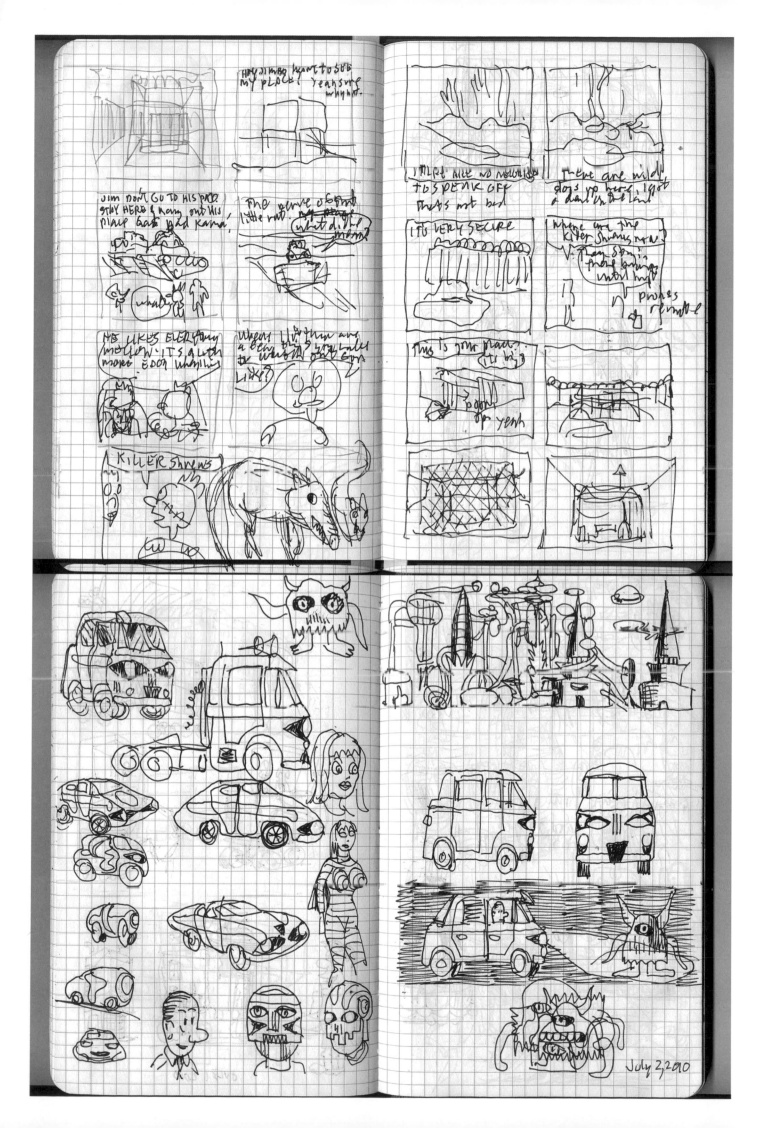

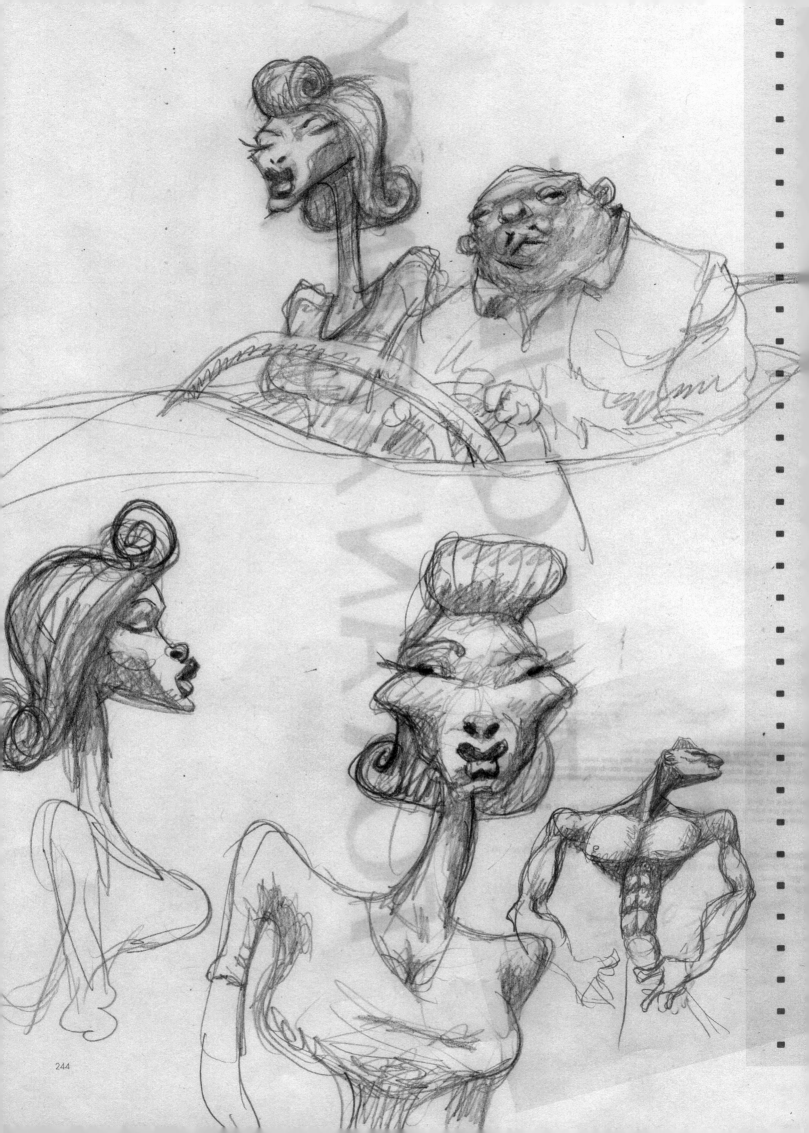

244

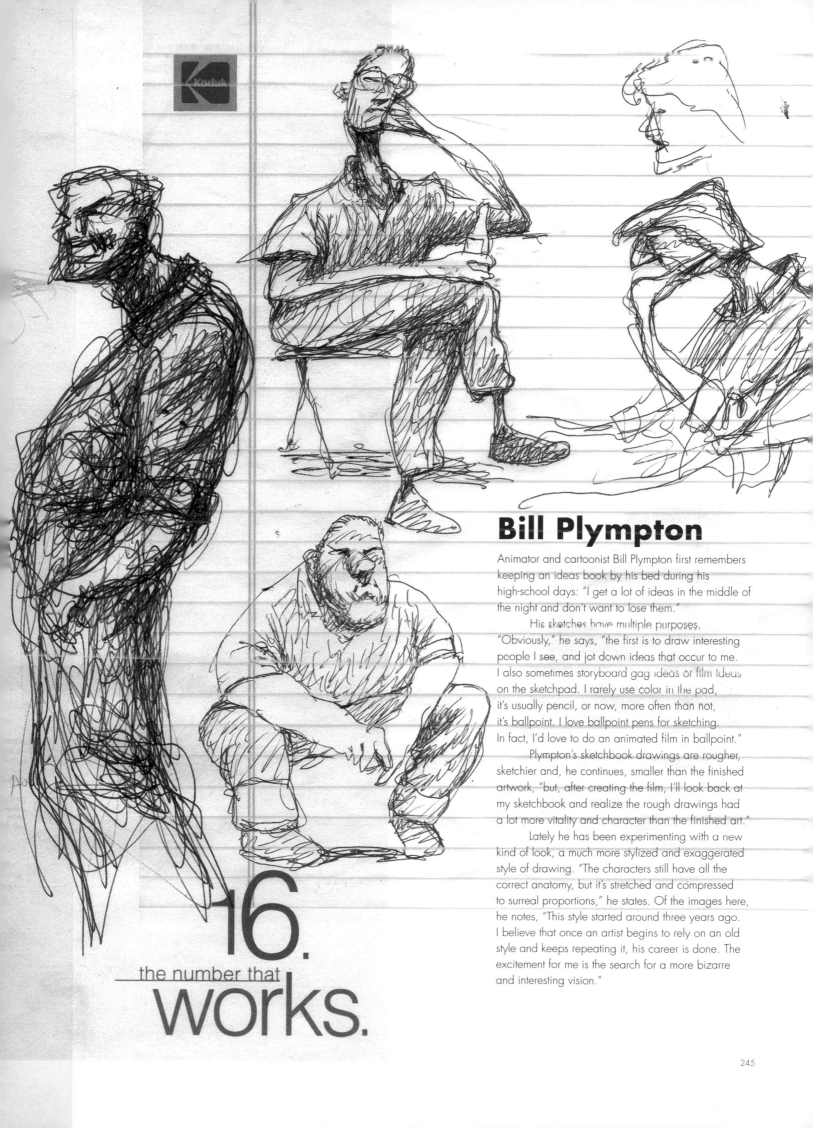

Bill Plympton

Animator and cartoonist Bill Plympton first remembers
keeping an ideas book by his bed during his
high-school days: "I get a lot of ideas in the middle of
the night and don't want to lose them."

His sketches have multiple purposes.
"Obviously," he says, "the first is to draw interesting
people I see, and jot down ideas that occur to me.
I also sometimes storyboard gag ideas or film ideas
on the sketchpad. I rarely use color in the pad,
it's usually pencil, or now, more often than not,
it's ballpoint. I love ballpoint pens for sketching.
In fact, I'd love to do an animated film in ballpoint."

Plympton's sketchbook drawings are rougher,
sketchier and, he continues, smaller than the finished
artwork, "but, after creating the film, I'll look back at
my sketchbook and realize the rough drawings had
a lot more vitality and character than the finished art."

Lately he has been experimenting with a new
kind of look, a much more stylized and exaggerated
style of drawing. "The characters still have all the
correct anatomy, but it's stretched and compressed
to surreal proportions," he states. Of the images here,
he notes, "This style started around three years ago.
I believe that once an artist begins to rely on an old
style and keeps repeating it, his career is done. The
excitement for me is the search for a more bizarre
and interesting vision."

16.
the number that
works.

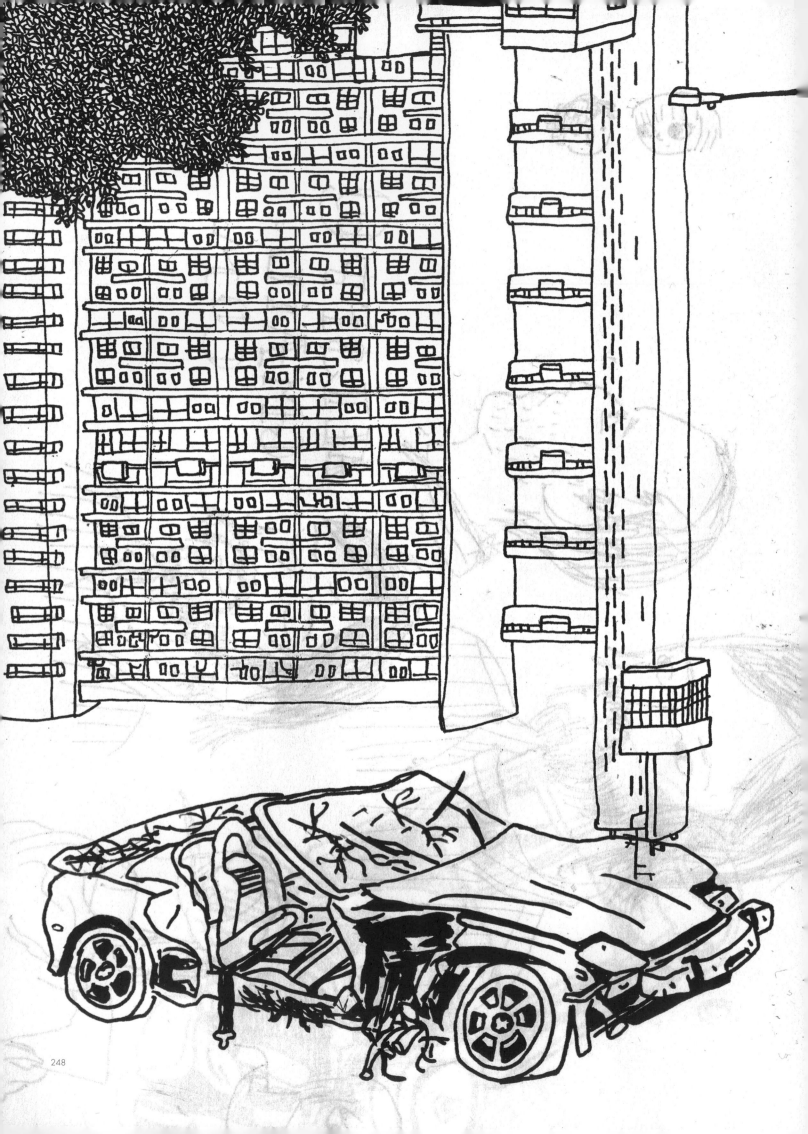

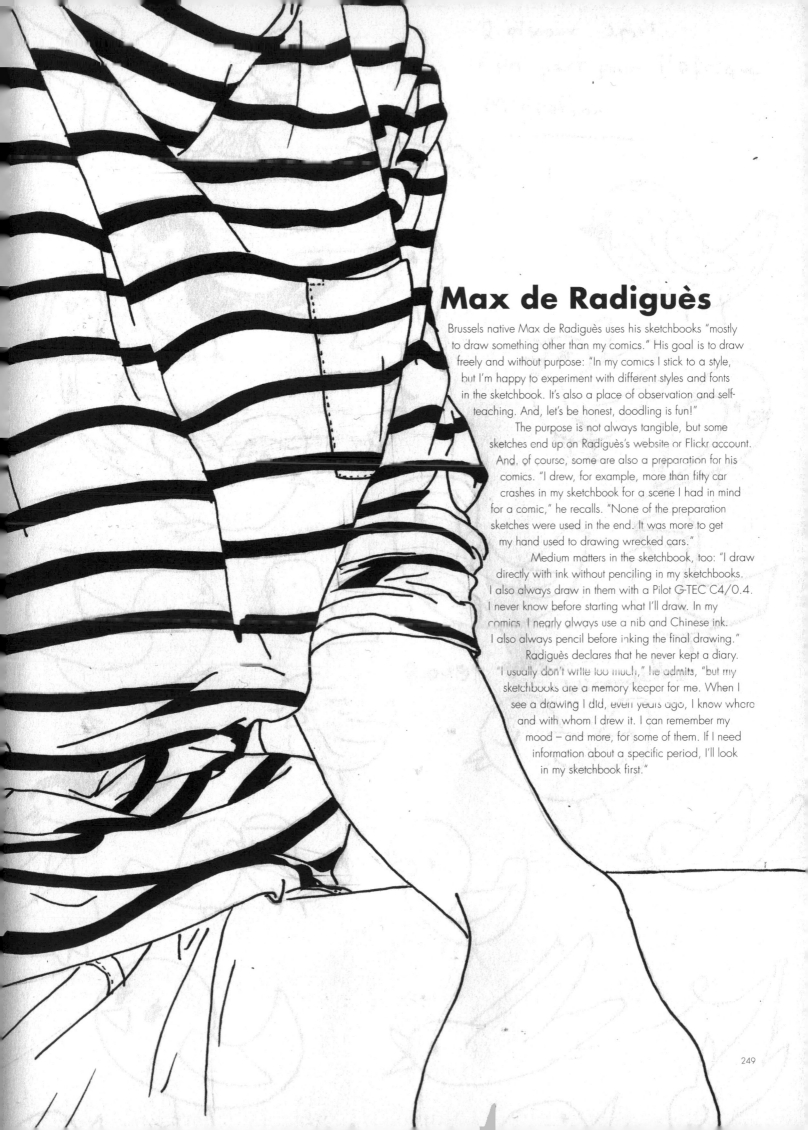

Max de Radiguès

Brussels native Max de Radiguès uses his sketchbooks "mostly to draw something other than my comics." His goal is to draw freely and without purpose: "In my comics I stick to a style, but I'm happy to experiment with different styles and fonts in the sketchbook. It's also a place of observation and self-teaching. And, let's be honest, doodling is fun!"

The purpose is not always tangible, but some sketches end up on Radiguès's website or Flickr account. And, of course, some are also a preparation for his comics. "I drew, for example, more than fifty car crashes in my sketchbook for a scene I had in mind for a comic," he recalls. "None of the preparation sketches were used in the end. It was more to get my hand used to drawing wrecked cars."

Medium matters in the sketchbook, too: "I draw directly with ink without penciling in my sketchbooks. I also always draw in them with a Pilot G-TEC C4/0.4. I never know before starting what I'll draw. In my comics, I nearly always use a nib and Chinese ink. I also always pencil before inking the final drawing."

Radiguès declares that he never kept a diary. "I usually don't write too much," he admits, "but my sketchbooks are a memory keeper for me. When I see a drawing I did, even years ago, I know where and with whom I drew it. I can remember my mood – and more, for some of them. If I need information about a specific period, I'll look in my sketchbook first."

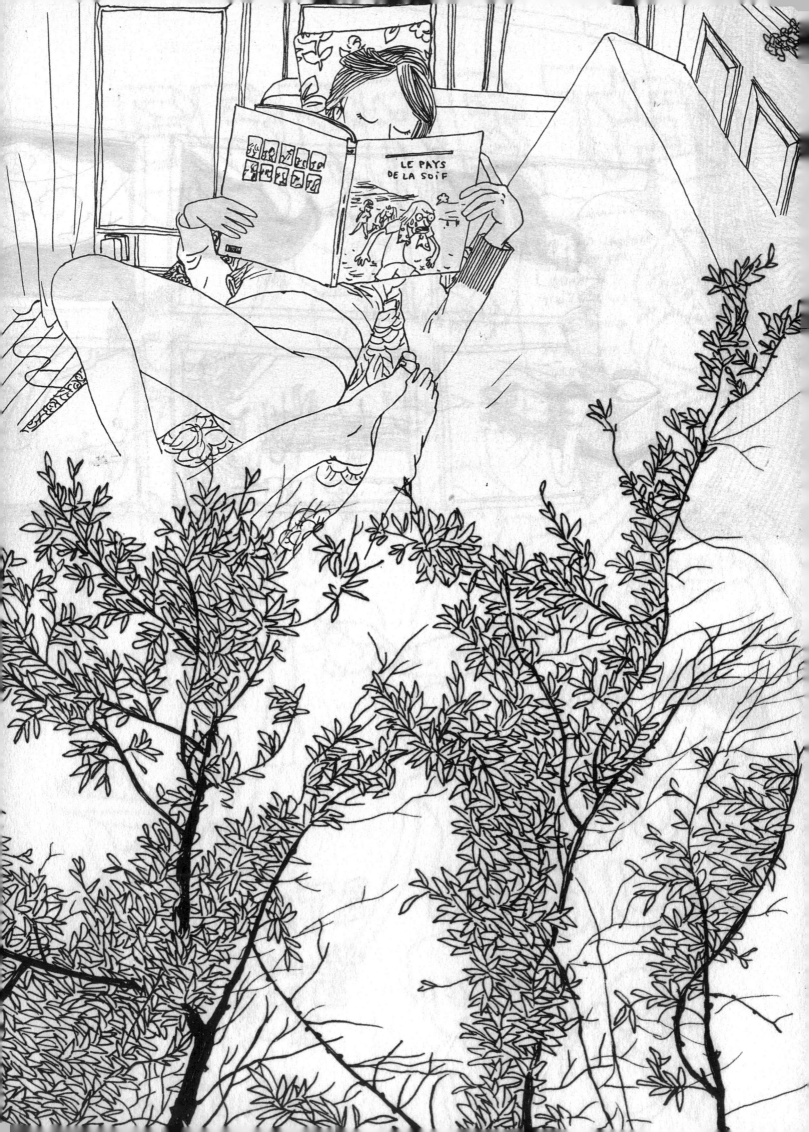

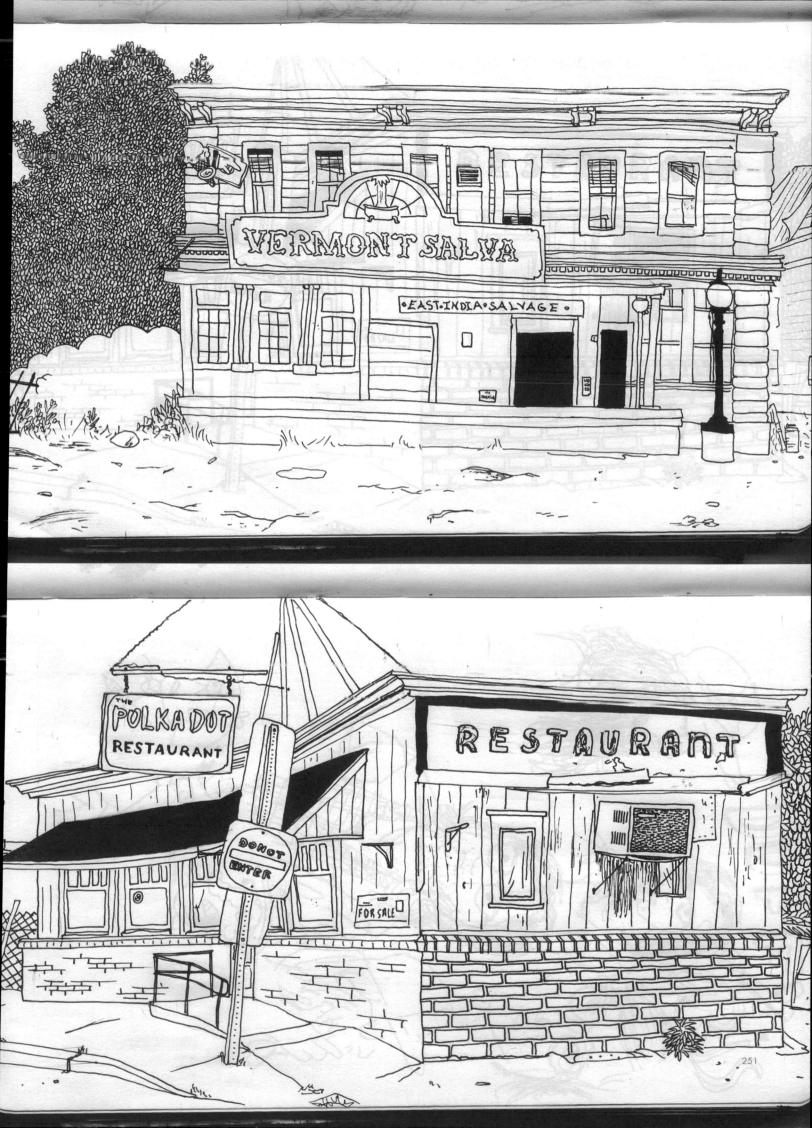

251

MATT ROURKE/ASSOCIATED PRESS

His Past Lives

'Uncle Boonmee Who Can Recall

Apichatpong Weerasethakul's

After a two-year, 23 million euro

STRAND RELEASING

RIALTO PICTURES

Charles Denner in "Z." Costa-Gavras's 1969 political thriller.

"Two of the images by Ruth Jacobi

spectacles owned by
John McAllister, SR.,
Optometrist — appear in
1812 portrait by
James Peale

KENNY TRICE

Room 1105 was not so much a room as it was a place to lie low.

Lauren Redniss

"If I don't record things, I feel uneasy," admits author and illustrator Lauren Redniss. "I don't want the memory of a face or a scene to slip away. I often go back to my sketchbooks to pull images that I can use in finished work. For instance, a marble figure atop a fountain that I drew in Rome became, on a page in my new book *Radioactive* [2010], a servant at a 1911 royal banquet celebrating Marie Curie's second Nobel Prize. In that same banquet scene, a drawing of a Parsons colleague from a faculty meeting is now King Gustav V of Sweden, some radishes I drew as a still life once are getting served on silver platters, and musicians from a jazz club downtown are now playing chamber music for the historic occasion."

Redniss remarks that she wants the sketchbooks to be interesting objects in and of themselves, in addition to being repositories for memory and notes. "They are little laboratories where collaged materials and ideas and drawings mash up against one another. I can indulge obsessions (collecting pictures of hair blowing in the wind, say) that may not be presently apparent in my more formal work, but could be later," she notes.

Redniss's finished work is often about unexpected connections. Her thematic juxtapositions are both visual and narrative. "I wouldn't doubt if the impulse to make these type of connections comes in part from keeping sketchbooks in which images from very different times and places get paired up and collaged together on a page, allowing me to see surprising associations," she concludes.

253

APHRODITE

Giotto di
Bondone
1315-1320

Firenze
Collezione

Ent.
Fondazione
Casa di
Risparmio
di
Firenze

Luke
Giotto e bottega

1325ca

Detail
San Francesco
Saint Francis, Battista
San Giovanni, Battista
St. John The Baptist

Giotto di Bondone
1315-1320
Firenze

ARDA 070 BOSC4 *(mirrored handwriting, illegible)*

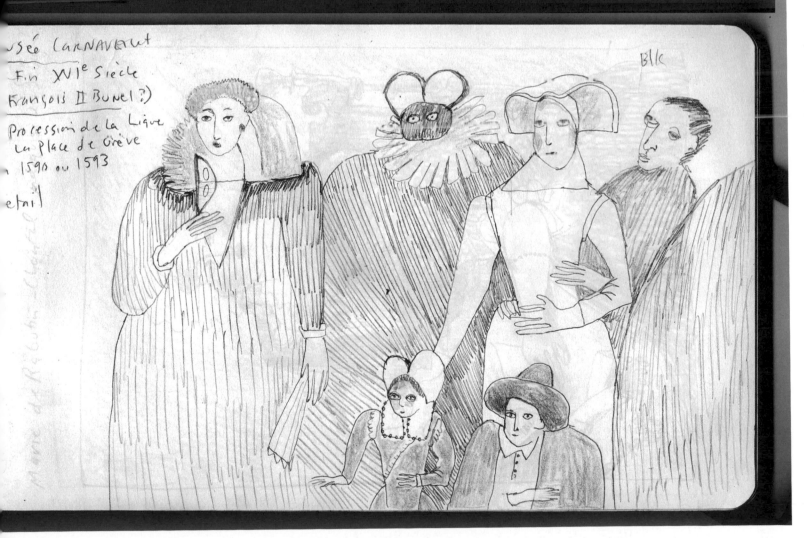

Musée CARNAVALET

Fin XVIe siècle
François II Bunel ?)

Procession de la Ligue
sur la Place de Grève
en 1590 ou 1593

détail

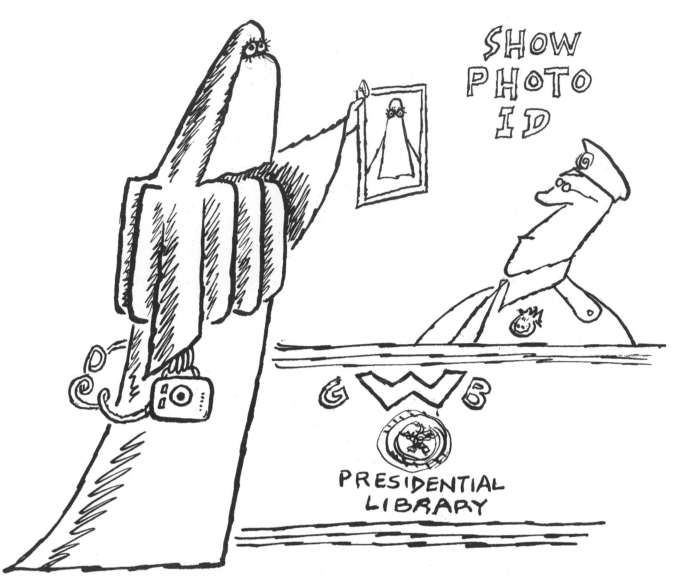

SHOW PHOTO ID

GWB

PRESIDENTIAL LIBRARY

Arnold Roth

Arnold Roth, one of the original comic artists for the humor magazines *Help* and *Humbug* in the 1950s, and a frequent contributor today to many magazines including the *New Yorker*, has had a long and illustrious career as an illustrious illustrator whose line and character are illustriously funny.

All the sketches shown here were ideas for the *New Yorker*. He explains: "After reading the text of the piece, I provide as many ideas on the subject, title, and so on, as scant time allows. I don't like to do sketches, but the *New Yorker*'s system demands it. I prefer to think of the ideas, select what I consider the funniest idea and give my best realization…which is the way I have worked during my entire career. As YOU well know."

The four written pieces involved here were: "'College Graduation Gifts,' 'Leaf Blowers,' 'Debtors' Prison,' 'George W. Bush Presidential Library.' If you can't tell which is which, I am worse than the *New Yorker* could ever imagine."

H.

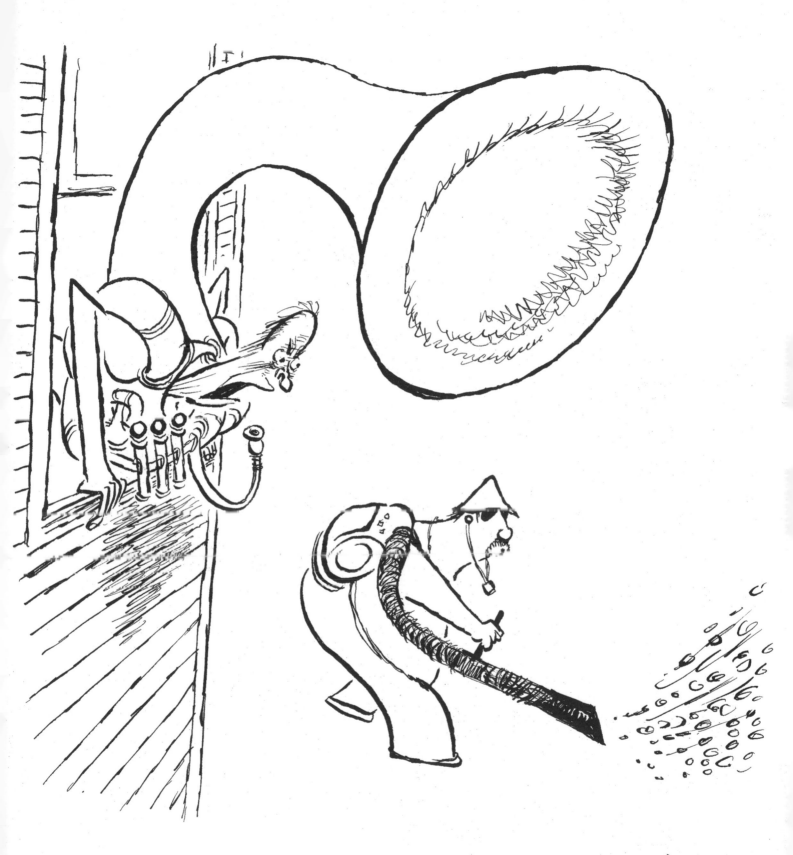

C.

ARNOLD ROTH

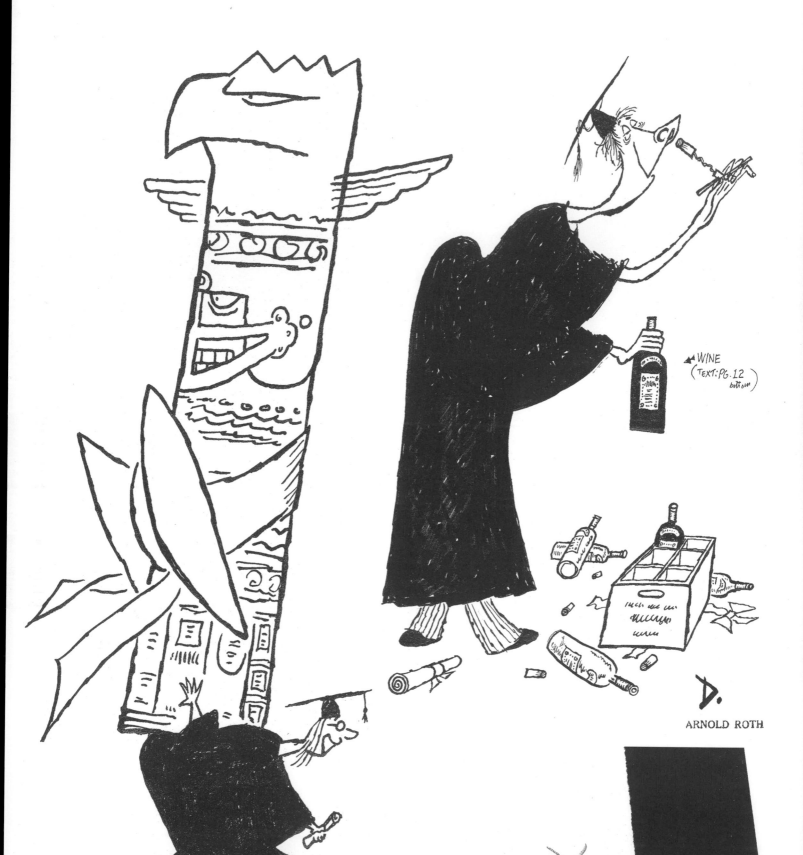

WINE
(TEXT: PG. 12 bottom)

D.

ARNOLD ROTH

E.

ARNOLD ROTH

CONGRATULATIONS!

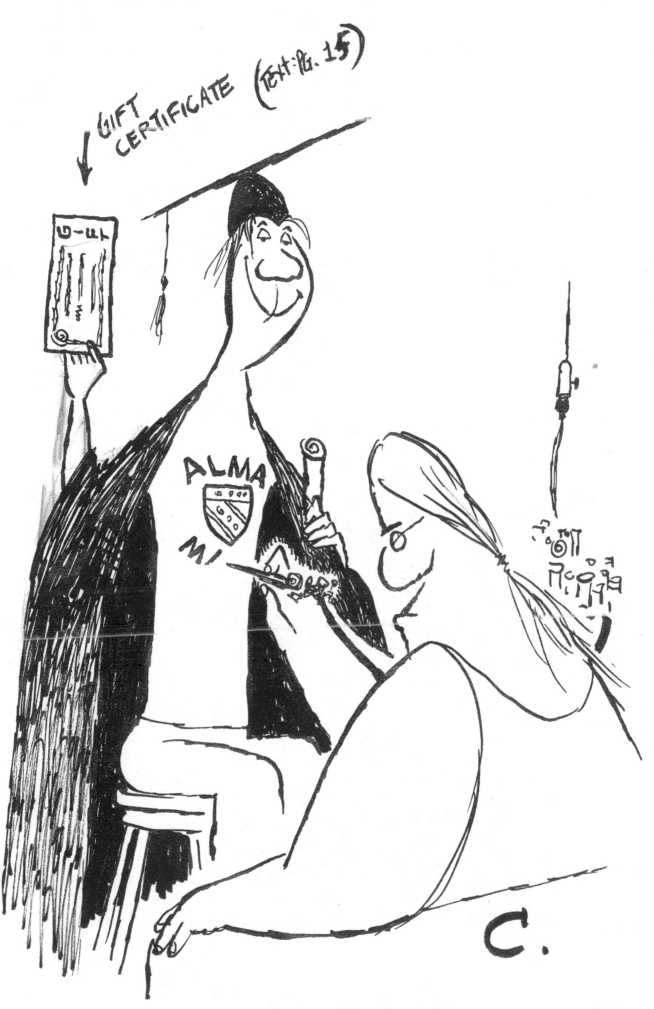

CONGRATULATIONS!

ARNOLD ROTH

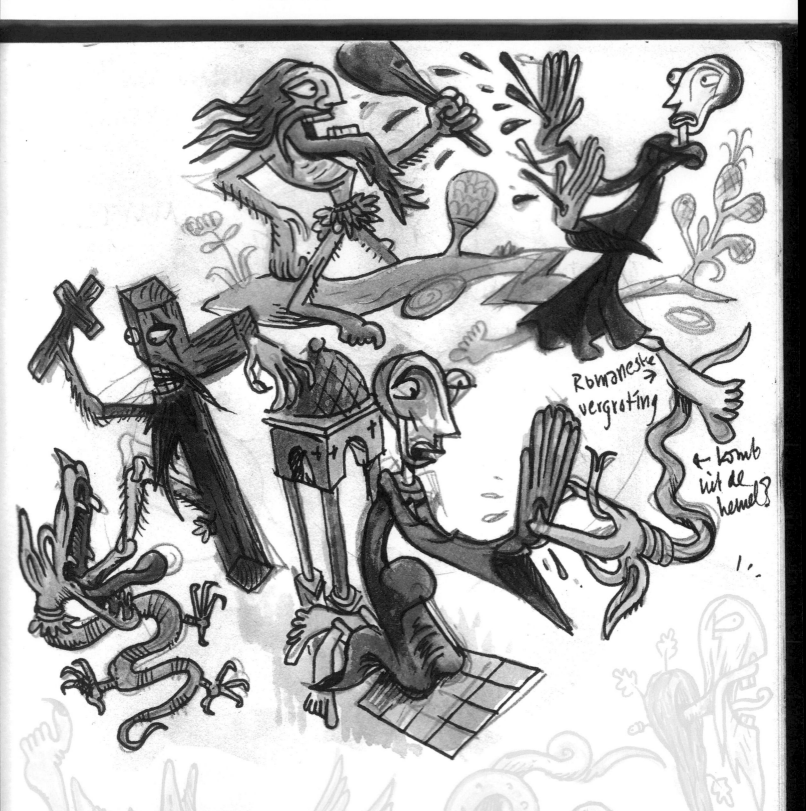

Marcel Ruijters

Marcel Ruijters started keeping A5 format sketchbooks in Rotterdam in 1991. It takes him about eight months to finish one, he says, so that their number is slowly gaining on the years of his life: "I have 37 of them now."

His sketchbooks serve a practical purpose. "Sketches will rot away if you leave them in the back of a drawer," he asserts. "You never know what you can use later. And if it does not happen, that is OK too, because each sketchbook becomes an artwork in itself. I have always painted on the covers (in acrylics), as the canvas structure feels so inviting. In the end, they are also like diaries. You can see your style evolving and your ideas shift toward other directions. In fact, I use different styles at the same time and it can be a mess, but the idea is to have some alternative to hand in

case you get bored with your main style of working. It makes you more versatile in that sense." He adds, "A sketchbook works as an incubator – ideas may be in there for months or even years before they end up in a story or painting. New things may turn up when you are leafing through them and combining ideas. My thinking works by associating. I did an adaptation of Dante's *Inferno* which won the VRPO award for Best Dutch Graphic Novel in 2008, but the first sketches I did for that project were from around 2000, when I just had read the book."

For Ruijters, the pleasure of sketchbooks comes down to "drawing in them as though you were a child. The sheer fun of it. None of this professional Taylorist attitude that an illustrator has to adapt to so often."

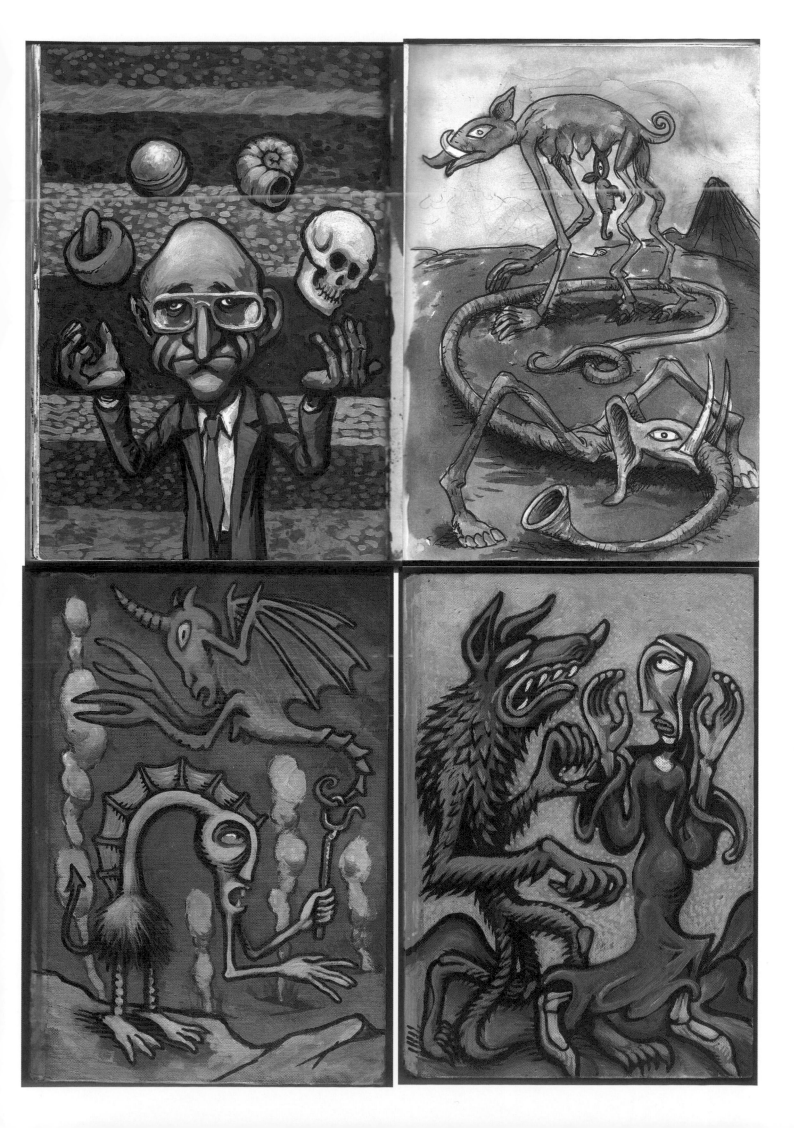

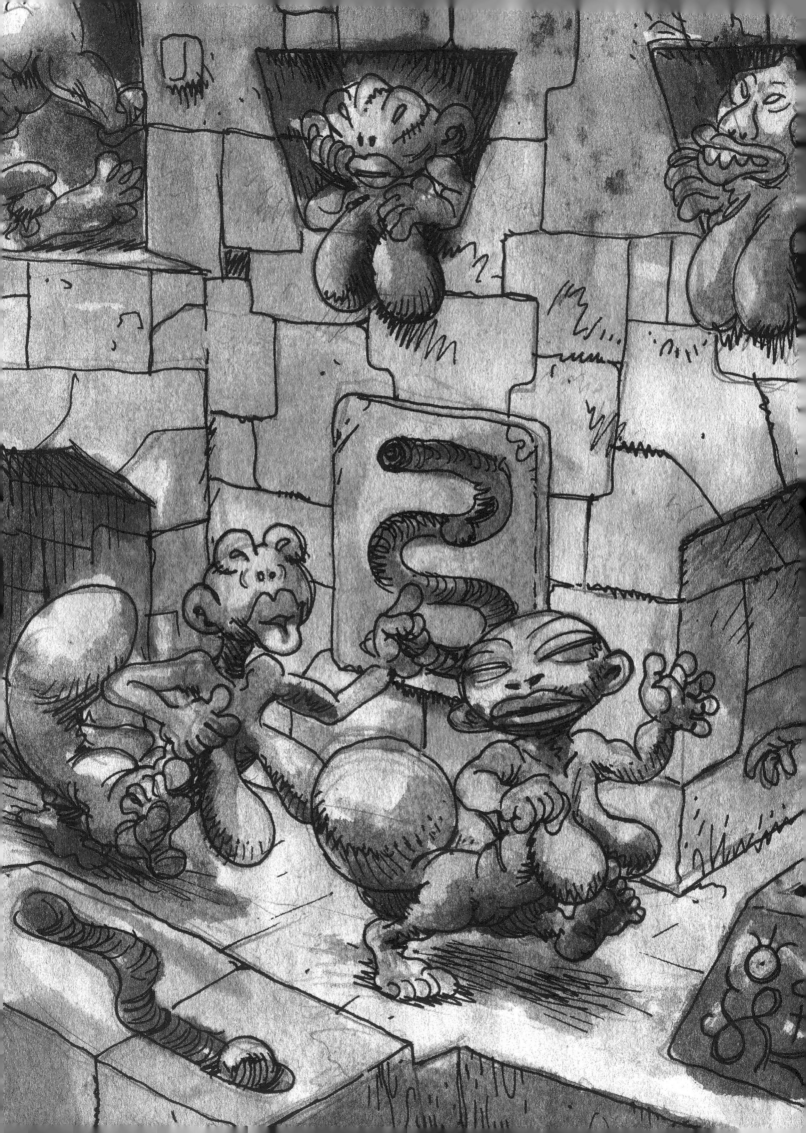

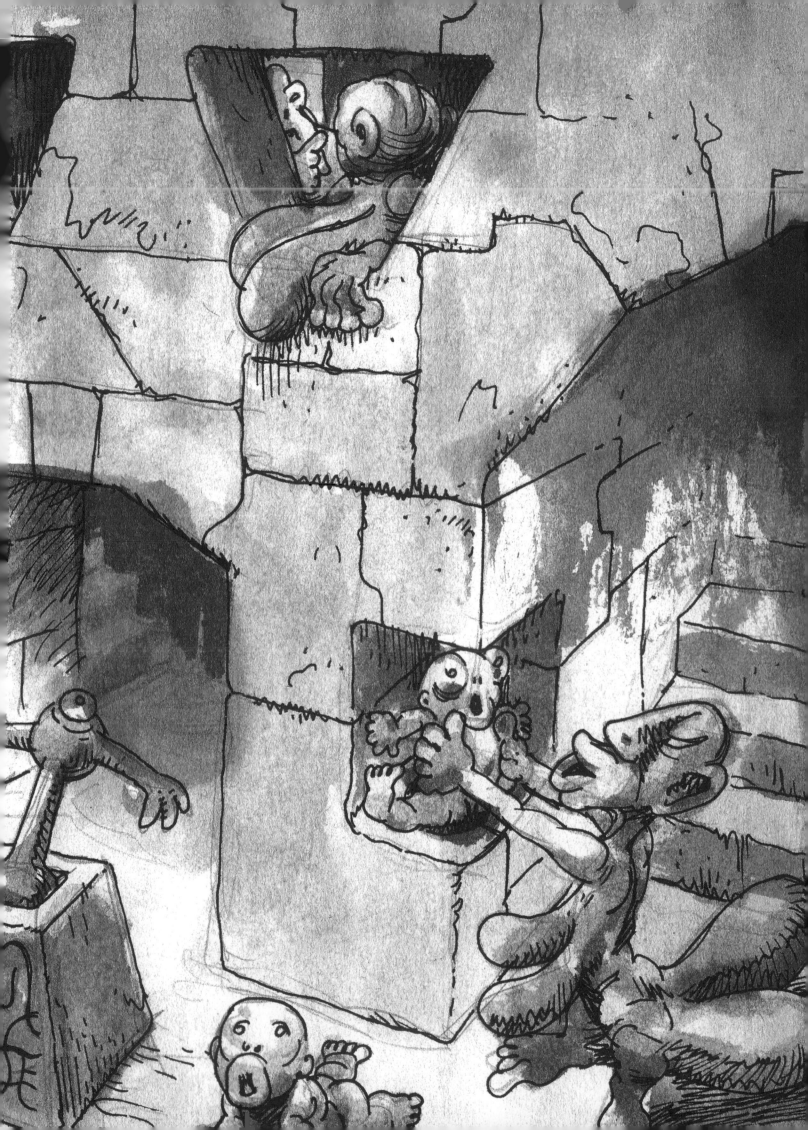

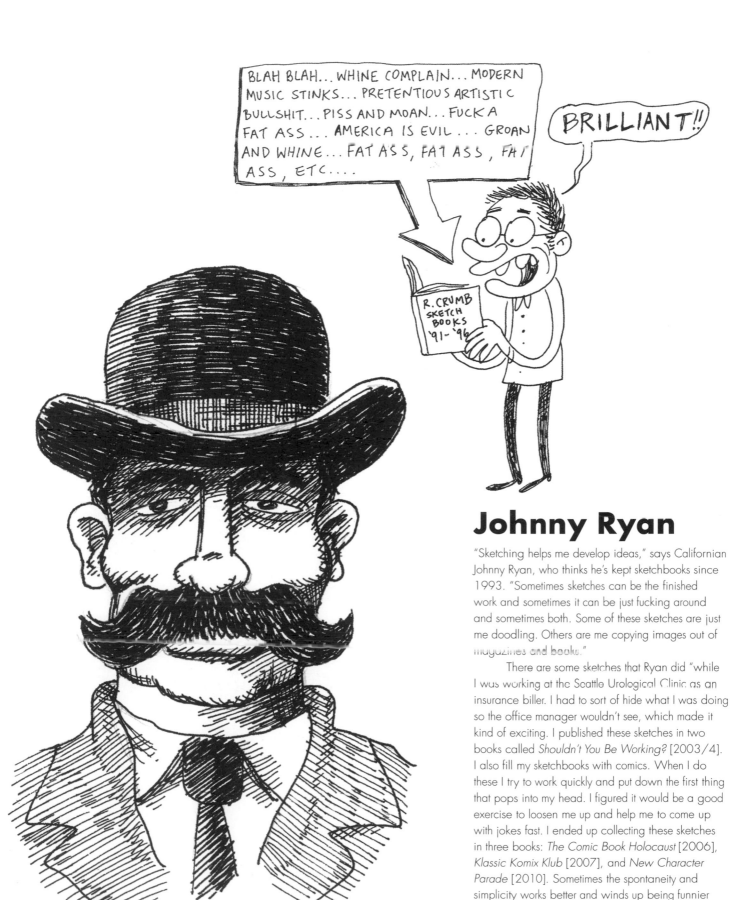

H.H. HOLMES

Johnny Ryan

"Sketching helps me develop ideas," says Californian Johnny Ryan, who thinks he's kept sketchbooks since 1993. "Sometimes sketches can be the finished work and sometimes it can be just fucking around and sometimes both. Some of these sketches are just me doodling. Others are me copying images out of magazines and books."

There are some sketches that Ryan did "while I was working at the Seattle Urological Clinic as an insurance biller. I had to sort of hide what I was doing so the office manager wouldn't see, which made it kind of exciting. I published these sketches in two books called *Shouldn't You Be Working?* [2003/4]. I also fill my sketchbooks with comics. When I do these I try to work quickly and put down the first thing that pops into my head. I figured it would be a good exercise to loosen me up and help me to come up with jokes fast. I ended up collecting these sketches in three books: *The Comic Book Holocaust* [2006], *Klassic Komix Klub* [2007], and *New Character Parade* [2010]. Sometimes the spontaneity and simplicity works better and winds up being funnier than the stuff I really work hard on," he observes.

Of the images shown here, from 2000–5, the *Dick Tracy* page "is a sample of the sketchbook comics I would do. The Video Dead I copied out of a book of movie posters from Ghana. The others are just a sampling of my sketchbook doodling."

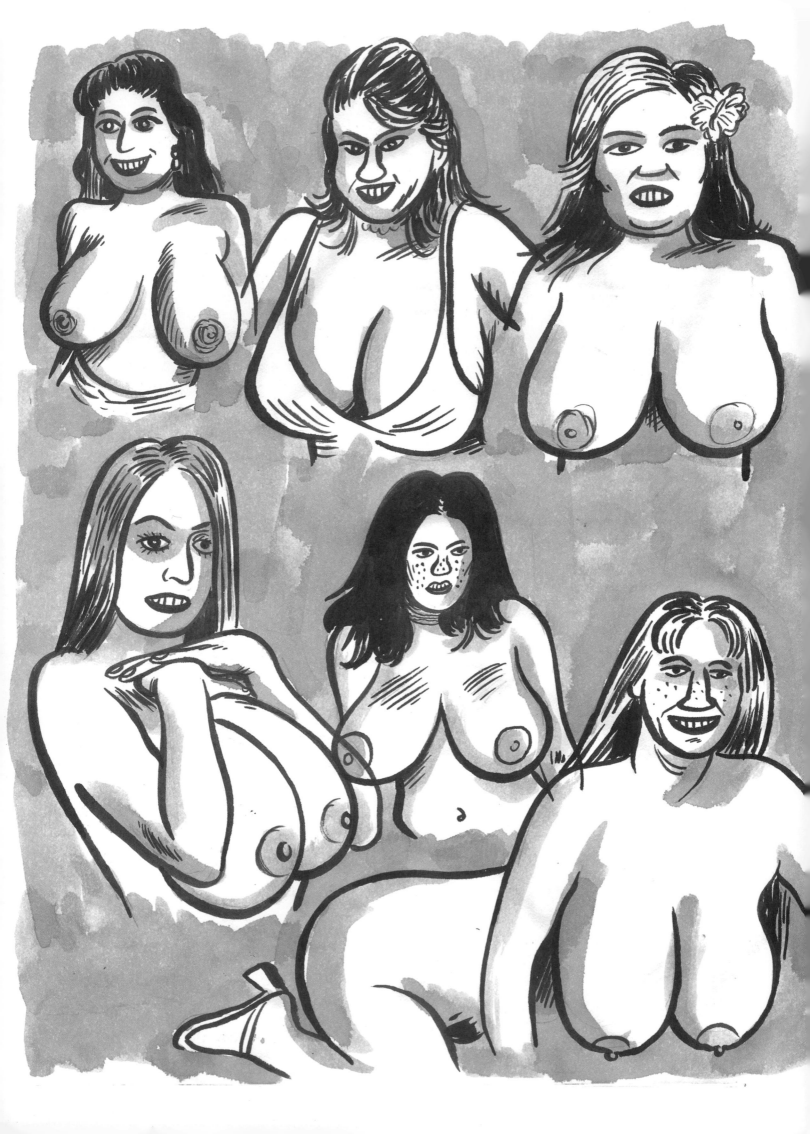

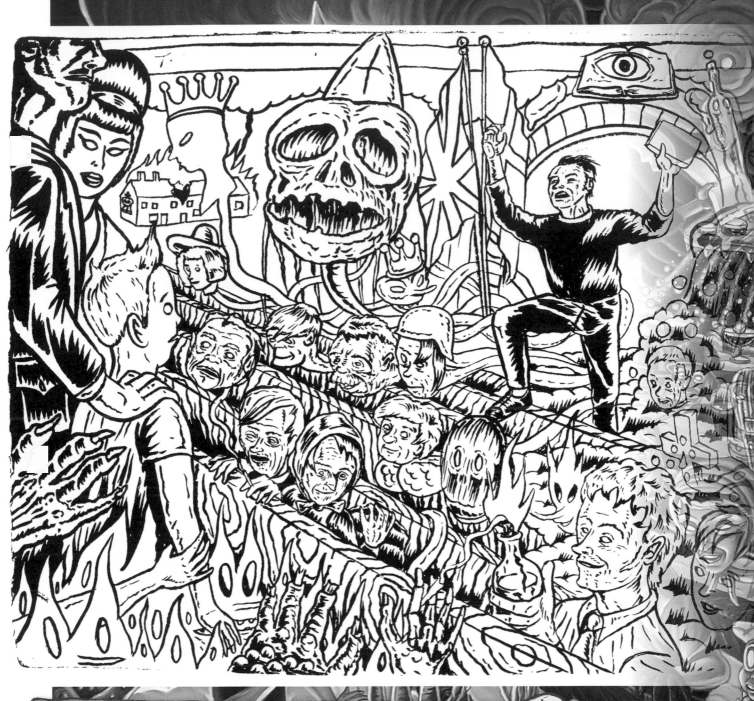

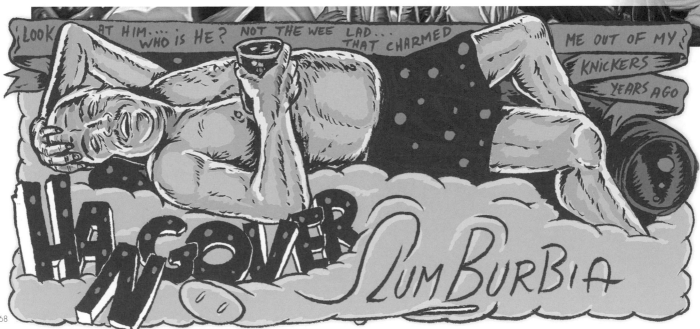

David Sandlin

David Sandlin proudly states, "I've kept sketches and notebooks since the 1970s. I use my sketchbooks for visual thinking, and for writing down ideas for future projects and thoughts about what I'm working on."

His sketches range from doodles to thumbnails to double-page spreads for working out compositions for paintings and prints. "Their very roughness and the freedom of line makes the sketches distinct from my finished work," he says. "I don't follow any overall theme in my sketchbooks, but certain ones tie in with particular books or series, so they are thematically unified by the project." These sketches divide into three groups and show his usual process of thinking about composition and visual narratives: "'True Church' (above) started as thumbnails in my

sketchbook, along with notes. Then I moved to larger drawings on copy paper; then Arches watercolor paper; and, in this case, eventually to an oil painting on canvas. 'Swamp Preacher' (opposite, above) followed a similar trajectory, but the finished piece was two pages of comics in a two-color compilation by Fantagraphics. 'Hangover' (opposite, below) is a quick ink drawing I did on glassine. This image ended up as a comic page and a page in a large-format silkscreened artist book, *Slumburbia*."

All of these images from 2004–8 are part of Sandlin's series "A Sinner's Progress" – a group of books, prints, and paintings that follow the misadventures of Bill Grimm, a salesman of puritanical fundamentalist novelty items.

Seth

Seth (the pen name of Gregory Gallant) from Ontario, Canada, makes sketches "to keep alive the pleasure of drawing." He started using sketchbooks to "allow some spontaneity into my work, but eventually the drawings got tighter and tighter and became pretty much finished artwork." At that point he realized he was continuing with the sketchbooks because he liked making drawings that were for no purpose other than his own pleasure.

The most important purpose of the books, for Seth, is "Freedom." He adds, "The drawings are less uptight. Plus, I do a lot more work using opaque paints in my sketchbooks. It's really my favorite way to work, but opaque paints are not a very good medium for comics. They're too fussy. Comics need to be more direct. Brush and ink. Plus, I need to use too much white-out when I'm doing my comics, and that wouldn't work so well with the poster paints."

He returns to the same sort of imagery over and over. "I either draw landscapes (or cityscapes) or I draw people from old photographs just standing there staring at the camera. I don't know why, it may just be that there is an endless amount of reference material in these veins to copy from, or it may be that these are the two basic things that genuinely interest me," he reflects. The images on these pages were drawn from old photos Seth's father kept from his Scout Master days back in the 1950s and 1960s. "I'm very drawn to any photo with a uniform in it. My dad is in every one of these drawings on this spread," he says.

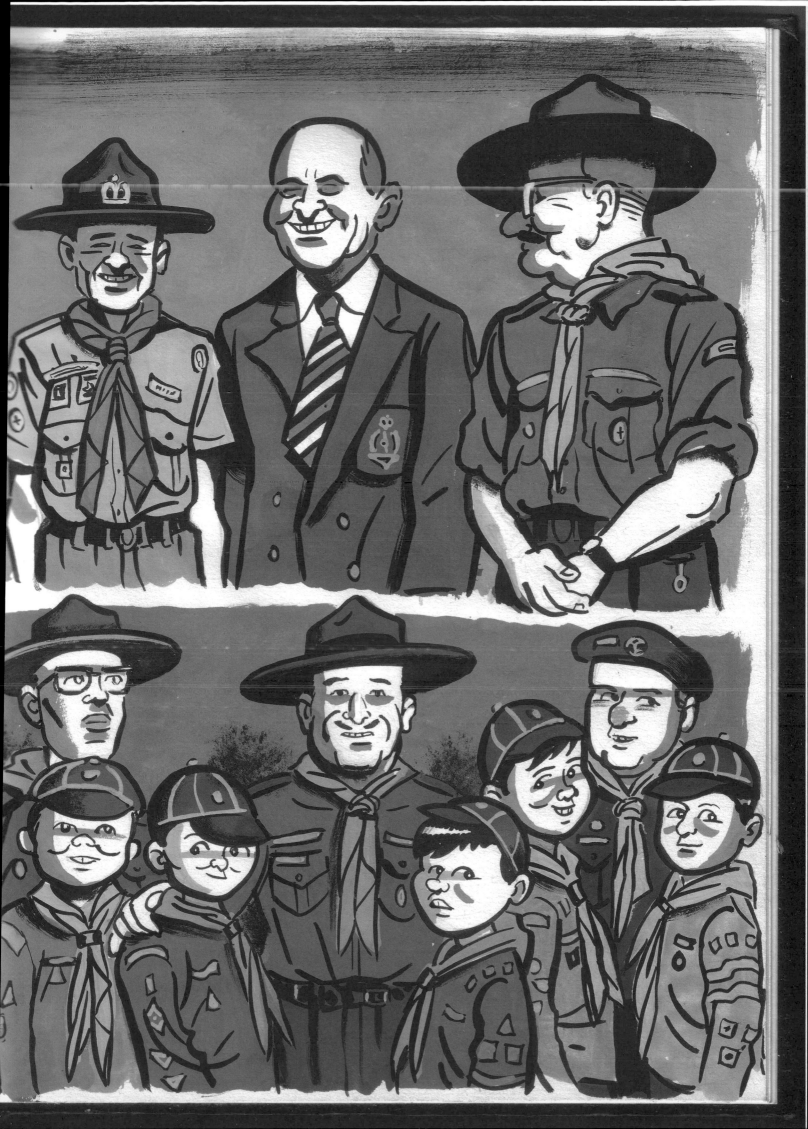

CONT. →

END.

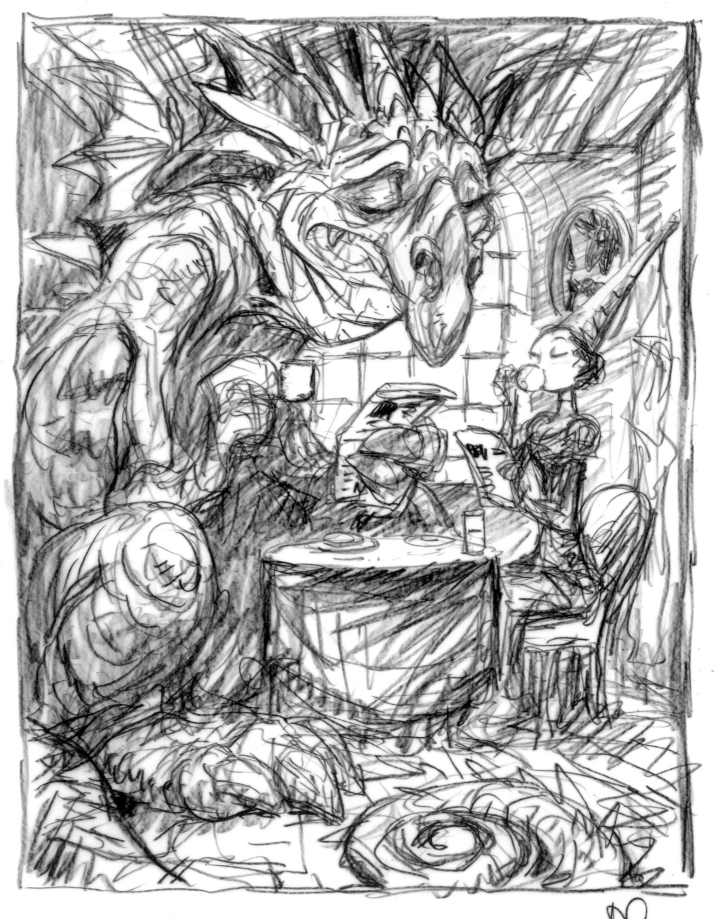

SPECTRUM

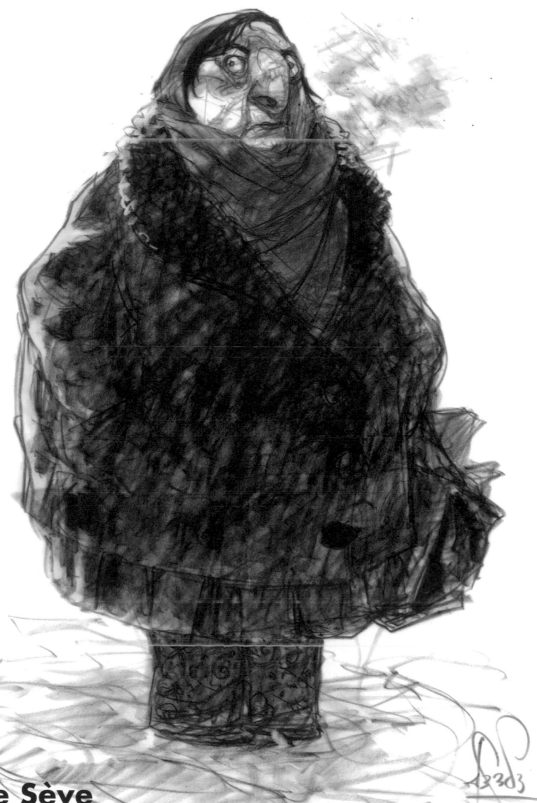

Peter de Sève

Peter de Sève, known for his characters in the film *Ice Age*, has always been a chronic doodler. The portfolio he submitted to Parsons School of Design in New York mostly comprised sketches he made during high-school math and science classes: "I was highly distracted, you might say."

Sketches come in handy "if I am trying to figure out an idea for a job, a *New Yorker* cover, for instance," he explains. "I might do several thumbnails that explore the concept, as well as the composition and the characters in it." But, he also admits, "the other purpose to my sketches is for them to serve no purpose at all. I do them to stay loose and to remind me of the value of the unexpected. I try to let the line be as unplanned and inventive as possible, without being too self-conscious about it. But it's not

an easy trick to say to yourself: 'Be spontaneous! NOW!' I imagine, in some ways, this must be how jazz musicians train themselves to improvise on a melody without doing it the same way twice." What sets de Sève's sketches apart from his finished work "is a genuine energy; a heartbeat. There is something really wonderful about putting a drawing down, quickly, for the first time. All too often, the finished piece is simply a sad attempt to recapture that moment. Like putting lipstick on a corpse."

His best drawings are done without thinking: "It's difficult to remain in that state where the hand is improvising with no real plan. Most of the time, I wake up in the middle of it, like a sleepwalker on a window ledge, and have to complete it without ruining it by drawing well," he confides.

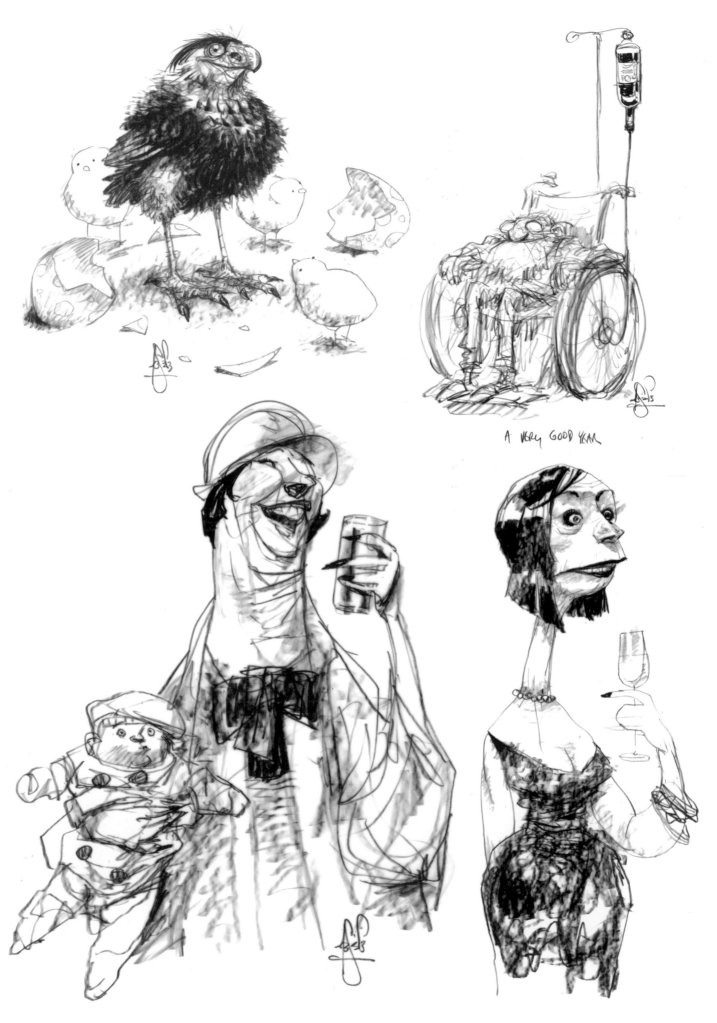

A VERY GOOD YEAR

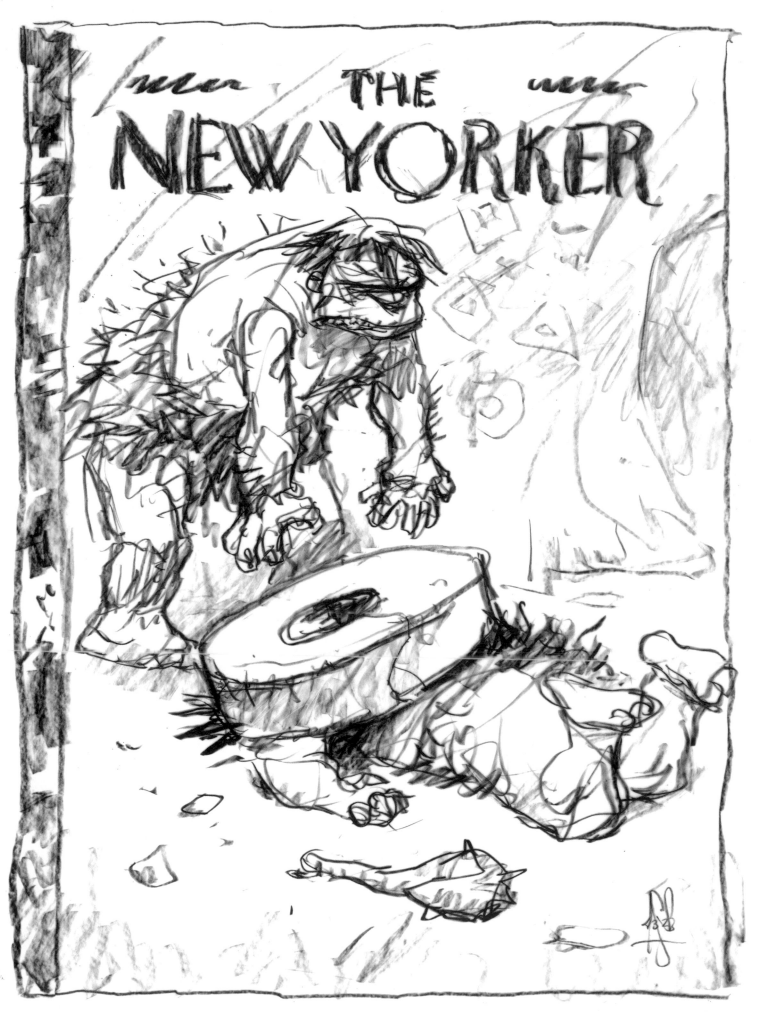

THE NEW YORKER

THE INNOVATION ISSUE

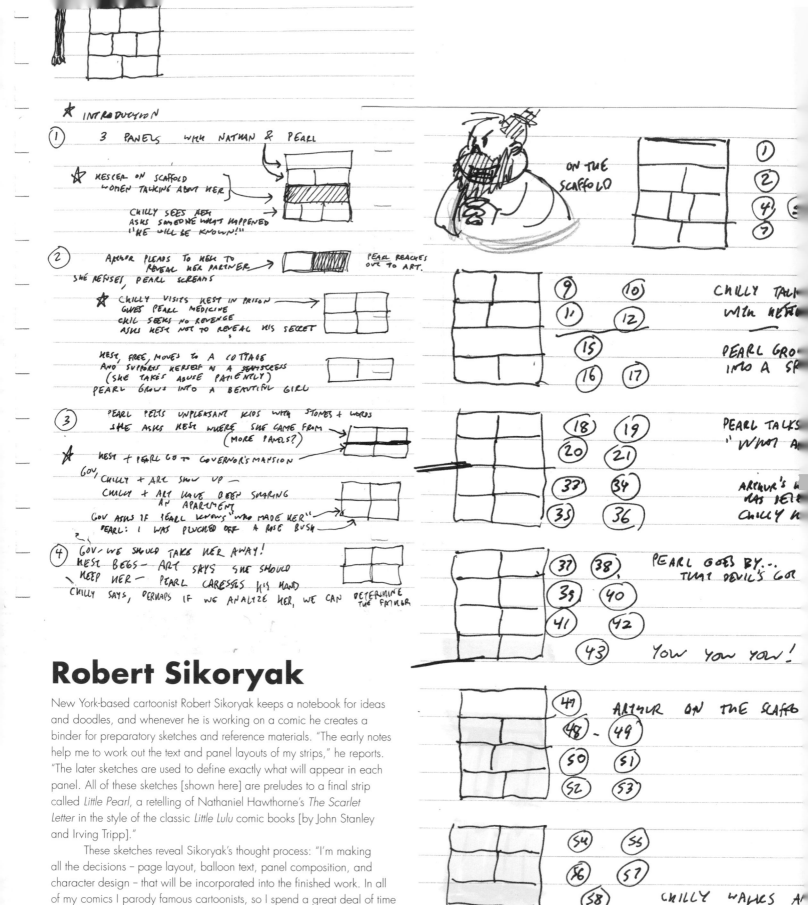

Robert Sikoryak

New York-based cartoonist Robert Sikoryak keeps a notebook for ideas and doodles, and whenever he is working on a comic he creates a binder for preparatory sketches and reference materials. "The early notes help me to work out the text and panel layouts of my strips," he reports. "The later sketches are used to define exactly what will appear in each panel. All of these sketches [shown here] are preludes to a final strip called *Little Pearl*, a retelling of Nathaniel Hawthorne's *The Scarlet Letter* in the style of the classic *Little Lulu* comic books [by John Stanley and Irving Tripp]."

These sketches reveal Sikoryak's thought process: "I'm making all the decisions – page layout, balloon text, panel composition, and character design – that will be incorporated into the finished work. In all of my comics I parody famous cartoonists, so I spend a great deal of time eliminating all traces of my own drawing style and storytelling habits. I accomplish this through multiple drafts, where I slowly learn the techniques and recreate the look of the source material. These images reveal some of that process."

Most of the sketches here were drawn over the course of a few months in 2000. "My process is similar today, although more of my current preparatory drawings are done in Photoshop, using a Cintiq pen and display," Sikoryak explains.

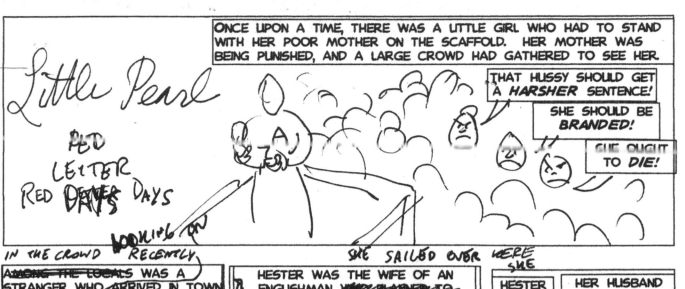

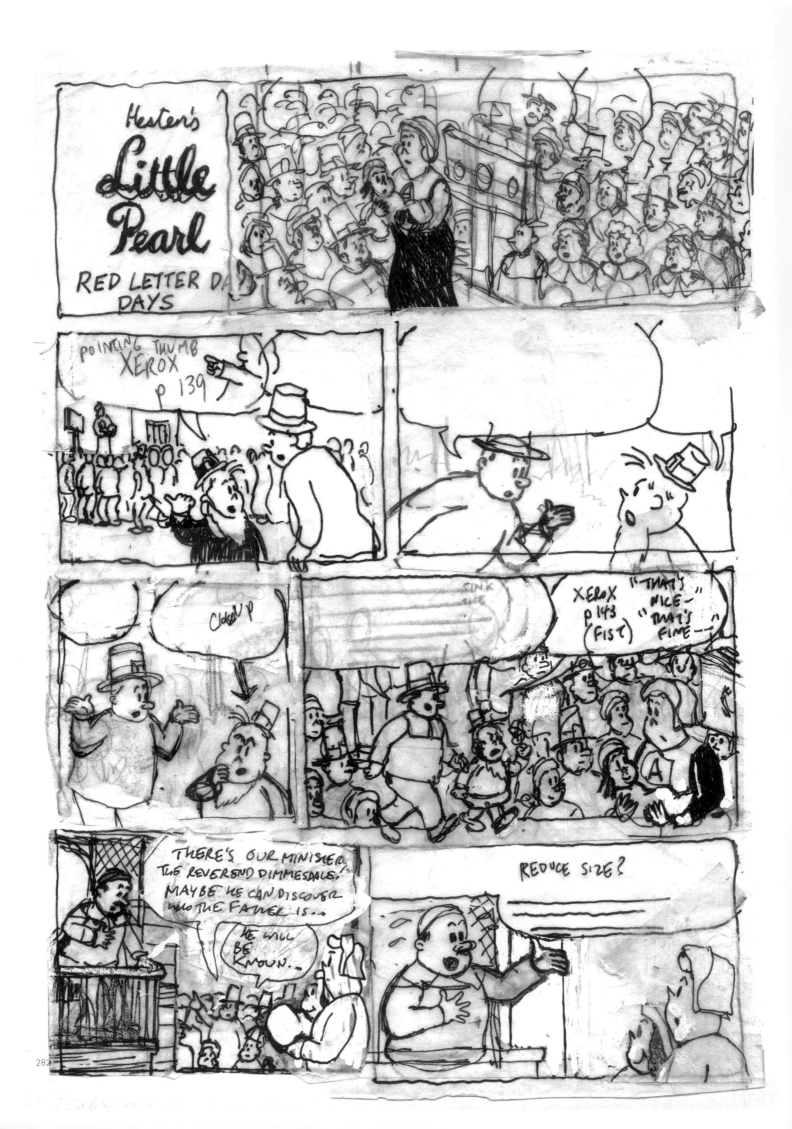

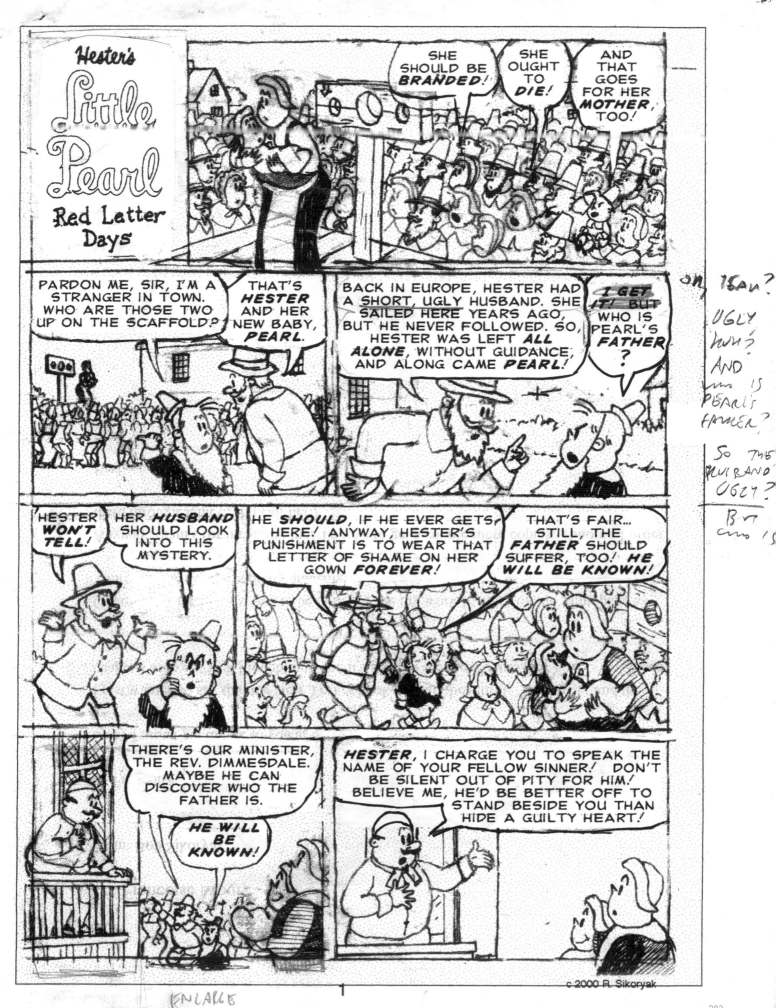

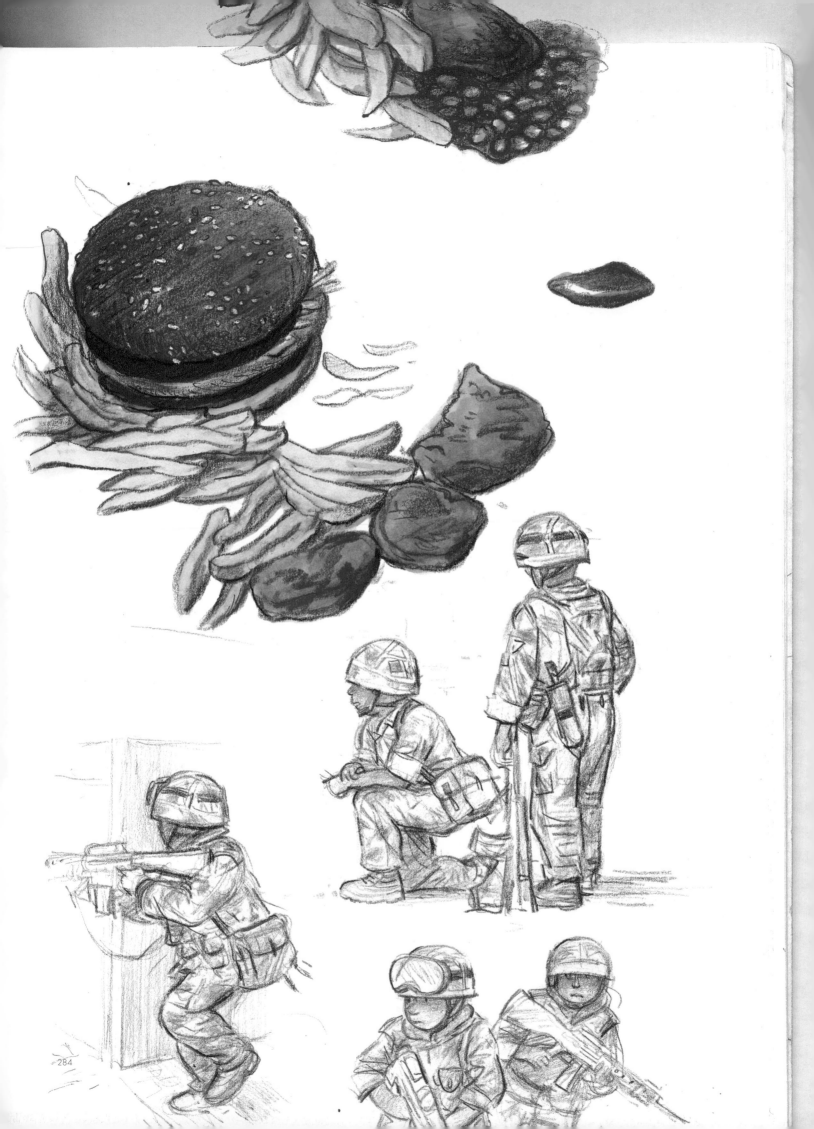

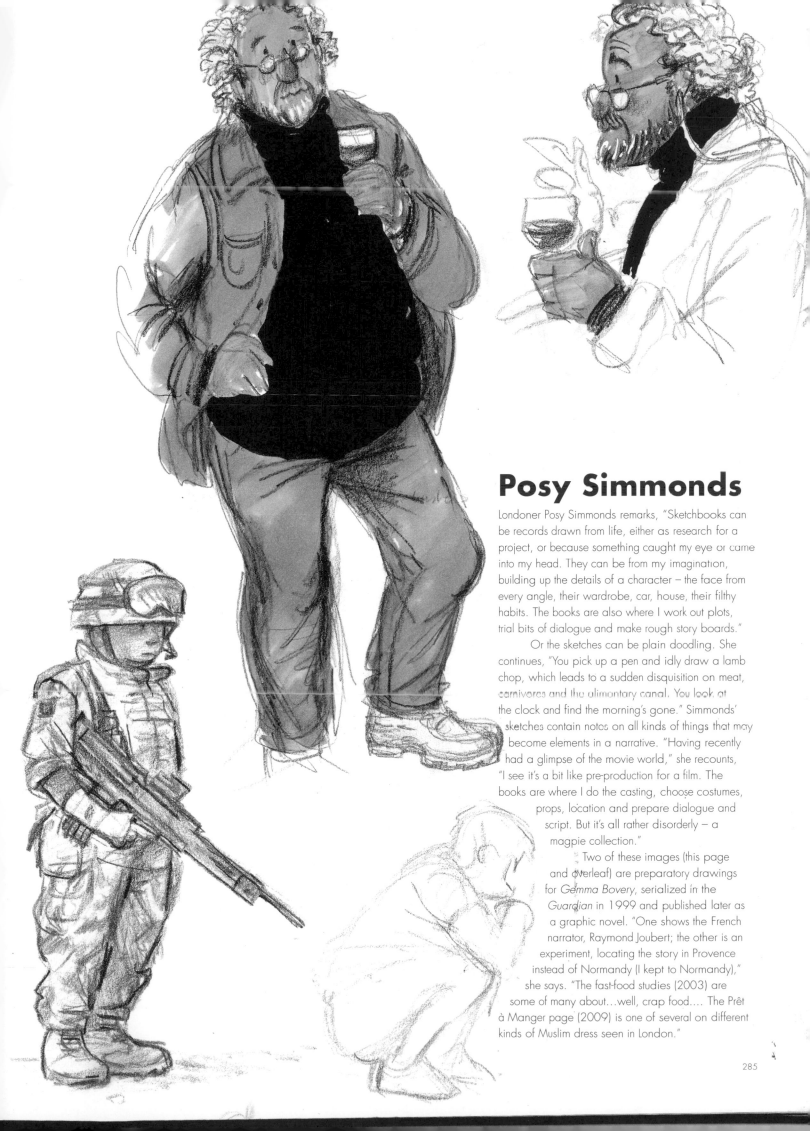

Posy Simmonds

Londoner Posy Simmonds remarks, "Sketchbooks can be records drawn from life, either as research for a project, or because something caught my eye or came into my head. They can be from my imagination, building up the details of a character – the face from every angle, their wardrobe, car, house, their filthy habits. The books are also where I work out plots, trial bits of dialogue and make rough story boards."

Or the sketches can be plain doodling. She continues, "You pick up a pen and idly draw a lamb chop, which leads to a sudden disquisition on meat, carnivores and the alimentary canal. You look at the clock and find the morning's gone." Simmonds' sketches contain notes on all kinds of things that may become elements in a narrative. "Having recently had a glimpse of the movie world," she recounts, "I see it's a bit like pre-production for a film. The books are where I do the casting, choose costumes, props, location and prepare dialogue and script. But it's all rather disorderly – a magpie collection."

Two of these images (this page and overleaf) are preparatory drawings for *Gemma Bovery*, serialized in the *Guardian* in 1999 and published later as a graphic novel. "One shows the French narrator, Raymond Joubert; the other is an experiment, locating the story in Provence instead of Normandy (I kept to Normandy)," she says. "The fast-food studies (2003) are some of many about…well, crap food…. The Prêt à Manger page (2009) is one of several on different kinds of Muslim dress seen in London."

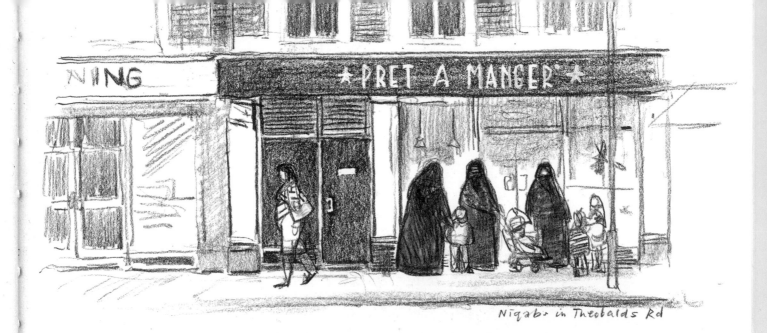

Niqabs in Theobalds Rd

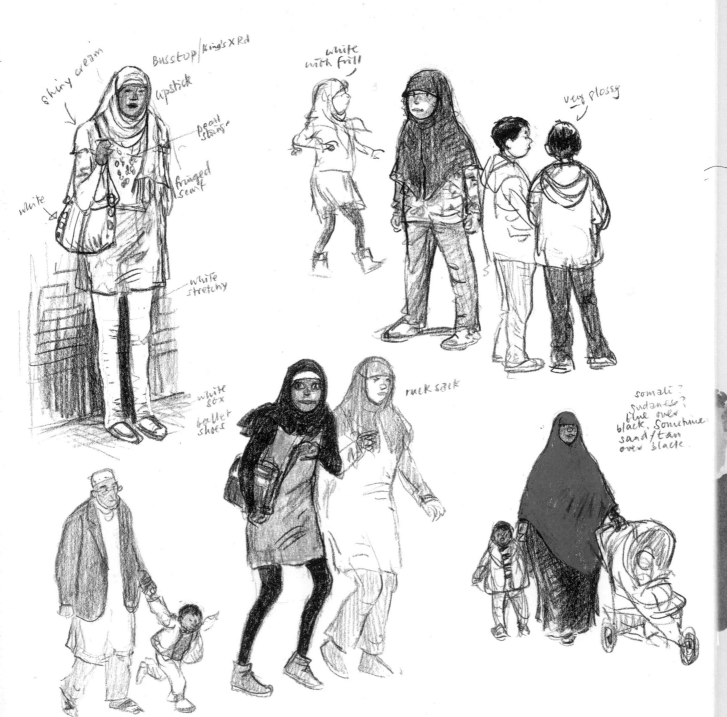

Busstop/King's X Rd

shiny cream

lipstick

pearl string

fringed scarf

white

white stretchy

white sox
ballet shoes

white with frill

very glossy

rucksack

somali?
sudanese?
blue over
black. Sometime
sand/tan
over black

286

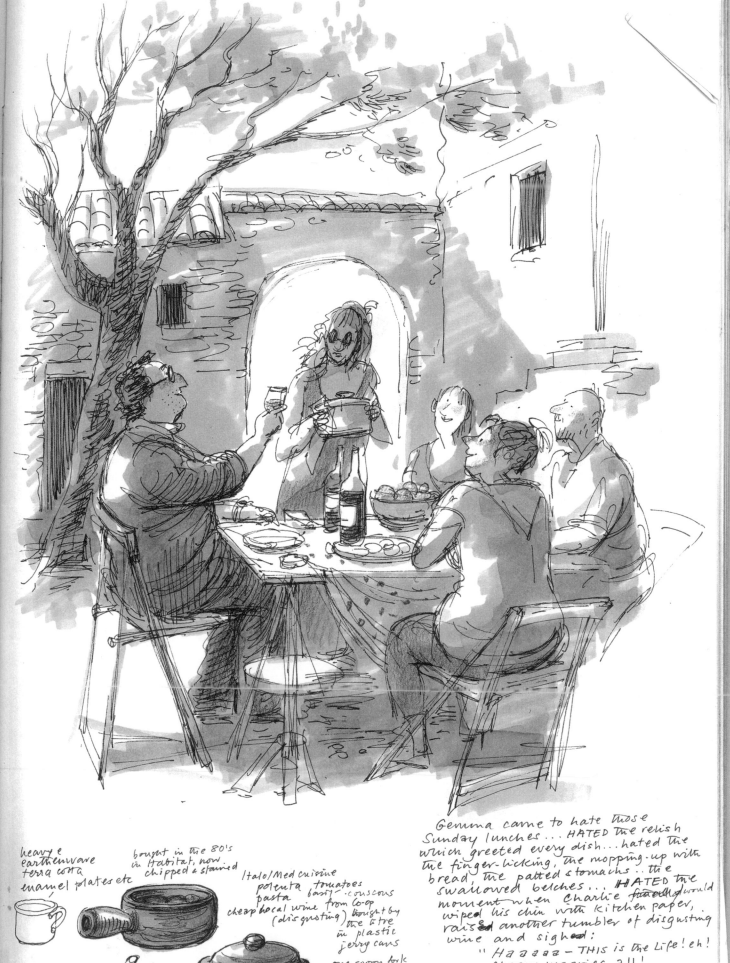

heavy e
earthenware
terra cotta
enamel plates etc

bought in the 80's
in Habitat, now
chipped & stained

Italo/Med cuisine
polenta tomatoes
pasta basil .couscous
cheap local wine from Co-op
(disgusting) bought by
 the litre
 in plastic
 jerry cans

one spoon fork
knife & plate
for the whole
meal
kitchen paper
round the neck
plate mopped
with bread

brioches

breath
always smelt strongly of garlic

dobs of butter

Gemma came to hate those
Sunday lunches... HATED the relish
which greeted every dish...hated the
the finger-licking, the mopping-up with
bread, the patted stomachs...the
swallowed belches... HATED the
moment when Charlie finally would
wiped his chin with kitchen paper,
raised another tumbler of disgusting
wine and sighed:
 "Haaaaa — THIS is the Life! eh!
 Cheery-weeries, all!

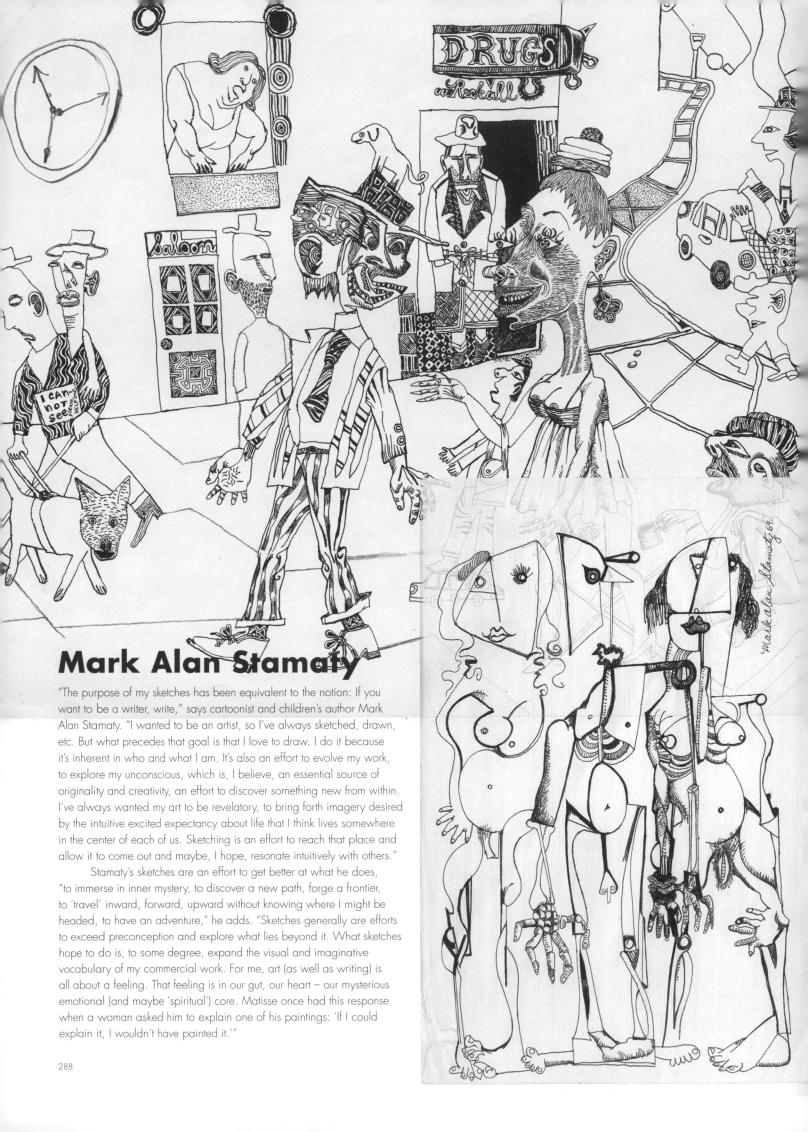

Mark Alan Stamaty

"The purpose of my sketches has been equivalent to the notion: If you want to be a writer, write," says cartoonist and children's author Mark Alan Stamaty. "I wanted to be an artist, so I've always sketched, drawn, etc. But what precedes that goal is that I love to draw. I do it because it's inherent in who and what I am. It's also an effort to evolve my work, to explore my unconscious, which is, I believe, an essential source of originality and creativity, an effort to discover something new from within. I've always wanted my art to be revelatory, to bring forth imagery desired by the intuitive excited expectancy about life that I think lives somewhere in the center of each of us. Sketching is an effort to reach that place and allow it to come out and maybe, I hope, resonate intuitively with others."

Stamaty's sketches are an effort to get better at what he does, "to immerse in inner mystery, to discover a new path, forge a frontier, to 'travel' inward, forward, upward without knowing where I might be headed, to have an adventure," he adds. "Sketches generally are efforts to exceed preconception and explore what lies beyond it. What sketches hope to do is, to some degree, expand the visual and imaginative vocabulary of my commercial work. For me, art (as well as writing) is all about a feeling. That feeling is in our gut, our heart — our mysterious emotional (and maybe 'spiritual') core. Matisse once had this response when a woman asked him to explain one of his paintings: 'If I could explain it, I wouldn't have painted it.'"

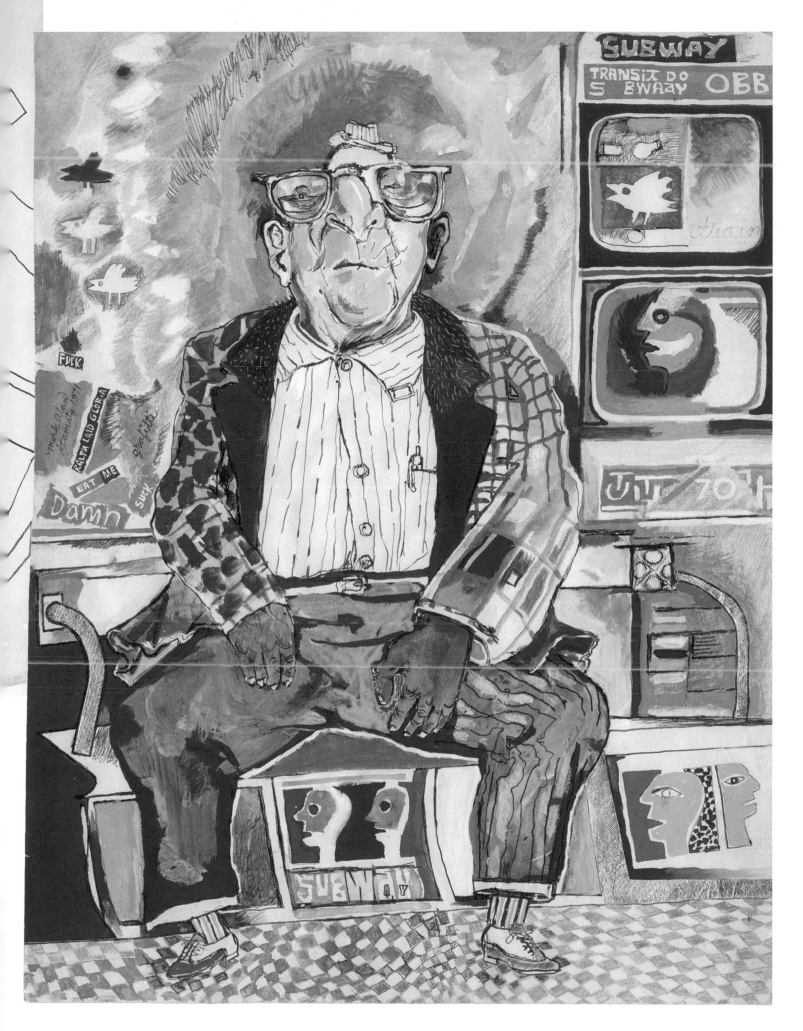

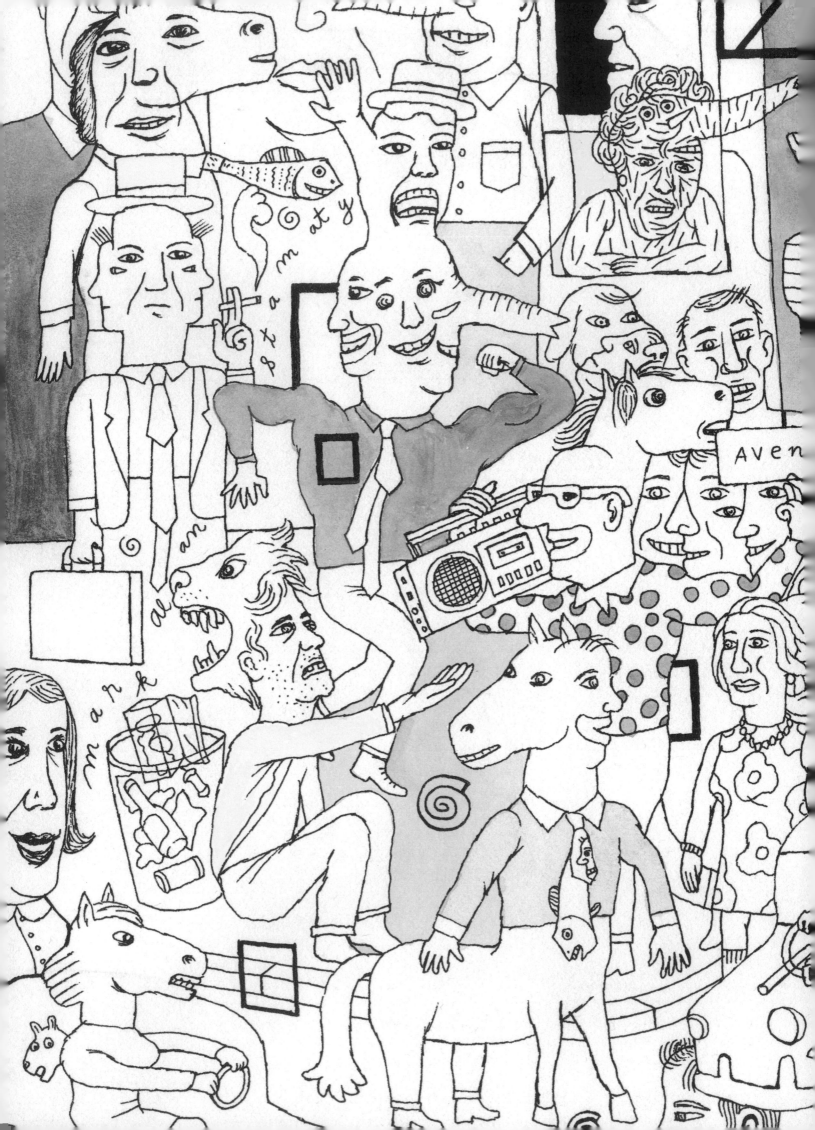

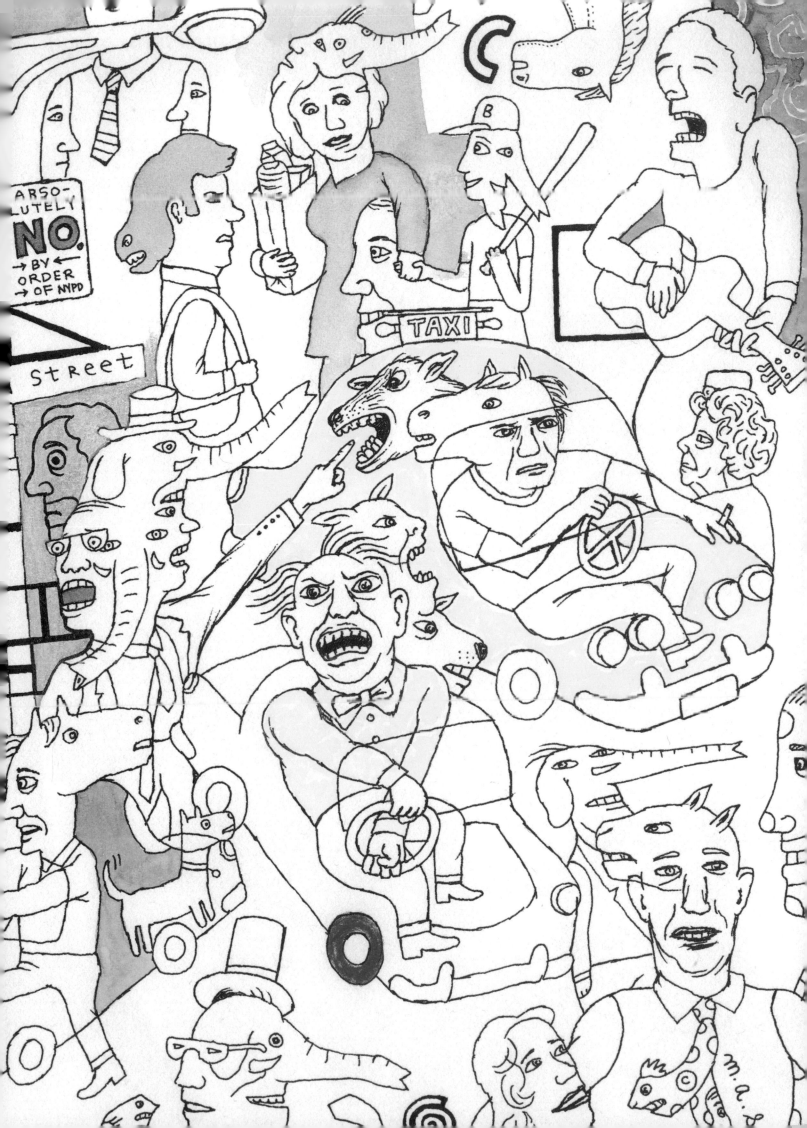

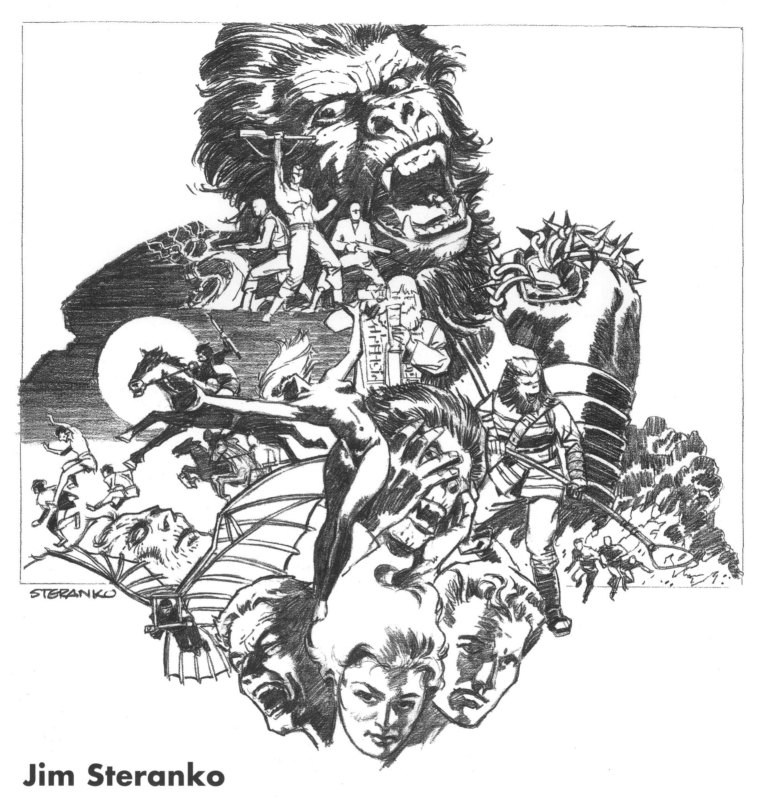

Jim Steranko

Comics historian, publisher, and artist of many Marvel comics Jim Steranko declares, "I sketch to develop compelling solutions to puzzles that just happen to be creative assignments. I treat them all as puzzles to be solved using three tools: imagination, intelligence, and integrity. It's a philosophical approach that keeps every job fresh and challenging. And challenges bring me to life, artistically."

But sketching is but a small part of his oeuvre. "I'll confess right up front – I just play at being an artist," he claims. "Although I love the graphic arts, late in the day, I'd rather find a new chord progression on piano or run with my dogs. I never draw for amusement. Drawing is work, and the only reason I do it is because of my religious affiliation: I worship

money! Relax, it's a joke! Frankly, I just can't say no to clients I like – especially when they insist on unreasonably littering my bank account."

Of his process, he says, "After accepting an assignment, I begin evolving it on the drawing board of my imagination, often while rendering another piece of art on my studio drawing board." Clients generally want to exploit Steranko's ability to visualize larger-than-life characters: "I believe I may have set a record for heroic images in print, from Indiana Jones to James Bond, from the Shadow to Sherlock Holmes. I'm a commercial messenger, a twenty-first-century Mercury with a CS5 persona; I convey other people's ideas because I speak a kind of bravura language they haven't yet mastered. And, every so often, I become my own client."

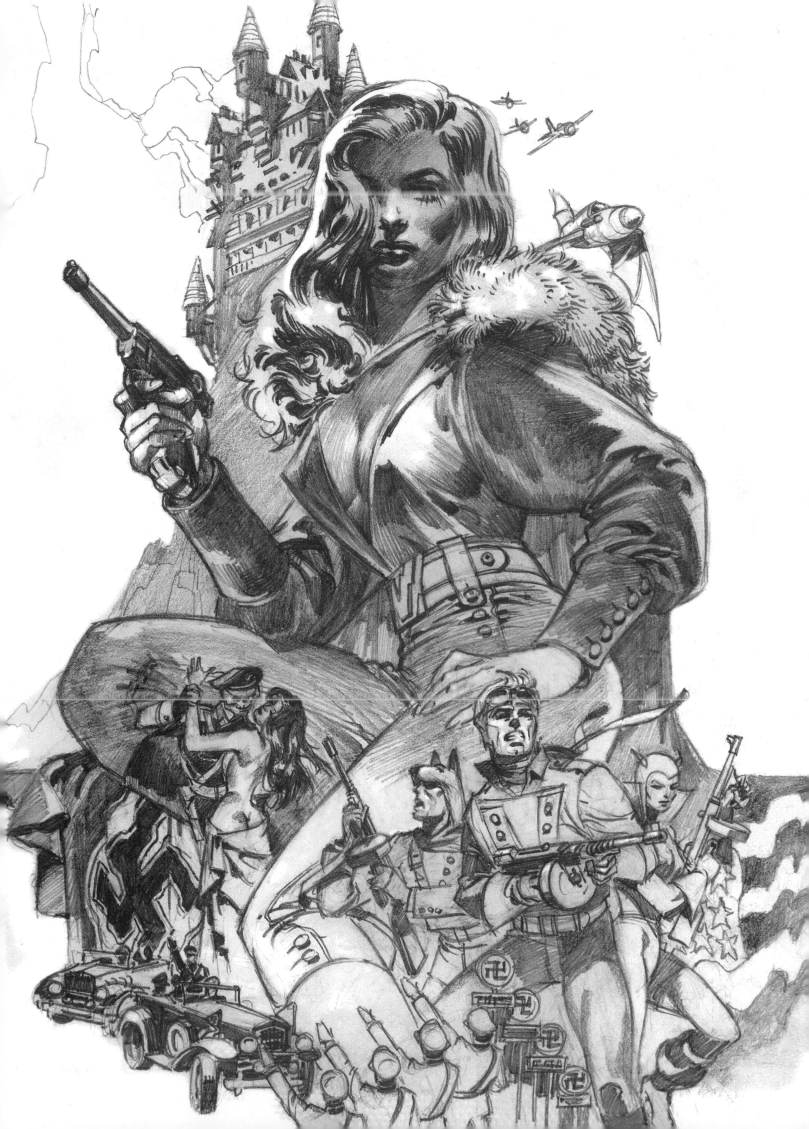

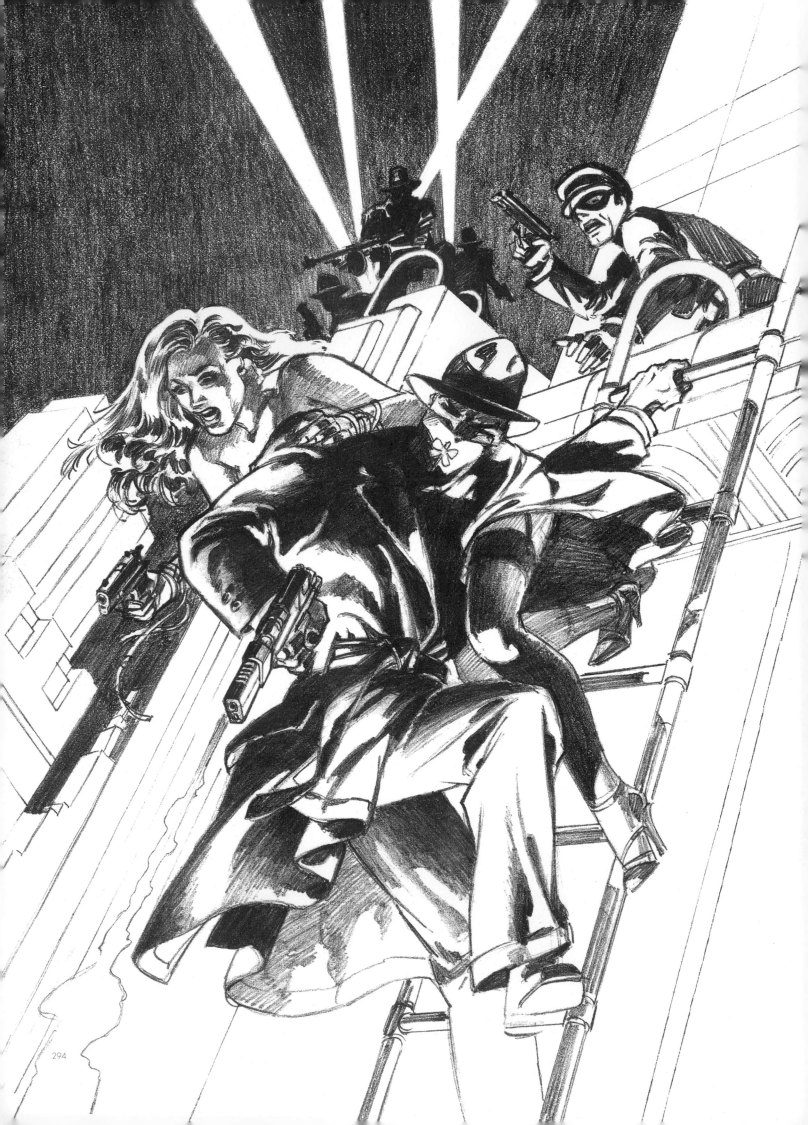

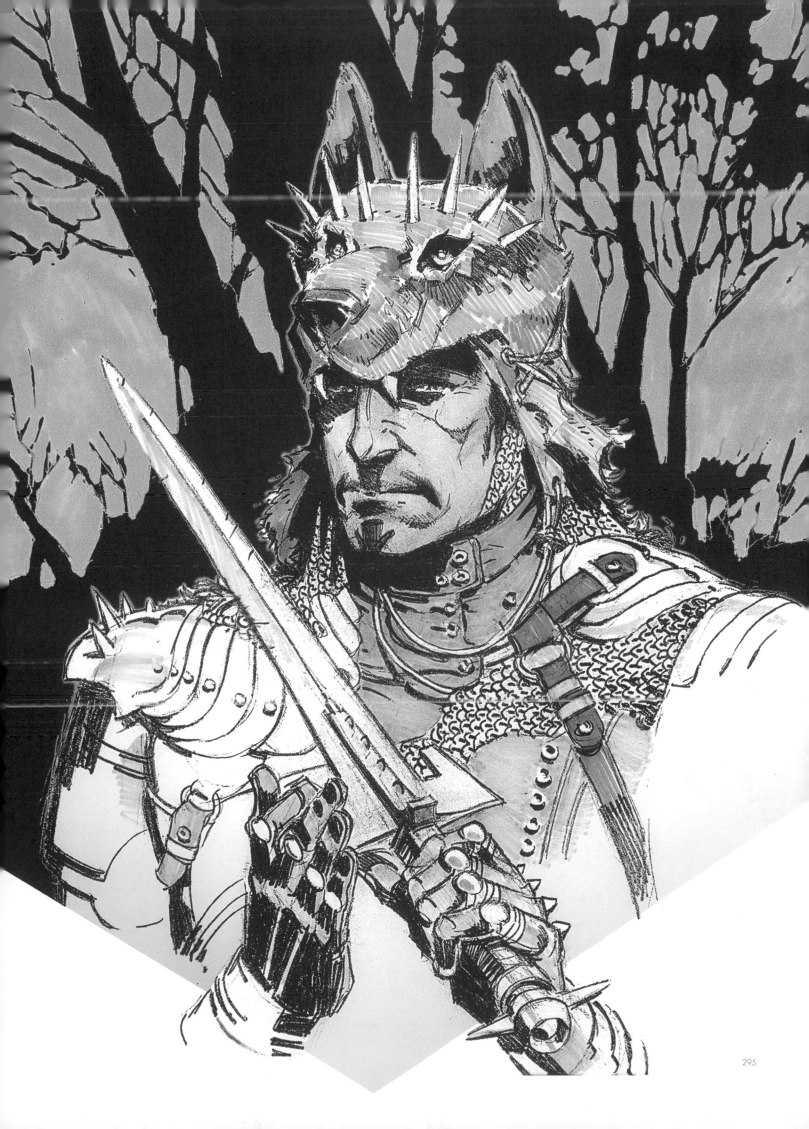

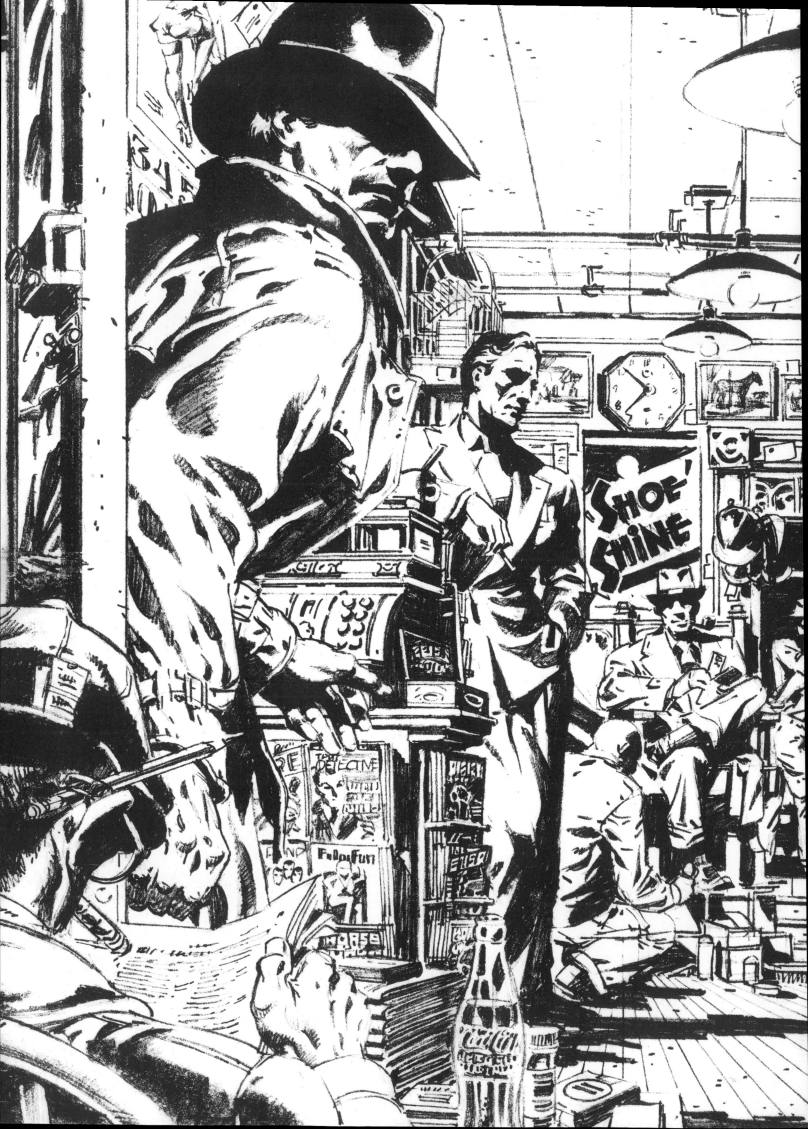

James Sturm

James Sturm, founder of the Center for Cartoon Studies in White River Junction, Vermont, has been keeping a journal/sketchbook since 1984. "For me, cartoons are doodles that have to hit their mark (serve the purpose of a larger narrative)," he asserts. "Doodling that isn't a means to an end is very liberating, especially because my published comics and graphic novels are the result of a long and grueling process consisting of many drafts."

What's more, "Sketchbooks also allow me to put down a wide variety of images that have colonized my brain and look for connections. I'm still working through these images of a robot, a rabbi, and guy in an elephant suit (in a setting that is one part *shtetl* and one part Granite State)," he explains.

For some time, Sturm has been using photo albums as sketchbooks, which "allows me to move images around (which would be harder to do in a bound book) and look for intuitive connections between images as opposed to taming the imagery in service of a story," he says.

Joost Swarte

Joost Swarte, the comics artist, letterer, and interior and architectural designer from Haarlem in the Netherlands – the city of Frans Hals and Pieter Saenredam – says he always sketches, "preferably on loose sheets," and most of these are preparations for an illustration or comic art. "Aside from that, I draw for no specific reason," he states.

Some sketches, therefore, are preludes to finals – "they serve as a memory assistant" – while others are more eclectic. "There was a period when I provided the family's Saturday shopping list with a tiny cover illustration," Swarte admits. "I made hundreds."

Known for his tight renderings of exquisitely loony characters, for Swarte sketches are a natural means of self-expression: "Free sketches are closer to my instinct, close to what Surrealists describe as *écriture automatique* [automatic writing]." Poetically speaking, Swarte adds, "Sketches come from a lake of thoughts, so they seem to be more free than finals, although I do try to keep this freedom in the more elaborated final works."

These sketches were made on tracing paper in the summer of 2010.

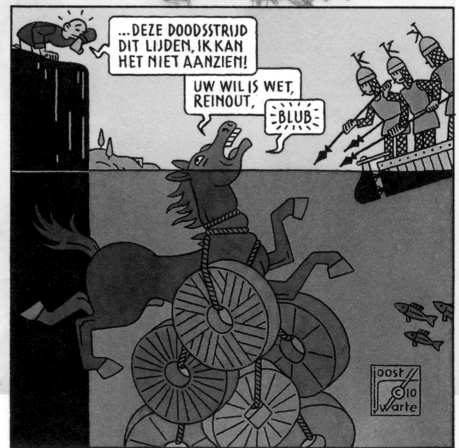

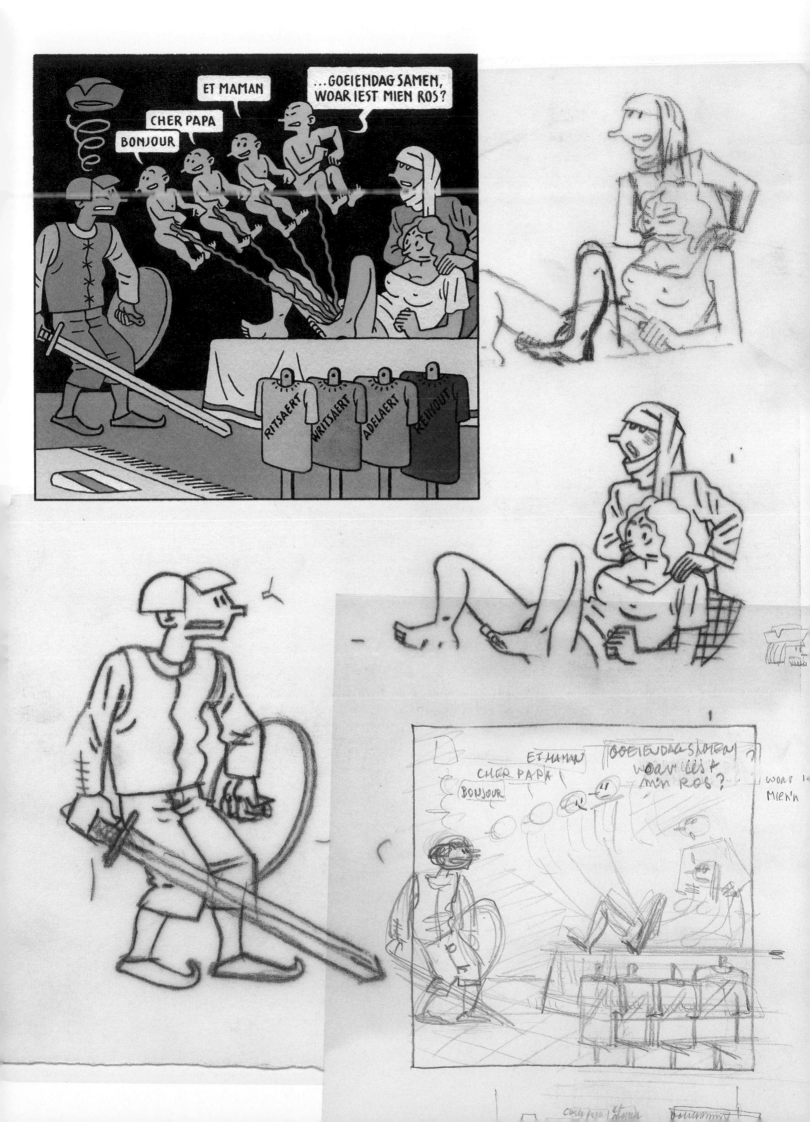

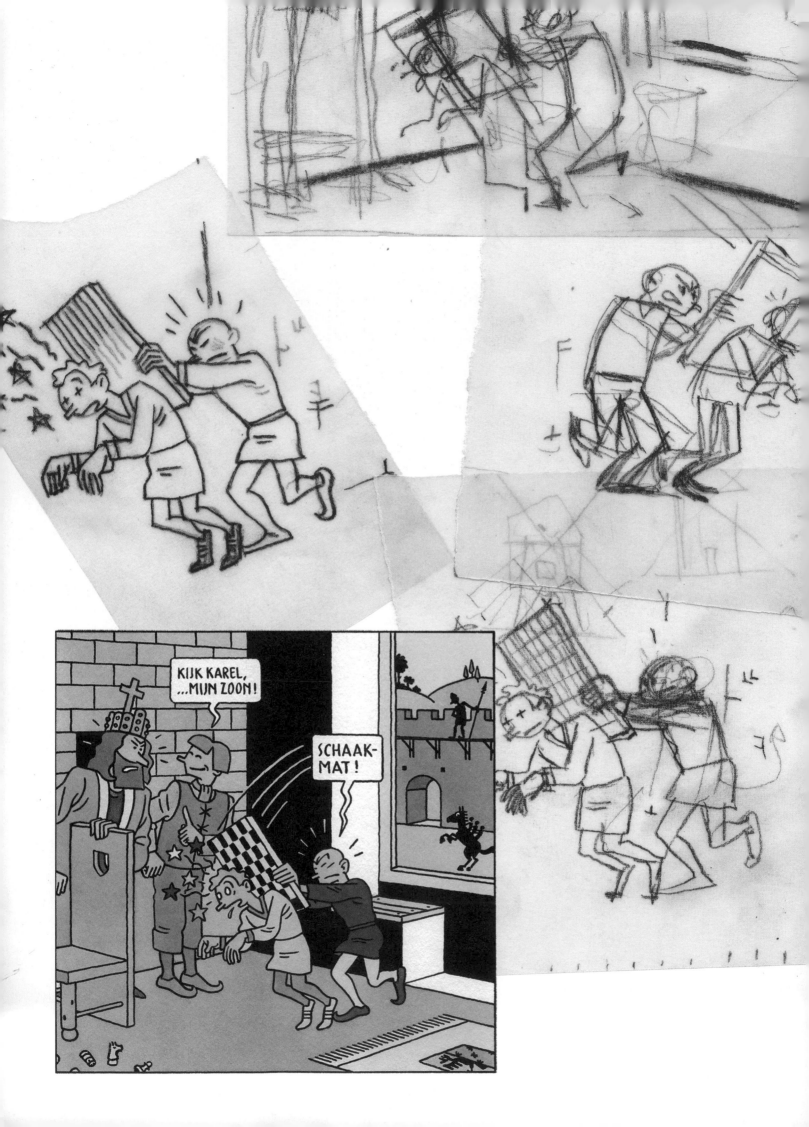

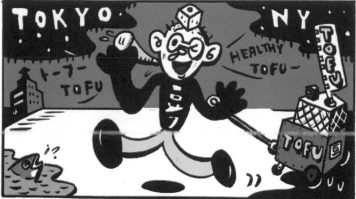

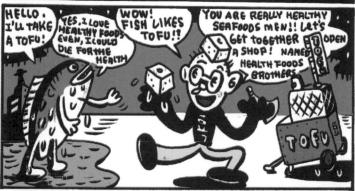

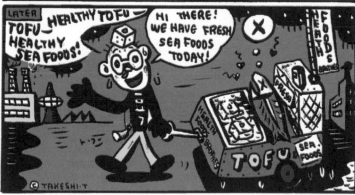

Takeshi Tadatsu

Takeshi Tadatsu came to New York from Tokyo in 1991, when he started to draw the comic strip "Tokyo NY" for *New York Press*. "I met Gary Panter [see p. 242] at his studio and he showed me his great sketchbooks," Tadatsu recalls. "It was a thunderbolt shock to me. Every single page and the covers were great and soooo cool. I've never seen such works in Japan. After that, I met many artists doing sketchbooks in the US, so I began to do it, too."

Back in Japan, his sketchbooks are primarily for drawings, "not comic strips. Those are mostly on tear sheets and I don't keep many of them." Tadatsu's sketches are both preparatory for final work and experimental. "I think sketches are free; some are even more free than in my imagination," he acknowledges. "I create and dig out new ideas and images in my brain."

Sketching helps his narratives, he says: "Over 70 percent of my comic strips don't have a story before I draw them. Sketches bring me to the final panel (somebody said that's why my strips are incomprehensible)."

These days, Tadatsu is focusing on the Fukushima nuclear disaster. "It has made me want to draw about having no nukes," he reveals. "Also, I make many shoebox cars made from cookie boxes and papers, which are now showing in the window of the office of a local Green Party city councilman."

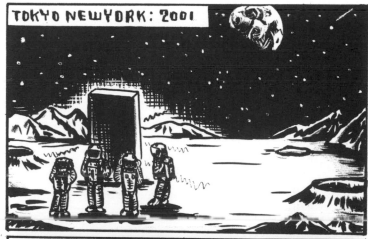

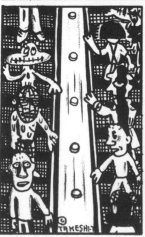

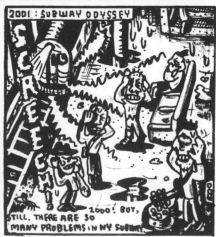

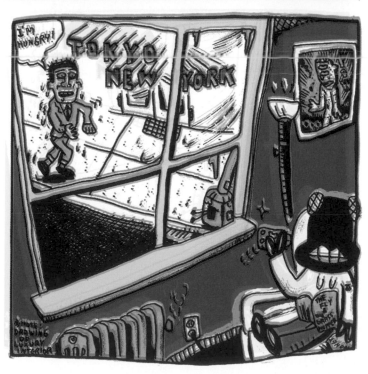

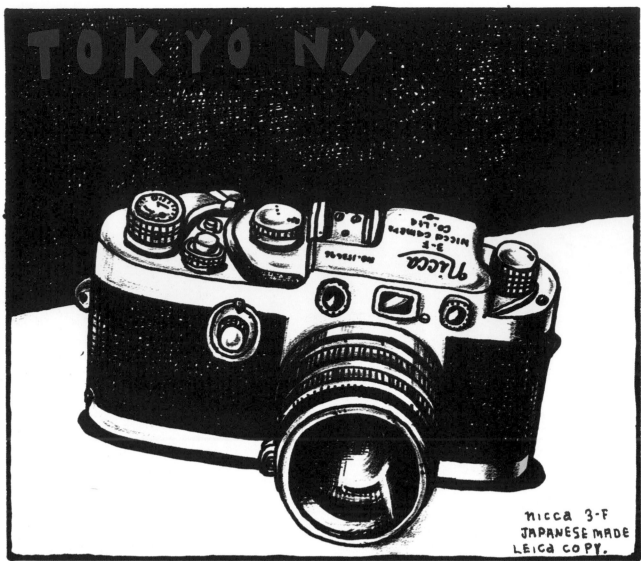

nicca 3-F
JAPANESE MADE
LEICA COPY.

HI THERE, HE DID THIS AGAIN. BIG TITLE PANEL, NO RELATION TO THE STORY. SO, WE DON'T HAVE ENOUGH SPACE AGAIN! MAKE A STORY SIMPLE AND CLEAR OK?! WELL, TODAY, I WANT TO HOLD CONVERSATION ABOUT THE ADLUT SUBJECT FOR A WHILE.

FINALLY, INTO THE FORBIDDEN ADLUT SUBJECT XXX

WOW! WE CAN MAKE DIRTY, DEEP REAL X RATED COMIC STRIP NOW!!

SIMPLE & CLEAR DRAWING!!

AND ALSO, WE HAVE A GUEST TODAY! WELL, ARE YOU READY!?

HI GUYS

xxx

XXX

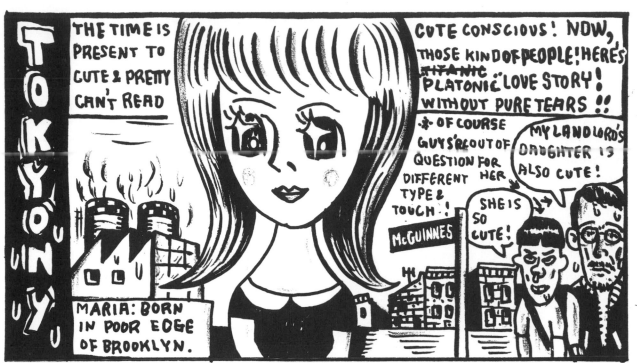

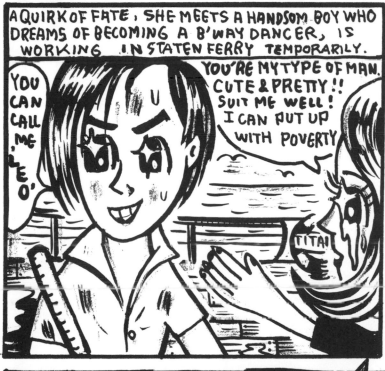

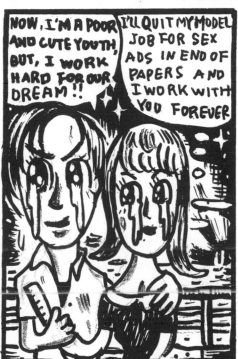

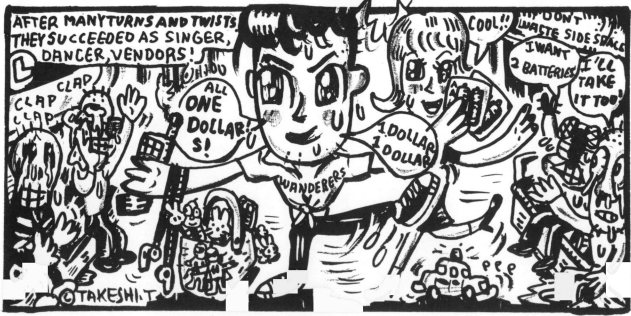

Ann Telnaes

In Washington, D.C., Swedish-born
Ann Telnaes always uses sketchbooks for
her print editorial cartoons. These images are from the
books she keeps for animated editorial cartoons, and
so are less structured. "In addition to drawing quick
sketches of ideas and caricatures," she explains, "I
also note audio possibilities to record later." Telnaes's
finished work tends to be simplified and clean, yet
"I'm sure people will be surprised to see how rough
the sketches can be – sometimes I can't make out my
own thumbnails!" she says. "Sketchbooks are a tool
for me to keep on schedule. I'll grab a piece of paper
(notepads, napkins, envelopes) to sketch ideas but
tend to lose them unless I stick them in a proper book."

Among these sketches for animations for the
Washington Post is one about the Congressional
Oversight Panel (COP), which issued a report noting
that the $700 billion bailout fund (TARP) benefited
not just US banks, but foreign ones as well. The
head of the COP, Elizabeth Warren, said "...there
was no information where this money was going..."
(this page). Another is about President Obama who,
while opposing Proposition 8 (on same-sex marriage),
had stated during the 2008 president campaign,
"I believe marriage is between a man and a
woman." And one focuses on election gains by
Tea Party candidates and the consequences for the
Republican Party (both overleaf).

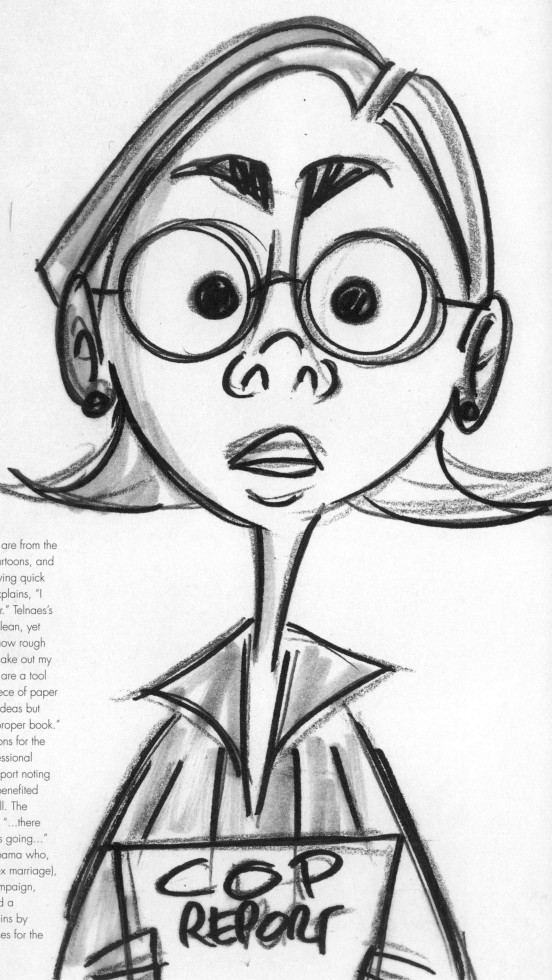

AND THE WINNER IS...

YOU

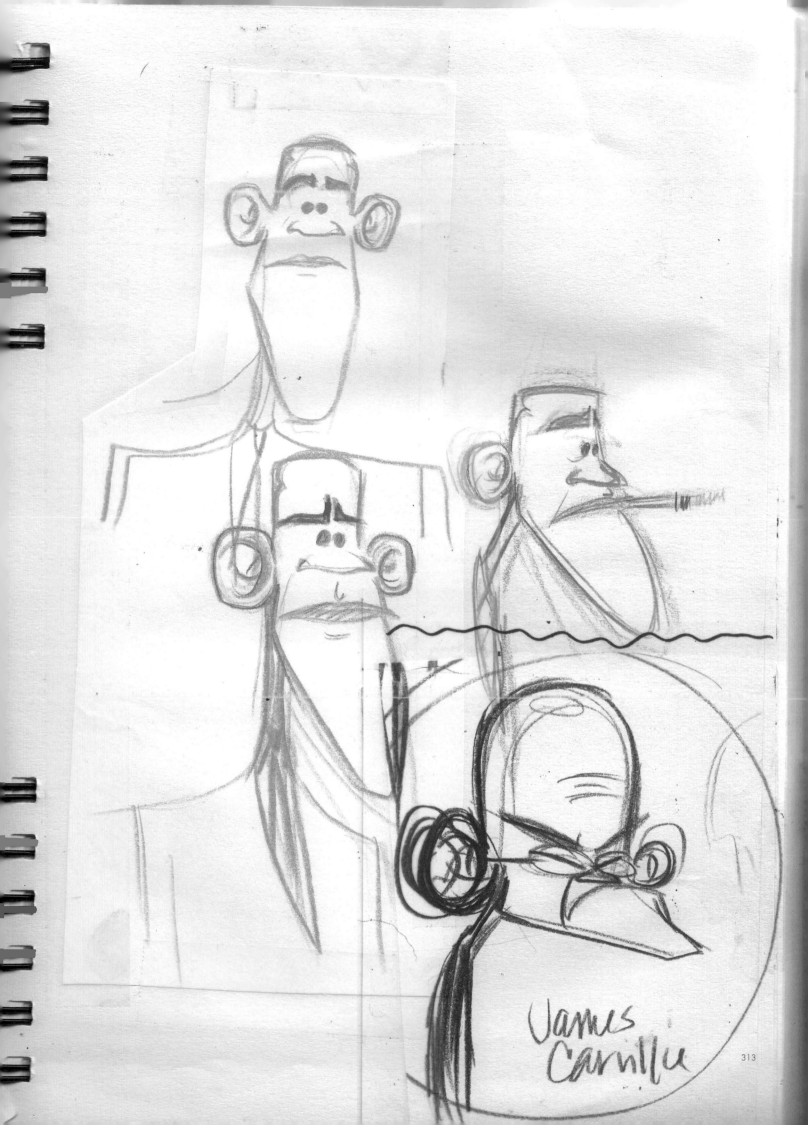

James
Carrillu

313

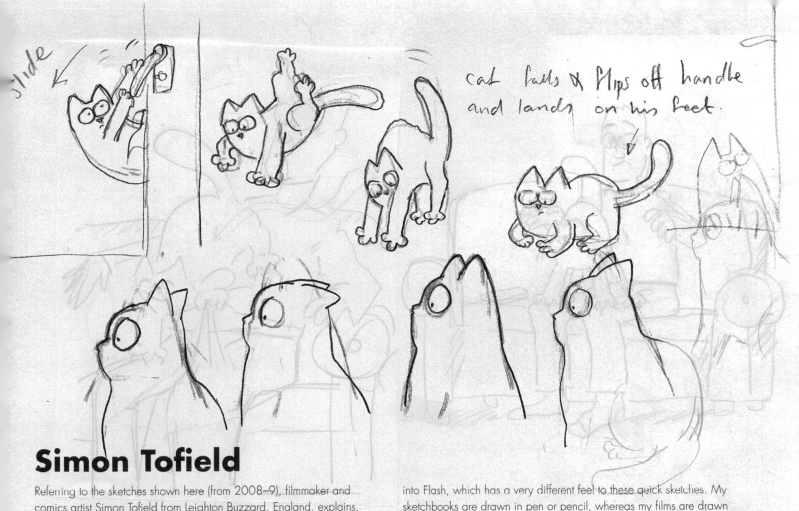

Simon Tofield

Referring to the sketches shown here (from 2008–9), filmmaker and comics artist Simon Tofield from Leighton Buzzard, England, explains, "These sketches were done to work out a rough storyline for my short films. I don't like to write too much during this process. I prefer to work it out visually through drawings. This often means a lot of crossing out or swapping around of images in the sequence. I work a lot better with drawings than with writing."

Tofield adds that, even when sketching, "I don't normally commit to paper until it is clear in my mind first. The quality of the line is very rough and these are drawn very quickly. My finished films are drawn directly

into Flash, which has a very different feel to these quick sketches. My sketchbooks are drawn in pen or pencil, whereas my films are drawn digitally with a Wacom pen."

He injects a caveat: "I wouldn't normally show people my work at this stage of the process. Usually people only see the finished films before I put them on YouTube or onto the page of one of my books. So the drawings might seem a little unusual for someone familiar with my work. Also, my sketches read very much like a storyboard or comic," he adds.

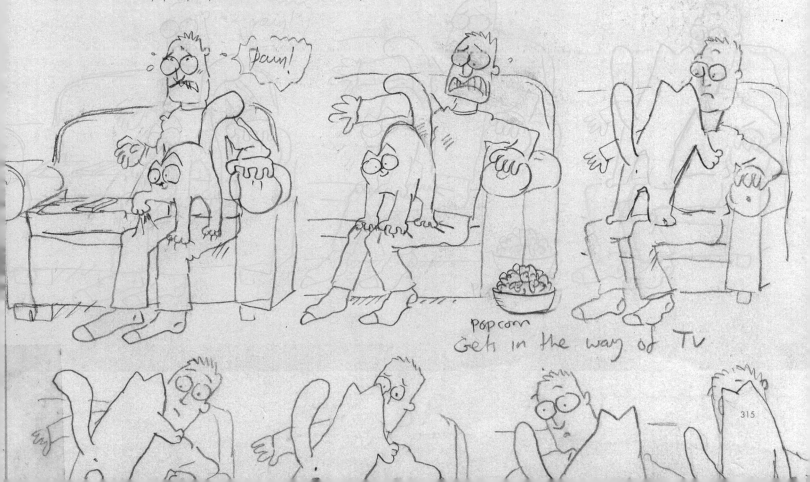

315

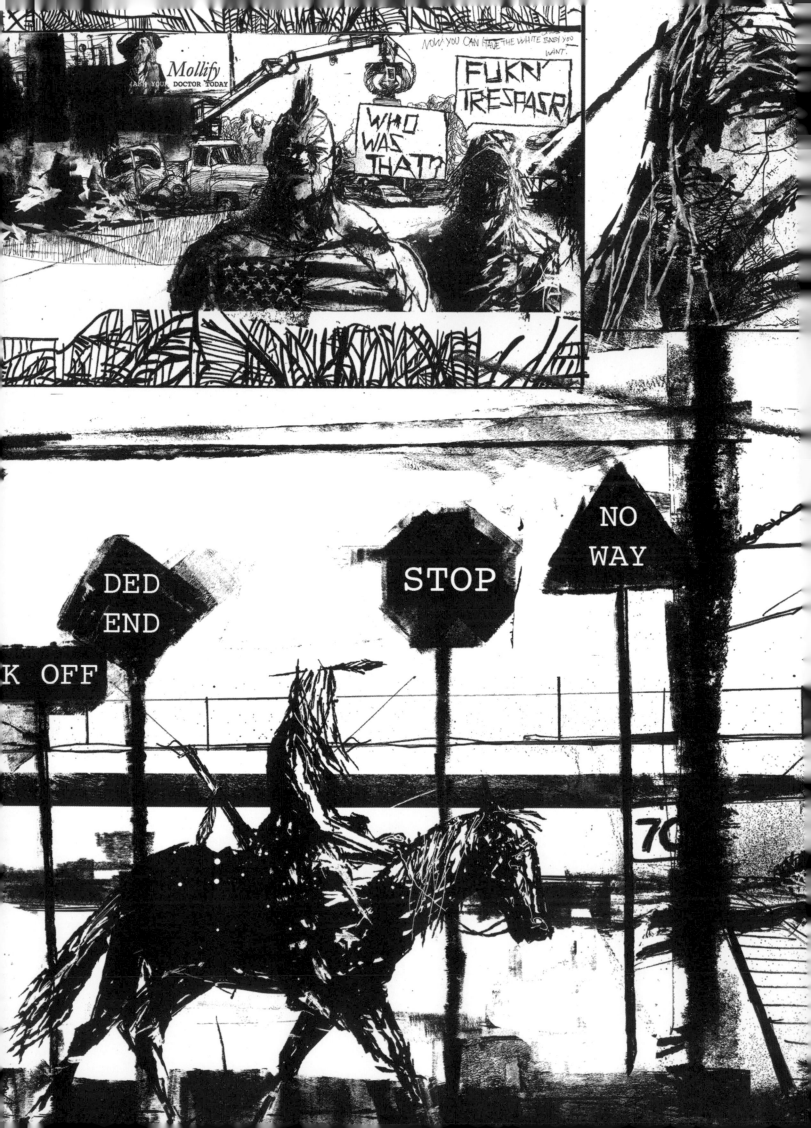

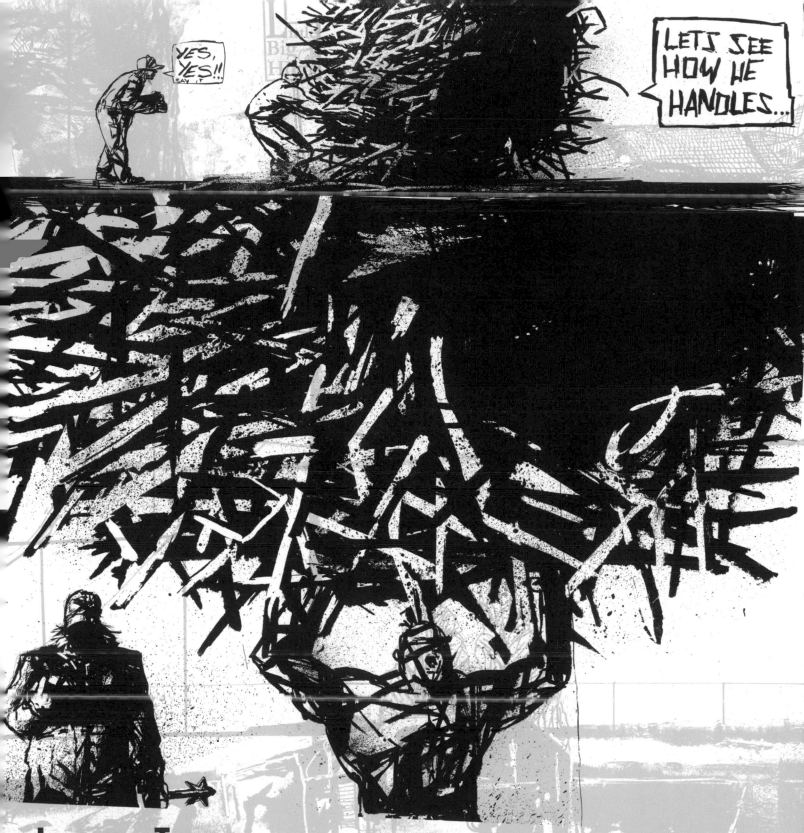

Jeremy Traum

Jeremy Traum's Portland, Oregon, sketchbooks mostly contain anatomical and nature studies. "That's the one big tip that I garnered from other successful artists," he remarks. "I went to Frank Frazetta's museum in Pennsylvania one time and had the pleasure of meeting his wife. The one thing he always stressed was anatomy, anatomy, anatomy. You should be able to do it from your head, and that only comes from doing studies. Nobody is born with that skill."

Traum also does thumbnail compositions, and sometimes "I just enjoy doodling nonsense from my head," he adds. "I got used to jumping right into the finish and if it didn't work I'd do another. But since I started putting things together for this book, I've been sketching and studying a lot more and it's paid off." The more studies Traum does, "the more I feel like I've added to my repertoire of things I can convey and in turn convince myself that I'm a better artist now than I was then. I start freaking out if my work stagnates and I don't feel like I'm getting better. I have so many interests that I couldn't possibly draw the same character over and over again, there's just no fascination in it. From a morbid viewpoint, I know I have so much I want to accomplish and I know I'm gonna die, so it's kind of a race-against-the-clock scenario. How much content can I get through before I'm dead? Do other people think like that? I think about death every day. I'm using the word 'I' too much, I think. I should use 'me' instead. Me thinks me had too much coffee and me thinks me gonna die one day."

Carol Tyler

Carol Tyler, who lives in Cleveland, Ohio, explains she's been working in her sketchbooks for "going on fifty years. Sketching is my shorthand," she continues. "Years ago, I used to sketch to remember things, but now I sketch for accuracy as a preliminary to a final drawing. These days my drawings serve a purpose, and that is to work out compositions and 'figure out' the figures. Rarely do I doodle for the sake of free-form activity, but that's because I'm in the middle of a major project. I would like to play more, and hopefully someday I can do that again." By all appearances, the sketches are "a little rougher in terms of being looser, and they are softer because I find my images by using soft pencil on a very toothy paper. When I transfer them to the plate finish paper, they tighten up. And then they REALLY tighten up when I ink them," she says. "Whenever I draw something, even if I'm trying to convey something specific, I'm always amazed at the outcome. I feel like these are precious gems and I'm a miner. They're not an extension of my ego, but images that I find in order to communicate. When I finish something that turns out pretty awesome, I thank my sister in heaven, because I could NOT create things on my own." These sketches are from 2006–11.

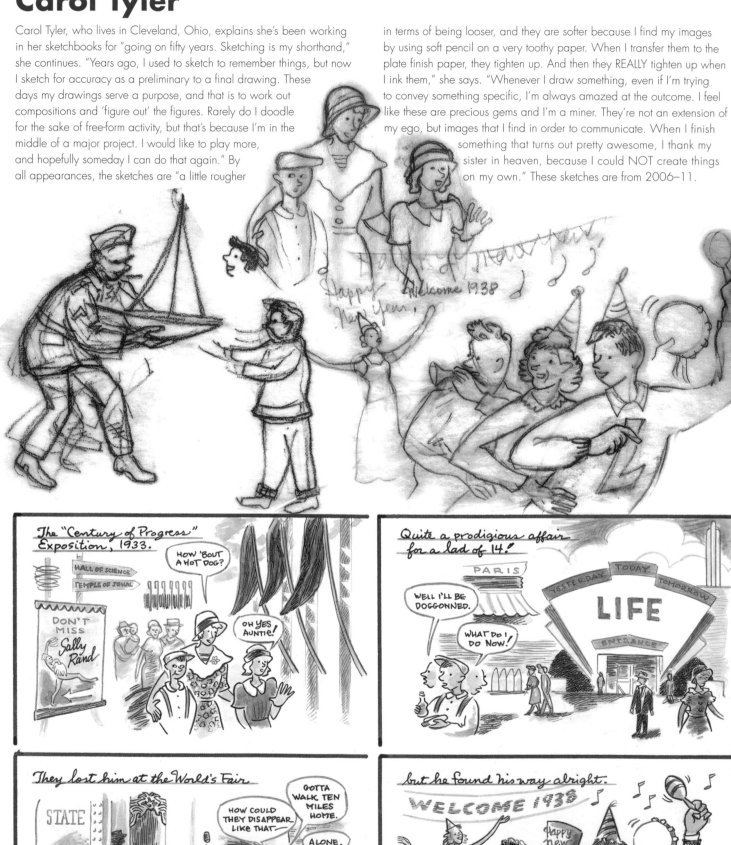

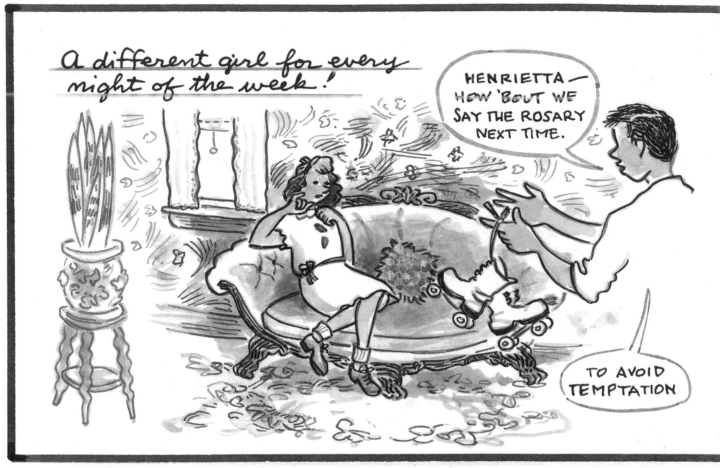

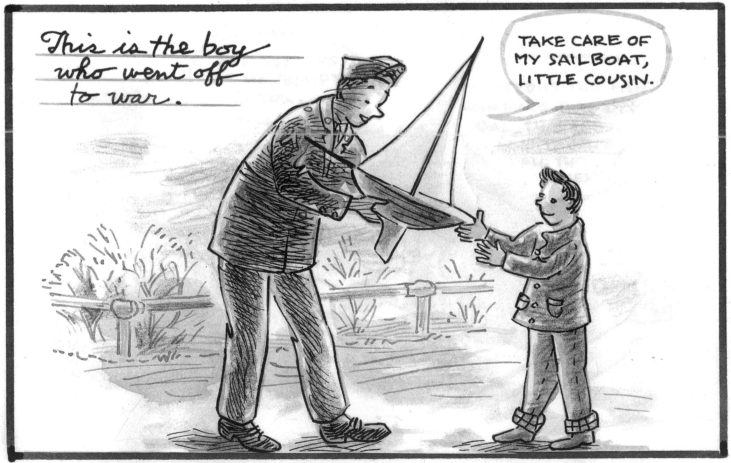

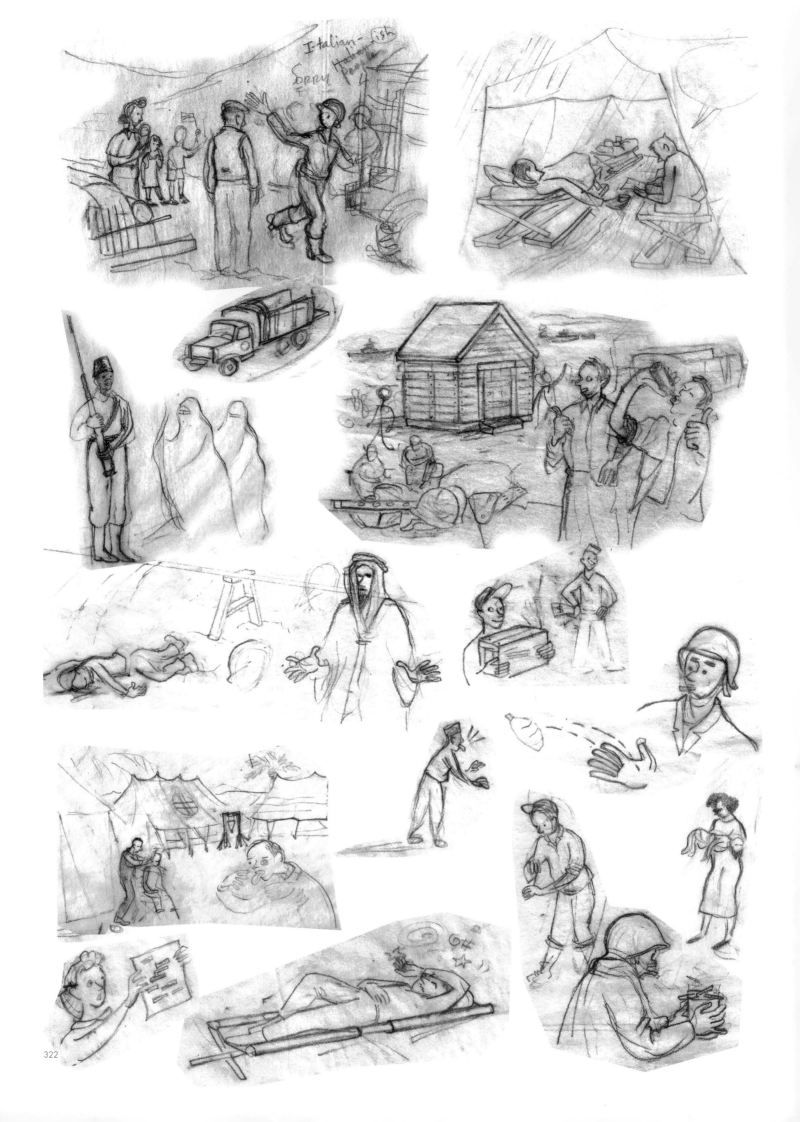

27

"The deal was, his men would not kill our soldiers if we would let his harum come in and use the shower. Oh boy, did we ever agree to that one! All those girls! Everyone volunteered, but the Sheik brought in his own private security force: French Moroccan soldiers, all cut up, lips bleeding from fights, every one 6'6" or better, each one wearing a fez and a sword, and holding a long rifle. They stood sentry at the shower tent, the one I built, to keep me and all the other GIs at a distance."

28

"After that, they didn't know what to do with me. I completed every task they assigned right away. I even rebuilt the latrines, but that was nothing—dig a trench and put down a wooden board with holes in it. There just wasn't any plumbing left to do. So they gave me busy work and that's when the drinking began in earnest, to ease the boredom. To not miss home. Everybody drank. That was just the way it was. To forget where we were."

29

"Enlisted had beer, but the officers had booze. The Navy always had booze on the ships. And since I had to work with the Navy on water projects, I had access. Once, I was working out in the heat and this guy hands me a little bottle of Anisette. I drank it down. 'This is nothing,' I thought. So I went over to the Navy ship and got 3-4 more bottles. Swilled it all down, clean like water. Boy, the next morning, I couldn't scratch my head with both hands. Oh, that was awful!"

30

"Bad times the next morning, too. My head was pounding and I was never so thirsty. So I stumbled over to the middle of the base to get me a drink of water. They had this triangular bag hanging there with these nipple spouts below. I drew myself a long, cool drink of water, but AWGH!—Quinine water for malaria. On top of my Anisette hang-over: P.U.! But that was the only water available. And then when I realized that I had lost my picture of Red... this was worst of all. After this incident, I quit foolin' around with shit I didn't know."

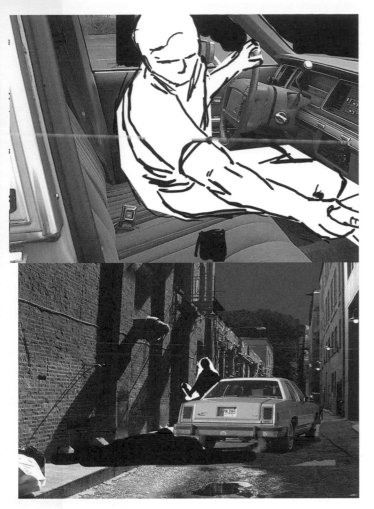

Andrés Vera Martínez

Ever since he was a child, Texas-born Andrés Vera Martínez has sketched. But, "now that I'm a professional," he states, "I don't keep a sketchbook." He says he would, "if I had the time, but I spend most of my spare time with my wife and daughter. So when I sketch it's usually thumbnails to show editors. When I'm working on a book, I sketch out the whole thing in a binder to the size at which it's going to be printed. This is an important part of my process, since it helps to keep the art and writing in order. I also make character sketches and sometimes location sketches, but they are all kept in a three-ring binder for each specific project. The process of sketching out a book seems very different to me than keeping a sketchbook. I tend to think of a sketchbook as being a free flow of creative ideas."

Mostly sketches are a plan for a finished project. Style, storytelling, and content are all developed for the most part in his sketches. "My finished work is usually a refinement of my sketches, for elements such as line quality, design, and dialogue of the characters. Sometimes there are big changes made from the sketches, but not often," he reports.

The images on these pages are from *Dear Chicago*, "a comic about my time spent in that city attending the School of the Art Institute of Chicago," he recalls. "This was one of the more dramatic experiences. I took up a new style because of the 'Dexter' project I had done earlier, and found a way to incorporate photo reference more fluidly into my sketches."

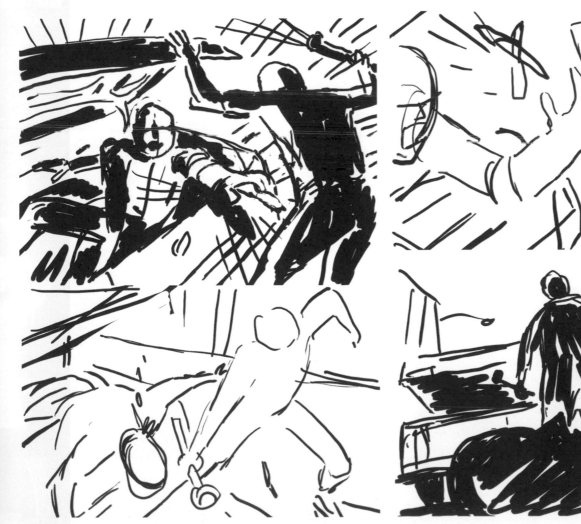

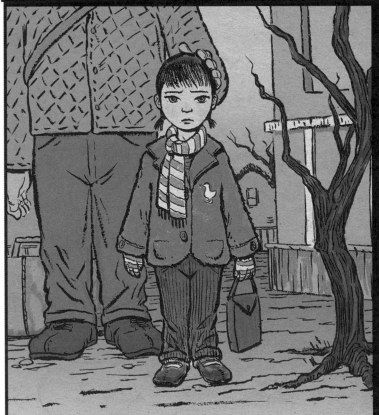

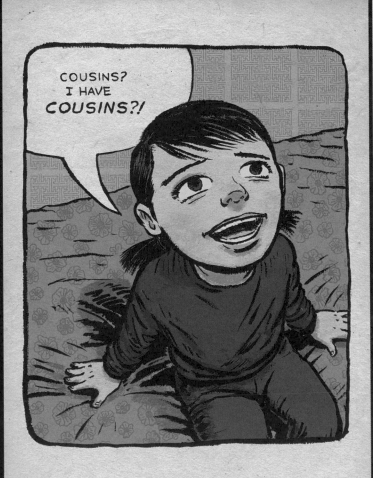

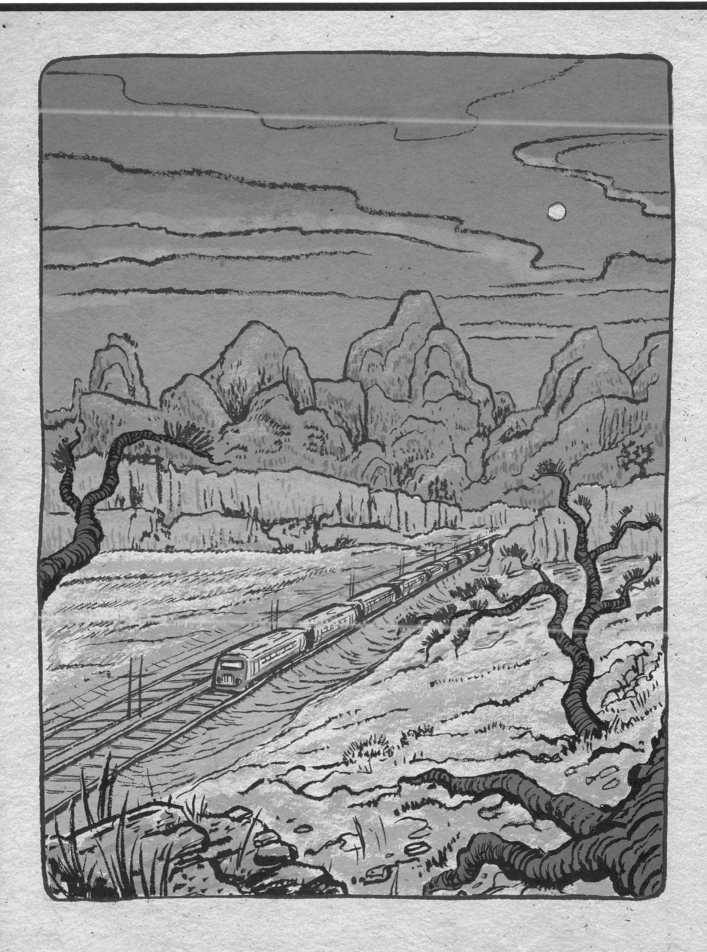

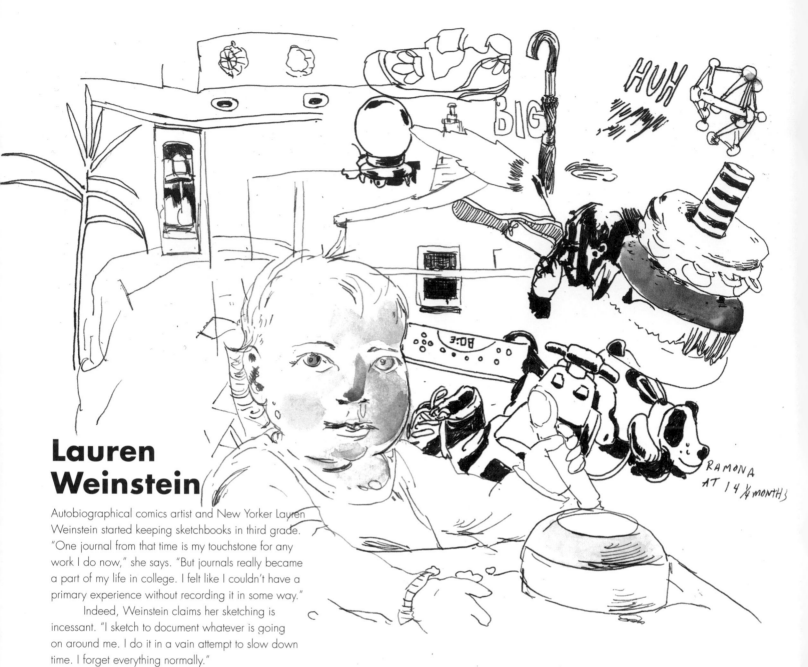

Lauren Weinstein

Autobiographical comics artist and New Yorker Lauren Weinstein started keeping sketchbooks in third grade. "One journal from that time is my touchstone for any work I do now," she says. "But journals really became a part of my life in college. I felt like I couldn't have a primary experience without recording it in some way."

Indeed, Weinstein claims her sketching is incessant. "I sketch to document whatever is going on around me. I do it in a vain attempt to slow down time. I forget everything normally."

Her sketches can serve as experiments: "Sometimes they are a place to record my deepest desires, misgivings or fears – stuff that I wouldn't want to publish any time soon," she confides. "The stuff is usually pretty raw. But sometimes I imagine an audience: I want to make my handwriting very good for these imaginary readers."

The work shown here is very raw. "I don't try and edit too much. My finished work usually goes through a couple of revisions." This is what it is.

RAMONA AT 14½ MONTHS

THE WORST DAYS ARE WHEN YOU HAVEN'T SLEPT FROM THE NIGHT BEFORE.

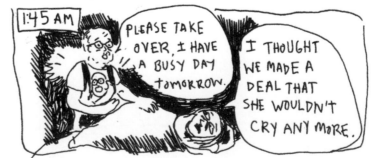

1:45 AM

PLEASE TAKE OVER. I HAVE A BUSY DAY TOMORROW.

I THOUGHT WE MADE A DEAL THAT SHE WOULDN'T CRY ANY MORE.

SO THE NEXT DAY I WALK AROUND AT THE HEAPS OF LAUNDRY, AND MY HALF PENCILED PAGES OF MY FOUR YEAR LATE BOOK. AND HERE WE ARE IN BED, I'M TRYING TO GET HER TO SLEEP SO I CAN SLEEP.

HOW TO DRAW A BABY....

SHE'S SO PERFECT, THAT SHE HAS TO BE DRAWN WITHOUT HATCHING, WHICH WOULD JUST MAR THE EFFECT OF HER PURE SKIN.
IT HAS TO BE ONE PURE LINE.

BUT I ALWAYS GET HER PROPORTIONS WRONG.

I NEVER GET THE CRANIUM BIG ENOUGH.

FORESHORTENED VIEW IS EVEN MORE UNBELIEVABLE.

WRONG!

WRONG

WRONG.

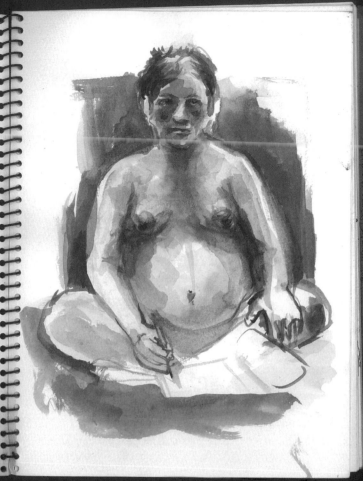

COMING HERE, DR. WAS IN AN ORGY WITH NATURE NOW HE SITS BESIDE ME, SLEEPING ON OUR LOOKOUT POST IN NORTH LUBEC LOOKING ACROSS THE BAY OVER INTO THE TOWN.

WE ARE COMPLETELY SILENT. CROWS WENT FROM WEST TO EAST CACKLING AND SWARMING AROUND AND CLOSER IN, IN SURROUND SOUND ARE CRICKETS. THE CROWS ARE NOW SPREAD OUT IN A CIRCLE AROUND ME CALLING CAW CAW CAW TO EACH OTHER. NOW A TRUCK GOES BY. DR. BUDDY SITS UPRIGHT WITH HIS EARS COCKED TRYING TO TAKE IT ALL IN. NEITHER OF US ARE USED TO THE LOUDNESS OF NATURE.

YESTERDAY WE WENT TO THE QUODDY HEAD NATURE PRESERVE, WHICH WAS MORE GERIATRIC THAN CUTLER BUT WAY BETTER FOR ACTUALLY SITTING AROUND AND OBSERVING THE WILDS. TIM WAS THE FIRST TO SEE SOMETHING — A PORPOISE, OR PERHAPS A MINKE WHALE, SLOWLY BREACHING, GLIDING ABOVE THE SURFACE LIKE A BLACK SLIT OPENING UP IN THE FOG

I KEPT MY EYES TRAINED ON THE WATER AND SAW A LOT OF SEA BIRDS FISHING AND THEN I SAW THIS ——→ A SEAL'S HEAD CHUGGING ALONG THE SURFACE OF THE WATER

WE ARE UP ON THE LOOKOUT AGAIN. A DENSE FOG HAS SETTLED OVER EVERYTHING AND SUDDENLY IT'S FALL. IT'S A LITTLE COLDER. THERE'S A FAINT BURNT SMELL IN THE AIR. EVERYTHING FEELS FORBODING AND CALM. THEN, VERY SUBTLY THE FOG LIFTS, BUT IT GETS DARKER, LIKE THE WORLD IS EXHALING A LITTLE.

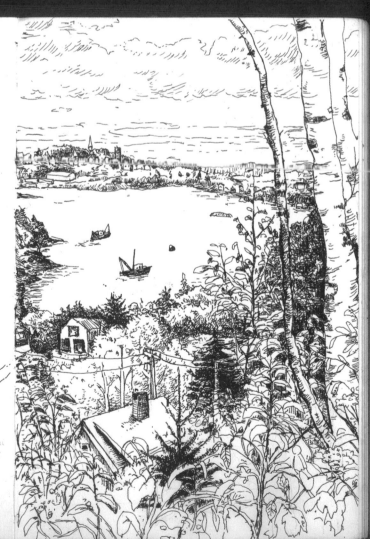

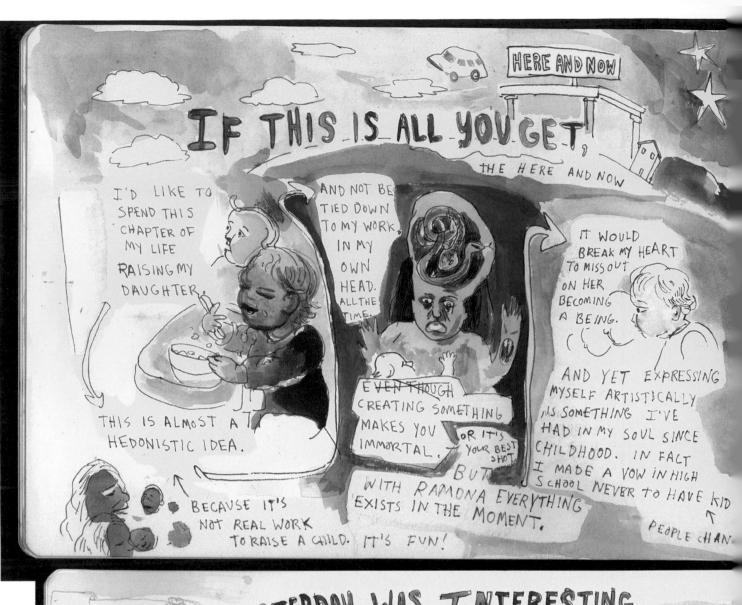

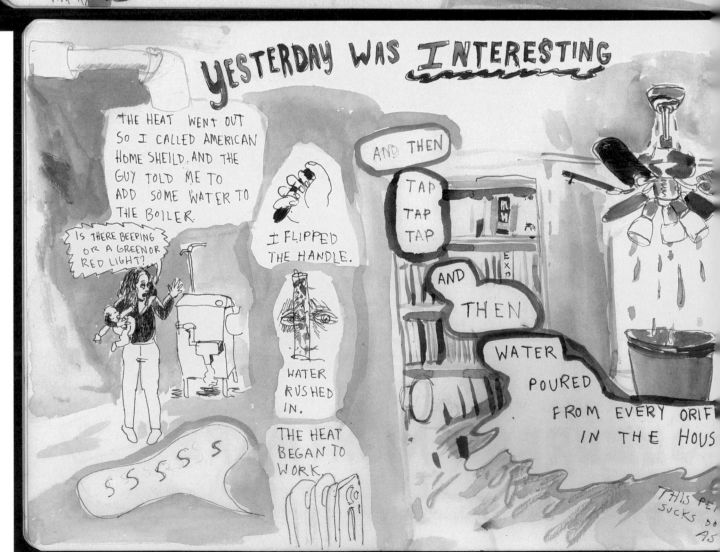

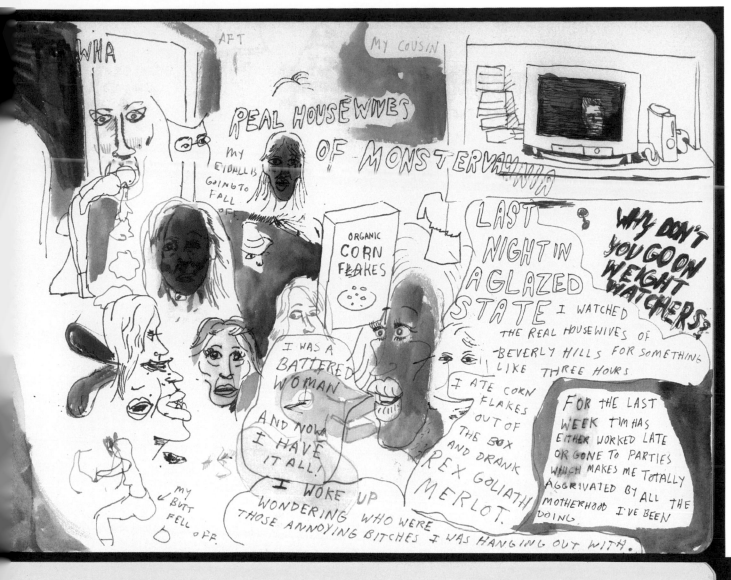

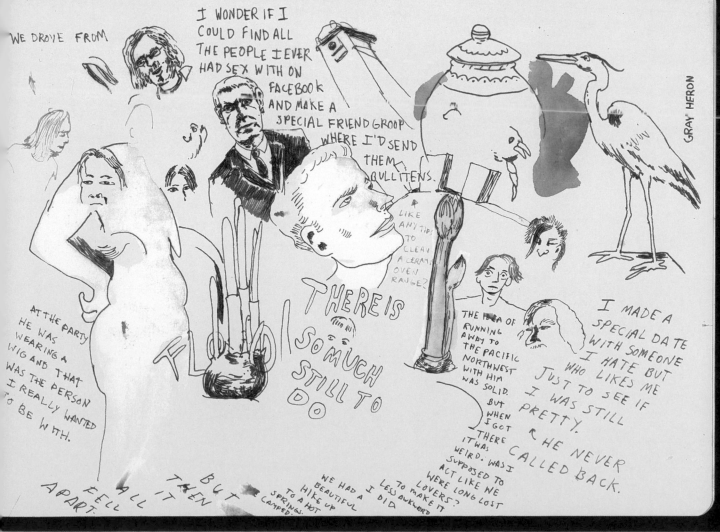

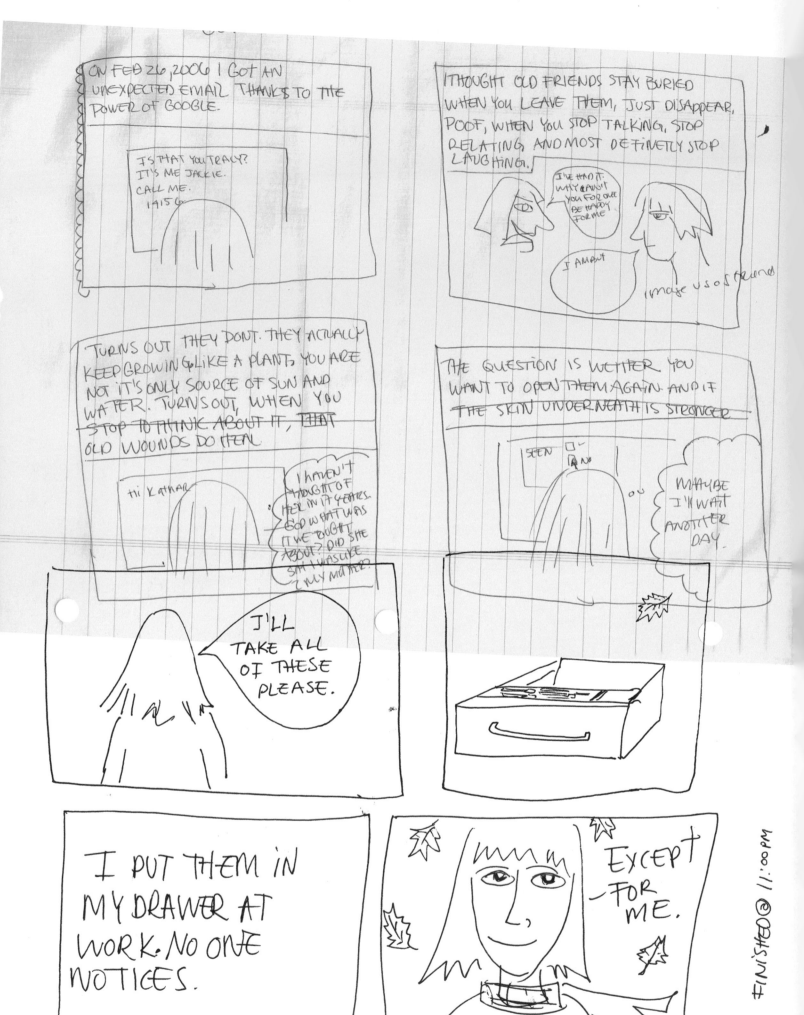

Tracy White

New Yorker Tracy White, a webcomic writer and book author, is reluctant to use the word "sketchbooks" to describe her work. "Mostly I draw on the yellow lined paper in the pads I bulk buy from Staples and use for my writing," she clarifies. "Or I doodle in the small notebooks that I always carry around. What I do keep are diaries that I sometimes draw and glue ephemera into, and those diaries are large hardcover black sketchbooks."

She is quite clear on the purpose of sketching: "To mess around, relax, occupy my brain just enough so the real ideas, the ones deep down, can come out," she announces, "although I think all musings serve a purpose, even if we don't have that intention."

The images shown here were drawn using a pen and paper instead of her tool of choice, a Wacom tablet and screen. Their primary attributes are "serendipity, memory, daily life. I tend to work with a noun I pull off a list from a set of cards I've made, or from a magazine, then think about an association with that word. Or else the drawings are very project-specific, revolving around what I'm working on. They are all ways I am trying to solve a visual story," she explains.

→ online connections
 ↳ sharing
→ narrative comp
→ transport acro
 Borders
→ reach people en
→ networked n
– vividly expre
→ new ways o/tra
→ provide conter
virtuosity
* promote tha

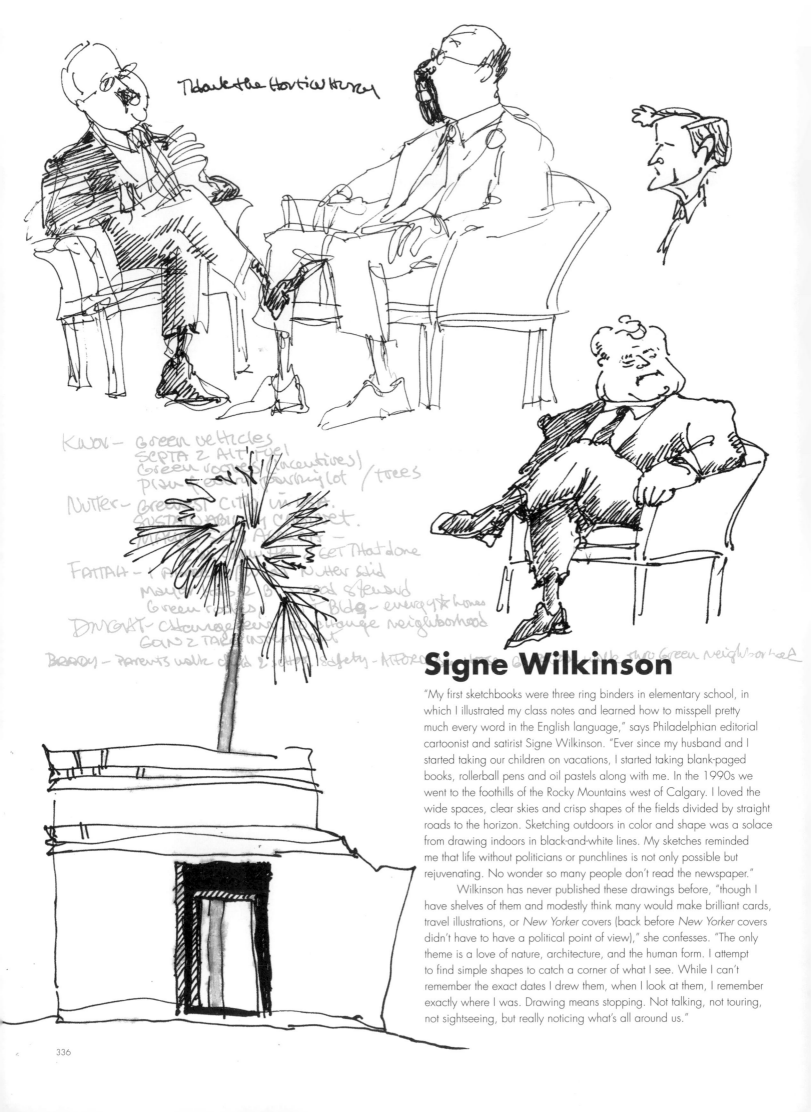

Signe Wilkinson

"My first sketchbooks were three ring binders in elementary school, in which I illustrated my class notes and learned how to misspell pretty much every word in the English language," says Philadelphian editorial cartoonist and satirist Signe Wilkinson. "Ever since my husband and I started taking our children on vacations, I started taking blank-paged books, rollerball pens and oil pastels along with me. In the 1990s we went to the foothills of the Rocky Mountains west of Calgary. I loved the wide spaces, clear skies and crisp shapes of the fields divided by straight roads to the horizon. Sketching outdoors in color and shape was a solace from drawing indoors in black-and-white lines. My sketches reminded me that life without politicians or punchlines is not only possible but rejuvenating. No wonder so many people don't read the newspaper."

Wilkinson has never published these drawings before, "though I have shelves of them and modestly think many would make brilliant cards, travel illustrations, or *New Yorker* covers (back before *New Yorker* covers didn't have to have a political point of view)," she confesses. "The only theme is a love of nature, architecture, and the human form. I attempt to find simple shapes to catch a corner of what I see. While I can't remember the exact dates I drew them, when I look at them, I remember exactly where I was. Drawing means stopping. Not talking, not touring, not sightseeing, but really noticing what's all around us."

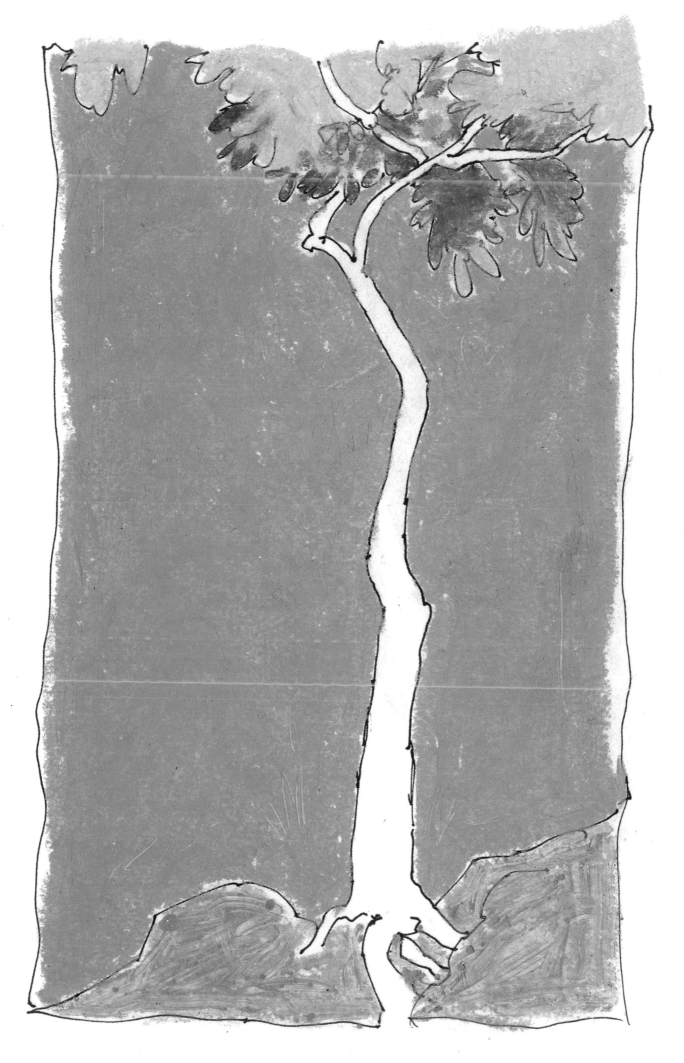

without
eyes.

heart left

FRE

without head?

endless r

opening some kind of

338

Run Wrake

When Run Wrake, the animator from Kent, England, who has made films, artwork, and videos for clients including MTV, U2, and DJ Howie B, talks about sketchbooks, his primary focus is "spontaneity." His books are for unfettered thinking, "the place for initial thoughts, either developing an idea from a brief or just oiling the wheels, looking for a spark," he explains. "But I often find that it's as much a place to see what doesn't work as what does."

He wants to be clear that the work in a sketchbook "is only designed to help me – the aesthetic quality is secondary to that, whereas with the finished work aesthetic quality is all. Actually, having said that, I remember trying to make them look as good as Picasso's, which were exhibited in London while I was at Chelsea [College of Art and Design in London]. Ha! Some chance." Shown here are sketches, doodles, and roughs from 1993–2009.

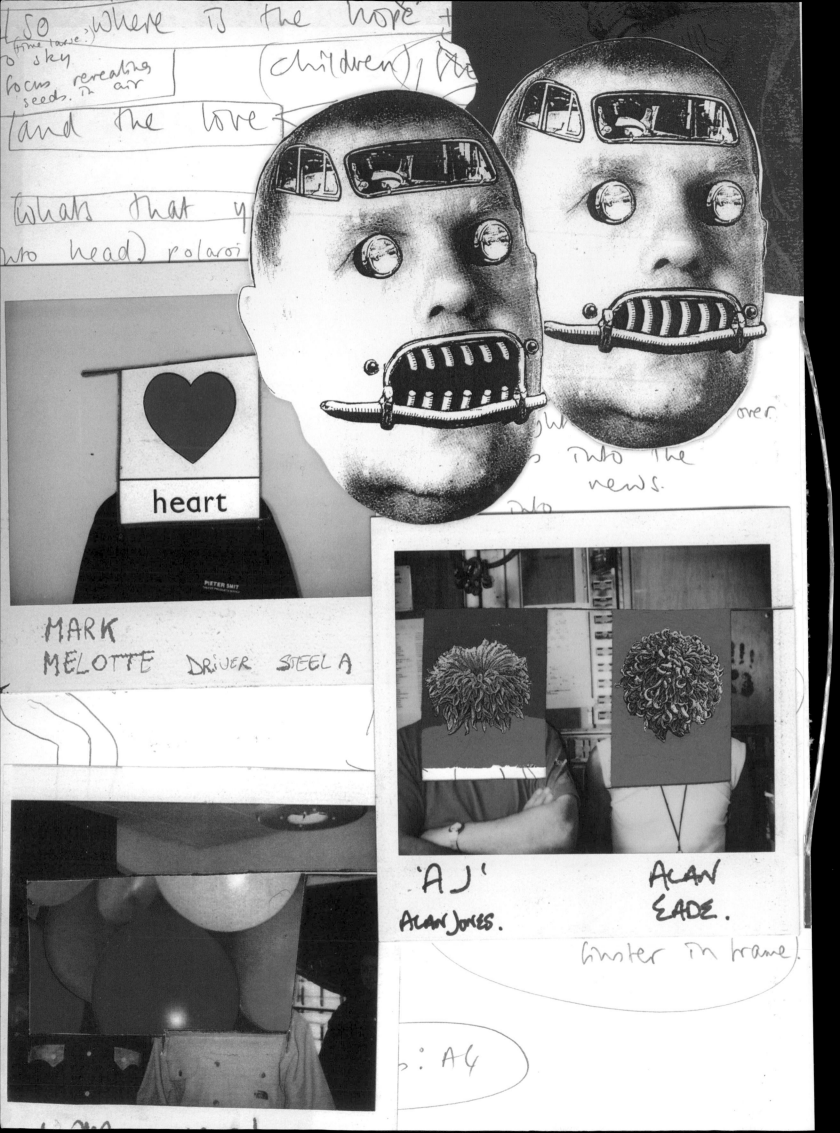

SO WHERE IS the hope
sky
focus revealing
seeds in air

(children)

and the love

whats that y

to head) polaroi

heart

over.

into the
news.

into

MARK
MELOTTE DRIVER STEEL A

'AJ'
ALAN JONES.

ALAN
EADE.

(sister in frame).

: A4

14

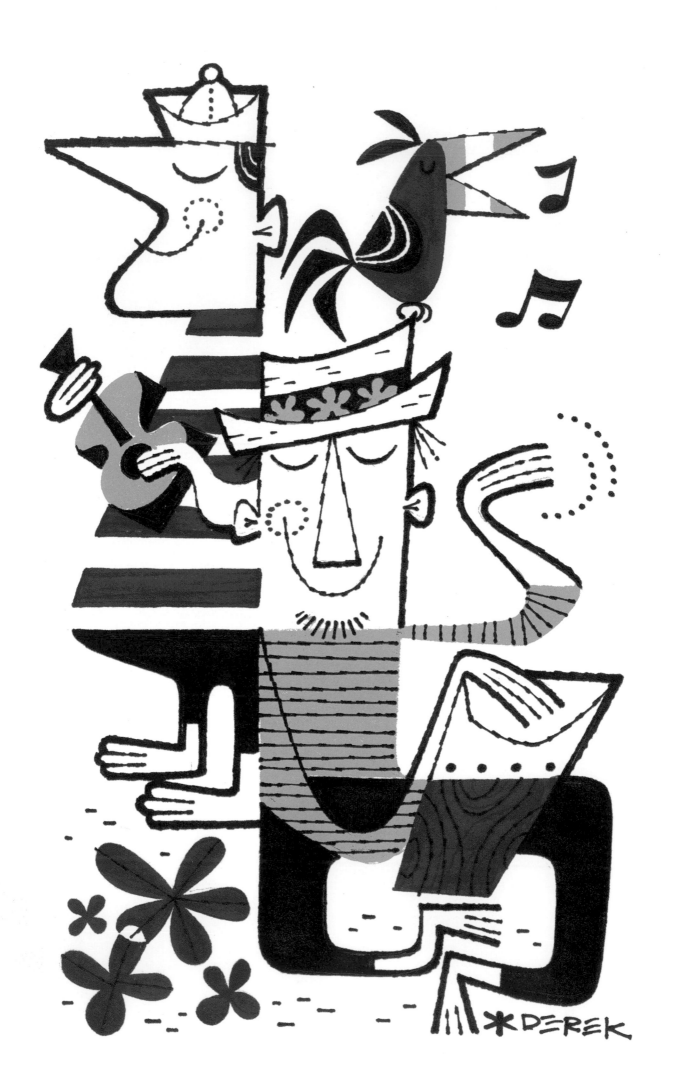

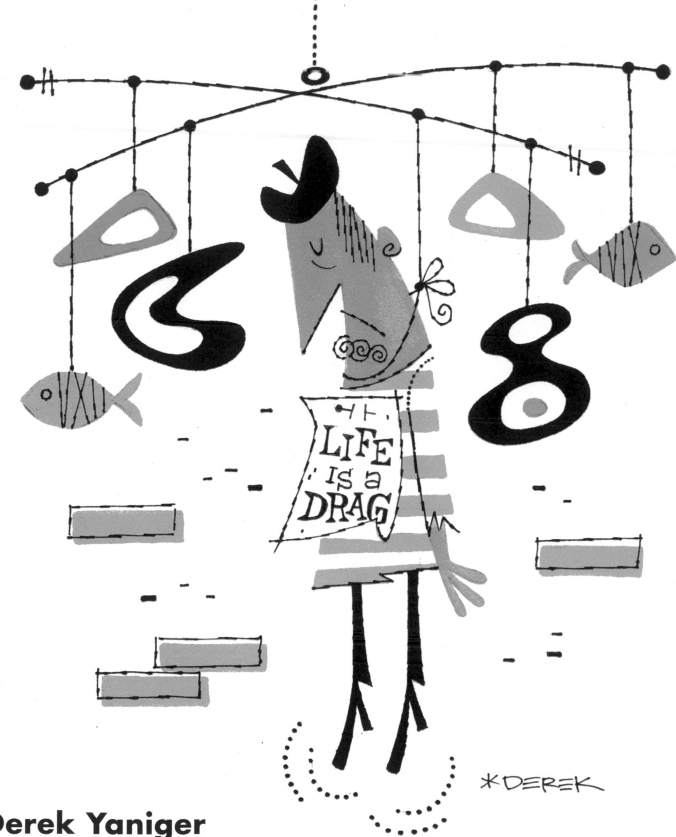

Derek Yaniger

Atlanta-based, Georgia-accented Derek Yaniger colorfully reports, "I've been scribblin' in sketchbooks since I was a snot-nosed lil' crumb-snatcher! I kinda got outta the habit when I was makin' art for the Man [Marvel, Cartoon Network]. But once I gave the nine-to-five bit the heave-ho and started dancin' to the beat of my own bongos, I started sketchin' again. These days I never leave my digs without a sketchbook and a fistful of pens 'n' pencils!" Sketching started out as a way to "kill some tick-tocks… ya know…standin' in line at the post office or waitin' for a haircut," he adds. "But I started really gettin' into it…some of my best stuff was comin' outta the scribbles. As my work became more and more popular and my paintings started really sellin', sketchbook originals became a way

for chicks 'n' chucks to get their mitts on my work for a lot less cabbage, dig?" When Yaniger cracks open the book "and I start a-scratchin', I have no idea where it will end up. Lots of my scribbles have become full-scale paintings or serigraphs, but I think most sketches stay just that, sketches. Lots of shirts 'n' skirts think my paintings are screenprints on wood because they's tighter than a duck's ass!" One look at his scribbles and "you probably get that I dig art with a retro vibe. Tryin' to capture the look and feel of those way-gone illustrations of the fifties and early sixties is what I'm all about. I mess with all kinds of vintage themes…boozers, beats 'n' tiki freaks, sophisticats 'n' fine felines…swingers, flingers 'n' ring-a-ding-dingers!!" Crazy man! The images here are from 2007–10.

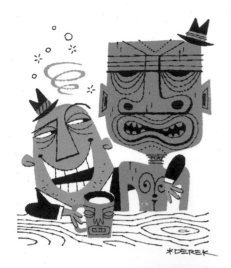

NAME YOUR POISON.

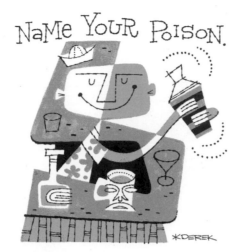

C IS for CAD.

B IS for BURLESQUE.

346

Danijel Žeželj

Perhaps residing in poetic Brooklyn, New York, is the reason why Croatian Danijel Žeželj has a romantic view of his richly endowed sketchbooks. "They are gymnastics in visual narration, remembrances and reconstructions of things I've seen, or exercises in visual thinking, preparations for specific projects," he enthuses.

Are his sketches the first stage to a final, or musings without an end purpose? "They are both," he confirms. "Sometimes sketches begin from the specific idea growing towards the specific end, sometimes they are just free hand improvisations."

They are usually "more expressive, emotional, raw, dirty, and capture life and movement better that anything else I draw," he continues. "Maybe there is always a narrative line behind these drawings, and looking back at old sketchbooks I often find that the entire book has a story in it (although it was drawn over the period of weeks and not planned as a story layout). It is a chaotic, disarranged and crude storyline, but it's there."

Thematically, the human body in motion, and the body versus architecture are frequently rendered. But, more than anything else, these examples from 2010 "are my daily mental exercises, black-and-white ink meditations," he confides.

WEBSITES

SOTOS ANAGNOS hypokondriak.gr	**MANUEL GÓMEZ BURNS** mgomezburns.blogspot.com
CHRIS BATTLE chrisbattleillustration.blogspot.com	**BILL GRIFFITH** zippythepinhead.com/pages/aabillgr.html
LOU BEACH loubeach.com	**ROBERT GROSSMAN** robertgrossman.com
KAYE BLEGVAD kayeblegvad.com	**BENOÎT GUILLAUME** benoitguillaume.blogspot.com
PETER BLEGVAD amateur.org.uk	**CYRIL GURU** www.monsieurbuzz.fr
RUSS BRAUN weirdass.net/pages/2005/gallery/gall_russ.html	**DAVID HEATLEY** drawger.com/heatley
STEVE BRODNER stevebrodner.com	**RIAN HUGHES** devicefonts.co.uk
CHARLES BURNS fantagraphics.com/artist-bios/artist-bio-charles-burns.html	**KEVIN HUIZENGA** usscatastrophe.com/kh
CHRIS CAPUOZZO intergalactico.com	**NATHAN JUREVICIUS** nathanj.com.au
LILLI CARRÉ lillicarre.com	**BEN KATCHOR** katchor.com
SEYMOUR CHWAST pushpininc.com	**DENIS KITCHEN** deniskitchen.com
COLONEL MOUTARDE colonelmoutarde.com	**JAKOB KLEMENČIČ** ljudmila.org/stripcore/bee/jakob
R. CRUMB crumbproducts.com	**THOMAS KNOWLER** knowlerdraws.co.uk
JOHN CUNEO johncuneo.com	**MATEJ KOCJAN** kocominds.blogspot.com
VANESSA DAVIS spanielrage.com	**NORA KRUG** nora-krug.com
KIM DEITCH twinkleland.com/deitch	**OLIVIER KUGLER** olivierkugler.com
JULIE DELPORTE juliedelporte.com	**PETER KUPER** peterkuper.com
ERIC DROOKER drooker.com	**JOSEPH LAMBERT** submarinesubmarine.com/p/about.html
DREW FRIEDMAN drewfriedman.net	**BRENDAN LEACH** iknowashortcut.com

ÉTIENNE LÉCROART e.lecroart.free.fr	**JOHNNY RYAN** johnnyryan.com
MATTHIAS LEHMANN lambiek.net/artists/l/lehmann_matthias.htm	**DAVID SANDLIN** davidsandlin.com
MARTIN LEMELMAN mendelsdaughter.com	**SETH** lambiek.net/artists/s/seth.htm
DAVID LIBENS badaboumtwist.blogspot.com	**PETER DE SÈVE** peterdeseve.com
SÉBASTIEN LUMINEAU lambiek.net/artists/l/lumineau_sebastien.htm	**ROBERT SIKORYAK** rsikoryak.com
PATRICK McHALE vimeo.com/patrickmchale	**POSY SIMMONDS** facebook.com/pages/Posy-Simmonds/112439905438174
MATT MADDEN mattmadden.com	**MARK ALAN STAMATY** markstamaty.com
JAVIER MARISCAL mariscal.com/en	**JIM STERANKO** thedrawingsofsteranko.com
DAVID MAZZUCCHELLI randomhouse.com/pantheon/graphicnovels/catalog/ author.pperl?authorid=83506	**JAMES STURM** cartoonstudies.org
RUTU MODAN modan.blogs.nytimes.com	**JOOST SWARTE** joostswarte.com
SAXTON MOORE sacks10.blogspot.com	**TAKESHI TADATSU** http://web.me.com/tadara
VICTOR MOSCOSO victormoscoso.com	**ANN TELNAES** anntelnaes.com
JOANNA NEBORSKY joannaneborsky.com	**SIMON TOFIELD** simonscat.com
JOSH NEUFELD joshneufeld.com	**JEREMY TRAUM** jeremytraum.com
MARK NEWGARDEN laffpix.com	**CAROL TYLER** bloomerland.com
VLADAN NIKOLIĆ vladanland.daportfolio.com	**ANDRÉS VERA MARTÍNEZ** andresvera.com
GARY PANTER garypanter.com	**LAUREN WEINSTEIN** laurenweinstein.com
BILL PLYMPTON plymptoons.com	**TRACY WHITE** traced.com
MAX DE RADIGUÈS maxderadigues.com	**SIGNE WILKINSON** signetoons.com
LAUREN REDNISS laurenredniss.com	**RUN WRAKE** runwrake.com
ARNOLD ROTH arnoldroth.com	**DEREK YANIGER** derekart.com
MARCEL RUIJTERS troglo.home.xs4all.nl	**DANIJEL ŽEŽELJ** dzezelj.com

ACKNOWLEDGMENTS

I am so grateful to Lucas Dietrich, my editor at Thames & Hudson, for his faith in this and other projects. To Jennie Condell for her compassionate editing. To Ashley Olsson for his always very fine design, predicated on a real interest in the material.

I appreciate the good will of all the artists contacted to be in this book.

Thanks also to Art Spiegelman, who is always an inspiration, for helping me locate some of the artists in this book. To Marshall Arisman, friend and colleague for his help. To Benedikt Taschen for his generosity.

Also, to Louise Fili, thanks for her constant love and support.

Steven Heller

First published in the United Kingdom in 2012 by Thames & Hudson Ltd, 181A High Holborn, London WC1V 7QX

Copyright © 2012 Steven Heller

Extracts from sketchbooks copyright © 2012 the artists and designers

British Library Cataloguing-in-Publication Data
A catalogue record for this book is available from the British Library

ISBN 978-0-500-28994-5

Printed and bound in China by C & C Offset Printing Co. Ltd

To find out about all our publications, please visit
www.thamesandhudson.com. There you can
subscribe to our e-newsletter, browse or download
our current catalogue, and buy any titles that are in print.